To: Erica

A beautiful book for
our beautiful daughter....
may you continue to keep
our earth safe.
Love, Mom and Dad
Christmas 2007

SACRED EARTH

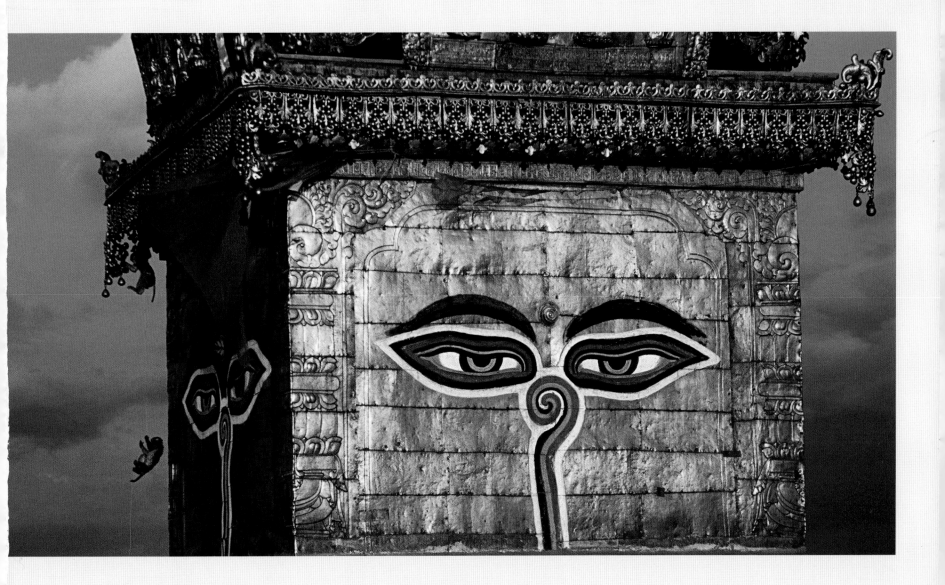

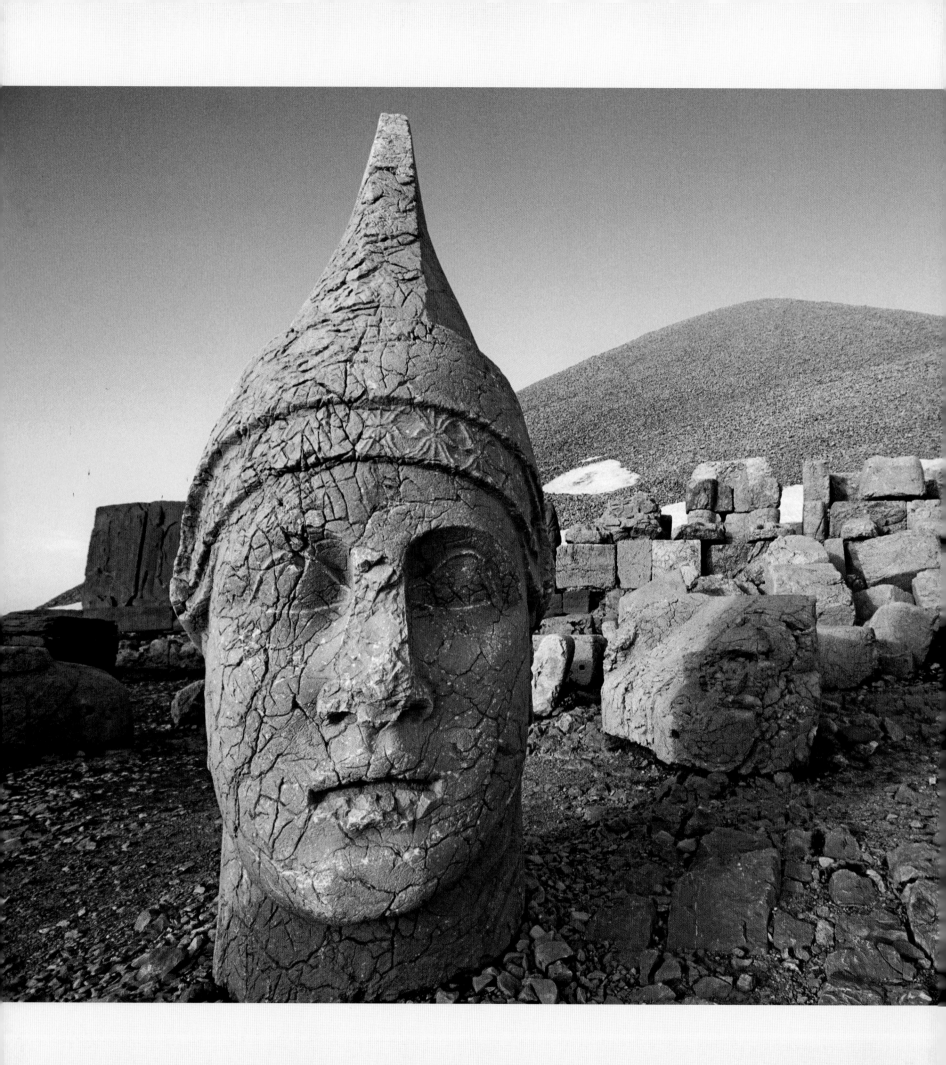

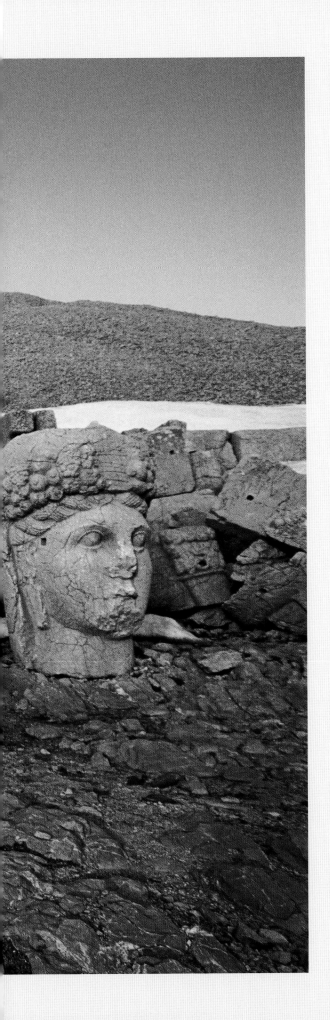

SACRED EARTH

PLACES OF PEACE AND POWER

MARTIN GRAY

FOREWORD BY GRAHAM HANCOCK

STERLING

New York / London
www.sterlingpublishing.com

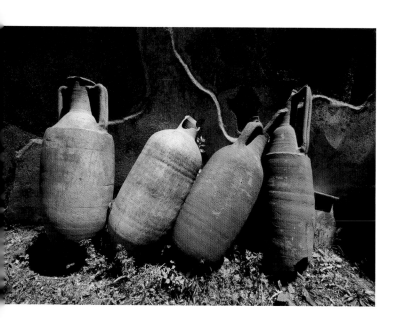

Above:

Ancient urns in Pompeii, Italy

Page i:

Detail of Swayambhunath Stupa, Kathmandu, Nepal

Page ii–iii:

Stone head at Nemrut Dagi, Turkey

STERLING and the distinctive Sterling logo are registered trademarks of Sterling Publishing Co., Inc.

Library of Congress Cataloging-in-Publication Data

10 9 8 7 6 5 4 3 2 1

Gray, Martin.
Sacred earth : places of peace and power / Martin Gray; foreword by Graham Hancock.

p. cm.

Includes bibliographical references and index.
ISBN-13: 978-1-4027-4737-3
ISBN-10: 1-4027-4737-3
1. Sacred space. 2. Pilgrims and pilgrimages. 3. Gray, Martin—Travel. I. Title.

BL580G73 2007
203'.5—dc22

2006100795

Art direction: Edwin Kuo and Rachel Maloney
Book design and layout: Patrica Childers

Published by Sterling Publishing Co., Inc.
387 Park Avenue South, New York, NY 10016
© 2007 by Martin Gray
Maps © 2007 by the National Geographic Society
Foreword © 2007 by Graham Hancock
Distributed in Canada by Sterling Publishing
c/o Canadian Manda Group, 165 Dufferin Street
Toronto, Ontario, Canada M6K 3H6
Distributed in the United Kingdom by GMC Distribution Services
Castle Place, 166 High Street, Lewes, East Sussex, England BN7 1XU
Distributed in Australia by Capricorn Link (Australia) Pty. Ltd.
P.O. Box 704, Windsor, NSW 2756, Australia

Printed in Singapore
All rights reserved

Sterling ISBN-13: 978-1-4027-4737-3
ISBN-10: 1-4027-4737-3

For information about custom editions, special sales, premium and corporate purchases, please contact Sterling Special Sales Department at 800-805-5489 or specialsales@sterlingpub.com.

CONTENTS

FOREWORD

AMONG THE VAST ARCHIVES OF SACRED SCRIPTURES that have come down to us from ancient Egypt, inscribed on the walls of tombs and temples, inside coffin lids, and written on papyrus scrolls, one group of texts in particular stands out for its unusually mysterious and recondite quality. These are the Edfu Building Texts, which were engraved, in the form we see them now, around 200 BCE on the walls of the great Temple of Horus, at Edfu, Egypt. That is a relatively late date in the long history of Egypt, but scholarly study has revealed that both the Temple of Horus and its texts have much older origins. In the case of the temple, archaeological excavations have uncovered traces of a continuous regression of earlier temples that once occupied this site, going back at least as far as the Old Kingdom (2575–2134 BCE). Likewise, internal evidence in the Edfu Building Texts confirms that they were not *composed* in 200 BCE, but were *copied* at that time from a much more ancient, much larger, and much more coherent body of cosmogonical literature—now long lost—that contained a complete mythical history of the foundation of Egypt by the gods and of the temples built to honor them.

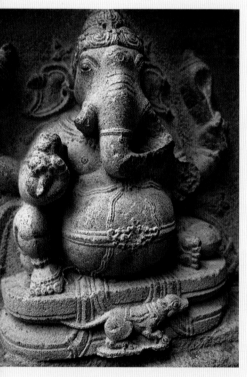
Detail of Ganesh carving, India.

The fragments of this lost mythical history preserved in the Edfu Building Texts contain intriguing references to a remote epoch—the "Early Primeval Age"—when a mysterious group of beings called the "builder gods" were believed to have settled in Egypt. It seems that their former homeland had been destroyed in a flood (so they were refugees, these builder gods), and we're told that the first thing they did once they arrived in Egypt was build "sacred mounds" at various latitudes along the Nile, among them the "Great Primeval Mound," associated by many scholars with the Great Pyramid of Giza, which—significantly—is built on top of a natural rocky mound. It is highly relevant to the theme of Martin Gray's present work that these mounds—great and small—with which the builder gods busied themselves were explicitly created to serve as *the foundations of all future temples to be built in Egypt*. There is even a reference in the Edfu Building Texts to a lost book called the *Specifications of the Mounds of the Early Primeval Age!* So there is a sense that this was an organized and systematic project, and indeed we learn that the development of "primeval mounds" into temples and pyramids was intended to bring about nothing less than "the resurrection of the former world of the gods."

But why would the builder gods have chosen one location over another—this place rather than that—in deciding where to site their mounds? And why was so much importance given to the task of surveying and setting out these mounds at all? In his superb photo-pilgrimage, taking us to many ancient sacred sites all around the world, Martin has put his finger—and his camera—on the answers to these questions. True sacred sites—as opposed to "whited sepulchres"—are sacred not because men have said they are so, and not even because of the majesty of the architecture that may (or may not) adorn them, but *purely and simply because of the uncanny energetic powers of the places on which they stand*. It also seems to be the case that these uncanny powers wax and wane with the seasons, rising in strength at certain special times of the year and dying down at others. It is here that the astronomical alignments of temples and pyramids come into play—telling us by their orientation when we may expect to find them at their most potent, when the gods who animate them return to walk among us.

Human consciousness is a great mystery, perhaps the ultimate mystery confronting science today. We do not know what it is or where it comes from. Reductionists argue that it is merely an epiphenomenon of brain activity—that it is generated by the brain and that when the brain dies, consciousness dies also. But it is important to be clear that this is an opinion, not a fact. It may equally well be the case that the brain is a *receiver* of consciousness—as virtually every religion in the world has taught since we first had religions, and as increasing numbers of leading neuropsychologists are prepared to contemplate. In that case, when the receiver dies, consciousness does *not* die with it but instead continues on in non-physical realms and dimensions.

This notion of the brain as a receiver rather than a generator of consciousness offers a completely new explanation for an important category of universally reported human experiences—namely the experiences of encounters with spirit worlds and supernatural beings that have provided the initial impetus and inspiration for all the world's religions. Instead of being mere hallucinations, much new evidence suggests that these visionary encounters may be veridical, or genuine experiences of freestanding parallel realities that become accessible to consciousness only when the receiver wavelength of the brain is retuned.

Some individuals—apparently around 2 percent of every population—can enter into deep, visionary states spontaneously. For the rest of us, many different techniques have been developed by the shamans of tribal and hunter-gatherer societies over hundreds of centuries to allow us to put ourselves into such states at will. These techniques include fasting and other austerities, the consumption of powerful vision-inducing plants (such as ayahuasca—a hallucinogenic beverage made from the bark of a South American vine—peyote, and

psilocybin mushrooms), meditation, the use of rhythmic dancing and certain kinds of music, and sensory deprivation, among other techniques. Additionally, the shamans of all periods and cultures have paid special attention to the *power of place*—to the repeated experience that in certain locations, for unknown reasons, the veil between realms becomes thin, and supernatural encounters are facilitated.

Could it be that what is happening in such places is that a subtle energy, perhaps one that is entirely undetectable by modern scientific instruments, retunes the receiver wavelength of the brain just as effectively as forty days of fasting or the consumption of ayahuasca? Could this be the explanation for haunted houses— an ethereal vibration that alters human consciousness and allows us to perceive realities that are normally inaccessible to us? Could this be why fairies and elves, and more recently their modern counterparts known as aliens, are very frequently reported to have been seen around great megalithic stone circles? Could this be why large numbers of us who have had the opportunity to spend time in the Great Pyramid of Giza, or in the numinous temples dotted along the banks of the sacred Nile, or at Angkor, or amid the megalithic ruins of the Andes, or in the great Gothic cathedrals of Europe, have experienced profound spiritual encounters there?

As Martin's photographs show, there was an ancient science of place that has left its fingerprints in carefully nurtured sacred sites all around the world. These sites are a legacy to us from wise ancestors, and by working on us at the level of consciousness, they offer us the prospect of reunion with the larger, undiscovered, part of ourselves.

—GRAHAM HANCOCK
EXPLORER AND AUTHOR OF *THE SIGN AND THE SEAL,*
FINGERPRINTS OF THE GODS, AND *HEAVEN'S MIRROR*

The Pilgrim
My Journeys

WHEN I WAS A YOUNG BOY, I BEGAN TO EXPERIENCE remarkable inner visions of something I might do when I grew to be a man. Inspired by these visions, I yearned to serve one day as a paintbrush in the hand of God, to express beauty and goodness in the world. That yearning has guided my life during the past four decades and has resulted in the book you now hold in your hands.

National Geographic magazine awakened my early enchantment with photography and archaeology. From the age of eight, I dreamed of becoming an explorer and photographer in exotic lands. When I was twelve, my father's work took our family to India for four years. During those years, I traveled frequently, alone and in the company of pilgrims, to the temples, mosques, and sacred caves of India, Nepal, and Kashmir. Reading of Hinduism and Buddhism, and fascinated by the mysterious allure of these religions' sacred places, I thought of one day producing a photography book of the great Asian pilgrimage shrines.

After my family's return to the United States, I entered the University of Arizona and began studying Mesoamerican archaeology. But the call of the spiritual quest was strong in my heart, and I soon returned to India. While traveling there, I became a member of a monastic order and for the next ten years, in India and the West, cultivated a deep practice of meditation.

Carving of monk reaching to heaven, Wu Tai Shan Temple, China.

The rule of no realm is mine …
But all worthy things that are in peril as the world
now stands, those are my care. And for my part,
I shall not wholly fail in my task if anything passes
through this night that can still grow fair or bear
fruit and flower again in days to come.
For I too am a steward. Did you not know?

—GANDALF, FROM ***The Lord of the Rings*** (1954–55),
J.R.R. TOLKIEN

At the age of twenty-eight, I left monastic life behind, returned to the States, and started a travel business. Within two years my company was sending hundreds of people to the Caribbean and Mexico, and I was becoming a successful businessman. Yet I felt a sense of emptiness, for I yearned to do something more aligned with my spiritual ideals. My prayers were answered in a most unexpected way. While meditating one evening, I had a visionary experience in which I saw an image of the stone heads on Easter Island and received a message saying, "Go here and you will begin to find the answers to your prayers." Traveling to South America, I had two more visionary experiences. At Easter Island I was told to "follow the pilgrimage routes of the ancient religions," and at Machu Picchu in Peru, I was directed to begin my pilgrimage in Japan.

So compelling were these visionary experiences that I sold my business and began a twenty-year period of traveling as a wandering pilgrim to more than one thousand sacred sites in eighty countries around the world. Often traveling by bicycle and staying at temples, monasteries, and on sacred mountains, I conducted extensive mythological and anthropological research, as well as photographic documentation, of the holy places. Along the way, at sacred sites of both ancient and contemporary religions, I continued to experience visions regarding my pilgrimage.

The effects these visions produce in the soul are: quietude, illumination, gladness resembling that of glory, delight, purity, love, humility, and an elevation and inclination toward God.

—St. John of the Cross

My journeys to these places were pilgrimages in the real sense of the word. The term *pilgrimage* means much more than common travel. In its original and pure meaning, *pilgrimage* describes a spiritual journey to a site, or set of sites, invested with sanctity by tradition. Pilgrimage is exterior mysticism, while mysticism is internal pilgrimage. My journeys were an inner exploration of my heart, mind, and soul. While I was concerned with the scholarly study and photography of the sacred places, my primary intention was always to interact with the sacred sites as a pilgrim.

Carving of forest sage with disciples, Temple of Phra That Phutthabat Bua Bok, Thailand.

To gather information on the sacred sites, I used two methods: the objective method of the scientist and the subjective method of the mystic or shaman. Neither method is an inherently better way of knowing; rather, each offers a different view of what is essentially a unitary reality. While both methods are valuable and complementary, in today's world the scientific method is dominant, and the mystic's approach is often forgotten. Mystical experience, however, offers a means of gathering information beyond the realm of scientific instruments, for its source is the direct and personal experience of the sacred.

We know ourselves to be made from this earth. We know this earth is made from our bodies. For we see ourselves. And we are nature. We are nature seeing nature. We are nature with a concept of nature. Nature speaking to nature of nature.

—SUSAN GRIFFIN, PHILOSOPHER AND POET

In applying this dual approach—both objective and subjective—to the study of holy places, I have done something rare. Many anthropologists and cultural geographers studying the institution of pilgrimage visit only a limited number of sites, while doing the bulk of their research in libraries. To write knowingly about sacred sites and pilgrimage traditions of the world, it is essential for the researcher to have personally traveled as a pilgrim and visited a large number of holy places. And the experience of pilgrimage to sacred places is certainly enriched by a parallel journey through their mythology and history. To achieve this, I examined and read more than 1,500 sources of information: books, journals, and academic dissertations. This material ranged widely and included mythology, earth sciences, astronomy, archaeology, anthropology, ethnology, folklore studies, shamanism, comparative religion, geomancy and sacred geometry,

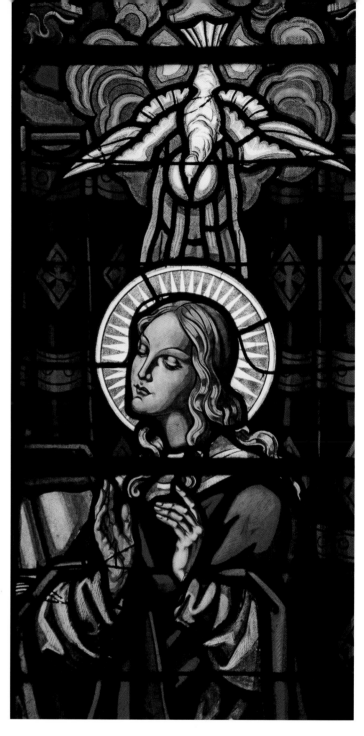

Stained-glass window of the Virgin Mary, European medieval cathedral.

hagiography, parapsychology, and mysticism. Combining this scholarly study with my long-term pilgrimage experience allowed me to make conceptual leaps of understanding, which I share in these pages.

There were three primary reasons for my pilgrimage to the world's sacred sites. The first reason was to gather evidence showing that many pre-industrial cultures recognized the earth as a sacred being worthy of deep respect. Studying the development of sanctity at

sacred sites, I realized that some ancient peoples had a reverential relationship with the living earth. If such a relationship can be reawakened and encouraged in our own times, we will be better able to address the crisis of worldwide ecological degradation.

The second reason for my travels was to document photographically the world's great sacred architecture before it is lost to the ravages of modernization and industrial pollution. Sacred architecture represents the most sublime example of humanity's artistic expression. Because of their outdoor locations, however, many of these great art pieces do not receive the protection that paintings and sculptures receive in environmentally controlled museums. Through the international presentation of my photographs, I hope to stimulate increased public and government awareness of the value and fragility of these wondrous works of art.

The third reason was to study the miraculous phenomena reported at sacred sites around the world. There is indeed a density of holiness that saturates and surrounds the locality of pilgrimage places, and this holiness, or field of energy, contributes to a variety of beneficial human experiences. The living earth has much to teach, and the ancient sacred sites are classrooms where this instruction is abundantly given.

Since 1984, I have explored the planet extensively, gathering knowledge that, I believe, is significant to the well-being of the earth and to humanity. During the past twenty years, I have communicated this knowledge by presenting slide shows to more than 125,000 people in the United States, Latin America, Europe, and Asia. In 1997, I started the Web site SacredSites.com, and by 2005 more than nine million people had visited the site to view the photographs and read the accompanying essays.

Sacred Earth: Places of Peace and Power is a visual meditation, a passionate prayer, and an expression of loving gratitude. My purpose in creating this book has been to share the teachings I received as a wandering pilgrim passionately in love with the earth. Perhaps these words and photographs will inspire you to travel. Perhaps they will inspire you to love and respect this wonderful earth in new and meaningful ways—ways that open your own conscious awareness to the gifts of the planet to you and all beings. This is my hope and prayer, and my deepest intention in writing and creating this book.

I do not know what your destiny will be, but one thing I know: the only ones among you who will be truly happy are those who will have sought and found how to serve.

—ALBERT SCHWEITZER

—MARTIN GRAY

Painted stone sculpture of the Hindu deity Hanuman, Mt. Girnar, India.

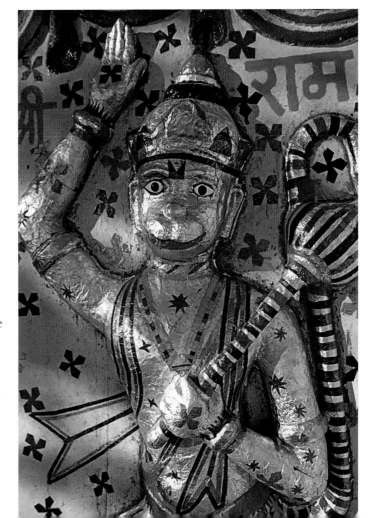

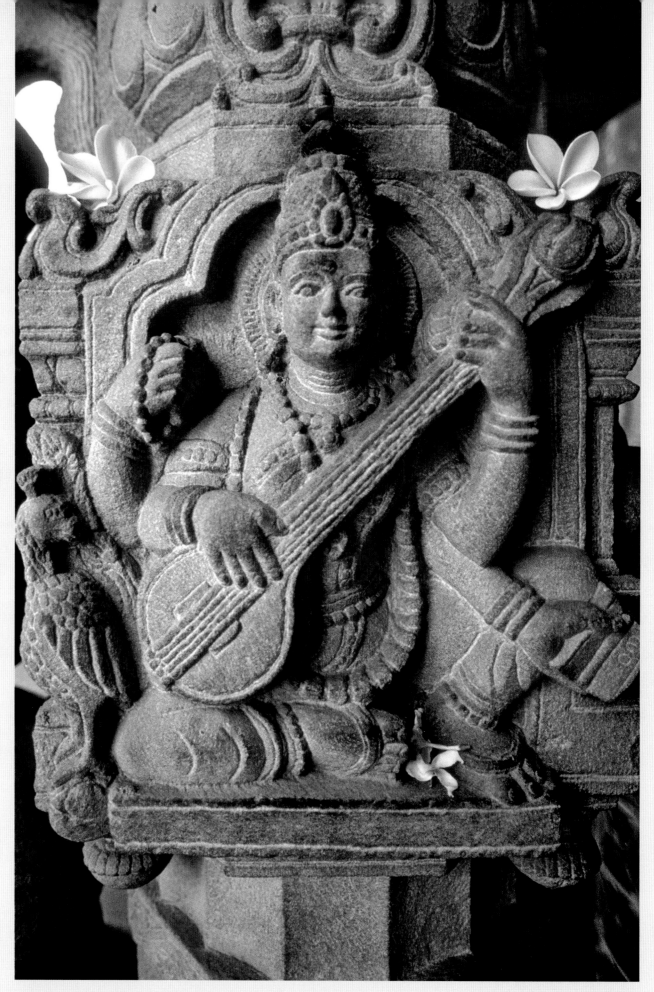

Stone carving of the goddess Saraswati, Srisailam, Andhra Pradesh, India.

The Power of Place
Sacred Sites and the Presence of the Miraculous

LONG BEFORE THERE WERE RELIGIONS, there were regions of the earth. Early people, following herds of animals, wandered these regions as hunters and gatherers. Walking over large areas of land and in tune with the vital earth, they occasionally discovered certain power places, perhaps a spring, a cave, or a mountain, or maybe a site that had no remarkable visual appearance. Yet these places had a mysterious power, a numinosity, and a spirit. Because of this quality, ancient people began to mark these magical places in different ways, often with piles of stones, so that the sites might be seen from a distance if other humans passed by in years to come. With the continuing seasonal movements of the animal herds, the early nomads moved too, thereby gradually discovering more and more power places on the living earth.

Eventually, at different times and places, early humans learned to grow their own crops and to domesticate animals. Now, for the first time ever, they could settle in permanent locations. Where did they settle? What sites did they choose? Archaeological excavations reveal that these people often settled at or near those potent power places first discovered by their wandering ancestors. These first groupings of people were small, as we know from studies of more recent nomadic settlers. Yet the groups grew in size to become clusters of huts, then villages, then towns, and then cities such as Paris, Mexico City, London, Lima, Cairo, and Calcutta. As the social centers grew, so did people's awareness of the characteristics of the power places. These magical focal points, through their mysterious powers, affected people in different ways. This was noticed and talked about, and slowly, over long periods of time, myths arose in the descriptions of the power places.

Living at or near these sites and feeling their energy on a daily basis, people began to notice that there were temporal fluctuations to the power of place. During the course of the yearly cycle, there were periodic increases and decreases of the localized energy. Wondering about this cyclic fluctuation of the earth spirit, early humans noticed a relationship between the positions of different celestial bodies and the amplification of the power of a place. Slowly they understood that the sun and the moon had a periodic influence upon the emanations of earth spirit at the power places.

Desiring to know of these charged periods in advance of their arrival, humans began to observe the night skies with greater attention. To observe with precision, they had to innovate and construct astronomical observation devices. These were quite simple in design yet extremely accurate in function: purposeful arrangements of individual standing stones that made it possible to set up sight lines pointing toward the horizons. These sight lines were used to monitor carefully the rise and fall of different celestial bodies along the horizons.

Different places on the face of the earth have different vital effluence, different vibration, different polarity with different stars: call it what you like, but the spirit of place is a great reality.

—D. H. LAWRENCE

Cycles of Heaven

Early humans recognized that the sun and the moon had different cycles, so specific arrangements of stones were set up to monitor those cycles. Perhaps the first cyclic period discovered was that of the sun. During the course of the year, the sun was observed to rise and set at different positions along the horizon. This annual back-and-forth movement of the sun—north, then south, then north

again—repeats endlessly over the passage of centuries. The most northerly and southerly rising and setting positions are called the solstices. *Solstice* is a Latin word meaning "sun stands still," and this is exactly what appeared to happen twice each year. For a few days in between its northerly and southerly passage, the sun seemed to stop its movement and to rise and set in the exact same position. These periods became the two most important times of the year for ancient people. Throughout the ancient world, countless myths speak of energies or spirits being more present during these phases.

The next most important periods of the sun's movement were the equinoxes. An equinox (Latin for "equal night") signified the biannual period when day and night were of equal duration. These equinoctial times were also determined with the standing stones by watching the shadows and their relationship with the yearly movement of the sun across the sky. These equinoxes were midway between the two solstices; thus, ancient humans observed a division of time into four nearly equal periods. From this observation of celestial cycles, and the resulting periodic fluctuation of earth spirit energies, came the earliest protoreligious festivals of humankind. In later eras, these four periods would become associated with agricultural planting and harvesting. Yet long before the development of agriculture, humans were watching the heavens and observing their effects upon the earth (diagram left).

With the passage of time, humans became ever more interested in celestial mechanics and developed increasingly sophisticated observational devices with which to watch the sun, moon, stars, and planets. All across the globe, spanning many different archaeological epochs, people created a variety of structures that functioned both as astronomical observation devices and spiritual temples. Numerous examples can be found in different cultures, from Europe, Asia, and Africa to the Americas. Some of the oldest and most mathematically advanced examples were those created by the megalithic (great stone) culture of

SUMMER SOLSTICE
JUNE 21
Pagan midsummer day festivals usurped by Fête-Dieu (Corpus Christi), June 19, and St. John's Day, June 24

CROSS QUARTER
MAY 1
Celtic Beltane fire festival supplanted by Christian May Day and Ascension Day

CROSS QUARTER
AUGUST 8
Pagan summer abundance/harvest festivals of Lughnasadh and Diana supplanted by Christian festival of the Assumption of the Virgin Mary

SPRING EQUINOX
MARCH 21
Pagan equinox festivals and Roman Carnival of Hilaria in honor of the mother goddess Cybele supplanted by Christian festival of Annunciation, March 25

AUTUMN EQUINOX
SEPTEMBER 21
Pagan equinox celebration festivals taken over by Michaelmas Day, September 29

CROSS QUARTER
FEBRUARY 4
Pagan festivals of returning light, Lupercalia, and Imbolc usurped by Christian festival of Candlemas, February 2

CROSS QUARTER
OCTOBER 31
Pagan Samhain (Halloween) festival usurped by Christian festivals of All Saints, November 1, and All Souls, November 2

WINTER SOLSTICE
DECEMBER 21
Pagan festivals of Saturnalia, Lussi, and Mithras usurped by Christian festival of Christmas, December 25

Pagan-Christian Solstice-Equinox Calendar

The solstices and equinoxes were key astrological periods for early pagan people. This diagram shows the original pagan festivals celebrated on the solstices and equinoxes, along with the Christian religious festivals that later supplanted them.

Europe, which existed from approximately 4000 to 1500 BCE. From Scandinavia to Iberia, several types of structures exist that have astronomical and ceremonial functions, including single or multiple standing stones known as menhirs and dolmens, respectively; enormous earthen mounds with rock-lined passages and hidden chambers; and the stunningly beautiful stone rings, of which Stonehenge and Avebury are the most famous examples.

More than nine hundred stone rings exist in the British Isles, and scholars estimate that twice that many may originally have been built. Research conducted over the past thirty years, combining insights from archaeo-astronomy, mythology, and geophysical energy monitoring, has demonstrated that the stone rings functioned as both astronomical observation devices and ceremonial centers. The recent scientific recognition of megalithic stone rings as astronomical observatories is the accomplishment of Alexander Thom, a professor of engineering at Oxford University. In 1934, Thom began meticulously surveying megalithic sites. By 1954, he had surveyed and analyzed more than six hundred sites in Britain and France and had begun to publish his findings. Initially his claims were not well received. Professor Thom was not an archaeologist but an engineer, and the archaeological community did not welcome what they considered to be the heretical views of an untrained outsider.

Thom's evidence, however, could not be dismissed. Both overwhelming in quantity and highly accurate in presentation, it indisputably demonstrated the astronomical knowledge, mathematical understanding, and engineering ability of ancient megalithic people. Indeed, these abilities were so advanced that they surpassed that of any European culture for more than four thousand years. Thom's books, *Megalithic Sites in Britain* (1967) and *Megalithic Lunar Observatories* (1971), show with certainty that megalithic astronomers knew the yearly cycle to be

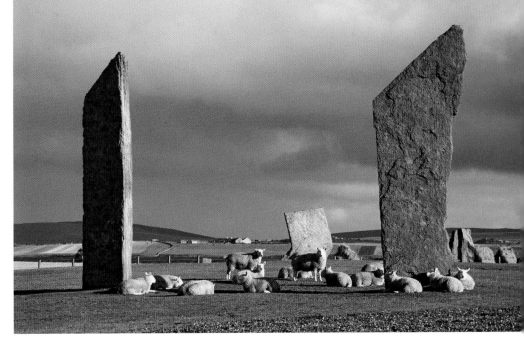

Megalithic stones
Stenness, Scotland.

a quarter of a day longer than a year of 365 days, and that they recognized the precession of the equinoxes and the various cycles of the moon, which allowed them to predict eclipses accurately. Furthermore, these megalithic builders were keen engineers and architects, skilled in advanced geometry two thousand years before Euclid recorded the Pythagorean triangle theorems and more than three thousand years before the value of pi (3.14) was discovered by Indian and Egyptian mathematicians. These ancient builders surveyed sites with an accuracy equal to that of a modern theodolite (a surveying instrument). These ancients also developed a unit of measure—the megalithic yard of 2.72 feet (83 cm)—that they used in stone monuments from northern Scotland to Spain with an accuracy of ± 0.003 feet, or about $1/28$ inch (0.9 mm).

Simply stated, many of the megalithic stone structures are situated at places with measurable geophysical anomalies (the so-called earth energies) such as localized magnetism, geothermal activity, specific minerals, and the presence of underground water. While there is nothing paranormal about these forces, what is fascinating is that ancient people located the specific sites where these energies were present. For reasons still not fully under-stood, these energies seem to fluctuate in radiant intensity according to the cyclic influences of different celestial bodies (primarily the sun and the moon but

also the planets and the stars). The architectural configurations of the megalithic structures were designed to determine those particular periods of increased energetic potency at the sites, and those periods were then used by people for a variety of healing, spiritual, and oracular purposes.

The tradition of pilgrimage in megalithic times consisted of people traveling long distances to visit sites known to have specific powers. Due to the absence of historical documentation from the megalithic age, many assume that we cannot know how different power places were used, but this is a limited view based on the mechanistic rationality of modern science. An analysis of relevant mythology, however, reveals that the legends and myths of sacred sites are in fact clear messages indicating the magical powers of these places.

Festivals of Regeneration

Students of mythology and cultural anthropology will be familiar with the fact that many ancient cultures held festivals on the solstices and equinoxes. The most common interpretation of these festivals is that they were symbolic occasions for renewal—the renewal of the people and the land by the celestial powers, as well as the renewal of the land and the celestial beings through the agency of human intention and celebration. The interpretation usually stops there. Discussion may continue regarding the characteristics of the festivals or their sociological function of contributing to the bonding of a particular cultural group, but a deeper or more comprehensive interpretation concerning the times and original purpose of the festivals is rarely pursued. Why would this be so? The answer is quite simple.

Nearly all scholars and writers possessing the academic knowledge to be able to discuss ancient cultures

> *It is a fact that myths work upon us, whether consciously or unconsciously, as energy-releasing, life-motivating, and directing agents.*
>
> —JOSEPH CAMPBELL

and their mythologies have acquired that knowledge while spending their lives in towns or cities, removed from the very land-based experience that allows a sensory, or felt, understanding of the subtle energy rhythms of the natural world. In other words, the tendency of modern urban- and suburban-based life to isolate people from the natural world automatically instills and perpetuates a bias that often limits anthropologists and archaeologists (and most everyone else) from *experientially* understanding the nature-based life of Neolithic cultures. We moderns may, with sometimes quite admirable scholarship, catalog the behaviors of the ancients, yet a deep appreciation of the motivations and meanings of those behaviors often eludes us. This is especially true regarding the festivals of renewal that occurred on the solstices and equinoxes at power places.

Prehistorians and archaeologists often speak about the myths of renewal in ancient cultures, but to the ancient people their festivals were not symbolic celebrations of myth but rather celebrations of their *current reality*. That reality, and the focus of events in celebration of it, was profoundly influenced by the periodic energetic effects of solar, lunar, and stellar cycles on human beings, the animal kingdom, and the earth itself.

Stars, Deities, and the Power of Place

An archaeoastronomical study of numerous ancient sites around the world reveals that a variety of stars and star constellations exerted significant influences on the development of religious cosmologies. In Old Kingdom Egypt, astronomers keenly observed the stars and precisely aligned a multitude of temples with the Orion constellation and Gamma Draconis, while the Dogon culture of West Africa had a particular fascination with the three stars of the Sirius system. In addition to their

remarkable solar alignments, many of the Khmer temples at Angkor in Cambodia display an enigmatic terrestrial resonance with the Draco and Corona Borealis constellations. In Europe, researchers have shown that the round towers of Celtic monasteries throughout Ireland are positioned to represent the location of certain stars.

Across the Atlantic, a number of native cultures also watched the heavens and fashioned structures to mark particular periods. The Mayans of Mexico, besides developing some of the most accurate calendrical systems of the ancient world, were deeply concerned with the movements of Venus, planetary conjunctions, and the slowly changing relationship of the earth with the galactic center. Andean cultures such as the Inca were fascinated by the constellation of Scorpius and its relation to the plane of the ecliptic (the imaginary plane containing the earth's orbit around the sun), the rise of the Pleiades, and the constellations of Vega and the Southern Cross. Even the nomadic tribes of North America built astronomical observation devices, commonly called medicine wheels, which indicated the solstices and equinoxes as well as the rise of stars like Aldebaran and Rigel.

Why were the myths and legends of so many ancient cultures associated with these types of celestial phenomena? Furthermore, why were particular stars often associated with certain types of deities? Could it be possible, in some mysterious way, that different celestial objects and their cycles of movement might exert subtle influences on human behavior and evolution? In support of this notion, it is useful to bring attention to the unimaginably old practice of astrology, which has evolved in variant forms around the world but always as a descriptive analysis of how the sun, moon, and different stars influence human behavior.

Another important matter to ponder is why certain shrines were dedicated to either feminine or masculine deities. In ancient China, for example, feng shui (pronounced *fung shway*) geomancers spoke of the yin (feminine) and yang (masculine) essence of power places. In early Buddhism we find feminine and masculine bodhisattvas called Guan Yin and Manjushri. And in many geographical regions, there are sacred mountains and holy wells dedicated to either feminine or masculine deities. Seeking an explanation, various scholars have suggested that feminine and masculine deities may be mythic expressions of the subtle gender-specific energies of different sacred places. While contemporary science has

Stone carving of the goddess Shakti, Srisailam Temple, Andhra Pradesh, India.

not yet authenticated this explanation, it is vital to realize that everywhere across the ancient world, a wide variety of cultures dedicated their sacred places to feminine and masculine deities.

Additionally, the matter of different energetic characteristics at power places sometimes went beyond a mere categorization of deities according to gender. Hinduism and other mythically rich religions give specific tales from the lives of deities. These tales are

extremely important because they function as more precise indicators of the distinct power of a place. The deities, be they feminine or masculine, lived long lives and exhibited a variety of behaviors. In light of this, the crucial questions are, Where exactly did the particular mythic actions of the deities occur, and what were those actions? The legendary material associated with different deities may, if properly decoded, indicate specific ways that certain power places will affect human beings. While most deities are considered to be a manifestation of one universal spirit, some of them also express distinct visual and mythic messages indicating the unique energetic characteristics of the sacred sites with which they are associated. My own experience is that the sacred sites of different deities are source points of particular energetic frequencies. Because of this, it is beneficial to understand the deeper meaning of deity mythology, learn about the types of sites associated with different types of deities, intuitively recognize which sites might enhance well-being, and then go on a pilgrimage to such sites.

In all such qualities those places excel, in which there is a divine inspiration, and in which the gods have their appointed lots and are propitious to the dwellers in them.

—Plato

Sacred Geography

As we discover power places in the ancient world and become familiar with them, we become conscious of the existence of clusters of power places within specific geographical regions. This is known as sacred geography, which may be defined as the regional, or even global, geographic positioning of sacred places according to various mythological, symbolic, astrological, geodetic, and shamanic factors.

Perhaps the oldest form of sacred geography, and one that has its genesis in mythology, is that of the Aborigines of Australia. According to Aboriginal legends, in the mythic period of the beginning of the world known as Dreamtime, ancestral beings in the form of totemic animals and humans emerged from the interior of the earth and began to wander over the land. As these Dreamtime ancestors roamed the earth, they created features of the landscape through such everyday actions as birth, play, singing, fishing, hunting, marriage, and death. At the end of Dreamtime, these features hardened into stone, and the bodies of the ancestors turned into hills, boulders, caves, lakes, and other distinctive landforms. These places, such as Uluru (Ayers Rock) and Kata Tjuta (the Olgas Mountains), became sacred sites. The paths the totemic ancestors had traveled across the landscape became known as dreaming tracks, or songlines, and they connected the sacred places of power. The mythological wanderings of the ancestors thus gave the Aborigines a sacred geography, a pilgrimage tradition, and a nomadic way of life. For more than forty thousand years—making it the oldest continuing culture in the world—the Aborigines followed the dreaming tracks of their ancestors.

Another example of sacred geography, which derives from the realm of the symbolic, may be found in the landscape mandalas of Japanese Shingon Buddhism. Used as aids in meditation by both Hindus and Buddhists, mandalas are geometric arrangements of esoteric symbols or symbolic representations of the abodes of various deities. Drawn or painted on paper, cloth, wood, or metal

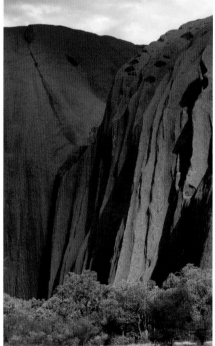

Detail of Ayers Rock, Uluru–Kata Tjuta National Park, Australia.

and gazed upon by meditators, mandalas are normally no more than a few square feet in size. On the Kii Peninsula in Japan, however, Shingon Buddhists projected mandalas over enormous geographical areas from as early as 1000 CE. Considered to be symbolic representations of the residence of the Buddha, these landscape mandalas produced a sacred geography for the practice and realization of Buddhahood. The mandalas were projected upon a number of pre-Buddhist (Shinto) and Buddhist sacred mountains, and monks and pilgrims traveled from peak to peak, venerating the Buddhas and bodhisattvas residing on them.

A fascinating form of sacred geography practiced in ancient China, feng shui, was a mixture of astrology, topography, landscape architecture, pre-Taoist mythology, and yin-yang magic. (It should be noted that the forms of feng shui currently practiced in the United States and Europe often show little relation to the original traditions of ancient China.) Beginning as early as 2000 BCE, the Chinese conducted topographical surveys and interpreted landforms according to feng shui philosophy. Feng shui, which literally means "wind water," was the practice of harmonizing the vital energy, or chi, of the land with the chi of human beings for the benefit of both. Temples, monasteries, dwellings, tombs, and seats of government were established at places with an abundance of good chi.

Astrology has also been the basis of sacred geographies found in different parts of the world. In an undeniable though currently little-perceived way, the Phoenicians, Hittites, Greeks, Etruscans, and Romans created a vast sacred geography indicating correspondences between the constellations of the zodiac and the positioning of temple sites on the ground. Studies reveal immense astrological zodiacs overlaid on the mainland and islands of Greece. With central points at such sacred sites as the island of Delos, Athens, and the oracle of Delphi (and also at the oracle of Siwa, in

Egypt), the zodiacs extended across the lands and seas, passing through numerous important pilgrimage centers of great antiquity.

Several sacred geographies have their basis in geodesy, a branch of applied mathematics concerned with the dimensions of the earth and the location of points on its surface. The early Egyptians were masters of this science. The prime longitudinal meridian of pre-Dynastic Egypt was laid out to bisect the country precisely in half, passing from Behdet on the Mediterranean coast through an island in the Nile near the Great Pyramid all the way to where it crossed the Nile again at the Second Cataract. Cities and ceremonial centers were purposely constructed at distances precisely measured from this sacred longitudinal line.

We also find tantalizing evidence of landscape geometries in Europe, where researchers have found linear arrangements of ancient sacred sites over long distances. Sometimes called ley lines, they were first brought to the attention of modern-day people by the British antiquarian Alfred Watkins with the publication of his book *The Old Straight Track* in 1925. These enigmatic lines are particularly evident in England, France, Italy, and Greece. Still another example, in the Languedoc region of southern France, is a complex arrangement of pentagons, pentacles, circles, hexagons, and grid lines laid out over some forty square miles (about 100 sq km) of territory. Ancient builders erected a vast landscape temple, situated around a natural and mathematically perfect pentagram of five mountain peaks, whose component parts were precisely positioned according to the arcane knowledge of sacred geometry.

Finally, we must also consider the enigma of the straight lines left on the landscape by ancient cultures in the Western Hemisphere. Examples include the Nazca

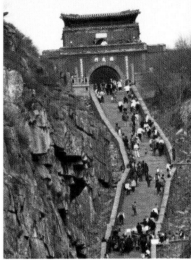

Detail of temple on top of the Stairway to Heaven, Tai Shan, China.

lines in Peru, similar lines on the altiplano deserts of western Bolivia, and the extensive linear markings left by the Anasazi people in the vicinity of Chaco Canyon in New Mexico.

Perhaps the most astonishing matter concerning many of these landscape geometries is that they show signs of having originated from an even more ancient, though now lost, sacred geography that spanned the entire globe. In support of this controversial notion, a number of maps dating from the European medieval era still exist. Among them are the Orontius Finaeus Map (named after the French cartographer Oronce Finé, who created it in 1530), the Piri Reis Map (created by an Ottoman naval captain of the same name in 1513), and also the portolans (port-to-port navigational charts). These maps accurately depicted hundreds of miles of coastlines in South America long before those areas were charted by Europeans in the eighteenth century. Even more intriguing, the maps show the coastline of Antarctica before it was covered by ice. Many of the maps contain written notes indicating that they were *copied from much older maps* whose sources are unknown. Many scholars believe that these astonishing maps suggest the existence of an advanced culture that explored and charted the planet a time long before recorded history.

Sacred Geometry

Any discussion of the sacred geographical arrangement of temple sites upon the land must also mention the sacred geometry with which many of those temples were constructed. Certain naturally occurring shapes and forms are mysteriously pleasing to the human eye, such as the graceful swirl of a nautilus shell, the crystalline structures of the mineral kingdom, and the remarkable patterns found in snowflakes and flowers. However, the subject matter of these forms is not the

only thing that captures our attention. Equally important are the proportional arrangements of the individual parts comprising the total form.

The same is true with certain works of art, such as classical paintings. The positioning of elements within the frame of a painting was considered as important as the subject matter itself. Late medieval and Renaissance painters laid out the basic composition of their paintings according to the mathematical principles of the golden ratio, or phi—a geometric ratio occurring throughout the natural world that the ancients believed to be a divine proportion. European classical painters are said to have inherited these positioning formulas from the Greeks and Arabs, who in turn received them from the ancient Egyptians. The Egyptians and other cultures of antiquity derived these formulas by observing the natural world.

The English writer Paul Devereux explains sacred geometry in a most lucid way in his book *Earth Memory* 1992:

The formation of matter ("dense energy") and the natural motions of the universe, from molecular vibration through the growth of organic forms to the spin and motion of planets, stars, and galaxies, are all governed by geometrical configurations of force.

He goes on to discuss how his geometry of nature is the essence of the sacred geometry used in the design and construction of so many of the world's ancient sacred shrines. These shrines encode ratios of creation and thereby mirror the universe. Certain shapes found in ancient temples, developed and designed according to the mathematical constants of sacred geometry, actually gather, concentrate, and radiate specific modes of vibration. For example, a particular structural geometry and the precise directional orientation of a pyramid completely alter the electromagnetic properties

of the space contained within the pyramid. Three-dimensional structure and vibration are absolutely, though mysteriously, connected. This is well known to makers of musical instruments. It was also known to the makers of ancient temples. Certain shapes resonate to cosmic frequencies too fine to be registered on the electromagnetic spectrum. The fineness of the vibration is the key to their powerful effect. It is similar to the concept behind homeopathy, where the slighter the application, the greater the response.

Fundamentally, sacred geometry is simply the ratio of numbers to each another. When such numerical ratios are incorporated into three-dimensional form, we have the most graceful and alluring architecture in the world. Goethe once said, "Architecture is frozen music." He was describing the relationship between musical ratios and their application to form and structure. An ancient Hindu architectural sutra says, "The universe is present in the temple in the form of proportion." Therefore, when you are within a structure fashioned with sacred geometry, you are within a model of the universe. The vibrational quality of sacred space thus brings your body, your mind, and, at a deeper level, your soul into harmony with the universe.

Sacred Sites and the Historical Religions

Over the long pageant of civilizations—endlessly rising, falling, and rising again—one phenomenon has remained constant in the background: the continuing use of power places by one culture after another. Prehistoric and historic cultures keep coming and going, yet the power places have exerted a spiritual magnetism that transcends human time. The great religions of the historical era—Hinduism, Taoism, Buddhism, Judaism, Christianity, and Islam—have each taken over the sacred places of earlier cultures and made them their own.

The Christian usurpation of pagan holy places during the medieval era is an intriguing manifestation of this practice. Christian rulers seeking to convert indigenous cultures to Christianity often syncretized the sacred places of the cultures already inhabiting those lands. With a strategy exercised over multiple centuries, sacred sites of the megalithic, Celtic, Greek, and Roman cultures were rededicated to Christ, Mary, and a variety of Christian saints and martyrs. An excerpt of a letter from Pope Gregory I to Abbot Mellitus in 601 CE illustrates that very early on this had become a policy for all of Christendom:

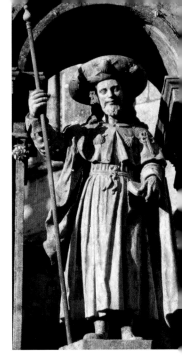

St. James sculpture, Cathedral of Santiago de Compostela, Spain.

When, by God's help, you come to our most reverend brother Bishop Augustine, I want you to tell him how earnestly I have been pondering over the affairs of the English: I have come to the conclusion that the temples of the idols in England should not on any account be destroyed. Augustine must smash the idols, but the temples themselves should be sprinkled with holy water, and altars set up in them in which relics are to be enclosed. For we ought to take advantage of well-built temples by purifying them from devil worship and dedicating them to the service of the true God. In this way, I hope the people, seeing their temples are not destroyed, will leave their idolatry and yet continue to frequent the places as formerly.

During the early centuries of Christianity's spread into Europe, hundreds of churches were erected upon pagan religious sites. A Christian holy-day calendar was also imposed; it was almost an exact duplicate of the solstice-equinox festival cycle of the earlier people.

During the late medieval period of the tenth to the fifteenth centuries, large numbers of people began traveling across Europe to visit these new Christian shrines. A little-known fact about this movement is that the numbers of people going on religious pilgrimages *exceeded* those traveling due to commerce or warfare, combined. Why were so many people going to the holy places? The answer given by the Christian authorities

was that many different types of miracles were occurring at the shrines. Yes, miracles did occur, but they were happening not so much because of the presence of saints' relics (often of dubious authenticity), but more likely because of the *locations* of those Christian shrines at the power places of the preceding cultures. This is evident at hundreds of pre-Reformation Christian shrines throughout Europe. Well-known Christian holy places such as Canterbury and Glastonbury in England, Mont-Saint-Michel and Chartres in France, Assisi and Monte Gargano in Italy, and Santiago de Compostela in Spain were all pre-Christian sacred sites.

Rich and poor, nobleman and peasant alike were drawn to the pilgrimage shrines. Kings and knights would pray for victory in war or give thanks for battles that had just been won, women would pray for children and for ease in childbirth, farmers for crops, diseased persons for miraculous healings, monks for ecstatic union with God, and everyone for a remission of the burden of sin, which medieval Christians believed was their preordained lot in life. Richard the Lionheart visited Westminster Abbey; Louis IV walked barefoot to Chartres; Charles VII visited the shrine at Le Puy five times; Pope Pius I walked barefoot through the snow to a shrine in Scotland; and hundreds of thousands of peasants, merchants, and monks undertook yearlong pilgrimages through bandit-infested territories and foreign lands.

Miracles do not happen in contradiction to nature, but only in contradiction to that which is known to us of nature.

—St. Augustine

Pilgrims visited these relic shrines primarily in the hopes that their prayers would induce the shrines' saints to intercede with Christ or Mary on their behalf. As more and more pilgrims visited the shrines, miracles did indeed begin to occur. Word of a shrine's miracle-causing ability began to spread to the surrounding countryside and then to the far corners of the European continent. With the extraordinary numbers of pilgrims

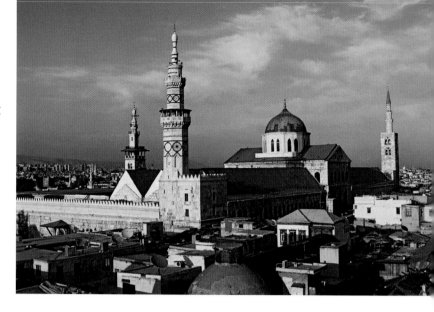

Detail of Great Mosque, Damascus, Syria.

visiting the shrines—often as many as ten thousand in a single day—church coffers increased in wealth, monasteries became politically powerful, and the enormous cathedrals of Canterbury, Lincoln, Chartres, Reims, Cologne, Burgos, and Santiago were built. Larger cathedrals attracted even greater numbers of pilgrims, who brought reports of miracles.

The religion of Islam has a similar usurpation of pre-existing pagan holy places. Mythological, archaeological, and historical research clearly proves that several primary holy places at the center of the Islamic world were sacred sites long before the birth of Muhammad and the ensuing growth of Islam. A few examples are important to note. The primary Muslim sacred sites in and around Mecca, such as the Ka'ba, Mt. Hira, and the plain of Arafat, were each venerated as holy places by pre-Islamic Arabic peoples. Traditions state that in 1892 BCE, Abraham and his son Ishmael constructed the first Ka'ba, where Mecca now stands, and placed within it a sacred stone given to Ishmael by the angel Gabriel. With the passage of centuries and the addition of various pagan elements, the plaza around the Ka'ba became home to other shrines. The pilgrims of pre-Islamic times visited not only the house of Abraham and the sacred stone of Gabriel but also a collection of stone idols, representing different deities, housed in other shrines around the Ka'ba.

After seeing an apparition of the angel Gabriel in a cave on the sacred mountain of Hira, Muhammad took control of Mecca in 630 CE. He destroyed 360 pagan idols, with the notable exception of the statues of Mary and Jesus. The idol of Hubal, the largest in Mecca, was a giant stone situated atop the Ka'ba. Following the command of the Prophet, Ali (the cousin of Muhammad) stood on Muhammad's shoulders, climbed to the top of the Ka'ba, and toppled the idol. After his destruction of the pagan idols, Muhammad linked certain ancient Meccan rituals with the hajj, or pilgrimage, to Mt. Arafat (another pre-Islamic tradition), declared the city of Mecca a center of Muslim pilgrimage, and dedicated it to the worship of Allah. In other words, he developed a pilgrimage practice and route that *incorporated* pre-existing holy places and rituals. Muhammad did not, however, destroy the Ka'ba and the sacred stone it housed. Rather, he made them the centerpiece of the Muslim religion, based on his belief that he was a prophetic reformer who had been sent by God to restore the rites that had first been established by Abraham and that had been corrupted over the centuries by the pagan influences. Thus, by gaining both religious and political control over Mecca, Muhammad was able to redefine the sacred territory and restore Abraham's original order to it.

In the years following the death of Muhammad in 632 CE, a succession of caliphs sought to extend the influence of Islam throughout the Middle East. It is an irrefutable historical fact that as Islam spread across this geographic region, its first great mosques were situated directly upon the foundations of extant holy places. Jerusalem is an excellent example. That ancient sacred site, whose name means City of Peace, has hosted several millennia of different cultures and their temples. Of vital importance is the fact that each shrine, temple, mosque, and church was built upon the same physical place. This holy place had been venerated for one hundred centuries before the advent of Judaism, Christianity, and Islam, as was the ancient city of Damascus, in Syria. In Jerusalem, all at the same place and overlaid upon one another like books in a stack, were built temples to the Aramaean god Haddad and goddess Atargatis, followed by the Roman god Jupiter. Next were built the First and Second Temples of the Jews, then a Christian church of St. John, and finally an Islamic mosque. Five different cultures with five different religions—and each of those religions used the same site for their major religious structures. Although certainly a measure of syncretization occurred throughout the history of this sacred place, there is also an undeniable indication that sites such as this one have a continuous, powerful quality.

Types of Sacred Sites and the Reasons for Their Power

Numerous different types of power places and sacred sites may be found around the world. Based on two decades of visiting many hundreds of sacred sites in eighty countries and reading more than a thousand books on the subject, I have identified the following distinct categories:

→ Sacred mountains
→ Human-built sacred mountains
→ Sacred bodies of water
→ Sacred islands
→ Healing springs
→ Healing and power stones
→ Sacred trees and forest groves
→ Places of ancient mythological importance
→ Ancient ceremonial sites
→ Ancient astronomical observatories
→ Human-erected solitary standing stones
→ Megalithic chambered mounds
→ Labyrinth sites

- Places with massive landscape carvings
- Regions delineated by sacred geography
- Oracular caves, mountains, and sites
- Male deity/god shrines/yang sites
- Female deity/goddess shrines/yin sites
- Birthplaces of saints
- Places where sages attained enlightenment
- Death places of saints
- Sites where relics of saints and martyrs were/are kept
- Places with enigmatic fertility legends and/or images
- Places with miracle-working icons
- Places chosen by animals or birds
- Places chosen by various geomantic divinatory methods
- Unique natural features
- Ancient esoteric schools
- Ancient monasteries
- Places where dragons were slain or sighted
- Places of Marian apparitions (for example, Lourdes and Fátima)

When you read this list, it is important to understand that some of these categories overlap and that many sacred sites could be listed in two or more categories. Nonetheless, the many different ways to indicate the locations of power places are clearly evident. Ancient legends and modern-day reports tell of extraordinary experiences that people have had while visiting these holy and magical places. Different sacred sites have the power to heal the body, enlighten the mind, increase creativity, develop psychic abilities, and awaken the soul to a knowing of its true purpose in life.

Seeking to explain this miraculous phenomenon, I suggest that there is a definite field of energy that saturates and surrounds the immediate locality of these sacred places. Concentrated at particular

holy sites is an energy field—a field of influence extending in space and continuing in time. How may we explain the origin and ongoing vitality of these site-specific energy fields? What is it that makes power places power places? What invigorates their undeniable spiritual magnetism? In my research, I recognize many different factors that contribute to the localized energy fields at the sacred sites. In the detailed writings on my Web site, SacredSites.com, I classify and analyze those factors according to the following four categories:

1. The influences of the earth
2. The influences of celestial bodies
3. The influences of the structures at the sacred sites
4. The influences of human intent

Previous sections of this introduction discussed the first three categories. The fourth factor contributing to the power of the sacred sites is perhaps the most mysterious and the least understood. This is the accumulated force of human *intention* and the effect that it has upon the amplification of the power or the influence of a sacred site. Just as photographic film (a small piece of earth) can record the energy of light, and as audiotape (another small piece of earth) can record the energy of sound, so also can a sacred site (a larger piece of earth) record or somehow contain the energy and intention of the millions of humans who have performed a ceremony there. Within shrines and sanctuaries is the intention—the energy—of countless priests, priestesses, and pilgrims who have gathered there over hundreds or thousands of years. Praying and meditating, they have continuously charged and amplified the presence of love and peace, healing and wisdom. The megalithic stone rings,

Certain areas on earth are more sacred than others, some on account of their situation, others because of their sparkling waters, and others because of the association or habitation of saintly people.

—Mahabharata Anusasana Parva

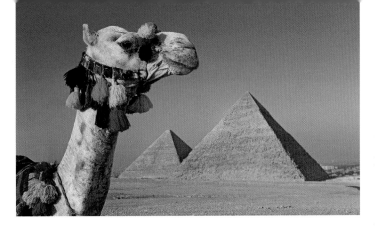

Camel in front of the pyramids of Giza, Egypt.

Celtic healing springs, Taoist sacred mountains, Mayan temples, Jewish holy sites, Gothic cathedrals, Islamic mosques, Hindu shrines, Buddhist stupas, and Egyptian pyramids are repositories of the concentrated spiritual aspirations of humanity. These are the places where the Buddha, Moses, Jesus, Muhammad, Zoroaster, Guru Nanak, Mahavira, and other sages and shamans awakened to the deepest realizations of spiritual wisdom.

The Transformational Powers of Sacred Sites

Given my long fascination and familiarity with sacred power places, you might ask what my philosophy is regarding them. I believe it is highly beneficial for people to make pilgrimages to sacred sites because of the trans-formational powers available there. These legendary places have the mysterious capacity to awaken and catalyze within visitors the qualities of compassion, wisdom, peace of mind, and respect for the earth. The development of these qualities in increasing numbers of the human species is of vital importance, considering the numerous ecological and social problems occurring in the world. At the root of all these problems may be human ignorance. Many human beings are out of touch with themselves (both with their bodies and the deeper states of spiritual consciousness), their fellow beings, and the earth they live on. Sacred sites and their subtle fields of influence can assist in the awakening and transformation of human consciousness and thereby in the healing of the earth.

In closing, let me say a few words about how to approach and benefit from the sacred sites. The experience of a sacred place actually begins well before a pilgrim arrives at the site. First, choose an area of the world whose power places you would like to explore. Next, consult the bibliography at the back of this book or on my Web site, SacredSites.com, which will give you the names of books concerning sacred sites in the region of your interest. In the months prior to your journey, read about the places you will visit, and begin to journey to them in your imagination.

When you finally reach the immediate area or city of the pilgrimage site, make the conscious mental effort to approach the shrine with the focused intention that you are going to plug into the power of place as you would plug an electrical appliance into a wall socket. This metaphor is very helpful to embody as it actually predisposes you to a more intense connection with the sacred site. Then go to the site with a free and open mind. Maybe you will wander around first and then meditate, or perhaps it will be the other way around. Alternatively, you may take a nap or pray or play. There are no rules. Simply let the spirit of the place and your own presence come into a relationship, and then let it go, letting it be whatever it is.

The energy transference at power places goes both ways: earth to human and human to earth. The wondrously beautiful living earth gives human beings subtle infusions of spirit, and as pilgrims, we give the earth something like planetary acupuncture in return. True, the power places were discovered mostly in the past, but they remain vital today, still emanating a potent field of transformational energy. Open yourself to this power of cosmic grace. Let it touch and teach you, while the planet is in turn graced by your own love.

'Tis, but I cannot name it, 'tis the sense of majesty, and beauty, and repose. A blended holiness of earth and sky, something that makes this individual spot, this small abiding place of many men, a termination, and a last retreat, a center, come from where so ever you will, a whole without dependence or defect, made for itself and happy in itself, perfect contentment, unity entire.

—**WILLIAM WORDSWORTH**

SACRED SITES OF
EUROPE

A Year on Bicycle Pilgrimage in Europe

In April 1986, I flew into Athens, Greece. During the following year, I planned on riding my custom-made mountain bike to more than one hundred pilgrimage sites across a dozen European countries. Why had I decided to make the journey by bicycle, when cars, buses, and trains would have been so much quicker? Precisely because I did not want to travel quickly; I wanted to travel at the pace of pilgrims from long ago. I also needed to be able to go where I wanted when I wanted, an essential condition for the photography I meant to do. Very often, the best times for photography are early in the morning or later in the afternoon when the sun's rays bathe the world in golden hues. I also liked the hard work of biking. If I wanted to get somewhere, I had to pedal there. During warm, sunny days in southern Europe, cycling was a pleasure—but when making my way north as autumn approached, I frequently cycled beneath gray skies, buffeted by cold winds and soaked by drizzling rain. At the end of long days, I spent equally long nights shivering in a wet sleeping bag with only a lightweight tent for protection.

Yet what a glorious journey it was. Often rising before the sun, I would snack on fruits and nuts purchased in local markets and then begin the day's ride, averaging eight hours and sixty-two miles (100 km) per day—definitely hard work. However, the easy days spent at the sacred places made the toil of getting to them more than worthwhile. I especially enjoyed arriving at places after the sun had set. With everything shrouded in darkness, I would feel as if I had been magically transported back in time to some long-forgotten era.

Mornings after a dusk arrival were equally fine, for in those moments it seemed as if I had awakened in a new world. Ambling along silent streets to the day's pilgrimage site, I would position myself to benefit from the most pleasing light. While making only a few photographs—one of the hallmarks of my photographic style— I would walk around the cathedrals until the monks or caretakers opened the massive wooden doors. The interiors of the holy structures were usually too dark for photography, so I would wander here and there within: through splendid cloisters, into crypts filled with the relics of old saints, and over stone floors polished smooth by the feet of countless thousands of pilgrims over the centuries.

The months passed, and I found growing within my being a deeper sensitivity to the power of the holy places. I began to discern a variation in energy between the sites—a mysterious presence that I could not explain but most certainly felt. Reading legends regarding the discovery and use of different sacred sites, I came to recognize a similarity between my own experiences and those of early pilgrims. These were indeed healing sites, as well as sites conducive to meditation and the awakening of spiritual insight, and, amazingly, there were rare oracular sites where pilgrims had experienced visions of the future.

I began to have such visions myself, faint and indistinct, of things I did not fully comprehend. Yet there was a thread of a story, pictures of things to come. Some of the visions concerned my own life, others the future of human civilization; still others showed a part that many of us might one day play in the unfolding of a swiftly growing global ecospiritual consciousness. Much of this was awe-inspiring, yet other times they were ominous in portent. I saw images of great beauty and wondrous times for our culture, but also images of intensifying human-caused environmental degradation of the planet. In this vision of duality, I saw both good and evil. With the awakening of human consciousness came the ability—and choice—to plunder and further destroy the earth or to bring balance and healing to the planet.

The most wondrous gift I received from my year of pilgrimage across Europe was learning that great inspiration and a sense of purpose are available to those of us who look beyond the often mundane concerns of our daily lives to a larger involvement in the growing community of conscious, life-serving people of the world.

St. Michael's Mount, Cornwall, England.

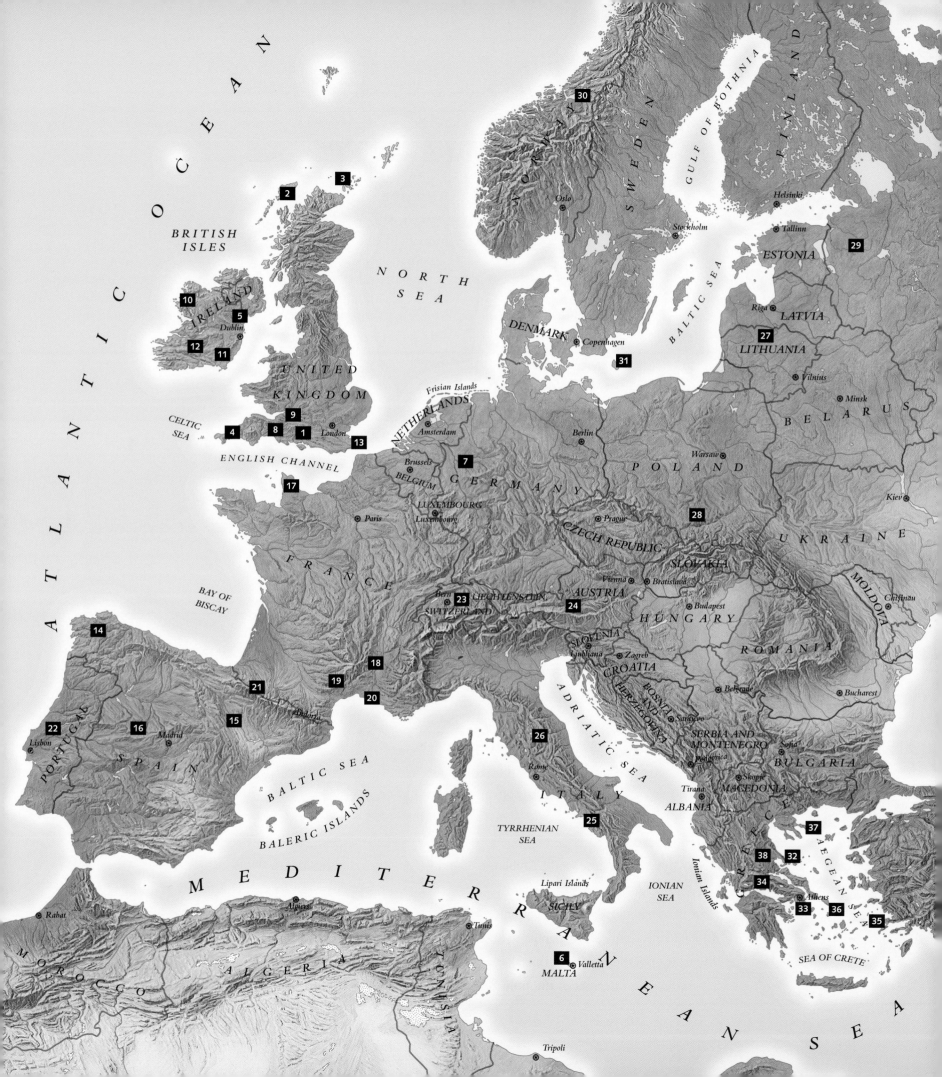

Sacred Sites of Europe

1. Wiltshire, England

2. The Isle of Lewis, Outer Hebrides, Scotland

3. Orkney, Scotland

4. Cornwall, England

5. Newgrange, County Meath, Ireland

6. Mnajdra, Malta

7. Teutoburger Wald, Germany

8. Cerne Abbas, England

9. Glastonbury Tor, England

10. Croagh Patrick, County Mayo, Ireland

11. Glendalough, County Wicklow, Ireland

12. Cashel, County Tipperary, Ireland

13. Canterbury, England

14. Santiago de Compostela, Spain

15. Zaragoza, Spain

16. Ávila, Spain

17. Normandy, France

18. Le Puy-en-Velay, France

19. Conques, France

20. Saintes-Maries-de-la-Mer, France

21. Lourdes, France

22. Fátima, Portugal

23. Einsiedeln, Switzerland

24. Hallstatt, Austria

25. Paestum, Italy

26. Assisi, Italy

27. Šiauliai, Lithuania

28. Czestochowa, Poland

29. Novgorod, Russia

30. Trondheim, Norway

31. Bornholm, Denmark

32. Thessaly, Greece

33. Athens, Greece

34. Delphi, Greece

35. Patmos, Greece

36. Tínos, Greece

37. Mt. Athos, Greece

38. Meteora, Greece

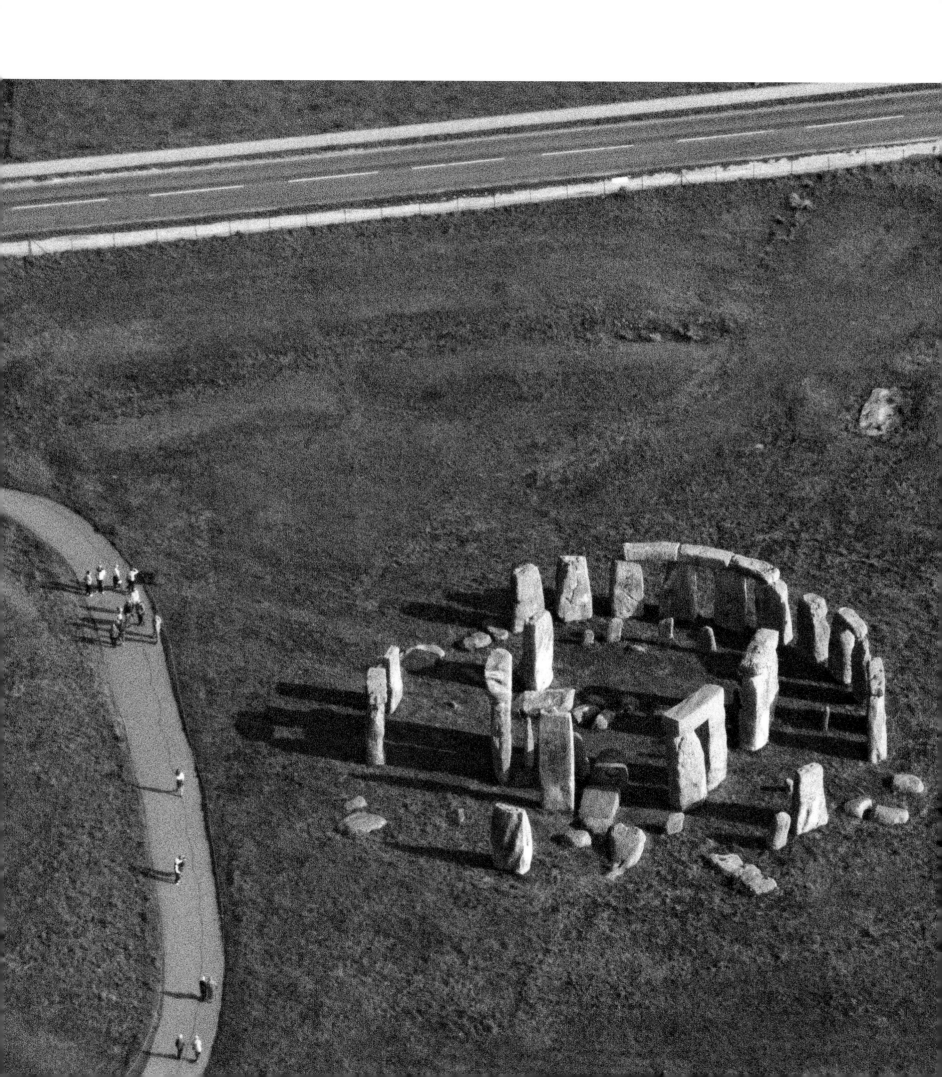

STONEHENGE STONE RING

Wiltshire, England

MAP SITE 1

More than nine hundred stone rings exist in the British Isles, and twice that number may originally have been built. These megalithic structures are more accurately called rings rather than circles because they often display noncircular elliptical shapes; Stonehenge, however, is circular. It is difficult to precisely date the stone rings because of the scarcity of datable remains associated with them, but it is known that they were constructed during the Neolithic period, which in southern England lasted from approximately 4000 to 2000 BCE.

Before the development of archaeological dating methods, seventeenth-century antiquarians assumed that Stonehenge, Avebury, and other megalithic structures were constructed by the Druids. The Druids, however, had nothing to do with the construction or use of the stone rings. The Celtic society, in which the Druid priesthood functioned, came into existence in Britain only after 300 BCE, more than fifteen hundred years *after* the last stone rings were constructed. Historians in the nineteenth century often attributed the stone rings to Egyptian travelers, who were thought to have infused Europe with Bronze Age culture. But with the development of Carbon-14 dating techniques, the infusion-diffusion concepts of European Neolithic history were abandoned, as many of the megalithic structures were shown to predate Egyptian culture.

Mid-twentieth-century archaeology generally assumed stone rings were used for ritual activities, and recent research has deepened our understanding. Beginning in the 1950s, Oxford University engineer Professor Alexander Thom and astronomer Gerald Hawkins pioneered the study of the astronomies of ancient civilizations, or archaeoastronomy. Conducting precise surveys at hundreds of stone rings, archaeoastronomers discovered significant celestial alignments, indicating that the stone rings were used as astronomical observatories. These studies also revealed the extraordinary mathematical sophistication and engineering abilities with which the stone rings were built.

Stonehenge, the best known stone ring, is a composite structure built during three periods from 3100 to 1100 BCE. It was constructed using massive stones weighing as much as twenty-five tons and transported from quarry locations hundreds of miles away.

Stonehenge is a structure that had multiple purposes. This monument of nearly imperishable nature, located at a specific site of terrestrial energetic power and celestial significance, was an astronomical observation device used to predict particular periods in the annual cycle when the earth energies were most highly influenced by the sun, moon, and stars. It was also a temple, built by and for the people, in which festivals of renewal were held at those energetic periods. Built with certain types of stones (positioned according to sacred geometry), which functioned as a sort of battery for gathering, concentrating, and emanating the earth energies of the site, Stonehenge was also an eclipse predictor of astonishing accuracy.

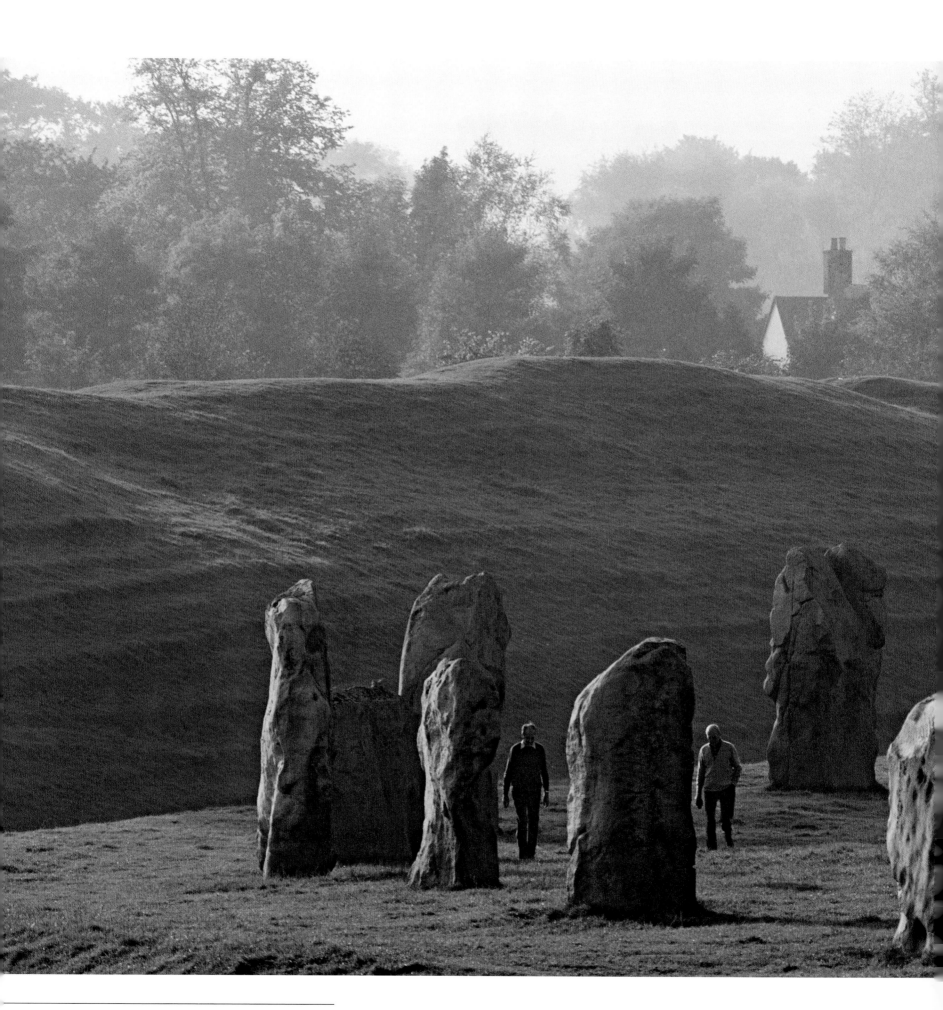

SACRED EARTH

AVEBURY STONE RING

Wiltshire, England

MAP SITE 1

North of Stonehenge, Avebury is the largest known stone ring in the world. The Avebury complex consists of a grass-covered stone bank enclosing twenty-eight acres (11 hectares) of land and a great circle of irregularly shaped stones, within which sit two other stone rings. The stones, ranging in height from nine to more than twenty feet (2.5–6 m), weigh as much as forty tons. Excavations have shown that the three rings originally contained at least 154 stones, of which only 36 remain standing. Beginning in the late medieval era, Christians broke up many stones in an effort to eradicate vestiges of pagan religious practices, and during the seventeenth and eighteenth centuries, more of the stones were used as construction materials for local churches and houses.

In the early years of the eighteenth century, the general outline of the Avebury complex was still discernible as the body of a serpent passing through a circle, which formed a traditional alchemical symbol. The head and tail of the enormous snake were delineated by fifty-foot-wide (15 m) avenues of standing stones that extended into the countryside. Adjacent to the Avebury rings is Silbury Hill, the largest megalithic construction in Europe. The surrounding countryside has numerous standing stones and underground chambers positioned according to astronomical alignments. The Avebury temple was part of a vast network of Neolithic sacred sites arranged along a two-hundred-mile (322 km) line stretching across southern England. Positioned directly on this line are other fabled pilgrimage sites such as Glastonbury Tor and St. Michael's Mount.

At the stone ring of Avebury, men walk through a group of stones in the outer part of the ring.

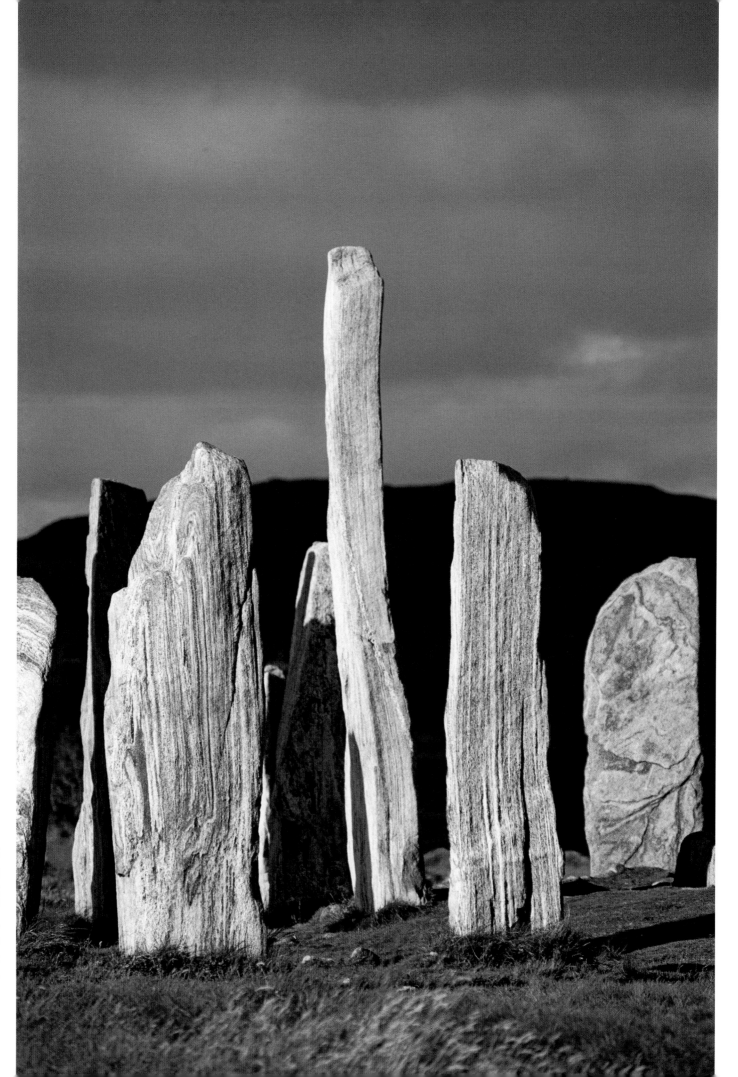

These prominent and visually striking stones are in the ring of Callanish, part of which is one part of a large cluster of some twenty megalithic ruins within a two-mile (3.2 km) radius.

CALLANISH STONE RING

The Isle of Lewis, Outer Hebrides, Scotland

MAP SITE 2

Remotely located on an island off the northwestern coast of Scotland, the stone ring of Callanish is one of the most beautiful megalithic constructions in Europe. Archaeological excavations at the stone ring have determined a construction period as early as 3400 BCE. The ring seems to have originally been the center of an arrangement of standing stones that was approached by an avenue of stones 270 feet (82 m) long. As it now exists, the ring is composed of thirteen stones, the tallest being fifteen feet (4.5 m) tall and weighing five to six tons. The ring of Callanish, like many similar structures in Europe, had both astronomical and ceremonial functions.

Unlike the astronomers of modern times, who use powerful telescopes to look far into the universe, ancient astronomers were interested in the movement and position of the sun, moon, and planets relative to the earth. The stones in the perimeter of the stone rings were used as sighting devices to track the rising and falling of these celestial bodies along the horizon. This was done to determine particular periods, such as the sun's solstices and equinoxes, and various lunar periods during which the stone rings were used for ceremonial and shamanic functions. Scientific studies conducted at megalithic sites across Europe have determined that different geophysical energies are unusually strong at the stone rings, especially during key solar and lunar periods, and that ancient sages used these energies for healing and spiritual functions.

STONES OF STENNESS

Orkney, Scotland

MAP SITE 3

The stones of Stenness were originally a ring of twelve, but now only four remain standing. It is believed that the ring was erected sometime during the third millennium BCE. While bicycling across the island of Orkney, I twice passed by the stones of Stenness early in the morning, and on both occasions I noticed a group of sheep sitting in the middle of the circle. There was no fence keeping the sheep within the circle; they moved from the circle only when humans entered and they returned to the center when the humans departed. What is to account for this phenomenon? In the case of the sheep being repeatedly attracted to the center of the stone ring, we can reasonably assume that they sense some sort of energy in the circle that is pleasant for them to experience, in the same way a house pet will repeatedly return to the thermal energy of a warm fireplace or a sunlit window on a cold winter day.

Experts in archaeology, geology, physics, and electronics, as well as skilled practitioners of the old art of dowsing, have studied this matter of energy fields existing within the stone rings of the British Isles. Based on studies of megalithic stone rings around Europe, it has been determined that within the perimeter of the rings there are measurable anomalies in radiation, magnetism, ultrasound, radio propagation, and infrared photography. There is nothing paranormal about these forces, and they are all well accepted by orthodox science. What is remarkable, however, is that people of the third millennium BCE knew about these forces, that they erected great stone structures to mark the source points of those energies, and that they used the sites for a variety of therapeutic, shamanic, and spiritual purposes.

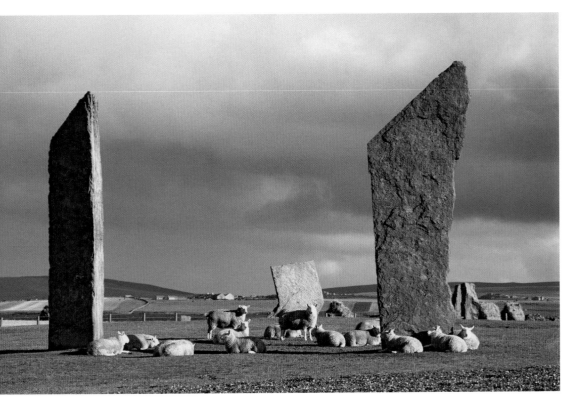

Sheep cluster in the center of the stones of Stenness.

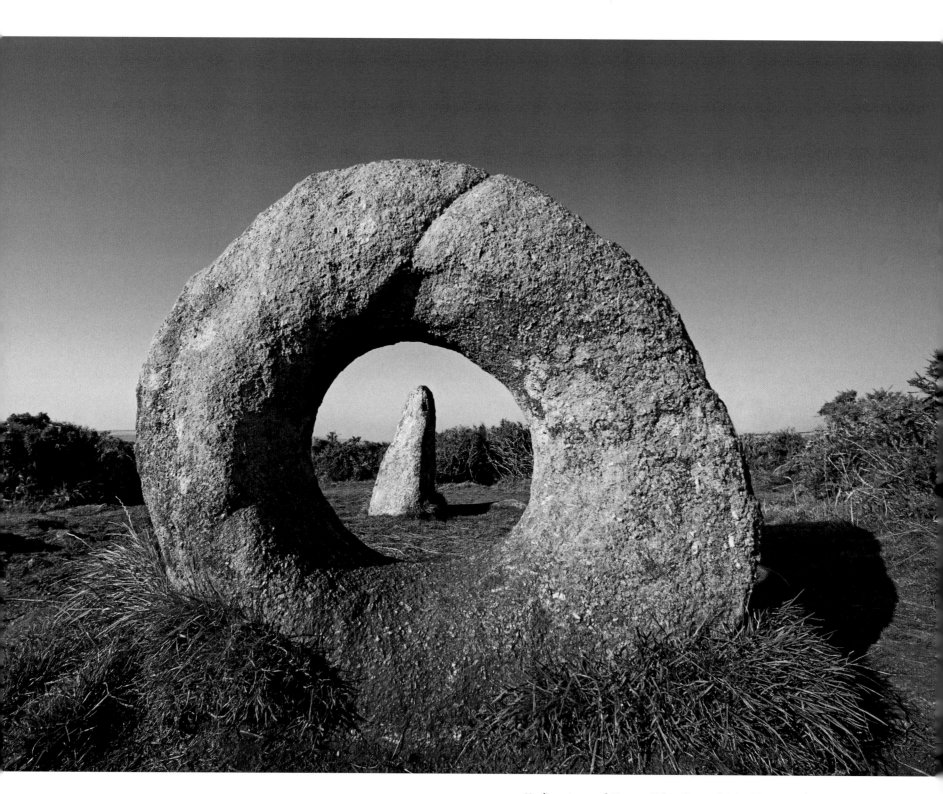

Healing stones of Men-an-Tol in Cornwall. The Men-an-Tol may also have been used to observe the summer and winter solstices.

Men-an-Tol Stones

Cornwall, England

Map site 4

Located near Penzance in southwestern England are the unique and enigmatic Men-an-Tol stones. Archaeologists suggest that the three stones comprising the Men-an-Tol are the remains of a Neolithic tomb because various types of holed stones have been found near the entrances to various burial chambers. However, ancient folklore of the surrounding region explains that the center stone has fertilizing and energizing properties capable of curing almost any ailment when one crawls through toward the sun. Young children were passed three times, naked, through the hole and then dragged through the grass three times toward the east to cure rickets or tuberculosis. Adults, seeking relief from such conditions as rheumatism or spinal problems, crawled nine times through the hole in a sunwise direction. Pilgrims who have crawled through the center Men-an-Tol stone have experienced feelings of euphoria and well-being. Contemporary medical theory speaks of psychosomatic illness and the mind-body connection. Perhaps there is simply much disease of the spirit and psyche, and the spiritual happiness that visitors have felt at the Men-an-Tol may have been the cause of the physical healings of ancient people.

Newgrange Megalithic Passage Cairn

County Meath, Ireland

Map site 5

Along the Boyne River north of Dublin stands the Brú na Bóinne, or Quarters of the Boyne, containing twenty-six extraordinary structures of which Newgrange, Knowth, and Dowth are the most significant. Newgrange dates to approximately 3700 BCE, was in decay by 2500 BCE, and seems to have been empty since it was last plundered by the Vikings in 861 CE. The Newgrange passage cairn covers one acre (4,000 sq m) of land and consists of a mound rising from the meadow and surrounded by a stone curbing. The cairn is 280 feet (85 m) across and 50 feet (15.25 m) high. Of the original thirty-eight pillar stones surrounding the cairn, only twelve remain. The bulk of the cairn is constructed of approximately 280,000 tons of granite stones. The facing of the cairn is several meters high and is made of sparkling white quartz.

Inside the cairn, a sixty-two-foot (19 m) passageway leads to a domed chamber that is twenty feet (6 m) high. Many of the stones within this chamber are carved with beautiful spirals and geometric figures. Just before 9 AM on the day of the winter solstice, December 21, the Newgrange passage is pierced by a shaft of sunlight that illuminates the end of the passage and lights up a series of carvings in the rock. This solar display lasts for five days around the time of the solstice, when the chamber is brilliantly lit for about seventeen minutes. The passage cairn of Newgrange has often been compared to the womb of an earth goddess. This notion is given support by the fact that very few burial remains have been found within any of the large cairns of Ireland.

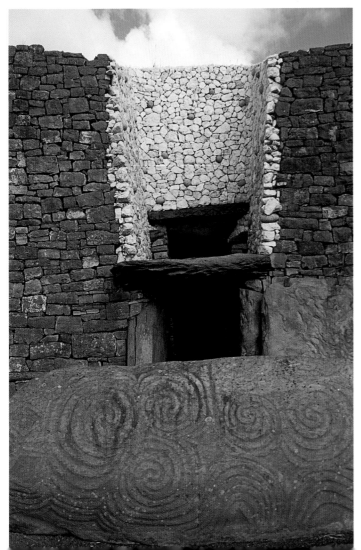

The entrance to the Newgrange passage cairn is marked by a large stone that is elaborately carved with spirals and diamond shapes.

Neolithic Temple of Mnajdra and Gozo

Malta

Map site 6

The small island of Malta, located in the Mediterranean halfway between Tunisia and Italy, is often associated with the Knights of St. John of Jerusalem, who arrived in 1530 CE. Yet Malta has a far greater importance in European prehistory due to its collection of mysterious stone temples. While Neanderthals in Paleolithic times first occupied Malta, the earliest Neolithic people probably arrived around 5200 BCE from the island of Sicily fifty miles (80 km) to the north. Approximately sixteen hundred years later, these people began to erect stupendous megalithic temples. By 2300 BCE, this megalithic culture had declined, and Malta seems to have been deserted until the arrival of Bronze Age people, around 2000 BCE.

On the islands of Malta and nearby Gozo, the remains of fifty megalithic temples, menhirs (single standing stones), and dolmens (rock chambers) have been found. The massive ruins of Hagar Qim (pronounced *agar eem*) and Mnajdra (*eem-na-eed-rah*) stand on a rocky plateau on the southwest coast of Malta. Mnajdra consists of two buildings: a main temple with two chambers and a smaller temple with one chamber. Among other possible uses, the temples of Mnajdra fulfilled astronomical observation and calendrical functions, in particular marking the periods of the solstices and equinoxes. In addition to their celestial alignments, the Maltese temples also reveal clear evidence of mathematical and engineering sophistication, such as their use of the megalithic yard of 2.72 feet (83 cm), a precise unit of measurement found throughout ancient Europe.

A common misconception about Malta concerns the human statues found in some of the stone temples. Their skirts, thick thighs, and small feet have caused some visitors to call them fertility goddesses. However, these statues are of indeterminate sex, and furthermore, the "ladies" have no breasts. Additionally, statues of men in skirts, with braided hair, and numerous examples of carved phalluses demonstrate that the Maltese temples had a fertility function that included both masculine and feminine elements. Also of importance as a pilgrimage site is the Romanesque basilica of Ta' Pinu on the nearby island of Gozo, a healing shrine that is sacred to local sailors.

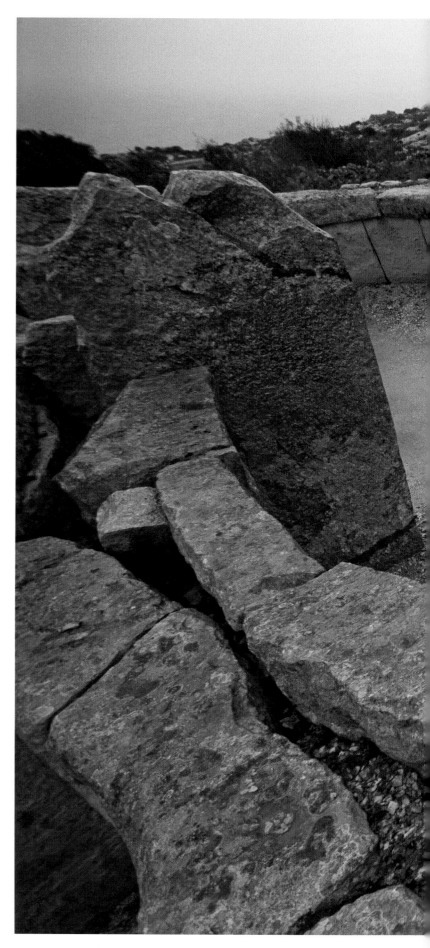

The temple of Mnajdra, whose celestial alignments indicate that it was constructed in approximately 3700 BCE, is one of Europe's most ancient megalithic sites.

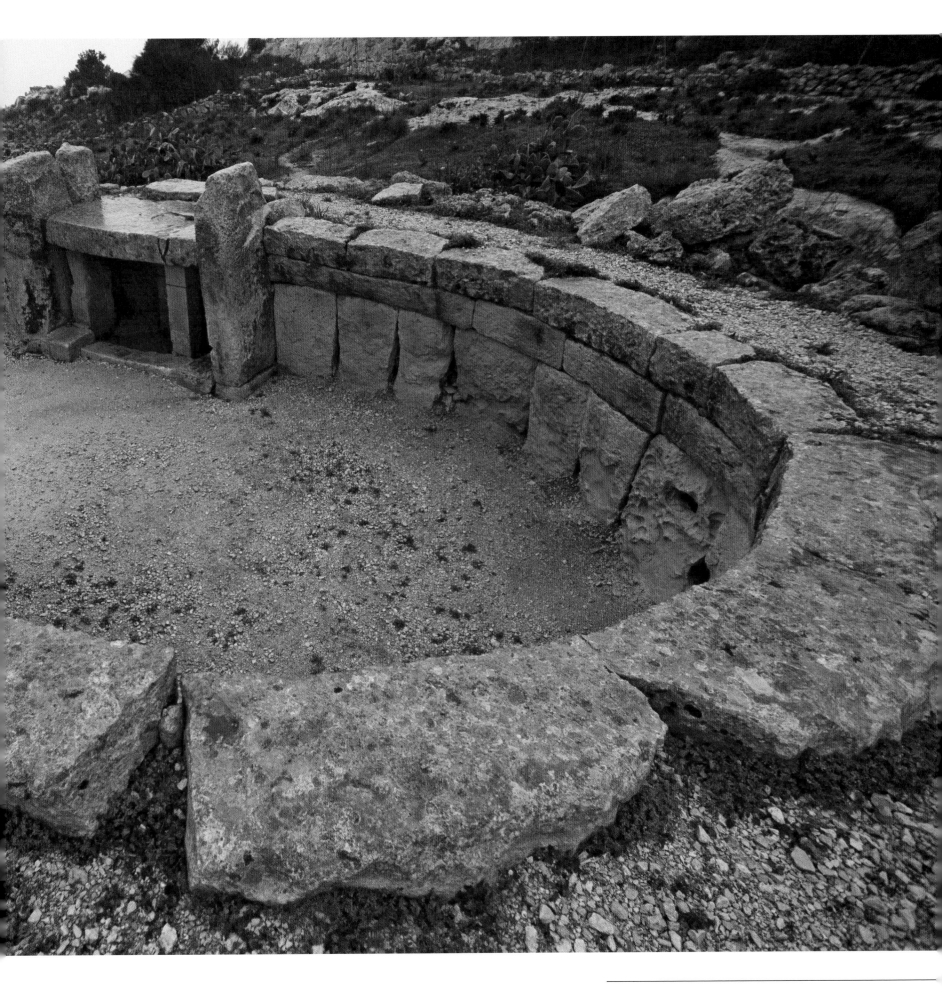

Neolithic Astronomical Observatory, Externsteine Rocks

Teutoburger Wald, Germany

Map site 7

Located in the sacred heartland of Germany, the Externsteine rocks were known as a place of pilgrimage in prehistoric, Celtic, and early Saxon times. Pagan rituals were performed here until the eighth century CE, when Charles the Great cut down the sacred Irmensul Tree, the German tree of life and symbol of the old religion. The earliest historical mention of Externsteine comes from the twelfth century when the site came under the control of a nearby Benedictine monastery. A series of artificial caves, which had been carved into the base of the sandstone spires in ancient times, was enlarged and used as dwellings for Christian hermits and monks.

The well-preserved remains of an enigmatic prehistoric temple sit atop the tallest rock spire. Different theories have been suggested concerning the identity of the temple's builders and the use to which the temple was put. Some have described the shrine as a *mithraeum*, or sanctuary, for Roman soldiers adhering to the Persian cult of Mithras, while other scholars believe that such deities as the Germanic Teut, the Nordic Woden, or the Bructerian prophetess Veleda were worshipped in the sanctuary. What is certain, however, is that the temple was constructed according to astronomical orientations. The round, windowlike opening has significant celestial alignments, including a view of the moon at its northern extreme and of the sun at sunrise on the summer solstice.

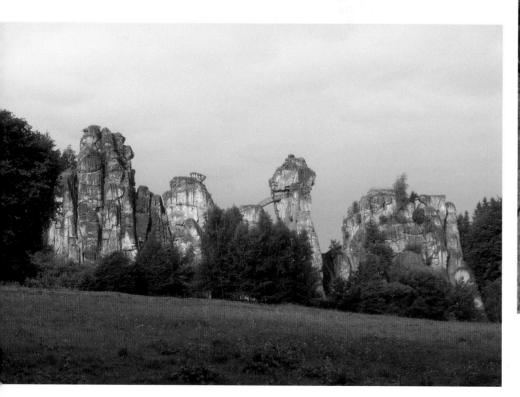

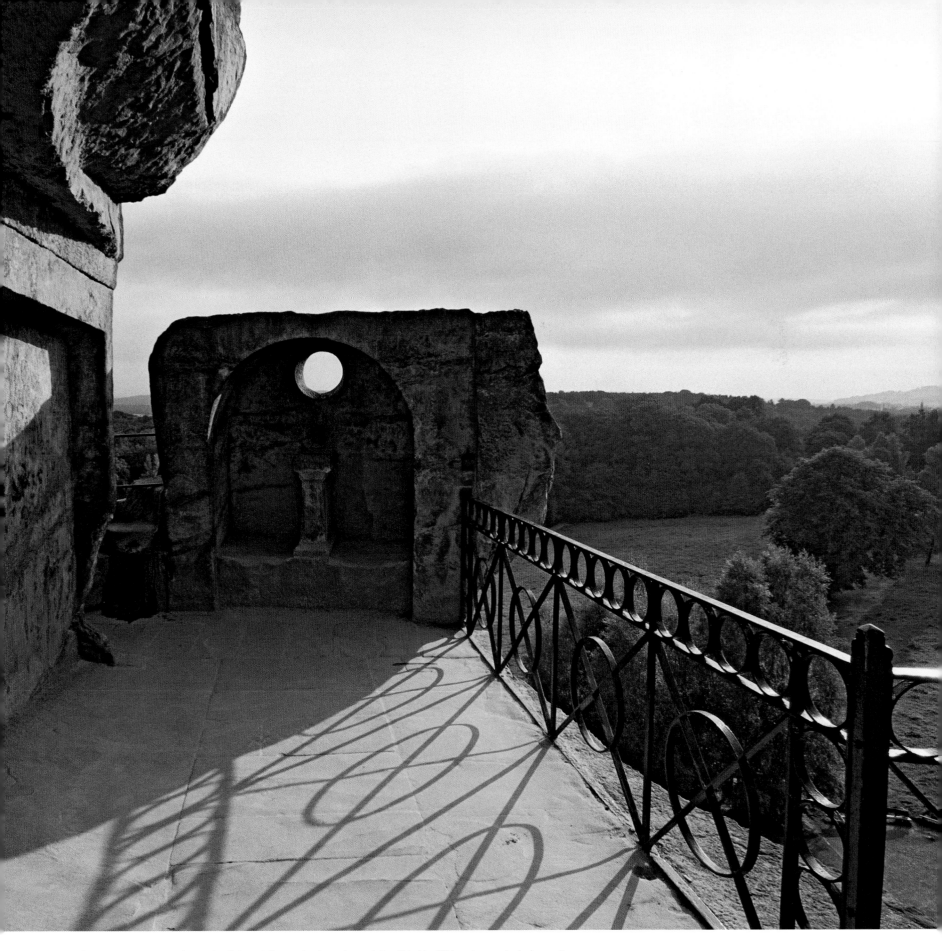

Above: **An upper temple on the Externsteine** rock pinnacle contains this Neolithic astronomical observatory, likely used by the priests of the temple to prophesize events based on the movement of the heavens.

Opposite: **Soaring towers** of the sandstone pillars at Externsteine stand more than 125 feet (38 m) tall.

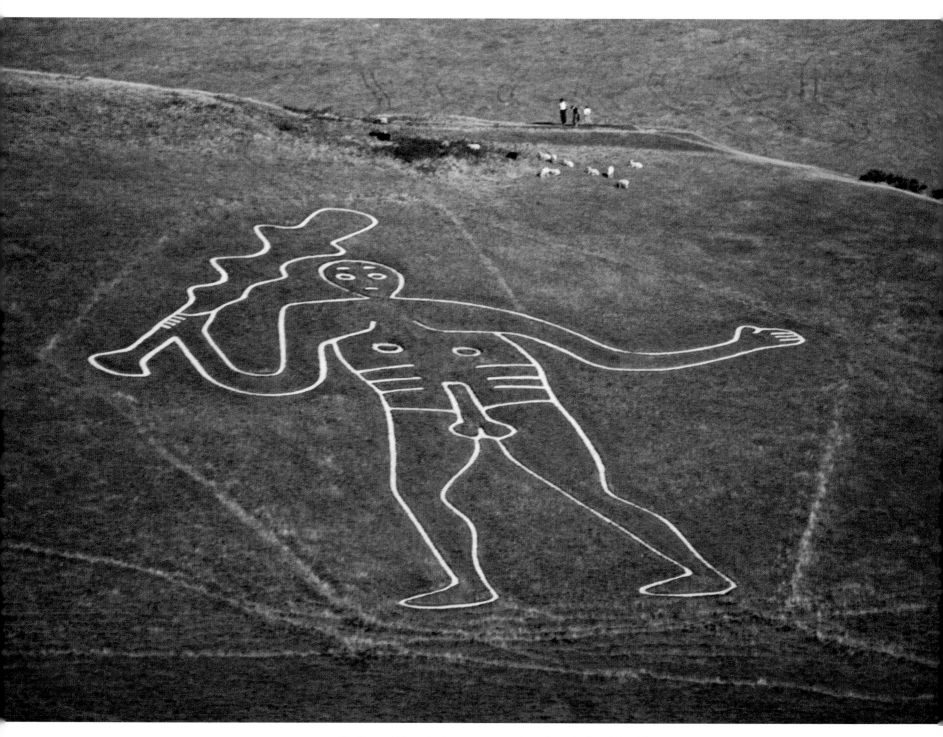

The Cerne Abbas giant measures an astounding 197 feet (60 m) long. During prudish Victorian times, the trenches of the giant's penis were filled with dirt and hidden beneath grass.

CERNE ABBAS GIANT

Cerne Abbas, England

MAP SITE 8

Upon a hill rising from the Dorset village of Cerne Abbas, the Cerne giant and the maypole mound above his head have marked a fertility site since ancient times. Local villagers have maintained trenches cut into the chalk rock of the hillside, which outline the giant's form, since at least the second millennium BCE. Maypole dancing still occurred at the site as recently as 1635 CE, until Christian authorities finally suppressed the pagan festivals.

The giant, whose name may derive from the Celtic fertility god Cernunnos, has the legendary power to cure infertility in women, and childless couples still copulate while lying on the grass in the giant's phallus. A sight line taken up the giant's penis on May Day points directly at the sun as it rises over the crest of the hill. Below the giant there flows an ancient healing spring, once known as the Silver Well but renamed St. Augustine's Well following the arrival of Christianity in the area. Unlike many pagan wells taken over by the Christians, the spring is still flowing, and the site has a wonderful feminine energy that balances the power of the male god on the hill above.

A place of pilgrimage from deepest antiquity, the mystic Glastonbury Tor abounds with legends of dragons and fairies, sages and shamans, as well as King Arthur.

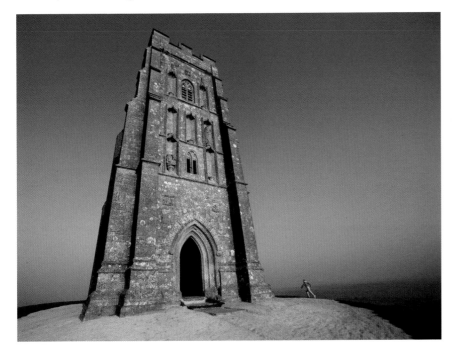

ST. MICHAEL'S TOWER

Glastonbury Tor, England

MAP SITE 9

The earliest knowledge of the Tor (Gaelic for "conical hill") comes from legends of prehistoric times, when it was the home of Gwyn ap Nudd, lord of the spirit world of Annwn and immortalized in Welsh folklore as a fairy king. Near the third century BCE, the realm of Annwn became associated with the mystic isle of Avalon. Long a holy place of pagan spirituality, the 558-foot-tall (170 m) hill shows extensive signs of being contoured by human hands in Neolithic times. These contours, indistinct after the passage of thousands of years, mark the course of a spiraling labyrinth, which encircles the hill from base to peak. Ancient myths tell that pilgrims to the sacred island would moor their boats upon the shore and, entering the great landscape labyrinth, begin a long ascent to the hilltop shrine. By following the winding route of the labyrinth rather than a more direct line, they gained a deep attunement with the Tor's terrestrial energies. Many archaeologists dismiss such legends, not understanding their deeper meanings, but studies by folklorists, dowsers, and other earth-mystery researchers suggest that these myths may be dim memories of long-forgotten realities.

Evidence exists of an enigmatic topographical alignment across southern England, linking Glastonbury Tor with the Avebury stone ring, St. Michael's Mount, and numerous Neolithic, Celtic, and early Christian holy places. Local folklore also tells of a visit by the young Jesus and also by Joseph of Arimathea, the later return of Joseph with the Holy Grail, and the burial of that sacred object near the enchanted Chalice Well at Glastonbury. Another intriguing mystery concerns the ruins of the Glastonbury Abbey, once the greatest monastery of medieval Europe. An analysis of its ground plan reveals proportions of sacred geometry equal to those found at nearby Stonehenge, and a line passing through the axis of the abbey runs straight to that famous stone ring, indicating a connection between the two holy places in deep antiquity. The Glastonbury region and its abbey also have strong associations with Arthurian legends. In 1190 CE, monks supposedly discovered two coffins buried in the abbey. Contained within were the bones of a man and a woman, and an inscribed cross identified the bodies as those of King Arthur and Queen Guinevere.

On top of the Tor stands a fourteenth-century church tower, built on the remains of an earlier monastic chapel that was likely destroyed in an earthquake in 1275.

St. Michael's Mount

Cornwall, England

Map site 4

Located on either side of the English Channel, the medieval pilgrimage shrines of St. Michael's Mount and Mont-Saint-Michel (see pages 44–45) are famous because of supposed appearances by the archangel Michael during the fourth and fifth centuries CE. According to different reckonings, St. Michael miraculously appeared—often killing dragons—at four hundred places throughout Europe. Did the archangel really appear and slay dragons, or should the myth rather be understood as having a metaphorical meaning?

Many pre-Christian legends from the regions of Europe that have megalithic standing stones tell of people who "speared a serpent" or "captured the dragon forces" at specific sites by placing great stones into the body of the earth. Equally important is the fact that prior to the arrival of Christianity, many pagan sacred sites were known as dragons' dens and serpents' lairs. The Christian story of St. Michael spearing a pagan serpent may thus be seen as a retelling of a far older pagan myth. Throughout the world, many other ancient cultures had memorialized power places with similar legends of dragons and giant serpents.

Another fascinating matter concerning St. Michael shrines in Britain is the mysterious linking of these shrines by straight lines running for hundreds of miles across the countryside. One such line, which originates at St. Michael's Mount, passes through the pre-Christian sacred sites of Glastonbury Tor and the Avebury stone ring, as well as many old churches dedicated to Michael. This extraordinary fact is evidence that some lost culture once knew and mapped the energy grid of the living earth.

St. Michael's Mount, seen here at sunset, precariously perches upon a coastal rock outcropping in the English Channel.

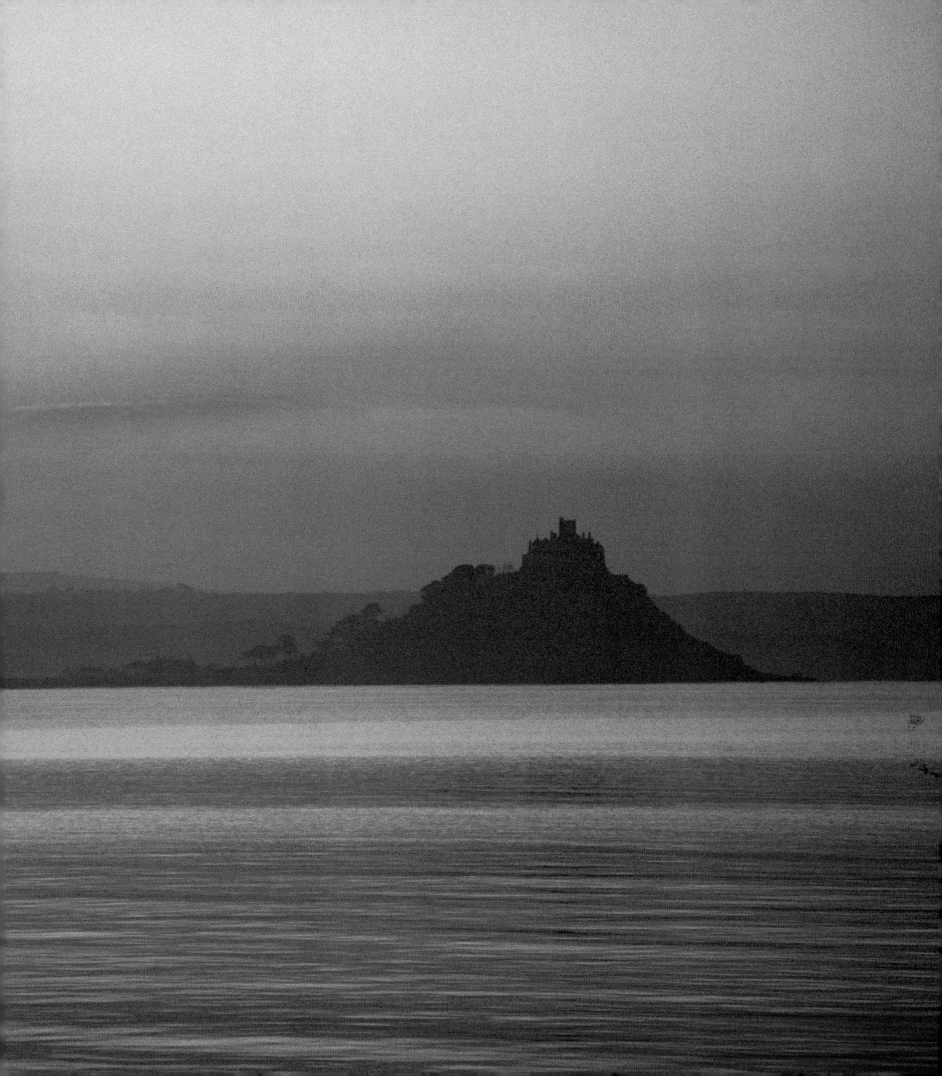

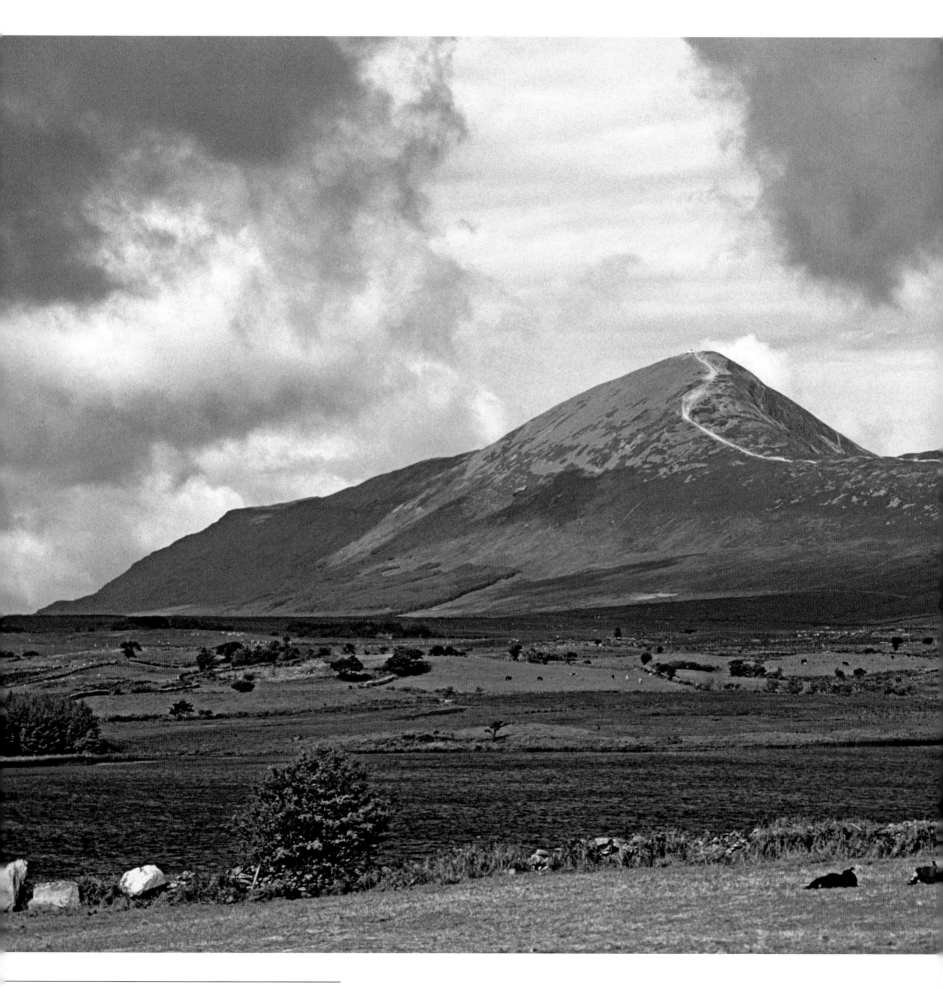

SACRED EARTH

CROAGH PATRICK

County Mayo, Ireland

MAP SITE 10

Croagh Patrick was a pagan sacred place long before the arrival of Christianity. Neolithic foundations have been found on the summit, as well as prehistoric rock art along the pilgrimage trail to the peak. For the Celtic people of Ireland, the mountain was the dwelling place of the deity Crom Dubh and the principal site of the harvest festival of Lughnasadh, traditionally held around August 1. According to Christian stories, St. Patrick visited the sacred mountain during the festival time in 441 CE and spent forty days banishing dragons, snakes, and demonic forces from the area. To shed light on the metaphorical meaning of this legend, it is important to know something of the historical figure of St. Patrick.

Patrick was not actually Irish. Born in Britain around 385 CE, captured by Irish pirates, and sold into slavery in Ireland, he later escaped to the European mainland. After spending some years studying at the monastery of St. Martin of Tours in France and becoming ordained as a priest, he decided to return to Ireland to undertake the conversion of the Celtic pagans. Arriving in Ireland in 432 CE, Patrick spent thirty years traveling about the countryside, introducing Christianity, and establishing churches and monastic foundations upon many Druidic sacred sites, which were themselves often situated upon far more ancient megalithic sites. Patrick later retired to Glastonbury, England, where he died at the age of 111. It was common for early Christians to view pagan religious practices as devil worship; thus the legend of Patrick slaying dragons and demonic forces on the sacred mountain can actually be seen as a metaphor for his subjugation and conversion of the pagan priests. By the seventh century, the mountain had become one of the most important Christian pilgrimage sites in all of Ireland. Currently, nearly one million pilgrims, and as many as forty thousand on the last Sunday in July, climb to the summit each year.

The quartzite peak of Croagh Patrick
rises 2,510 feet (765 m) above the
rolling hills of County Mayo.

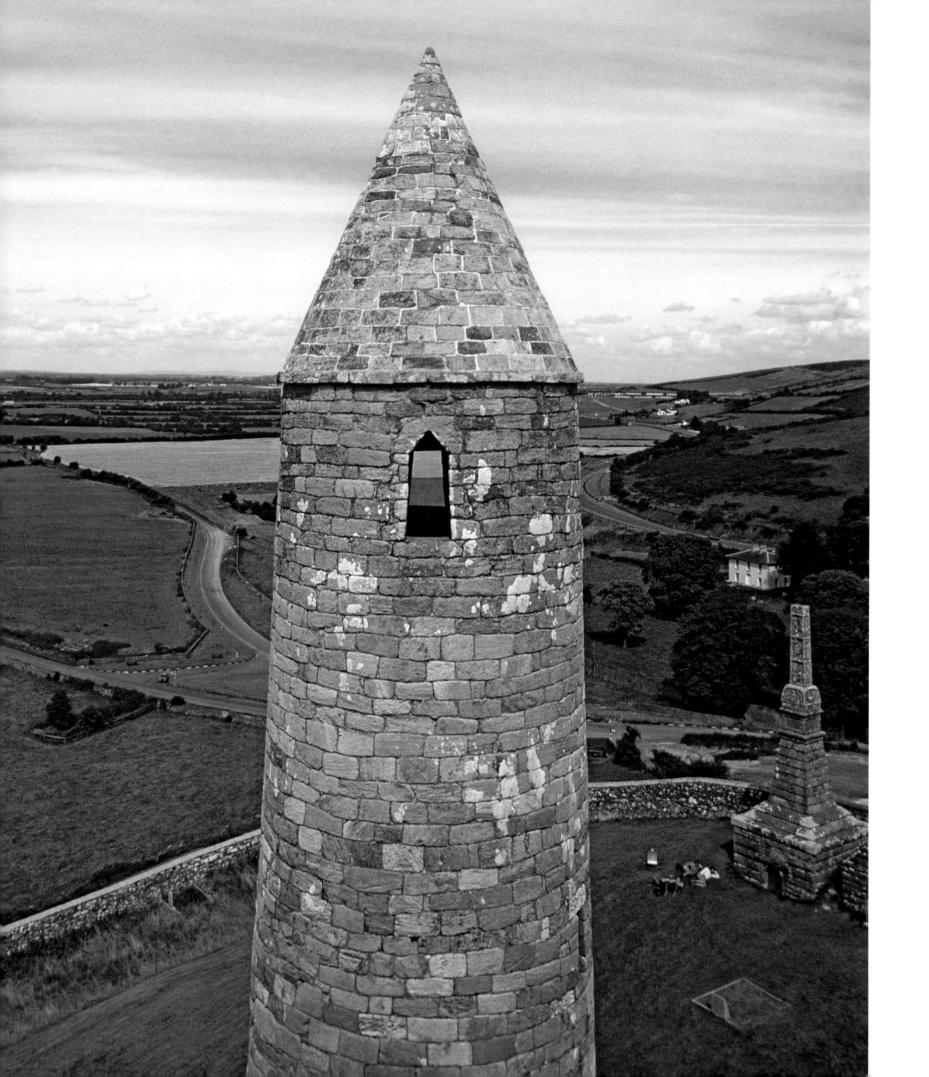

Irish Round Towers

Glendalough, County Wicklow, and Cashel, County Tipperary, Ireland

Map sites 11 and 12

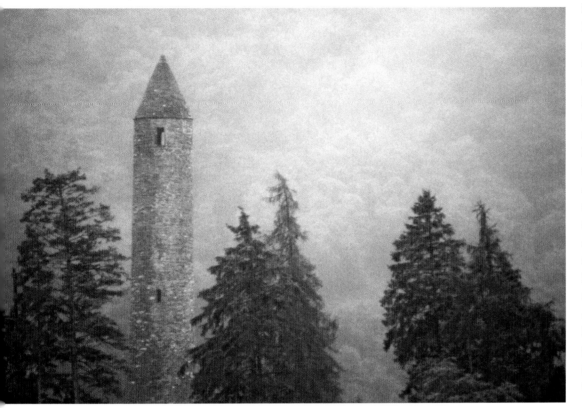

Above: **The round tower of Glendalough** is considered by scholars to be the most finely constructed and beautiful tower in Ireland. Situated in a thickly forested valley, the ninety-eight-foot-tall (30 m) tower is built of mica schist with a granite doorway. Glendalough was an ancient gathering place of pre-Christian hermits. The first Christian monastery was established by St. Kevin, who lived in the enchanted valley from 498 to 618 CE. Clustered about the base of the tower are remains of a twelve-hundred-year-old cathedral and the first functioning university in the Western world.

Left: **The round tower of Cashel** soars ninety-two feet (28 m) above the plain of Tipperary. While the tower dates from the eleventh century, the rock outcrop upon which it stands has fortifications from the early fourth century, when it was the stronghold and ceremonial center of a powerful clan. Patrick is said to have visited the site in 450 CE; hence, one of its popular names is St. Patrick's Rock.

Scattered across the rolling hills of Ireland are the remains of sixty-five round towers, of which thirteen still retain their conical caps. Scholars suggest a probable construction period between the seventh and tenth centuries CE, based on the fact that nearly every tower is at the site of a known Celtic church dating from the fifth to twelfth centuries. Archaeological excavations at the bases of the towers, however, have revealed that many towers were erected at sites considered to be sacred places prior to the arrival of Christianity in Ireland. Equally intriguing, the seemingly random geographical arrangement of the round towers throughout the Irish countryside actually mirrors the positions of the stars in the northern sky during the time of the winter solstice.

The conventional notion that the round towers were erected as watchtowers and places of protection is strongly contested by research indicating that the towers may have been designed, constructed, and utilized as huge resonant systems for collecting and storing meter-long wavelengths of magnetic and electromagnetic energy coming from the earth and skies. Based on studies of insect antennae and their capacity to resonate to micrometer-long electromagnetic waves, it has been suggested that the Irish round towers (and similarly shaped religious structures throughout the ancient world) were human-made antennae that collected subtle magnetic radiation from the sun and passed it on to the monks meditating in the towers. The round towers were able to function in this way because of their form and also because of their construction materials. Of the sixty-five towers, twenty-five were built of limestone, thirteen of iron-rich red sandstone, and the rest of basalt, clay, slate, or granite. All of these minerals have paramagnetic properties and can therefore act as magnetic antennae and electromagnetic energy conductors. Because paramagnetic stone is weakly attractive to magnetic fields, it can be used to gather, concentrate, and focus magnetic and electromagnetic energies for various uses.

CANTERBURY CATHEDRAL

Canterbury, England

MAP SITE 13

Canterbury Cathedral, the most famous of England's pilgrimage shrines during the late medieval era also marks what was once a pagan sacred place. While a Celtic church was built following the Roman occupation of England in 43 CE, and St. Augustine established the first cathedral after his arrival in 597 CE, Canterbury's importance as a Christian pilgrimage destination began with the martyrdom of Thomas Becket in 1170. Becket, the archbishop of Canterbury, had angered King Henry II and was thereafter murdered in the cathedral by four of the king's knights. Becket was certainly no saint (he was reportedly an arrogant, greedy, and manipulative opportunist), yet his martyrdom gave rise to England's greatest pilgrimage tradition. The reasons for this were the unjust circumstance of his murder, the coincidental occurrence of miracles of healing following the murder, the penance done at the shrine by Henry II four years later, and the widespread medieval belief in the spiritual powers emanating from the relics of martyrs.

For more than three hundred years, Canterbury attracted large numbers of pilgrims from all over England and Europe, and many hundreds of miracles of healing were recorded. A colorful description of the pilgrimage era is given in *The Canterbury Tales*, written by Geoffrey Chaucer in the fourteenth century. Pilgrimages to Canterbury and to most other English shrines waned in the mid-sixteenth century after King Henry VIII dissolved the monasteries and confiscated their property. A measure of the immense popularity of the Canterbury pilgrimage is evident from the fact that twenty-six wagons were required to haul away the confiscated gold, jewels, and other treasures that had been donated to the shrine. It is said that a forest of crutches left by the handicapped who had been miraculously healed also surrounded the shrine. When considering the healing miracles that occurred at Canterbury during Christian times, one should remember that it had long before been used as a healing site by the local pagan cultures.

A stained-glass window in the Canterbury Cathedral depicts the martyrdom of Thomas Becket.

CATHEDRAL OF SANTIAGO DE COMPOSTELA

Santiago de Compostela, Spain

MAP SITE 14

Medieval legends tell that St. James the Elder, one of the apostles of Jesus traveled on the Iberian Peninsula and spread Christianity. Following his martyrdom in Jerusalem around 44 CE, his relics were supposedly taken back to Spain and enshrined. The location of the shrine was forgotten after the fall of the Roman Empire, but a hermit, led by a beckoning star and celestial music, rediscovered the lost relics in 813 CE. Most Catholic historians, however, doubt that St. James ever visited Spain. There were also stories that Santiago Matamoros, St. James the Moor Slayer, had appeared on a white horse in 844 to lead the Christians into battle against the Moors. Scholars interpret these two legends as attempts to provide a rallying point for Spanish Christians living in territories then occupied by Muslim Moors. Church officials in Compostela often hired storytellers to travel the European countryside to spread news of the miracles of St. James and his relics.

Over the tomb where St. James's relics were believed to have been found, the first church was constructed in 829, and within one hundred years Santiago de Compostela became a popular holy place. Even though Rome and Jerusalem were more favored pilgrimage destinations, Santiago de Compostela received more visitors because it was closer and safer to visit. Over the centuries, four major land routes to Santiago were developed passing through places of pre-Christian sanctity where other pilgrimage churches had been built, and by the twelfth century, Compostela had become the greatest pilgrimage center in medieval Europe.

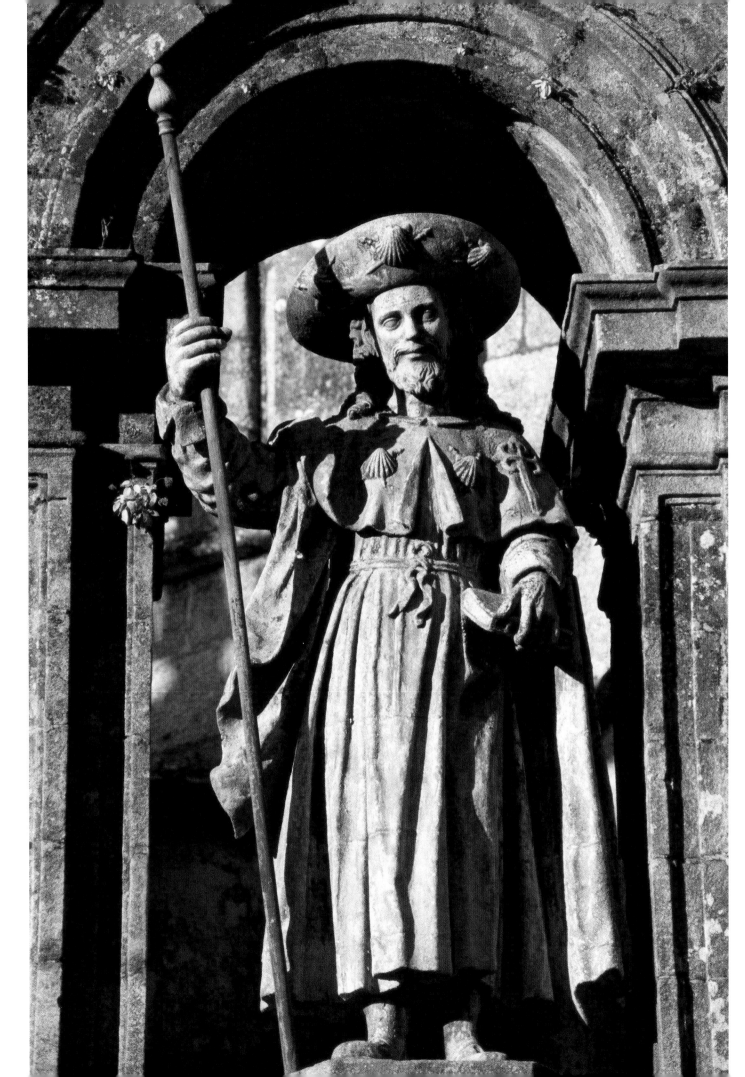

At the Cathedral of Santiago de Compostela, a stone sculpture depicts St. James in the garb of a wandering pilgrim. The seashells fastened on his cloak and hat were the badges of the medieval age and signified a pilgrim's visit to the shrine of Santiago.

Shrines of the Two Marys

Zaragoza, Spain

Map site 15

Toward the end of the first century BCE, the ancient Celtiberian sacred site of Salduba was conquered by the Romans and renamed Caesaraugusta, after the Roman emperor. Called Saraqustah by the Arabs, the modern name of the city, Zaragoza (Saragossa in English), is a corruption of these earlier names. There are two primary sacred places within the city: the tower of the Church of La Magdalena, shown in the foreground of the photograph, and the Cathedral of Nuestra Señora del Pilar, shown in the background. The cathedral, dedicated to the Virgin of the Pillar, the patroness of Spain, is the site of the earliest known Marian (meaning "of the Virgin Mary") apparition in Europe. The Christian legend of how the cathedral was built tells us that St. James the Apostle, the brother of St. John the Evangelist, spent the years after the crucifixion of Jesus preaching in Spain. St. James the Apostle arrived in Zaragoza in 40 CE and, upon a megalithic standing stone, saw an apparition of Mary, who instructed him to build a church. Because of its megalithic-era sanctity and its Marian apparition, Zaragoza soon grew in size and religious importance. The early chapel was frequently enlarged following wars and fires, and the existing cathedral was erected, upon the site of the original megalithic standing stone, between the seventeenth and eighteenth centuries.

Throughout the hundreds of years, mysterious apparitions have frequently been observed around the pillar, and large numbers of pilgrims, both Christian and neo-pagan, continue to visit the shrine. Each year on October 12, a small fifteenth-century statue of the Virgin is taken on a procession around the city.

Few visitors to Zaragoza take the time to meditate in the nearby quieter shrine of Mary Magdalene. The Magdalene, whose relics were originally stored at the French shrine of St. Maxim and later transferred to Vézelay, was highly venerated in the Middle Ages, largely in southern France, as the wife of Jesus and the mother of his children.

The tower of the Church of La Magdalena, in the foreground, is an example of Mudejar design, a style used in Spain from the twelfth to seventeenth centuries in Spain that combined Moorish and Gothic architectural traditions.

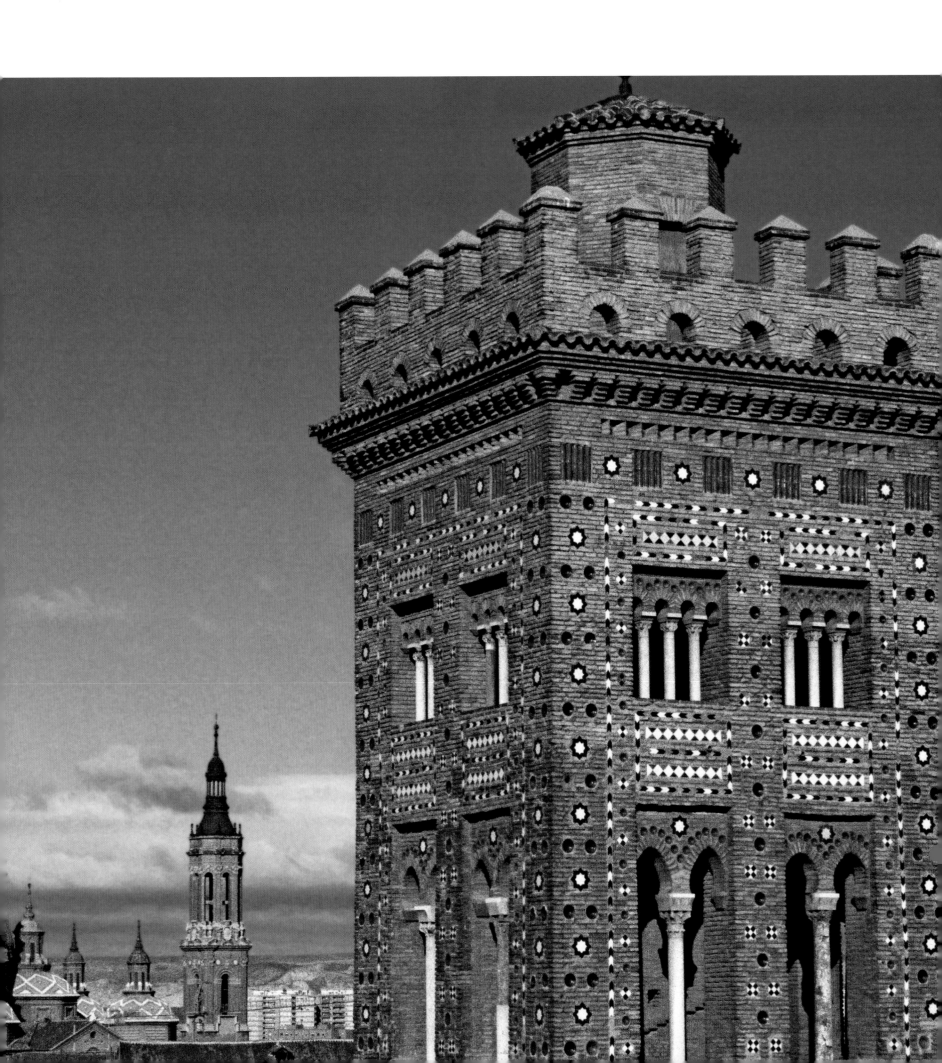

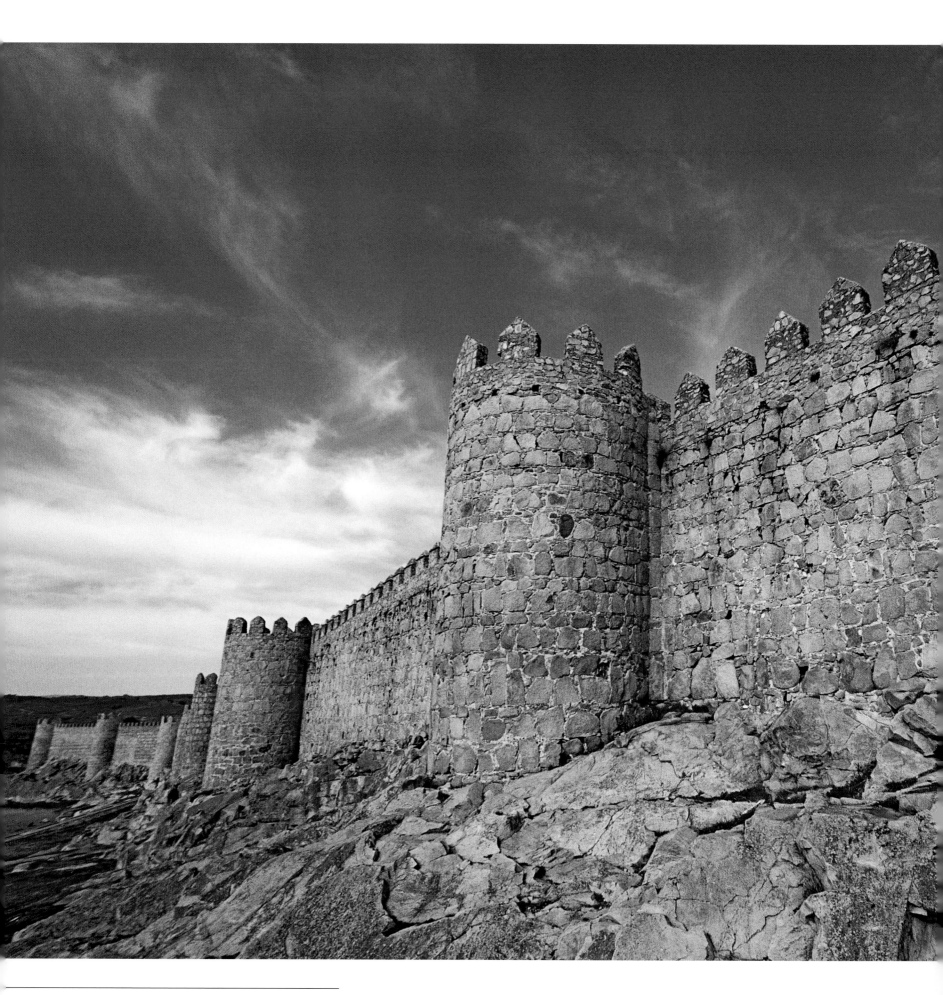

SACRED EARTH

Medieval Walls

Ávila, Spain

Map site 16

The walled town of Ávila was sacred to an ancient Celtiberian culture long before the arrival of the Romans or Christians, and it is one of the finest remnants of Europe's medieval era. After being captured by the Arab Moors in 714 CE and recaptured by the Christians in 1088, Ávila had protective walls built in the twelfth century. In the late medieval era, its visitors were pilgrims coming to visit the church in the center of the walled city. The current church, begun in 1091 and completed in the thirteenth century, is where the sixteenth-century mystic St. Teresa had frequent visions and ecstatic experiences. Tourists still visit Ávila, and there is a presence of holiness and peace inside this church that is wonderful to experience. Near the church stands the house where St. Teresa lived.

The massive walls encircling the sacred town of Ávila are punctuated by ninety heavily fortified stone towers.

MONT-SAINT-MICHEL

Normandy, France
MAP SITE 17

Rising out of the mist and fog often cloaking the coasts of Normandy, Mont-Saint-Michel seems like a fairy-tale castle from an ethereal realm. Known today primarily as a Christian holy place, the remarkable granite mount has been a sacred site of other cultures for thousands of years. The Celts worshipped their god Belenus here, the Romans built a shrine to Jove, and hermits occupied the craggy mount until the late seventh century CE. Additionally, the mount is located along the ancient Apollo-Athena line that links sacred places from Ireland to Greece, including St. Michael's Mount in Cornwall, England (see pages 32-33).

Mont-Saint-Michel first became a site of Christian importance in 708 CE, when a local bishop had a vision of the archangel Michael telling him that a shrine should be built atop the rock. From that time the mount had a checkered history, through periods of prosperity and decline, to become one of the most favored pilgrimage sites in medieval Europe. La Merveille, the beautiful thirteenth-century Gothic abbey towering five hundred feet (152 m) above sea level, is crowned by a statue of St. Michael in the act of killing the devil in the form of a dragon.

The centuries at the mount were not always peaceful for the monks. In the fourteenth century, the Hundred Years' War made it necessary to protect the abbey with walls and military constructions, thereby enabling it to resist a siege that lasted thirty years. Centuries later, during the French Revolution, the abbey was secularized, and the mount was used as a prison until 1863. In 1966, in celebration of the thousandth anniversary of the monastery, the French government permitted the restoration of monastic life on the mount. Today the mount has more than three million visitors a year, making it the second most visited place in France.

The rock upon which Mont-Saint-Michel sits is separated from the mainland by a narrow strip of sand, which in former times was submerged beneath the tides for several hours each day. A causeway now links the rock and the mainland, but it is still fascinating to observe the tides, which rise and fall as much as forty-five feet (14 m) per day and rush at speeds of two hundred ten feet (64 m) a minute.

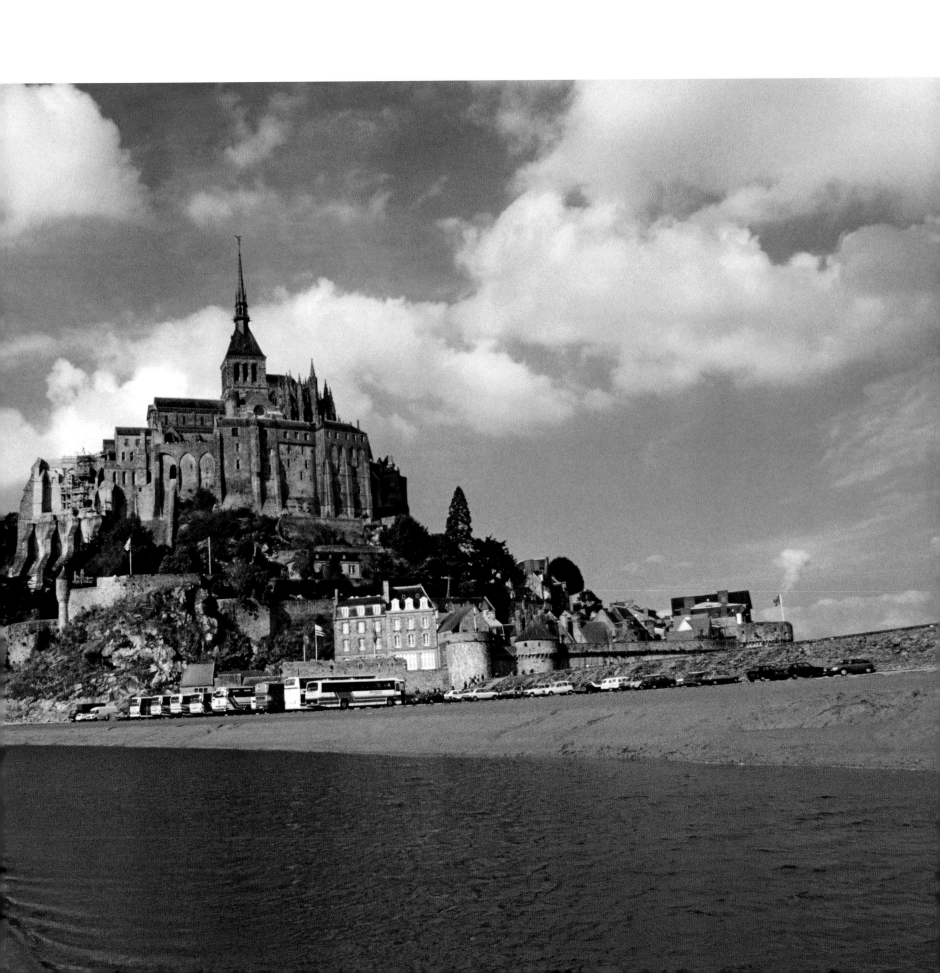

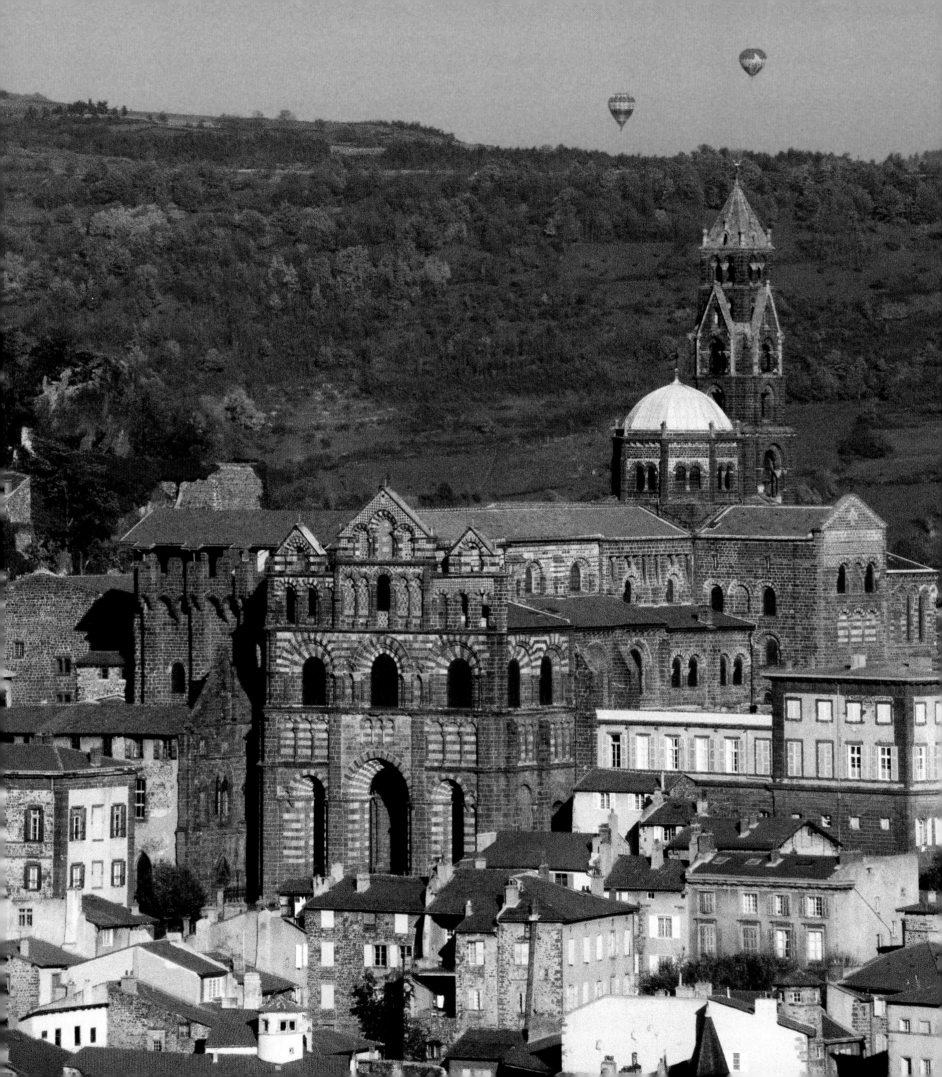

CATHEDRAL OF NOTRE DAME

Le Puy-en-Velay, France
MAP SITE 18

Located on Mt. Corneille in the Auvergne region of central France, the Cathedral of Notre Dame in Le Puy-en-Velay is one of Europe's oldest and most celebrated pilgrimage shrines. Much visited during medieval times by pilgrims on their way to Santiago de Compostela, it is highly venerated for its Black Madonna statue. The explanation for the black shade of the Madonna at Le Puy—and Madonnas at numerous other churches throughout Europe—is a matter of scholarly debate. While it is certain that the black coloring does not derive from the smoke of burning church candles, the actual reason for it is unknown. The prevailing explanation is that the black statues are representations of a pre-Christian deity, most likely the Egyptian goddess Isis, whose likeness was very probably adopted by medieval European Christianity.

Mt. Corneille's use as a sacred place has its roots in prehistoric times when a menhir stood atop the sacred hill. This stone played a decisive role in the development of Le Puy as a Christian pilgrimage site. Between the third and fourth centuries CE, a local woman suffering from an incurable disease had visions of Mary in which the woman was instructed to climb Mt. Corneille and sit near the menhir, where she would be cured. After following this advice, the woman was miraculously healed of her ailment. During a second vision, the woman was instructed to contact the local bishop and tell him to build a church on the hill. Convinced by these miracles, the bishop completed construction of the church by 430 CE. Despite ecclesiastical pressures, which sought to combat surviving pagan religious practices, the menhir was left standing in the center of the sanctuary and was consecrated as the Throne of Mary. By the eighth century, the megalithic stone, locally known as the Stone of Visions, was taken down and broken apart. Its pieces were then set into the floor of a section of the church that came to be called the Chambre Angélique, or the Angels' Chamber. However, visions and apparitions continued to occur in the church.

Another pilgrimage shrine in Le Puy, much visited during medieval times, is the Chapel of St. Michael. A site of known pre-Christian sanctity, it is located along the enigmatic Apollo-Athena energy line that runs arrow-straight from Skellig Michael in Ireland through Delphi, Delos, and other holy places of ancient Europe.

Balloons rise in the air behind the massive Cathedral of Notre Dame. While primarily an example of Romanesque architecture, the cathedral also displays Byzantine and Arabic influences in both its construction and its decoration.

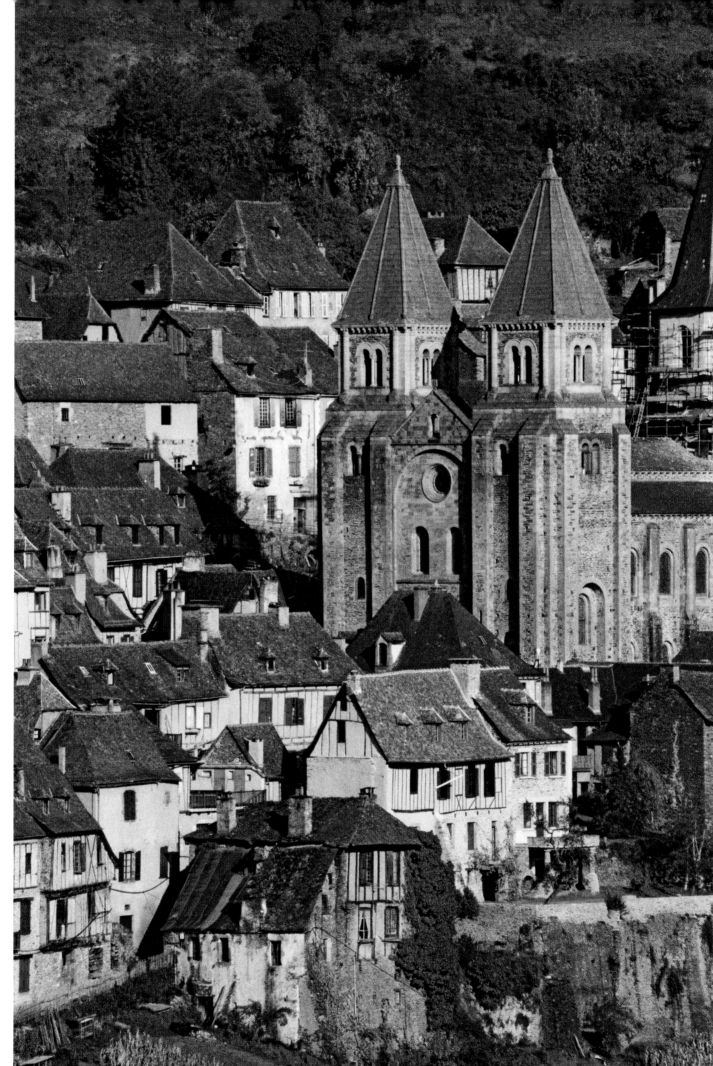

The Abbey of Conques was originally the site of a hermitage in the ninth century. It was founded by a reclusive monk looking for an isolated location to pray and meditate. The present-day abbey was constructed from 1050 to 1120 and restored in the nineteenth century.

Abbey of Conques

Conques, France

Map site 19

Located in a remote Auvergne valley upon a steep and thickly wooded mountain, the Abbey of Conques was one of medieval France's most visited pilgrimage shrines. Church authorities explain that Conques gained renown as an important shrine along one of the four principal routes leading to Santiago de Compostela because the twelfth-century Benedictine abbey contained the miraculous relics of St. Foy. Foy was a twelve-year-old girl living in Asia Minor who was burned as a Christian in 303 CE and therefore became a martyr.

The relics of Foy, like so many others in medieval times, are of dubious authenticity. Indeed, the relics originally were not even kept in Conques but were stolen by a Christian monk from the Church of Agen and then brought to Conques. While certain sacred objects, such as relics of truly saintly persons or ceremonial items used for centuries, do indeed have a power or mysterious energy that contributes to the occurrence of miraculous phenomena, this does not seem to be the explanation for the power of Conques. The site was holy ground from time immemorial, and we must look to the living earth for an explanation of the miracles.

Church of the Three Saints

Saintes-Maries-de-la-Mer, France

Map site 20

Saint Marys of the Sea is a small fishing village on the Mediterranean coast that has been venerated as a holy place by a succession of cultures. Once a sacred site of the Celtic threefold water goddess, the holy spring was known as Oppidum Priscum Ra. Replaced by a fourth-century BCE Roman temple dedicated to Mithras, the site was later taken over by the Christians and then became, sometime in the early 1400s, the most sacred place of the Gypsies. According to legend, Mary Magdalene, Mary Salome, Mary Jacobe, Lazarus, Joseph of Arimathea, and a black servant girl named Sarah were forced to flee from the Holy Land by boat after the Resurrection of Christ. Following a perilous journey across the Mediterranean, they landed near the present-day village of Saintes-Maries-de-la-Mer.

Over time, Mary Salome and Mary Jacobe became objects of veneration by the local people. Dating from the mid-twelfth century, the church enshrines three images—the two Marys and a statue of Sarah, whose origin and identity are unknown. Gypsies believe Sarah to have been a local queen who welcomed the travelers from the Holy Land, while other sources suggest she was an ancient pagan goddess or a black Egyptian woman who was the servant of Christ's mother, Mary. The three statues are the focus of the highly attended Pèlerinage des Gitans, or Pilgrimage of the Gypsies, held each year on May 24 and 25. During the pilgrimage festivities, the ecstatic Gypsies bring the statues from the church and venerate them. On the afternoon of May 24, the Gypsies carry the statue of Sarah on their shoulders in a procession to the sea. The following morning, the two Marys are placed in a small boat that is then temporarily floated just off the seashore, after which the statues are returned to the church. In the afternoon, a farewell ceremony is given to the saints, the Gypsies depart, and the village of Saintes-Maries-de-la-Mer returns to its quiet life.

The Church of Saintes-Maries-de-la-Mer enshrines images of three feminine saints venerated by European Gypsies. Thousands of Gypsies flock to the little seaside village from the far corners of Europe for the annual saints' festival held there every May.

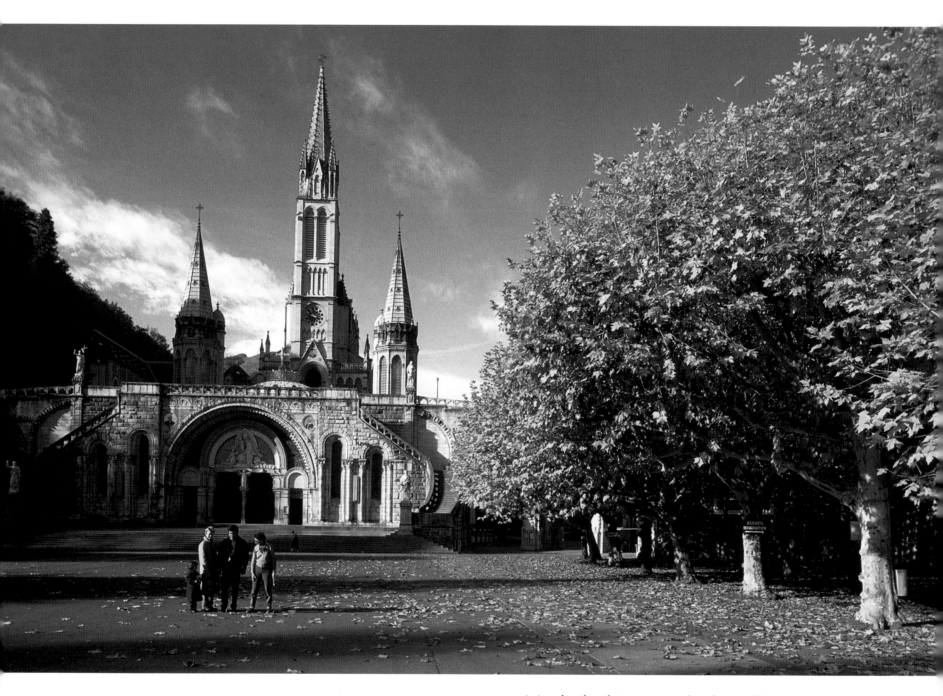

In Lourdes, the pilgrimage season lasts from April through October, the busiest day being August 15, the Marian Feast of the Assumption. Between four and six million pilgrims from around the world visit the shrine each year, and it is estimated that more than 200 million pilgrims have come to Lourdes since 1860.

BASILICA OF
OUR LADY OF LOURDES

Lourdes, France
MAP SITE 21

The most visited pilgrimage shrine in the Christian world, Lourdes is not an ancient site but of more recent development. The origins of its sanctity begin with a fourteen-year-old girl Bernadette Soubirous. Between February and July 1858, Bernadette saw eighteen apparitions of a white-robed lady in a small grotto called Massabiele, near the town of Lourdes. In these visions, the lady told Bernadette to instruct the village priest to build a chapel in the grotto, which many people would soon visit. On the day of the sixteenth apparition, March 25, during her ecstatic trance in the grotto, Bernadette began to dig in the earth until a small puddle of water appeared. Over the next few days, the puddle grew into a pool and eventually became the sacred spring for which Lourdes is now so famous.

Initially the spring was only a regional pilgrimage destination, but as incidents of healing were reported, it developed an international reputation for having therapeutic powers. Pilgrims visiting Lourdes for its healing qualities bathe in pools of water from Bernadette's spring. Reports of miracles are thoroughly examined, and evidence indicates that there are many cases of verifiable healings at the grotto. The increasing number of pilgrims eventually overcrowded the original church, built above the grotto in 1876, so in 1958 an immense basilica was constructed. Other important Marian apparitions have occurred in La Salette, France, in 1846; in Pontmain, France, in 1871; in Knock, Ireland, in 1879; in Castelpetroso, Italy, in 1888; in Fátima, Portugal, in 1916–1917; in Garabandal, Spain, in 1961–1965; in Zeitoun, Egypt, in 1968–1971; and in Medjugorje, Yugoslavia, in 1981.

During most of the year, the shrine of Fátima is a quiet and peaceful place, visited by locals and the few hundred pilgrims arriving each day. On May 13, to commemorate the day of the first apparition, and on October 13, the day of the final apparition, half a million pilgrims crowd into the great square in front of the basilica.

BASILICA OF
OUR LADY OF FÁTIMA

Fátima, Portugal
MAP SITE 22

The town of Fátima is one of the most visited Marian shrines in the world today. Unlike many of Europe's great Marian pilgrimage sites, the sanctity of Fátima dates not from the Middle Ages but from the early twentieth century. Most sources describing the Fátima events mention only the Marian apparitions that occurred in 1917. However, the girl Lúcia Santos, the sole recipient of the apparitions, revealed that three other apparitions in 1916, of a male figure, preceded the Marian apparitions of 1917. The series of apparitions for which Fátima is famous began on May 13, 1917, and continued through October, occuring on the thirteenth of each month. The first Marian vision came to Lúcia and her cousins Jacinta and Francisco as they tended sheep in an isolated ravine called Cova da Iria. The children first saw two flashes of lightning and then a "lady, brighter than the sun, shedding rays of light" who said she was from heaven. Lúcia asked, "What do you want of me?" The lady answered, "I want you to come here for six months in succession." During the following months, the three children returned, and each time Lúcia experienced more visionary experiences.

Uncomfortable with the attention brought to her by the apparitions, Lúcia left Fátima and became a nun in 1926. In 1930, after thoroughly investigating the events of 1917, the Vatican authenticated the apparitions. Donations arrived from believers around the world, and the great basilica of Fátima was built. Lúcia entered a Carmelite monastery in Spain in 1948.

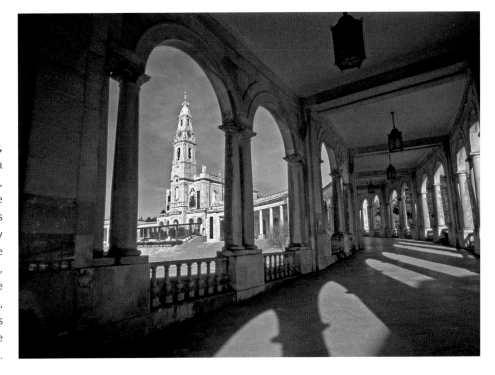

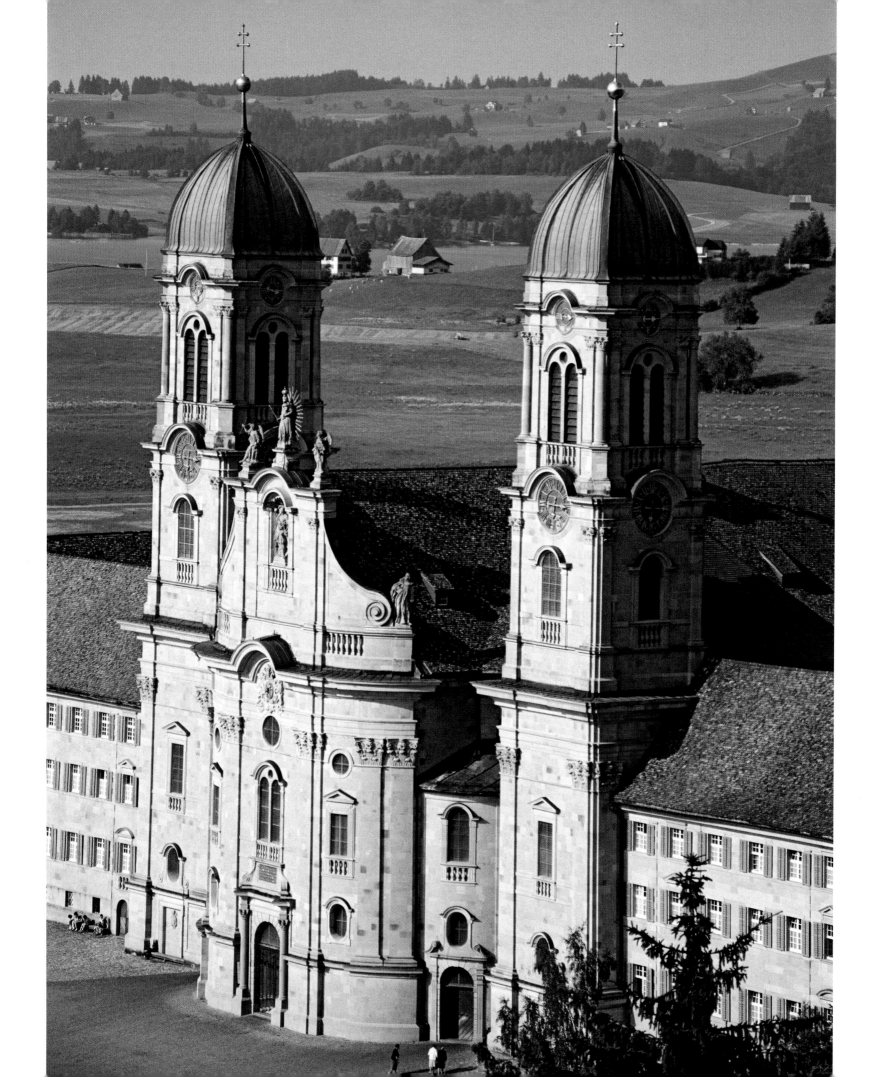

BENEDICTINE EINSIEDELN ABBEY

Einsiedeln, Switzerland

MAP SITE 23

While legends indicate that Einsiedeln was sacred in pre-Christian times, its historical fame dates from 835 CE, when the monk Meinrad lived as a hermit in the woods. When Meinrad came to the forest, he brought one of the mysterious Black Madonna statues, considered by scholars to be a Christianized form of the pagan Dark Goddess. After Meinrad's death, a Benedictine cloister was built at the site of his hermitage, and this cloister, housing the Black Madonna, soon became a pilgrimage site of great importance. Inside the church, the primary object of pilgrimage visitation is the Chapel of Grace, which houses a mid-fifteenth-century Black Madonna, the earlier statue having been destroyed in a fire. The Chapel of Grace, standing directly upon the site of Meinrad's original hermitage, is believed to have been consecrated by Jesus when he miraculously appeared in 948.

The Black Madonna statues in European pilgrimage shrines are a matter of controversy. Throughout Western Europe, there are more than two hundred examples of these black figures and, while heretical to the Catholic Church, they are widely venerated as having esoteric, magical, and wonder-working powers. A large percentage of the European shrines where Black Madonnas are venerated were centers of nature worship in pre-Christian times. Many scholars interpret the popularity of the Black Madonnas as a continuing veneration of pagan goddesses such as Isis, Diana of Ephesus, Artemis, Cybele, and the Celtic deity Hecate. The Catholic Church, in its effort to exterminate the ancient and immensely popular goddess cults, succeeded only in driving them underground. In contemporary Europe, however, the veneration of the feminine principle—and its sacred sites—is once again gaining power.

PILGRIMAGE CHURCH OF MARIAHILF

Hallstatt, Austria

MAP SITE 24

The small town of Hallstatt and its adjoining lake, Hallstattersee, derive their names from *hal*, the old Celtic word for salt. For at least 2,800 years, salt has been mined in the area, making the Hallstatt mines among the oldest in the world. From 1000 to 500 BCE, the town flourished as a European trading center, and this period of Celtic culture has become known as the Hallstatt epoch of the early Iron Age. Romans, and later medieval Europeans, worked the salt mines; today the mines are an underground museum of prehistoric technology. Little is known of Celtic or Roman religious practices at Hallstatt, yet by the 1300s the hillside Church of Mariahilf had become an important place of regional pilgrimage. Most scholars discuss Hallstatt solely in terms of its commercial activities during the Iron Age, but the beautiful lakeside town is more significant for its extraordinary atmosphere of peace. To meditate in the quiet shrine of Mariahilf, to walk amid the forests and hills surrounding the town, or to glide by rowboat across the placid waters of Hallstattersee is to leave the hustle-bustle of the modern world and enter an inner realm of timeless serenity.

The tranquil town of Hallstatt is reflected in the Hallstattersee (the lake of Halstatt). The Church of Mariahilf can be seen on the hill to the right of center.

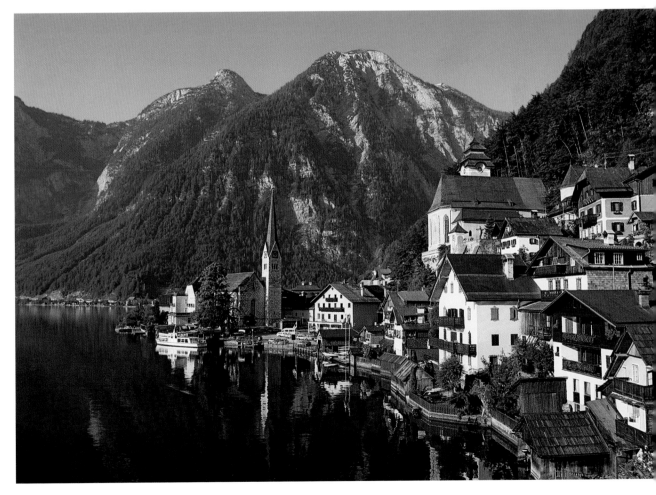

The enormous Benedictine abbey standing today in Einsiedeln was built over many centuries, and only legends are left regarding the site's sacred use in prehistoric times.

Temple of Hera

Paestum, Italy
Map site 25

Fifty miles (80 km) south of Naples stands the ancient city of Paestum. Legends tell of the city's founding by Jason and the Argonauts, though archaeologists attribute Paestum's birth to seventh-century BCE Greek colonists. Paestum was long known as Poseidonia, indicating that the site was once a ceremonial center of Poseidon, the god of the sea. The two primary temples, built between 550 and 450 BCE, were originally dedicated to the fertility goddess Hera. A third temple on the site was dedicated to Athena. Poseidonia was conquered and occupied in 400 BCE by the Lucans, an Italian people who ruled until 273 BCE, when the city became a Roman colony. Following the fall of the Roman Empire, the spread of malaria from nearby marshes, and Muslim raids in the ninth century CE, Paestum was deserted. It was rediscovered only in 1752 by an Italian road-building crew. Paestum is the finest-preserved Greek temple complex in the Mediterranean world.

The site was originally sacred to prehistoric earth-goddess cults before its usurpation by the patriarchal Poseidon priesthood. Hera was a goddess of fertility and creativity, and Athena a goddess of art and spiritual wisdom. Did Hera and Athena actually exist as physical beings at one time, or could these goddesses be better understood as metaphors for the energetic characteristics of the site?

Legends associated with the Temple of Hera indicate it was once favored for its power to stimulate creativity. It is interesting to note that a popular legend resonates with this idea. Childless couples come to the Temple of Hera to copulate beneath the night sky, in the belief that making love within the shrine of the goddess will call forth her fertilizing influence and thereby ensure pregnancy. Ultimately, these myths speak to us of the power of this place to birth newness in the human spirit.

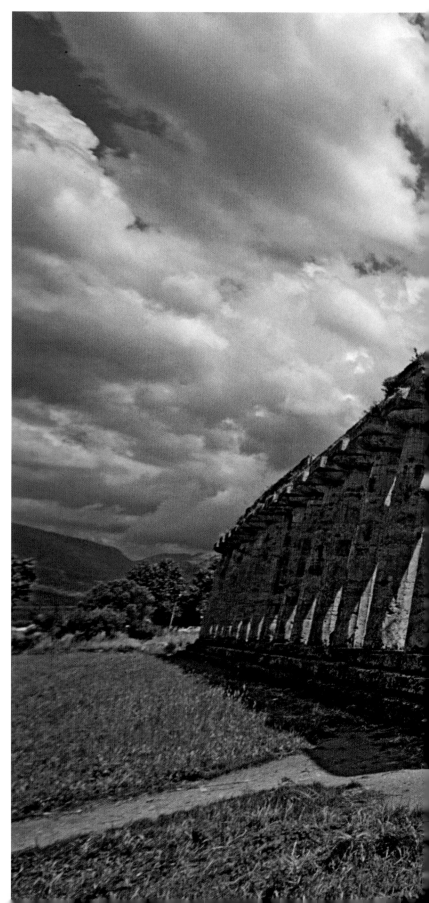

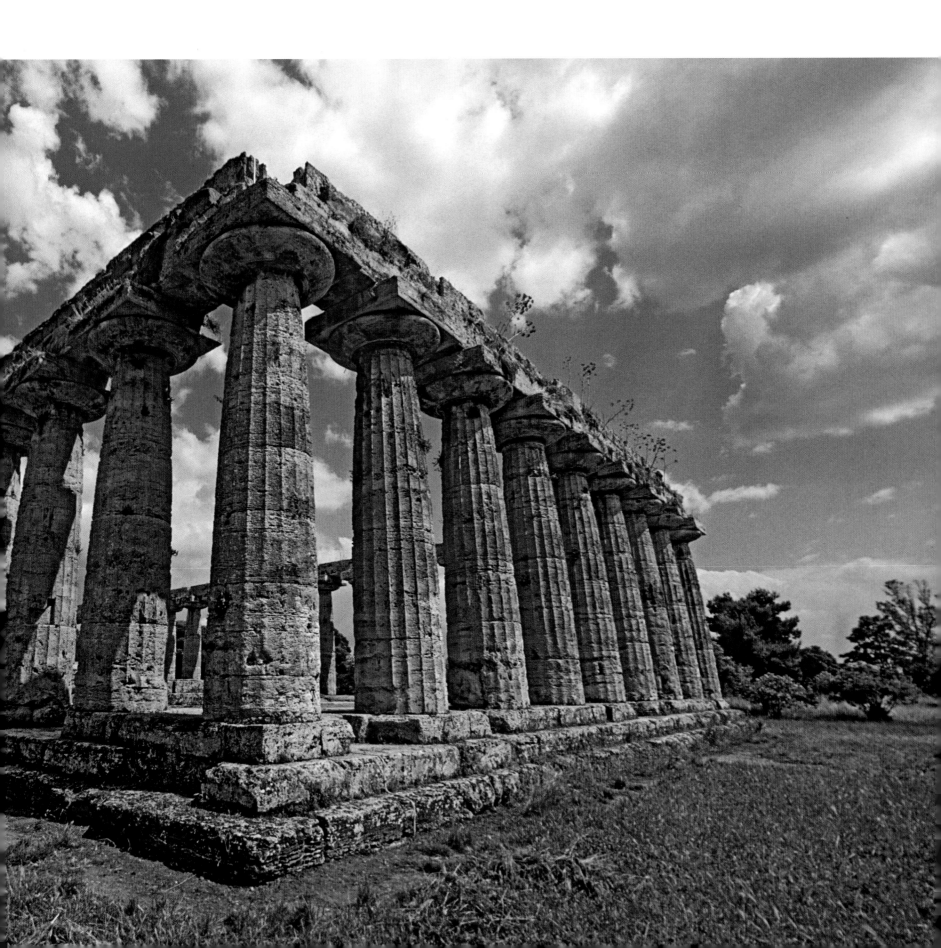

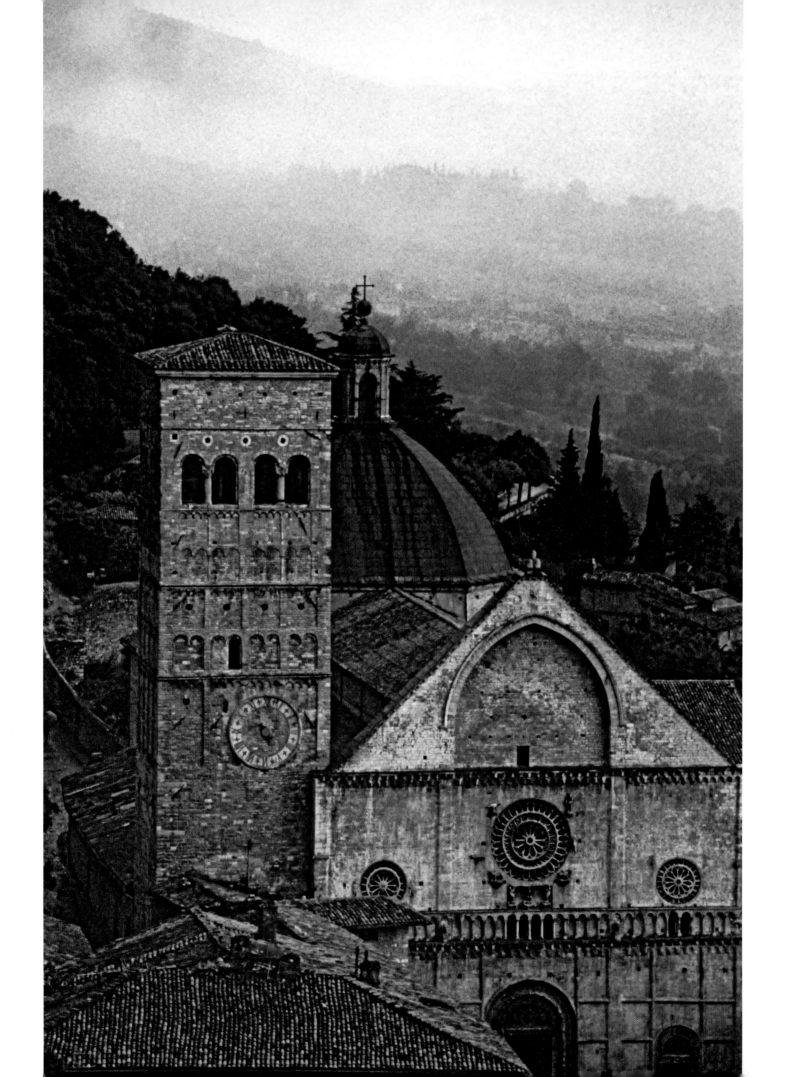

FRANCISCAN HOLY PLACES

Assisi, Italy

MAP SITE 26

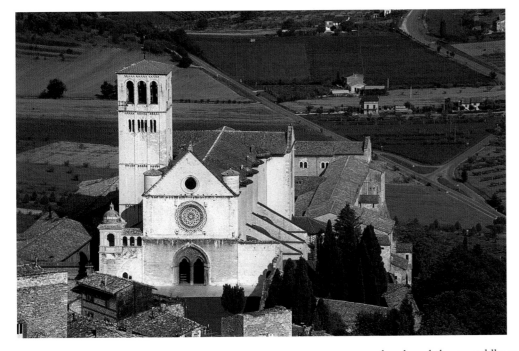

The Basilica di San Francesco was built between 1228 and 1253. By the 1400s, pilgrims were flocking to Assisi from all parts of Europe, and today the basilica is one of the most visited Christian shrines.

The enchantingly beautiful medieval town of Assisi, in the hills of Umbria, is best known as the birthplace of St. Francis. Yet long before the time of Francis, Assisi was already a holy place. Legends say the town grew around an Etruscan healing spring, which in the first century BCE became the site of a temple dedicated to Minerva, the Roman goddess of art and handicrafts. During early Christian times, the temple of Minerva, which still stands today, was used as a church, and the ancient sacred spring stopped flowing.

Francis, who lived from 1182 to 1226 CE, was the son of a prosperous Assisi merchant. In his youth he had dreams of achieving wealth, but he abandoned these worldly ambitions at the age of nineteen while a prisoner of war in nearby Perugia. He thereafter became a mystic who experienced numerous visions of Christ and Mary, composed poems about the beauties of nature, and founded the Franciscan order of monks. His repudiation of the worldliness and hypocrisy of the Church, his love of nature, and his humble character earned him a devoted following throughout Europe. Francis was the first known Christian to receive the stigmata, the spontaneously appearing wounds on the hands, feet, and side of the body corresponding to the torments of Christ on the cross.

Certain holy places have a distinct feeling or presence of peace. Assisi is one of these places. The entire town—and particularly the basilica—has a definite atmosphere of peacefulness that awakens and stimulates that same characteristic in the human heart.

The Duomo di San Rufino was the third church built on the site that housed the remains of St. Rufinus, who served as the first bishop of Assisi during the third century. St. Francis was baptized and later preached at this church.

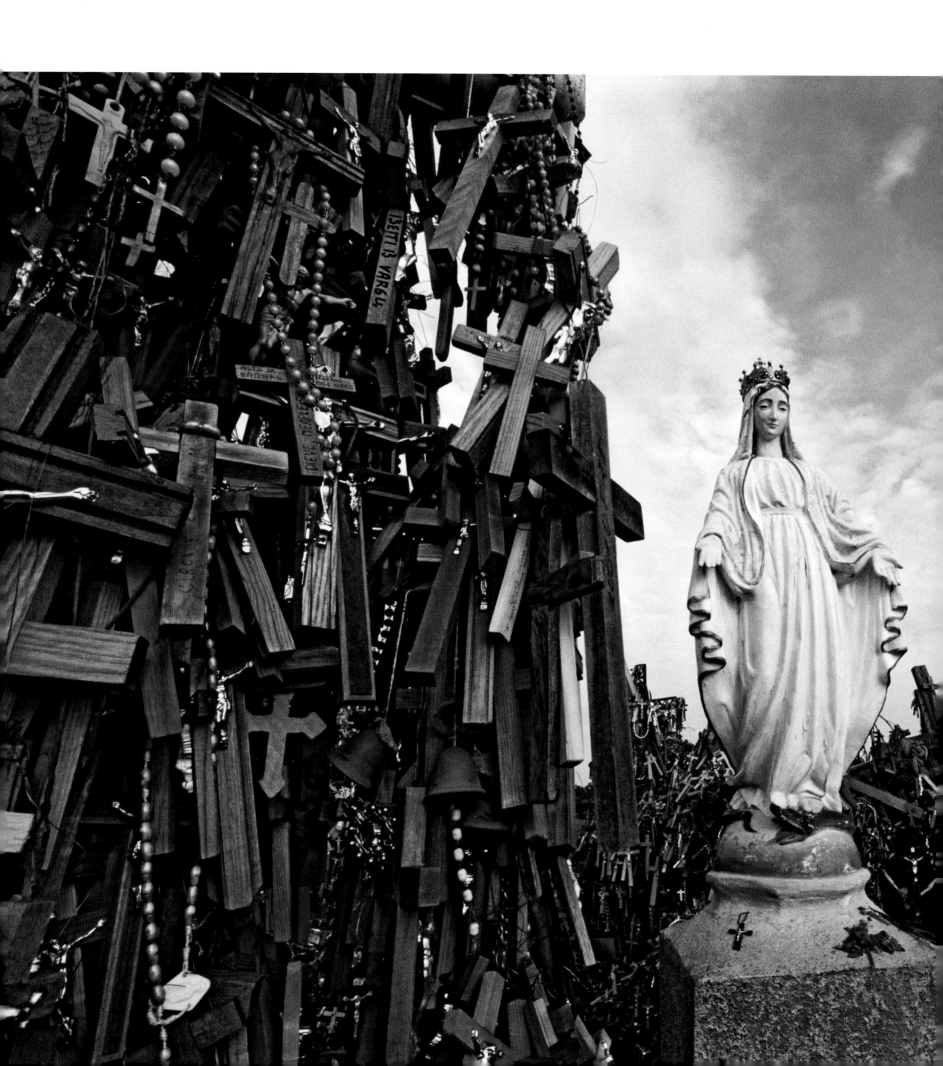

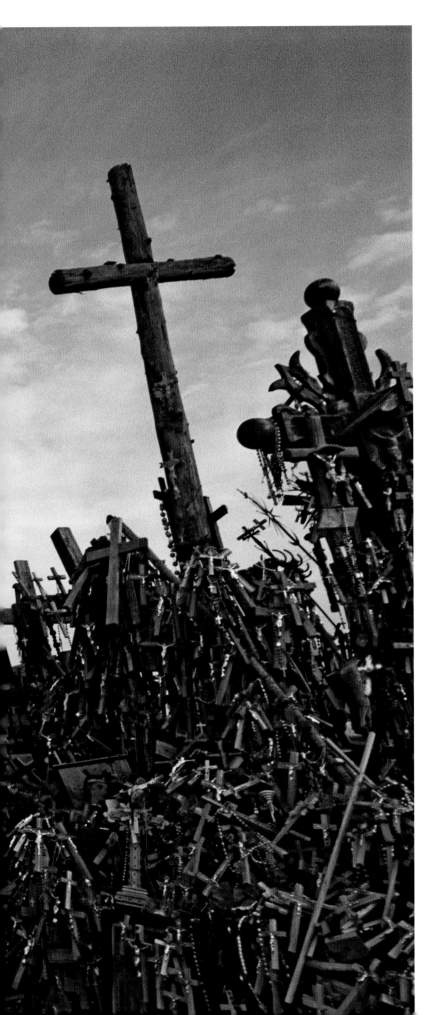

HILL OF CROSSES

Šiauliai, Lithuania

MAP SITE 27

The Hill of Crosses, located north of the city of Šiauliai (pronounced *shoo-lay*), is the Lithuanian national pilgrimage center. Standing upon the small hill are hundreds of thousands of crosses that represent Christian devotion and a memorial to Lithuanian national identity.

Šiauliai was founded in 1236 and occupied by Teutonic knights during the fourteenth century. The tradition of placing crosses on the hill dates from this period and probably first arose as a symbol of Lithuanian defiance of foreign invaders. Since the medieval period, the Hill of Crosses has represented the peaceful resistance of Lithuanian Catholicism to oppression.

Captured by Germany in World War II, the city suffered heavy damage when Soviet Russia retook it at the war's end. The Soviets repeatedly removed crosses placed on the hill by Lithuanians. Following each of these desecrations, local inhabitants and pilgrims from all over Lithuania rapidly replaced the crosses upon the sacred hill. In 1985, the Hill of Crosses was finally left in peace. The reputation of the sacred hill has since spread all over the world, and thousands of pilgrims visit it every year.

The size and variety of crosses is as amazing as their number. Beautifully carved out of wood or sculpted from metal, the crosses range from ten feet (3 m) tall to the countless tiny examples hanging profusely from the larger crosses. An hour spent on the sacred

hill reveals crosses brought by Christian pilgrims from all around the world. Rosaries, pictures of Jesus and the saints, and photographs of Lithuanian patriots also decorate the larger crosses. On windy days, breezes blowing through the forest of crosses and hanging rosaries produce a uniquely beautiful sound.

A statue of Jesus wearing the crown of thorns is covered in hundreds of crosses left by pilgrims.

On the Hill of Crosses, a statue of the Virgin Mary stands out in relief against the densely clustered crosses.

Marian Sanctuary of Jasna Góra

Czestochowa, Poland

Map site 28

The city of Czestochowa (pronounced *chen-sto-ko-vah*) and its Marian shrine of Jasna Góra are the spiritual heart of Poland and the country's national shrine. The event that decisively influenced the history of Czestochowa was the establishment of the Jasna Góra (Bright Mountain) monastery in 1382. Installed in the monastery was a painted icon, imported from Russia and already the focus of cultic veneration. Legends say that St. Luke painted the icon, but scholars put its creation at a later date, sometime between the fifth and fourteenth centuries. In 1430, the Jasna Góra monastery was attacked by raiders who damaged the icon, and its present appearance dates to the late fifteenth century, when it was repaired and repainted. As protection against further raids, fortifications were built during the early seventeenth century, which helped Jasna Góra survive a siege by the Swedish army in 1655. The heroic defense strengthened the Marian cult, integrating the religious values of the Jasna Góra shrine with Polish national values, thereby making the monastery and its miraculous icon the most venerated pilgrimage site in the country.

In 1682, 140,000 pilgrims celebrated the three hundredth anniversary of the coming of the icon to Jasna Góra. In 1717, more than 200,000 pilgrims from around the country walked there to attend the ceremonial crowning of the icon, Our Lady of Czestochowa, as the queen of Poland. Although the shrines are visited all year long, the most popular pilgrimage periods are the Marian Feasts, particularly the Birth of the Virgin Mary on September 8 and the day of her Assumption on August 15. Within the shrine, thousands of votives left by pilgrims over the centuries attest to the miraculous healing powers of the site. Each year, hundreds of thousands of pilgrims walk to the shrine from all over Poland, and more than 4.5 million pilgrims come from around the world, making the Marian shrine of Jasna Góra one of the most visited and venerated sacred sites on the planet.

A mosaic mural at Jasna Góra depicts the Black Madonna and Jesus underneath two angels holding a banner that reads *"Sub Tuum Praesidium"* ("Under Your Protection")—one of the oldest known prayers dedicated to the Virgin Mary, dating back to third-century Egypt.

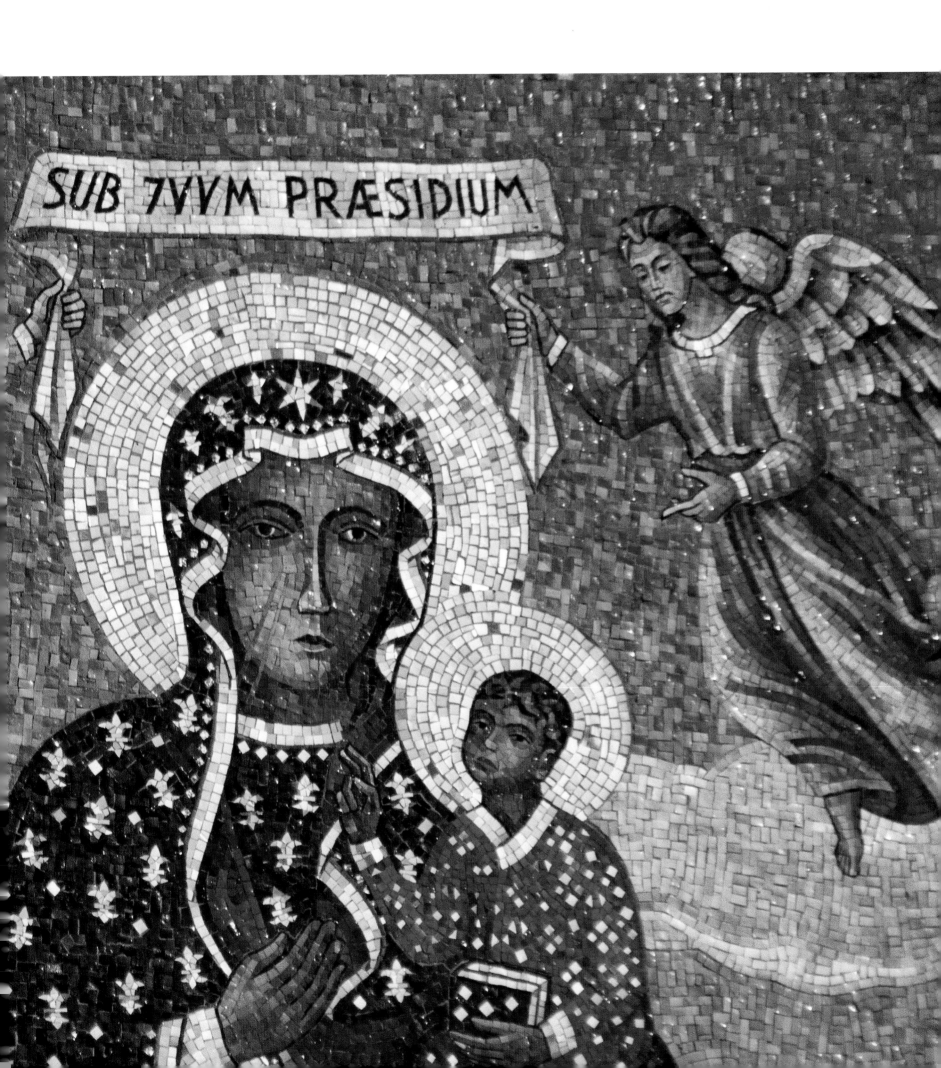

CATHEDRAL OF ST. SOPHIA

Novgorod, Russia
MAP SITE 29

Christianity became the religion of Russia in 988 CE, yet for uncounted centuries a variety of megalithic, pagan, and shamanic traditions existed. Concentrations of megaliths have been found near the White Sea and in the Caucasus Mountains. The Scythians, Huns, Greeks, Persians, Celts, and Slavs built temples for different deities. Following practices established by Roman Christianity, the Russians demolished temples, erected churches upon the foundations, and installed relics. Over the centuries, tens of thousands of Russians went on long walking pilgrimages to behold the sacred icons and relics.

Novgorod, one of the oldest cities in Russia, was founded in the fifth century CE. Its first church, erected upon the site of a pagan temple, was built in 989. In 1045 this building burned to the ground, and upon the same site a stone cathedral was built. The new Russian Orthodox cathedral was consecrated in 1052 to St. Sophia, who symbolized the feminine aspect of divine wisdom. Scholars interpret the dedication of Novgorod's cathedral to St. Sophia as a continuation of the cult of the Great Goddess which was widely practiced since ancient times.

In 1170 an event occurred that firmly established the cathedral as a place of pilgrimage. An army had attacked Novgorod and was threatening to overwhelm the inhabitants. The local bishop had a vision in which he was instructed to carry the cathedral's icon of the Virgin to the fortress walls. An attacker's arrow flew through the air and lodged directly in the icon, whereupon tears began to flow from the Virgin's eyes. At that moment, so the legend tells, all the attackers went blind and the army of Novgorod was able to defeat the enemy. Since that time, the icon of the Virgin has been named Znamenie, or Our Lady of the Sign, and she is believed to be the protector of the city. Her festival is celebrated on December 10.

The Cathedral of St. Sophia, one of the earliest stone structures in northern Russia, is topped with five onion domes—a shape characteristic of Russian Orthodox architecture.

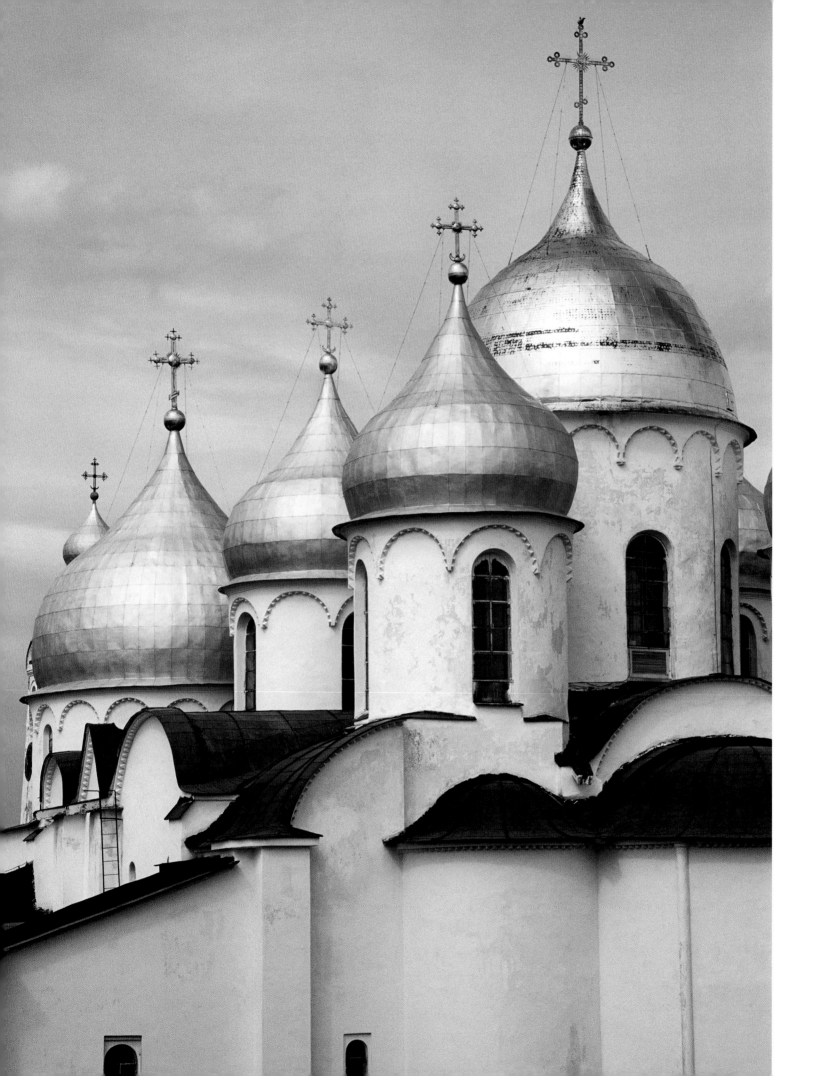

NIDAROS CATHEDRAL

Trondheim, Norway

MAP SITE 30

Located on the west coast of Norway, the town of Nidaros (now called Trondheim) was the most visited Christian pilgrimage site in the Nordic countries during the late Middle Ages. Long a regional trading center for products from land and sea, Nidaros became the first capital of Norway when King Olav Tryggvason established a royal fortress there in 997. The real source of the city's fame, however, was the life and death of Tryggvason's son, Olav Haraldsson, who became Norway's best-known religious crusader and saint.

Born in 995, Olav Haraldsson served as a Viking officer in England and France, where he was converted to Christianity. While on pilgrimage to Jerusalem, he had a vision directing him to return to Norway to claim the royal throne. Arriving in Nidaros in 1015, he went on several missionary excursions to remote parts of Norway, was dethroned by a Danish ruler of England, spent a year in exile in Russia, and then returned to Norway to continue his conversion of the pagans. Following his death in 1030, he was considered a martyr and his body was buried where Nidaros Cathedral now stands. Olav's body was exhumed a year after his death. It had not decayed, which prompted the local bishop to declare him a saint in 1031.

A wooden chapel was built above his grave. Hearing rumors of miraculous healings, pilgrims began to visit the shrine. The town rapidly grew in importance as a pilgrimage destination. Between 1070 and 1869, many cathedrals were erected. The high altar of the present cathedral is situated upon the burial site of St. Olav. Before the Reformation, Olav's shrine was opulently beautiful, with jewels and precious metals adorning his reliquary. After the Reformation, in 1537, the reliquary was taken to Copenhagen, melted down, and minted into coins. Pilgrimages to the cathedral were forbidden during the Reformation, and it is only within the past few decades that there has been a return of pilgrims to the great cathedral, especially on the July 29 anniversary of St. Olav's death. Today, large numbers of pilgrims walk from Oslo to Trondheim, a journey of several weeks.

The western front of Nidaros Cathedral, with its rows of stone statues. Among those depicted are King Olav, various bishops and saints, and the apostles Philip and Thomas.

ROUND TEMPLAR CHURCHES OF BORNHOLM

Bornholm, Denmark

MAP SITE 31

Located twenty-five miles (40.25 km) southeast of the southern tip of Sweden but territorially a part of Denmark, the island of Bornholm has an area of approximately 230 square miles (596 sq km). Archaeological excavation reveals that the island has been settled since at least 3600 BCE, when numerous dolmens and Neolithic mounds began to be constructed. Following the transition to Christianity between 1050 and 1150 CE, four churches, each with a mysterious round shape, were erected.

The current hypothesis among historians is that these structures were not intended solely for religious practices but that they also had a defensive function. Originally the churches had flat roofs so that they could be defended from any angle, and the cone-shaped roofs were not added until several centuries later. However, the idea that the churches were used for defensive purposes is problematic, considering the restricted interior space within. The lower floor of each church has limited space because of an enormous central pillar, and the two upper floors are too small and cramped to accommodate more than a few dozen people. Additionally, there are other mysteries concerning the Bornholm round churches that cannot be explained by conventional historical interpretations. Evidence has been found linking the four churches with the controversial religious brotherhood of the Templars; the locations of the churches correspond to mathematically precise patterns of landscape geometry; and enigmatic pagan symbols are encoded in carvings and frescoes in the churches. Therefore, it would seem the shape and function of the structures was intrinsically spiritual, and a defensive function (or motive) may not have existed at all.

The Templar church of Olsker in Bornholm; while there are scores of other churches throughout Denmark and other parts of Scandinavia dating from the twelfth century, there are no other churches with the distinctive roundness of the Bornholm buildings. Their mystery has yet to be fully uncovered.

SACRED EARTH

Mt. Olympus

Thessaly, Greece
Map site 32

Traditionally regarded as the abode of the Greek gods, Olympus seems to have originally existed as an idealized mountain that only later came to be associated with a specific peak. The early Homeric epics, the *Iliad* and the *Odyssey*, written around 700 BCE, offer little information regarding the geographic location of the heavenly mountain—and there are several peaks in Greece, Turkey, and Cyprus with the name Olympos or Olympus. The most favored mythological choice is the tallest mountain in Greece, Olympus, at 9,570 feet (2,917 m).

The deities believed to have dwelled upon the mythic mount were Zeus and his wife, brothers, sisters, and children. Zeus was the god of the mind and a protector of strangers; Hera was a goddess of fertility, the stages of a woman's life, and marriage; Apollo represented law and order; Aphrodite was a goddess of love; Hermes was the god of travelers and prophecy; Athena was the goddess of spiritual wisdom; Hephaestus was a god of the arts; and Ares represented the dark aspects of human nature.

While we know that these deities did not actually live upon Mt. Olympus, the ancient myth may be understood as a metaphor describing the powers of the sacred mountain. In ancient times, the Olympian gods and goddesses were seen as archetypes representing specific aspects of the human psyche. Worship of the deities was a method of invoking those aspects in the personality of the human worshipper. These spiritual powers had drawn hermits to live in the caves and forests of the mountain since long before the dawn of the Christian era. With the coming of Christianity, the myths and legends of the old Greeks were suppressed and forgotten, and the holy mountain was seldom visited. I lived for a month in the forests of the sacred peak and personally experienced the spiritual energies of the old gods and goddesses that are still powerfully present.

Mitikas, the highest peak on Mt. Olympus, rises dramatically against the Grecian sky.

PARTHENON

Athens, Greece

MAP SITE 33

The Parthenon is the supreme expression of ancient Greek architectural genius and has enchanted painters and poets for two thousand years. Neolithic remains indicate a continuous sacred use of the hill from at least 2800 BCE. Built upon the foundations of an earlier Mycenaean temple, the first known Hellenistic structures, dating from the sixth century BCE, were temples dedicated to the goddess Athena. In 480 BCE the Persians destroyed these temples, and in 447 BCE the Athenian leader Pericles erected the present temple of Athena. Made of white marble, the temple originally had forty-six columns, was roofed with tiles, and enshrined a golden statue of Athena that stood forty feet (12 m) tall. The Parthenon has suffered considerable damage over the centuries. In 296 BCE the gold from the statue was removed; in the fifth century CE the temple was converted into a Christian church; in 1460 it housed a Turkish mosque; and in 1687 gunpowder stored by the Turks inside the temple exploded and destroyed the central area. In 1803 much of the remaining sculpture was sold by the Turks—who controlled Greece at the time—to the Englishman Lord Elgin, who then removed the sculptures and sold them to the British Museum.

The name Parthenon refers to Athena Parthenos, the daughter of Zeus. Patroness of Athens, she represents spiritual development, intellect, and understanding, and she symbolizes the human aspiration for wisdom. Even though the character of Athena represented these qualities, it was the sacred geographical location, the astronomical orientation, and the sacred geometry of the temple that actually generated the qualities for which Athena was known. In the Greek religious tradition, particular geographical locations were known to have and to express specific energetic characteristics. Therefore, while Greek sacred architecture praises the qualities of certain deities, it was understood that the deities themselves were metaphors for unique natural powers that already existed before the temples were constructed. Certain holy places around Greece, being expressive of specific powers, were also understood to be in spatial relationship with one another, as shown by the study of sacred geography. The temples that developed at these sites incorporated sophisticated mathematical and astronomical knowledge that further enhanced the powers inherent to these places.

The moon rises over the ruins of the Parthenon, sacred temple to Athena.

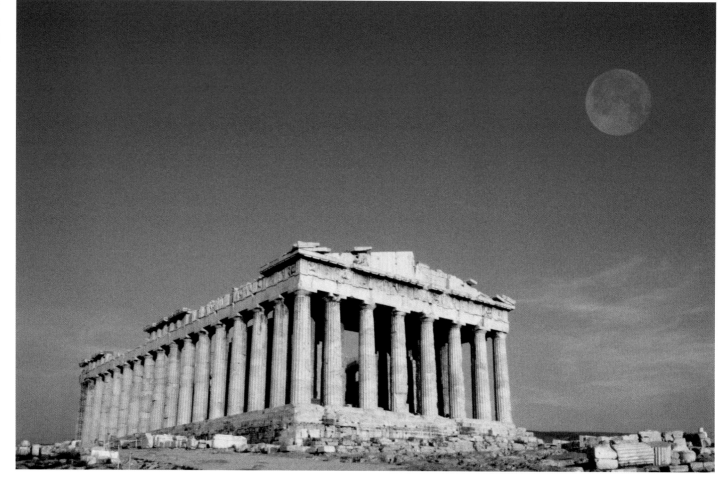

THOLOS TEMPLE IN THE SANCTUARY OF ATHENA PRONAIA

Delphi, Greece

Map site 34

Nestled in the forests of sacred Mt. Parnassus are the ruins of Delphi, the supreme oracle site of the ancient Mediterranean. Legends mention a holy place of the earth goddess Gaia, whose shrine was guarded by her daughter, the serpent Python. After Apollo killed the serpent, he erected an oracular temple on the site of the earlier shrine. Orienting its axis to align with the solstices, he placed an omphalos, or sacred stone, in the inner sanctum of the temple at the exact place where he had speared the serpent. The spearing of the serpent may be interpreted as the marking of an area of energetic power, and the omphalos was used to gather, concentrate, and emanate those energies.

Women, considered more sensitive than men to these energies, would sit near the omphalos, enter a visionary trance, and pronounce oracles. Plutarch, a Greek biographer, spoke of sweet geologic fumes known as pneuma, which inspired divine frenzies. Until recently, this matter was considered to be a fabrication from post-Delphic times. During the late 1990s, however, scientists proved the ancient legends to be accurate. The oracular temple is situated at the intersection of two geological faults, from which issue methane, ethane, and ethylene fumes. Ethylene, a psychoactive gas, produces feelings of euphoria and visionary insight. Further adding to the intrigue of Delphi is its location along that remarkable alignment of sacred sites stretching 2,500 miles (4,000 km) from Skellig Michael to Mt. Carmel.

Archaeologically, little is known about the beginnings of Delphi. Excavations have revealed a Mycenaean village from 1500 BCE, whose people belonged to an oracular cult of the earth goddess. Around 1000 BCE the worship of Apollo became dominant. Delphi achieved Panhellenic fame by the seventh century BCE. Exercising political and social influence for one thousand years, the Delphic oracle was in decline by the first century CE, and its last recorded oracle was in 362 CE.

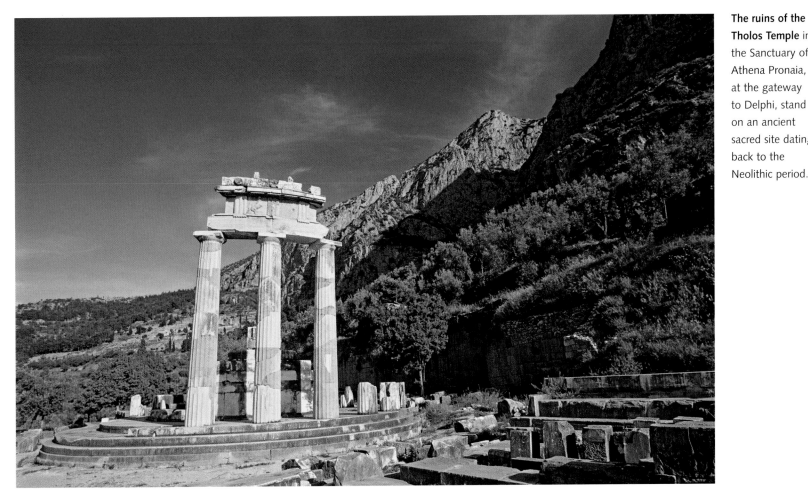

The ruins of the Tholos Temple in the Sanctuary of Athena Pronaia, at the gateway to Delphi, stand on an ancient sacred site dating back to the Neolithic period.

MONASTERY OF ST. JOHN

Patmos, Greece

MAP SITE 35

Rich in natural beauty, the island of Patmos was populated from as early as 500 BCE, and its first-known temple was a fourth-century BCE hilltop sanctuary of the goddess Diana. During the period of Roman rule, the island was used as a place of banishment for political and religious prisoners; St. John the Theologian, one of the twelve apostles of Jesus, was exiled there in 95 CE. St. John remained on the island for eighteen months, during which time he lived in a small cave near the temple of Diana. In that cave there is a fissure in the rock wall from which issued a series of oracular messages that St. John transcribed into the biblical book of Revelation. During his time in the sacred cave, now known as the Holy Grotto of the Revelation, St. John also composed the fourth Gospel.

The eastern Christian empire of Byzantium exercised control over the isle of Patmos, and in the fourth century the ancient shrine of the goddess Diana was torn down to be replaced by a church dedicated to St. John. The next development occurred in 1088, when a monastery was built upon the remains of the old church. Subjected to raids by Saracens and Norman pirates during the eleventh and twelfth centuries, the monastery was frequently enlarged and fortified, giving it the castlelike appearance it has today.

It is not the purpose of this book to discuss the biblical account of Revelation, but rather to draw attention to the matter of particular places upon the earth where human beings have seen visions or received messages regarding the future. Virtually all of the world's religious traditions have legends concerning such places, and this universality points to a mystery that neither theologians nor scientists can adequately explain.

The hilltop monastery of St. John is surrounded by the small town of Hora, which mostly dates from the seventeenth century. Its labyrinthine street arrangement was purposefully designed to confuse pirates intent on raiding the town and monastery.

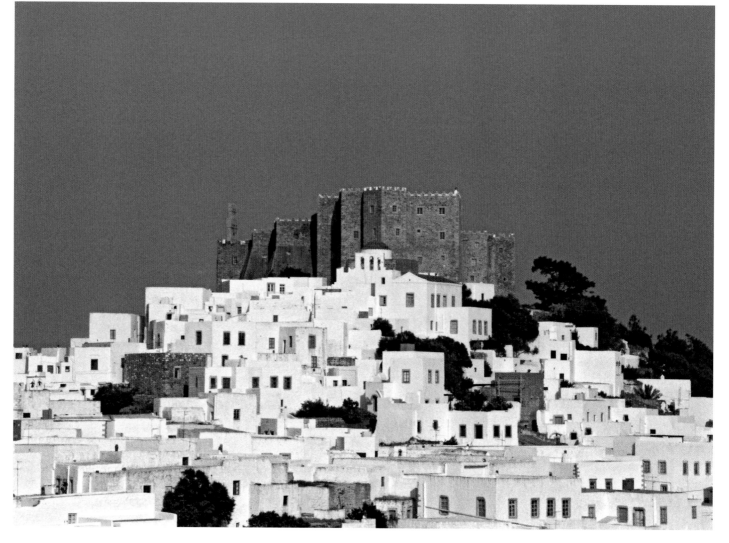

CHURCH OF THE MEGALOHARI

Tínos, Greece

MAP SITE 36

Windswept Tínos is a peaceful island of forty whitewashed villages scattered across rolling hills. In antiquity, Tínos, was venerated as a holy island, and pilgrims journeyed there for its temples to Poseidon and Dionysus. The first known Christian structure on the island, a Byzantine church, was built upon the foundations of the Temple of Dionysus. After being destroyed by Muslim raiders in the tenth century, the site was abandoned. In 1822 a local nun named Pelagia had visions of Mary describing the location of a buried icon, which was then found on January 30, 1823. Subsequent archaeological excavations determined the area of the icon's discovery to have been the site of the Byzantine church and, before that, the ancient Temple of Dionysus.

Famous throughout the Greek Orthodox world as a miraculous healing icon, Panagia Evangelistria, Our Lady of Good Tidings, is a beautiful portrayal of Mary kneeling with her head bent in prayer. Thought by scholars to be older than the Byzantine period, it may

be the work of the apostle St. Luke. It is assumed that the icon was a sacred object in the Byzantine church, hidden or lost around the time of the Muslim invasions. Shortly after the discovery of the icon, a new church was constructed and pilgrims began arriving from all over Greece. Numerous reports of miracles of healing increased the fame of the Church of the Megalohari, with the result that today the sacred icon is the most beloved pilgrimage object in Greece. Four major festival days are celebrated at the shrine: January 30, the anniversary of the discovery of the icon; March 25, the Annunciation of the Virgin Mary; July 23, the anniversary of Pelagia's vision; and August 15, the Assumption of the Virgin Mary. On each of these days, the normally quiet town of Tínos is filled with many thousands of celebrating pilgrims. Besides the Church of the Megalohari, Mt. Prophet Elias—the tallest peak on Tínos—is also a fine place to spend a day of quiet meditation.

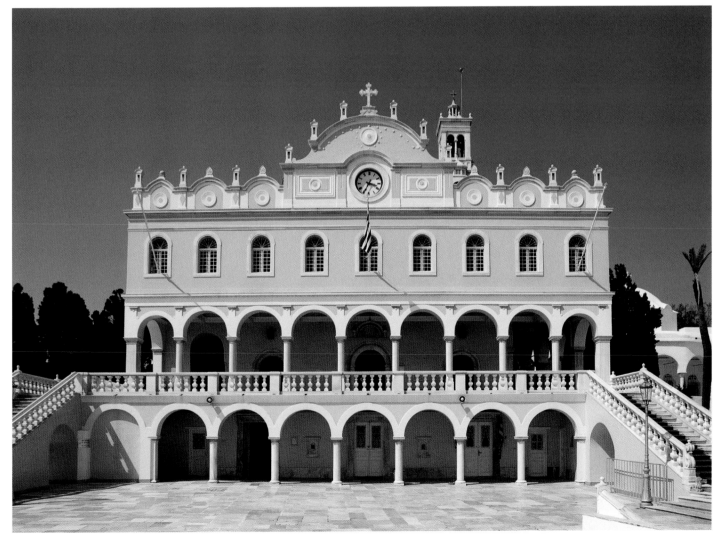

The Church of the Megalohari houses the most sacred relic in Greece, the painted wood icon of Panagia Evangelistria.

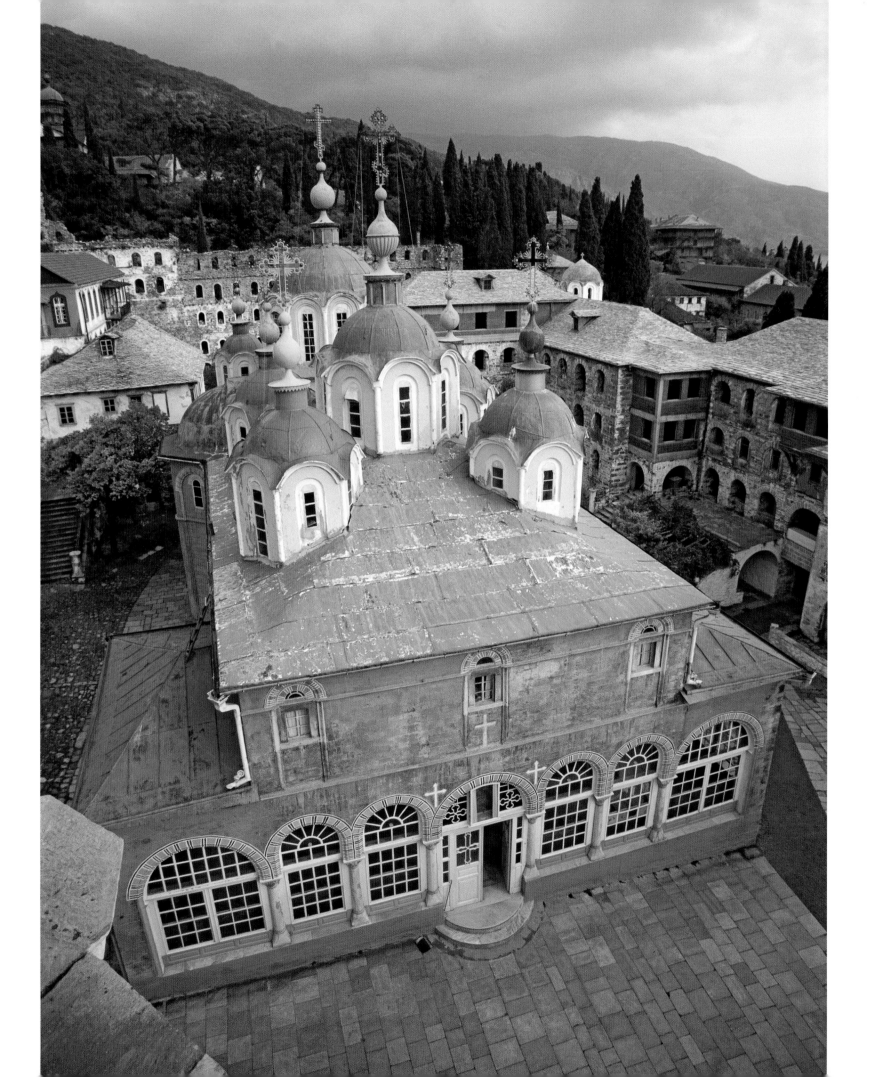

MONASTERIES OF MT. ATHOS

Agion Oros, Greece

MAP SITE 37

A mountainous and deeply forested peninsula in northern Greece, Mt. Athos 6,670 feet (2,033 m), is the home of twenty Orthodox monasteries built between the ninth and eleventh centuries. Known as Agion Oros (Holy Mountain) in modern Greek, Athos is a semi-autonomous community of Greek Orthodox monks and is strictly off-limits to tourism and women. Many hundreds of monks inhabit the large monasteries, smaller monastic houses, and remote mountain caves. The religious history of Athos goes back far before the birth of Christianity, however. Homer mentioned the great marble peak of Mt. Athos as the first home of the Greek gods Zeus and Apollo before they moved to Mt. Olympus.

According to legend, the Christian history of Mt. Athos begins with the Virgin Mary. In 49 CE Mary set sail for the island of Cyprus to visit Lazarus. During her journey, a great storm arose, and Mary's ship, blown far off course, was guided by divine signs to a protected bay on the eastern coast of Athos. Gazing upward at the towering mountain and its beautiful forests, Mary declared, "This mountain is holy ground. Let it now be my portion. Here let me remain." Mooring her boat near the site of the present-day Monastery of Iveron, Mary came upon an ancient temple and oracle dedicated to Apollo. As she stepped ashore, a deafening sound reverberated across the peninsula, and all the idols and pagan statues came crashing to the ground. (It is interesting to note that a well-documented earthquake occurred in northern Greece in 49 CE.) The great stone statue of Apollo spoke out, declaring itself a false idol and calling the forest hermits of Athos to come and pay homage to the Panagia, the true mother of God. According to legend, Mary baptized the hermits, and thus began the glorious Christian history of Mt. Athos.

According to historical sources, Athos first became a refuge for Christian hermits in the sixth and seventh centuries, and during the eighth and ninth centuries these hermits began to gather into small monastic communities. The era of the great monastic establishments began in 963 CE. Under the protection of the Byzantine emperors, the monastic communities flourished until their zenith in the fifteenth century, when Mt. Athos harbored forty monasteries and twenty thousand monks. Slowly declining after that, there has been a reawakening of interest in the monastic life since the 1950s, and currently more than three thousand monks live among the monasteries and forest hermitages. An edict of Emperor Constantine IX Monomachos in the year 1045, enforced to this day, forbids women from setting foot on the peninsula. Most of the monasteries are along the coast and consist of a quadrangle of buildings enclosing a church. The churches contain some of the finest examples of Byzantine art, icons, and treasures in the world, and the monastery libraries hold a vast number of classical and medieval manuscripts. There are seventeen Greek monasteries, one Russian, one Bulgarian, and one Serbian. I lived for some months in fifteen of these monasteries and also climbed the sacred peak.

Originally established in the eleventh century, the immense Russian monastery of Panteleimon gives the impression of a small township.

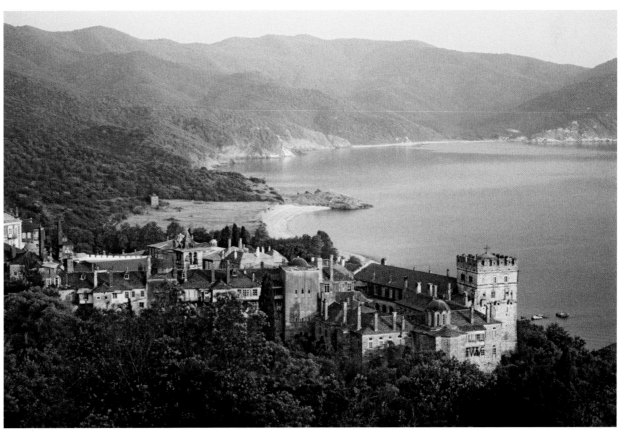

Left: **In an area where hermits once dwelled,** the Monastery of Vatopedi is dedicated to the Annunciation of Mary and has a rich collection of Byzantine mosaics and rare books.

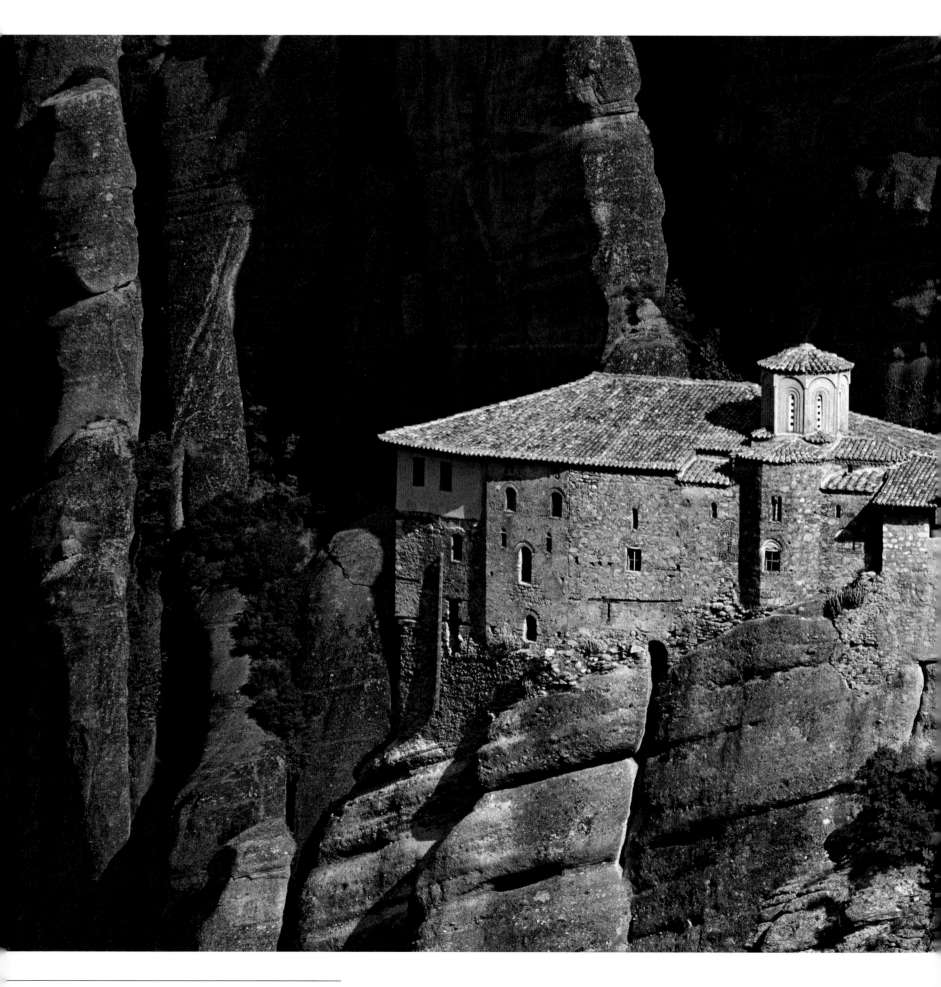

SACRED EARTH

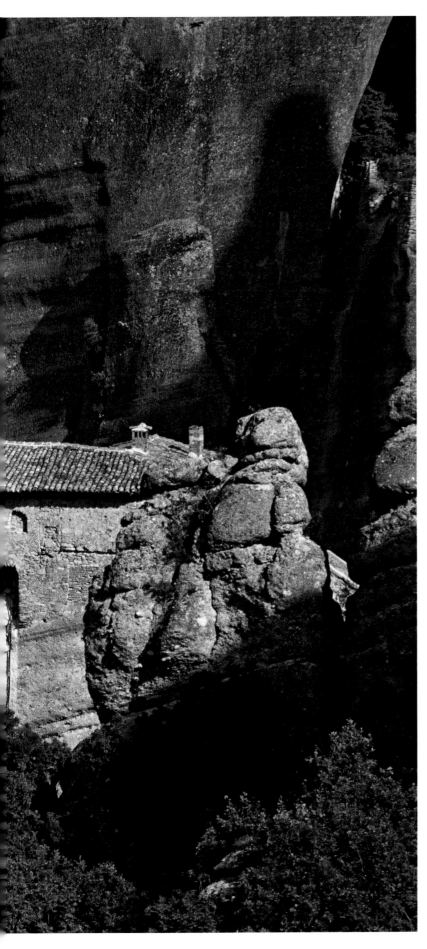

GREEK ORTHODOX MONASTERY OF ROUSANOU

Meteora, Greece

MAP SITE 38

Perched high atop spires of conglomerated sandstone rock, the monasteries of Meteora reside at one of the world's most spectacular sacred sites. Located in the Thessaly region of north-central Greece and overlooking the valley of the Piniós River, the towering rocks of Meteora ("rocks in the air") have long evoked awe. Paleolithic remains indicate the presence of settlements around the stones from 100,000 to 40,000 BCE, and hermits and ascetics have lived in the area since long before the Christian era. The arrival of Christianity began in the eighth century; organized monastic communities developed by the twelfth century; and by the mid-1500s, twenty-four Greek Orthodox monasteries had been constructed upon the spires of stone. The monasteries, which range from 650 to 1,970 feet (200–600 m) high—some accessible only by baskets lowered by ropes and winches—became a center of scholarship and art until the mid-eighteenth century, when popular interest in monasticism declined. Most of these *meteora monastiria* ("hanging monasteries") were abandoned, and today only six survive, of which four can be visited by way of bridges and rock-cut steps. The construction of a highway in the early 1960s made the remote monasteries, accessible to pilgrims and tourists.

Precariously situated high upon a rock spire, this monastery at Meteora was once accessible only by baskets lowered with ropes and winches; it is now reachable via a small, high bridge.

SACRED SITES OF

THE
MIDDLE
EAST
AND
NORTH
AFRICA

Mecca: Some Things I Learned Along the Way

During my twenty years of visiting and photographing pilgrimage places around the world, my travels took me to almost all of the great sacred sites of Islam. From Indonesia to India, Iran, the Middle East, Africa, and finally to Saudi Arabia, I went to the most celebrated and beautiful Muslim mosques and shrines. The fabled names of those holy places had drawn me since my youth, and I felt honored to visit them. Taking ten years to circle into Mecca, I began my pilgrimage by reading nearly one hundred books on the history and nature of Islam. All of this reading quite surprised me. Like many people in the Western world, I had been programmed to think that Muslims were the cause of many of the problems in the Middle East, both historically and in the present. I learned from my studies that in the great majority of cases, Muslims are peaceful and respectful of other religions and their followers. This behavior was certainly confirmed as I traveled throughout the Islamic world. Everywhere I went, among the poorer classes and the more educated, I was treated with utmost respect and generosity.

One important fact I learned from my studies was that scholars, both Muslim and non-Muslim, had decisively shown that much of the Koran was derived from and influenced by Talmudic Judaism, Syrian Christianity, and Persian Zoroastrianism, as well as the *Gilgamesh* epic and the Coptic history of the Virgin. Much of what is in the Koran concerning Christianity was actually derived from the heretical sects of the early Christians. Furthermore—and this is something particularly important for modern-day Christians to know—the Koran mentions Jesus ninety-three times, Mary is mentioned there more often than in the New Testament, and they both appear in a favorable light.

There are equally significant cultural and social facts about Islam and Muslims that need to be recognized. The Islamic world, which numbers a billion people, includes many countries, societies, traditions, religions, languages, and histories. All too often there is no direct correspondence between the word *Islam* in common Western usage and the enormously varied life that goes on in the world of Islam. Instead of true scholarship, we find journalists who make extravagant statements, which are then publicized and further dramatized. For example, the deliberately created associations between Islam and fundamentalism ensure that many people in Western nations regard Islam and fundamentalism as essentially the same thing. This could not be further from the truth. Clichés about Islam in the media, aside from perpetuating hostility toward Muslims, do great damage and grossly exaggerate the extent of extremism within the Islamic world.

Again, everywhere I traveled, I was met with extraordinary kindness and hospitality. I cannot begin to count the times that I was offered places to stay, was fed sumptuous meals, and was given all sorts of gifts. I was also offered assistance in making arrangements to photograph Muslim sacred places. A case in point was during my time in the holy cities of Mecca and Medina. I was flown and driven to both cities, accommodated in fine hotels, fed delicious food, given a translator and guide, and allowed access to perfect locations for making stunning photographs of the beautiful mosques and sacred architecture. I hope that Westerners who read my words and enjoy my photographs will refresh their notions of the Islamic world and take the time to visit and know the pleasant and peaceful cultures it contains.

The Great Mosque of Kairouan, Tunisia.

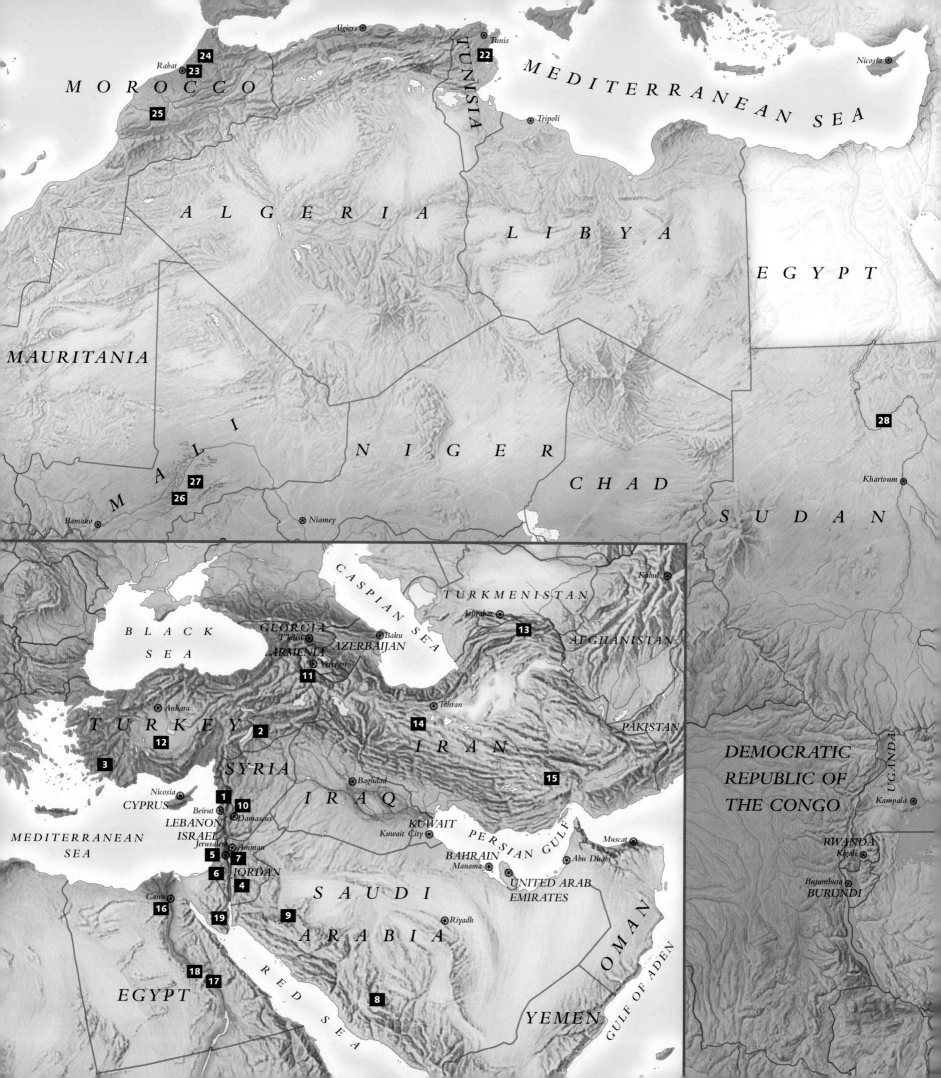

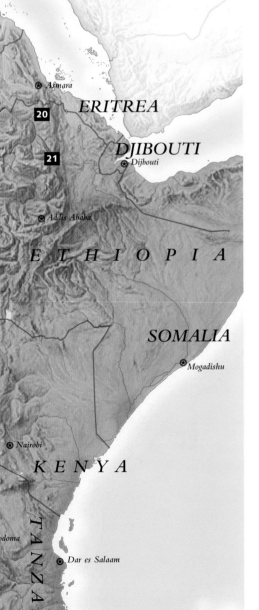

Sacred Sites of the Middle East and North Africa

1. Baalbek, Lebanon

2. Nemrut Dagi, South-Central Turkey

3. Aphrodisias, Turkey

4. Petra, Jordan

5. Jerusalem, Israel

6. Bethlehem, Israel

7. Jericho, Israel

8. Mecca, Saudi Arabia

9. Medina, Saudi Arabia

10. Damascus, Syria

11. Mt. Ararat, Eastern Turkey

12. Konya, Turkey

13. Mashhad, Iran

14. Qom, Iran

15. Bam, Iran

16. Giza, Egypt

17. Luxor, Egypt

18. Dendera, Egypt

19. Mt. Sinai, Egypt

20. Axum, Ethiopia

21. Lalibela, Ethiopia

22. Kairouan, Tunisia

23. Zerhoun, Morocco

24. Fez, Morocco

25. Marrakech, Morocco

26. Djenné, Mali

27. Bandiagara Region, Mali

28. Meroë, Nile Province, Sudan

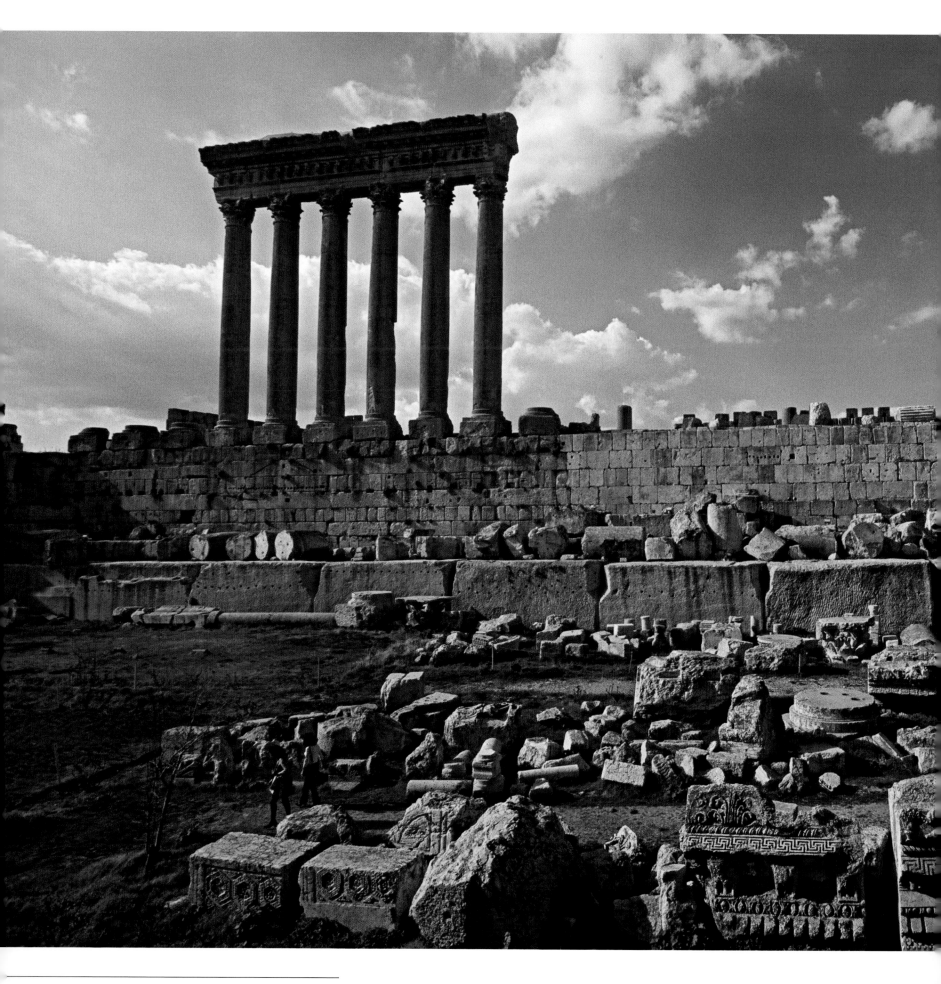

SACRED EARTH

TEMPLE COMPLEX

Baalbek, Lebanon

MAP SITE 1

In the hills of Lebanon stands the temple complex of Baalbek, one of the most enigmatic holy places of ancient times. According to traditional archaeological theory, the story of Baalbek goes back approximately five thousand years. Excavations around the Roman Temple of Jupiter have uncovered remains dating back to the early Bronze Age (2900 to 2300 BCE). During the first millennium BCE the Phoenicians chose the site of Baalbek for a temple to their sun god, Baal, as according to their legends it was his birthplace. Next came the Seleucids and Romans, and it is to the Romans (64 BCE to 312 CE) that archaeologists attribute the many and massive temple foundations at Baalbek.

The Roman city at Baalbek, called Heliopolis, or the City of the Sun, was dedicated to the sun god Jupiter and contains the largest stone structures ever built in the Roman Empire. The Romans, however, did not have the engineering or building skills necessary for the carving and placement of the enormous blocks of stone that underlie the temple's construction. The courtyard of the Temple of Jupiter, completed around 60 CE, is situated upon a platform called the Grand Terrace, which consists of a pre–Roman outer wall formed of immense, finely crafted, precisely positioned blocks. These blocks of stone, ranging in weight from 450 to 1,200 tons, some as big as sixty-nine feet (21 m) long by fourteen feet (4 m) wide, are the largest pieces of stonework ever crafted. The stones are an enigma to contemporary scientists, because the method of their quarrying, transportation, and placement is beyond the technological ability of any known ancient or modern builders. The stones of Baalbek show stylistic similarities to other cyclopean stone walls at verifiably pre–Roman sites such as the Acropolis foundation in Athens, the foundations of Mycenae, and the megalithic constructions of Ollantaytambo in Peru and Tiahuanaco in Bolivia.

Roman structures sit atop massive pre-Roman stones in the ancient city of Baalbek. These great blocks of stone show extensive evidence of wind and sand erosion that is absent from the Roman temples, indicating that Baalbek construction dates from a far earlier age.

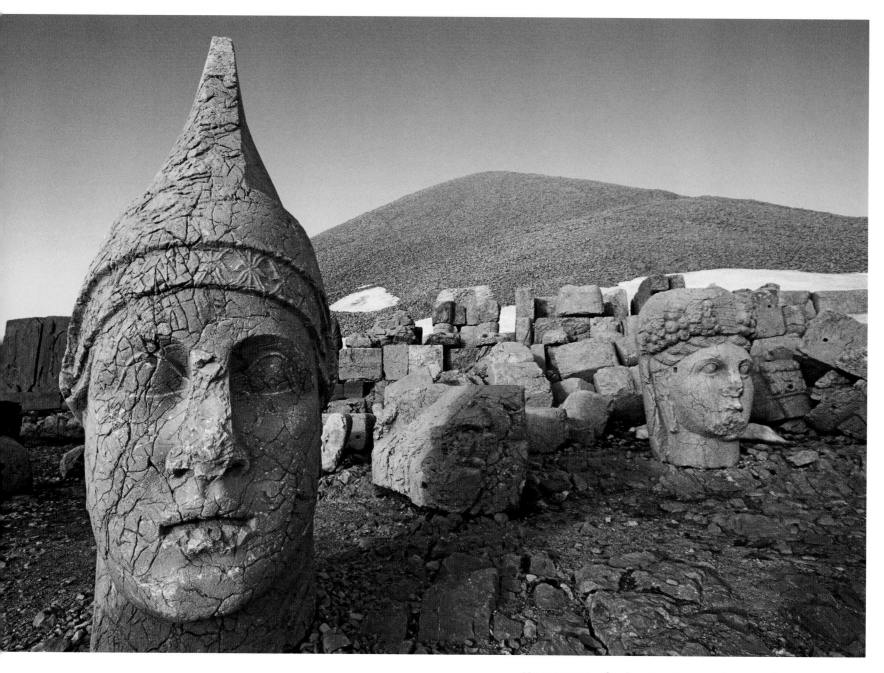

Mysterious stone heads rest on the ground among other enigmatic mythological figures at the ancient mountaintop shrine of Nemrut Dagi.

Nemrut Dagi

South-Central Turkey

Map Site 2

Situated at 7,053 feet (2,150 m) in the mountains of south-central Turkey is the archaeological site of Nemrut Dagi. The unique mountaintop shrine, previously known only to local herders, was discovered in 1881 by a geologist working for the Ottoman government. Assumed to be the burial site of Antiochus, a king of the first-century BCE Commagene Dynasty, the peak of Nemrut Dagi has been extensively contoured, capped with a conical mound, and ornamented with two temples and many beautiful stone sculptures. The conical mound rises 165 feet (50 m) above the temples, is 492 feet (150 m) in diameter, and is composed of countless thousands of fist-size pieces of white limestone. In 1953 archaeologists excavating there tunneled into the cone of rocks but found no burial remains and gained no insights into the construction methods or use of the high-altitude temples.

The mound is bounded on the east, west, and north by terraces, each carved from the mountain rock. The eastern and western terraces contain altars, the remains of walls, and stone statues twenty-six to thirty-two feet (8–10 m) tall. The statues depict various deities, and there are also carvings of Antiochus shaking hands with Zeus, Apollo, and Heracles. The heads of all the statues have fallen to the ground, probably the result of earthquakes, which frequently disturb the region. Among the carved stones on the western terrace is one known as the Lion of Commagene, which bears significant astronomical information. There are nineteen stars in the background and on the lion's body, and a crescent moon on the lion's neck. Above the lion's back there are three planets named Mars, Mercury, and Jupiter. These carvings, as interpreted by archaeoastronomers, seem to indicate the date of July 6, 61 BCE. Some scholars believe this is when the Roman general Pompey installed Antiochus on the throne, while others see it as an esoteric coronation of Antiochus as head of a secret Persian-Anatolian brotherhood. The purpose of the strange mound and its enigmatic carvings remains a mystery.

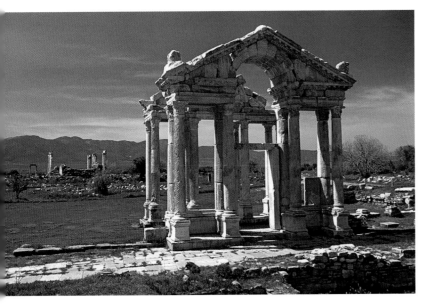

A grand tetrapylon sits directly to the east of the Temple of Aphrodite and functions as the temple's monumental gateway. The structure was constructed during the reign of Hadrian (117–138 CE). The process of repairing and re-erecting the four columns of the tetrapylon was completed in 1990.

Gateway to the Temple of Aphrodite

Aphrodisias, Turkey

Map Site 3

Located in the rolling hills of southeastern Turkey, the lovely ruins of Aphrodisias contain what was once the preeminent temple of the goddess Aphrodite in Asia Minor. Yet centuries before this Greek sanctuary of Aphrodite was constructed in the first century BCE, the site was a holy place and pilgrimage destination of importance to other cultures. Excavations conducted in the 1900s indicate settlements since at least the fifth millennium BCE. Once named Ninoë and associated with the goddess Astarte, also called Ishtar, the city was called Aphrodisias after the third century BCE. The similarities of Aphrodite, the goddess of nature, beauty, and love, to Artemis of Ephesus and other Anatolian mother goddesses are evident in cult statues found at the ruins. During the early years of Christianity, pilgrims still visited the shrine of Aphrodite because of the great popularity of the goddess. Later, Christians demolished the temple and erected a church in its place.

Nabataean Temple of Al-Deir

Petra, Jordan

Map site 4

Situated in mountainous terrain, the ancient city of Petra is an abandoned necropolis of temples and tombs cut into towering cliffs of red sandstone. Primarily known as the capital of the Nabataean culture during the centuries around the time of Christ, the region of Petra has been inhabited since antiquity. Archaeological excavations have revealed Paleolithic and Neolithic settlement sites, and the region was occupied around 1200 BCE by the Edomite culture of the Old Testament. During the sixth to fourth centuries BCE, the Nabataeans, Arabian merchant-traders, entered the Edomite territory and began construction of the city of Petra. By the second century BCE, Petra had developed into a powerful center of the caravan trade, and during the next four hundred years, the city's dominion spread as far north as Damascus.

In 106 CE, the Nabataean kingdom came under the control of the Roman Empire, yet Petra continued to prosper. In 324 CE, around the time Emperor Constantine proclaimed Christianity the religion of the Roman Empire, Petra to be ruled by the Byzantine Empire and slowly began to decline. Following the establishment of Islam in the seventh century, the region of Petra virtually disappeared from the historical record, but it was rediscovered in 1812 by the Swiss adventurer Johann Burckhardt.

The Nabataeans revered Petra as the sacred precinct of their god Dushara, whose main temple, Al-Deir, was located in a gorge northwest of the city. Dated to the first century CE, the temple is carved entirely out of the rock cliff; it is 164 feet (50 m) wide by 148 feet (45 m) tall, with a 26-foot-tall (8 m) entrance door. Inside the single empty chamber, the walls are unadorned except for a block of stone representing Dushara, whose symbolic animal was the bull. A processional way leads to Al-Deir from the center of Petra, and the large courtyard in front of the temple suggests that the site was used for grand ceremonies. Al-Deir is sometimes called the Monastery because of a belief that it served as a church during Byzantine times.

Detail of the facade of Al-Deir, a temple dedicated to the god Dushara; the temple was hewn from the surrounding rock cliff by the Nabataean culture in the first century CE.

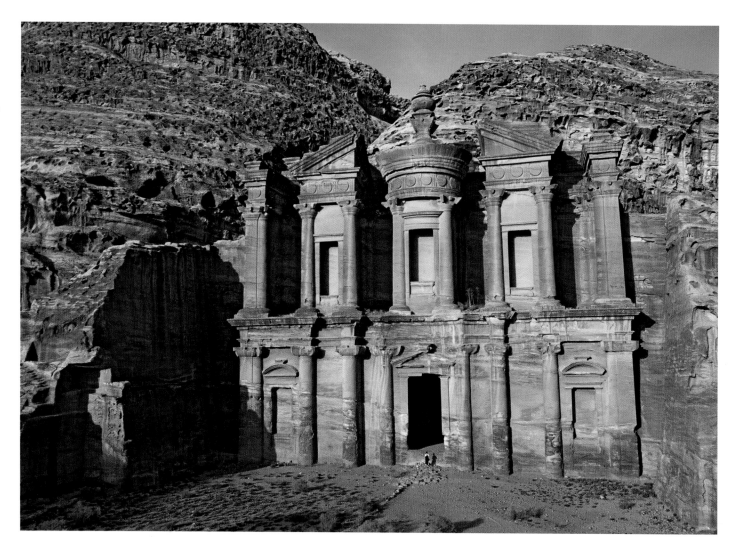

JEBEL HAROUN

Petra, Jordan

MAP SITE 4

Aaron (Haroun in Arabic) was the elder brother of the great Hebrew prophet Moses, a younger brother to Miriam, and a descendant of Abraham through Abraham's grandson Jacob. In Judaism, Christianity, and Islam, Aaron is venerated as a prophet and the first High Priest of the Israelites, while Moses is revered as a messenger, lawgiver, and prophet. Aaron shared with his brother in diplomatic missions to the Pharaoh, and in leading the tribes of Israel out of Egypt. Tradition holds that Aaron often acted as the voice of Moses, who may have had a speech defect. According to the Bible, Aaron was buried by Moses on the summit of Mt. Hor, near the ruins of Petra. Also called el-Barra, the mountain is 4,580 feet (1,396 m) tall, the highest in the Petra region. It has twin peaks, with the grave of Aaron perched on the cone of the higher one. Religious buildings have stood upon the peak since at least the Byzantine era, when Christians began to associate the mountain with the site of Aaron's burial. During the seventh century, Greek Christians administered the site, and local legends tell that the Prophet Muhammad visited the shrine when he was ten years old with his uncle. Muslim pilgrims, in homage to the Prophet, often drape the shrine with green and white fabric. Constructed in its present form in 1459, the shrine is a small domed mosque that is rarely open. Until recent times, the Bedouin jealously guarded the shrine, and non-Muslim travelers were forbidden to ascend the peak.

The shrine of Aaron, brother of Moses, on Jebel Haroun (Arabic for Aaron's Mountain) is believed by many to be on the biblical Mt. Hor.

Following pages: **The beautiful cityscape of Jerusalem** glitters with the gold onion domes of the Church of St. Mary Magdalene in the left foreground and the Dome of the Rock, shimmering on the right.

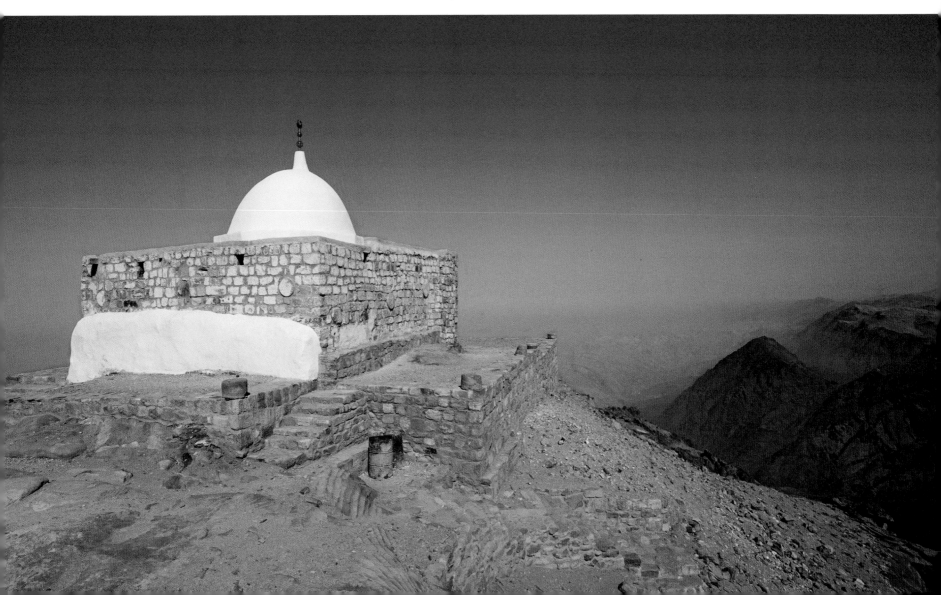

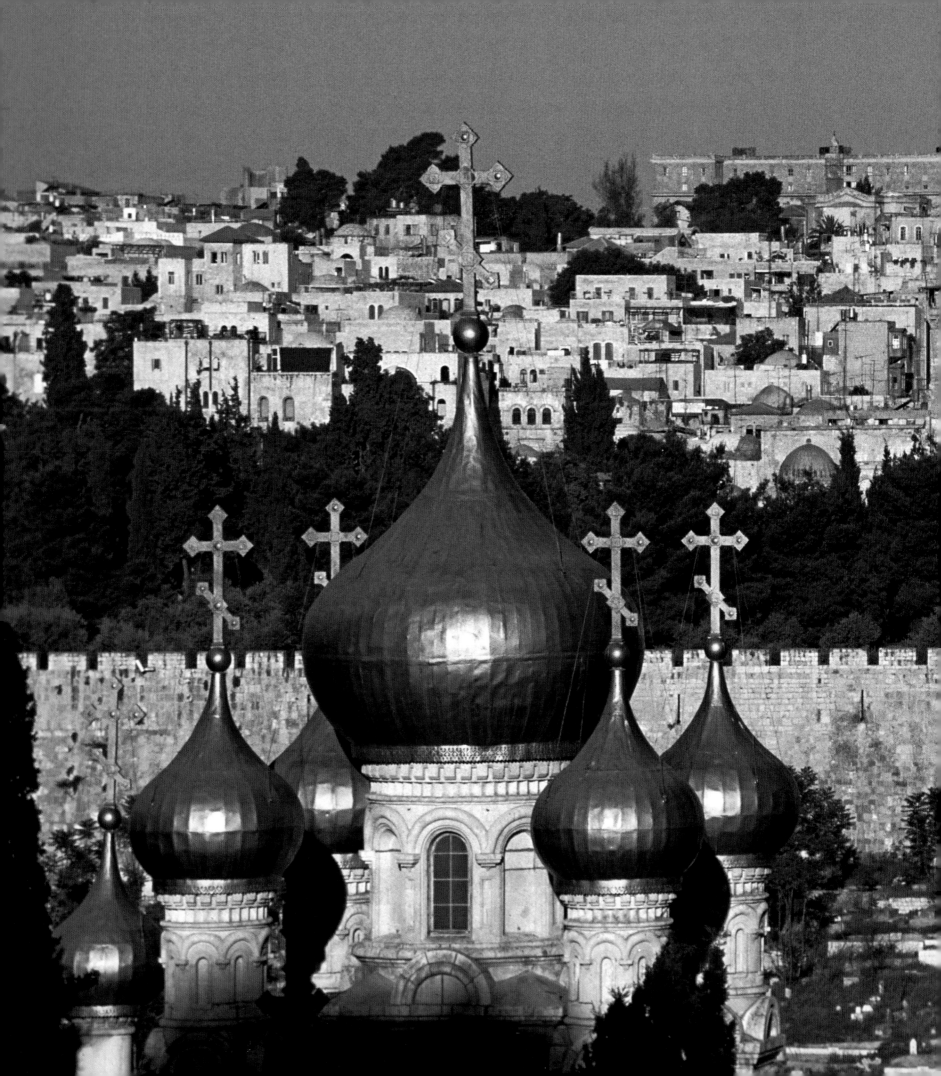

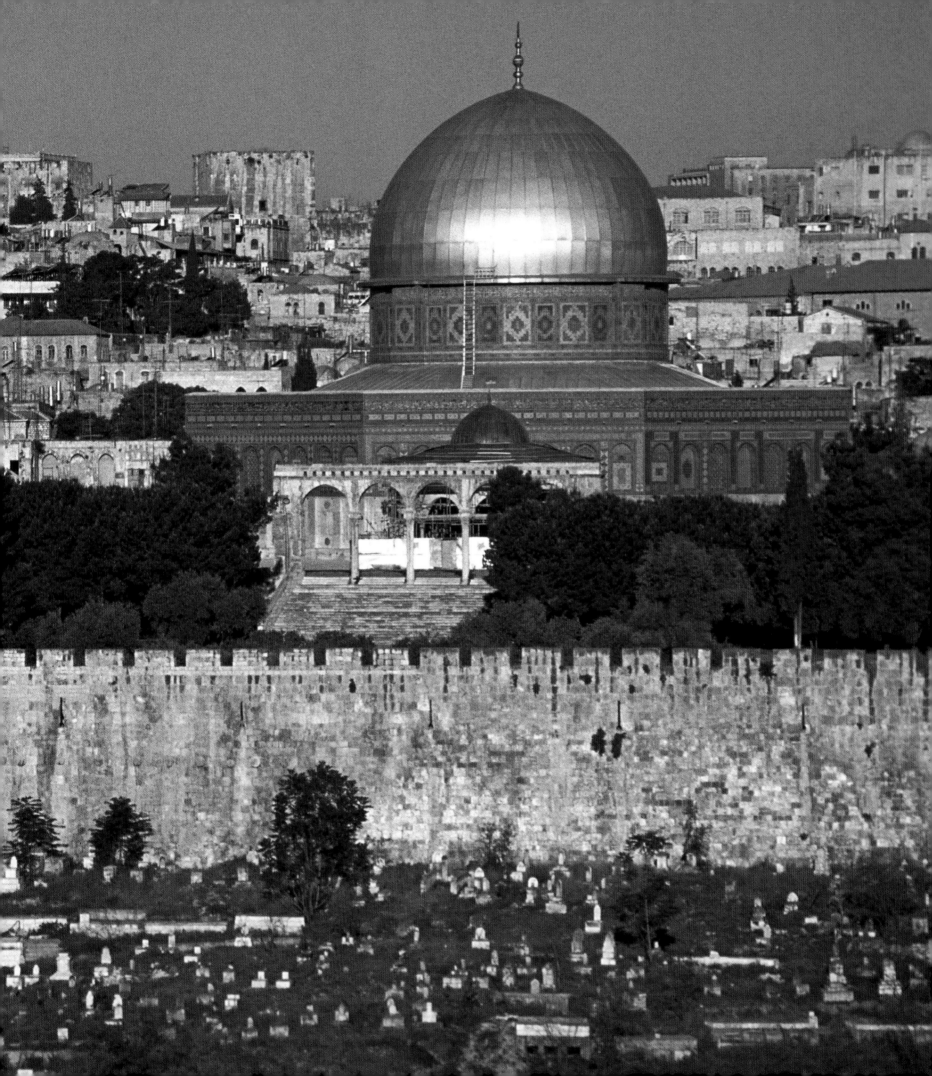

THE HOLY CITY

Jerusalem, Israel

MAP SITE 5

The Old City of Jerusalem, perched upon sacred Mt. Moriah, has been a place of holiness, devotion, and spiritual love since ancient times. An ancient Semitic tradition tells that the rock atop the mount was held in the mouth of the serpent Tahum and that the site was the intersection of the underworld and the upper world. According to the Bible, it was also the location where Abraham built an altar on which he prepared to sacrifice his son Isaac. Isaac's son Jacob used stone from this altar to rest his head on when he spent the night sleeping upon Mt. Moriah. Legend has it that upon Jacob's awakening from a visionary dream, the stone sank into the earth, to become the foundation of the great temple that would later be built by King Solomon. This hallowed site, known as Beth El, meaning House of God or Gate of Heaven, was also a holy place of the Mesopotamian harvest deity Tammuz.

The earliest archaeological traces of human settlement are from 3000 BCE, and excavations have shown that the Jebusites (a Canaanite tribe) existed in a town on Mt. Moriah called Urusalim, which can be translated as Foundation of God. To the Jewish people it is *Ir Hakodesh* (the Holy City), the biblical Zion, the city of David, and the site of Solomon's Temple. For the Romans it held a sanctuary of the god Jupiter. To the Christians it is where Jesus spent many days of his ministry, and where the Last Supper, the Crucifixion, and the Resurrection took place. Also venerated by the Muslims, it is where the Prophet Muhammad ascended to heaven. As a holy city, there is perhaps no other place on the planet that has been visited by more pilgrims.

About 1000 BCE, Urusalim was captured by King David and renamed Jerusalem, meaning City of Peace. David's son, King Solomon, completed the First Temple in 957 BCE and there installed the Ark of the Covenant. Nebuchadnezzar II of Babylon destroyed the Temple in 586 BCE, but the Second Temple was constructed by 515 BCE. The Second Temple did not, however, enshrine the Ark of the Covenant; that sacred object had been hidden beneath Solomon's Temple to protect it from the Babylonians. According to legend, more than seventeen hundred years later, a group of nine Frenchmen, known as the original Knights Templar, spent nine years excavating the ruins of Solomon's Temple. They retrieved a vast wealth of gold bullion, hidden treasures, and the Ark of the Covenant, and became one of the most powerful religious and political institutions in medieval Europe. The existence and exact location of the Ark are not currently known, but some people believe it is located at Axum, Ethiopia (see page 115).

Western Wall

Over the centuries, Jerusalem was captured by Alexander the Great and controlled by the Hellenistic, Egyptian, and Seleucid empires. In 64 BCE, the Roman general Pompey captured Jerusalem, ushering in several centuries of Roman rule. During this period, Herod created the famous Western Wall (also called the Wailing Wall) as part of the supporting structure for the enlarged Temple Mount. In 6 CE, the Romans turned the governance of Jerusalem over to a series of administrators, the fifth of whom, Pontius Pilate, ordered the execution of Jesus. In the year 135 CE, the Roman emperor Hadrian built a temple to the god Jupiter upon the foundation of the Second Temple, but this temple was itself demolished by the Byzantines after the empire became Christian.

The conversion to Christianity of the Byzantine emperor Constantine and the pilgrimage of his mother, Empress Helena, to Jerusalem in 326 CE inaugurated one of the city's most prosperous epochs. According to Christian legends, Empress Helena discovered the relics of the True Cross of the Crucifixion at the place of the Resurrection upon Mt. Calvary. To commemorate this site, the Church of the Holy Sepulchre was constructed in 335 CE, apparently upon the foundations of an earlier Roman shrine dedicated to the goddess Aphrodite, and it soon became the most sacred pilgrimage destination in all of Christendom.

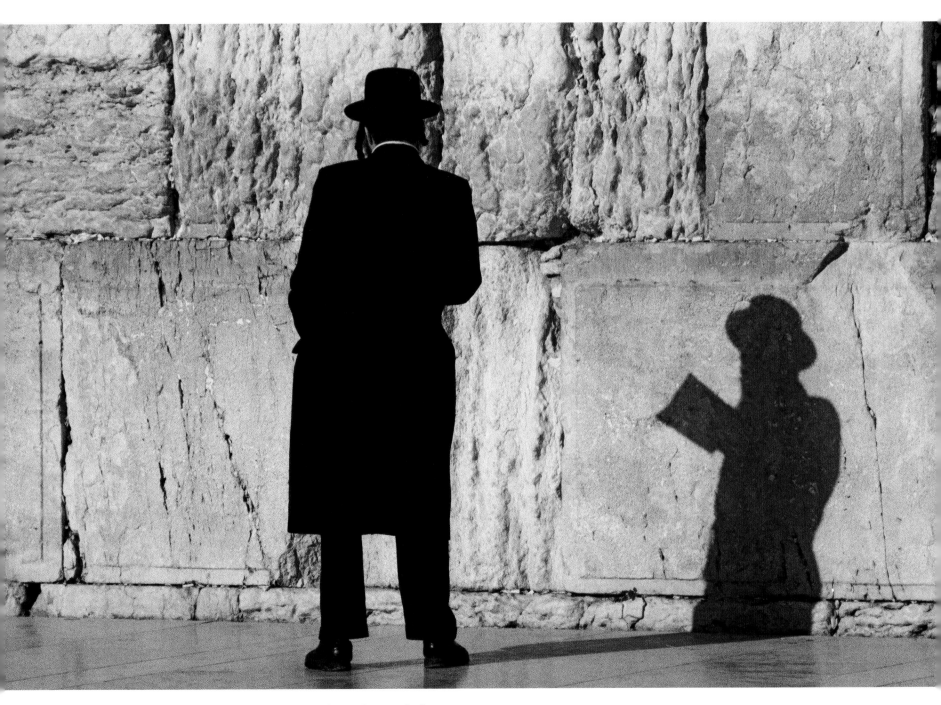

A Hasidic Jew prays at the Western Wall, one of the holiest sites in Judaism. The Jewish tradition of writing prayers on small pieces of paper and placing them inside the cracks in the wall goes back centuries. It is believed that the gateway to heaven sits directly above the wall.

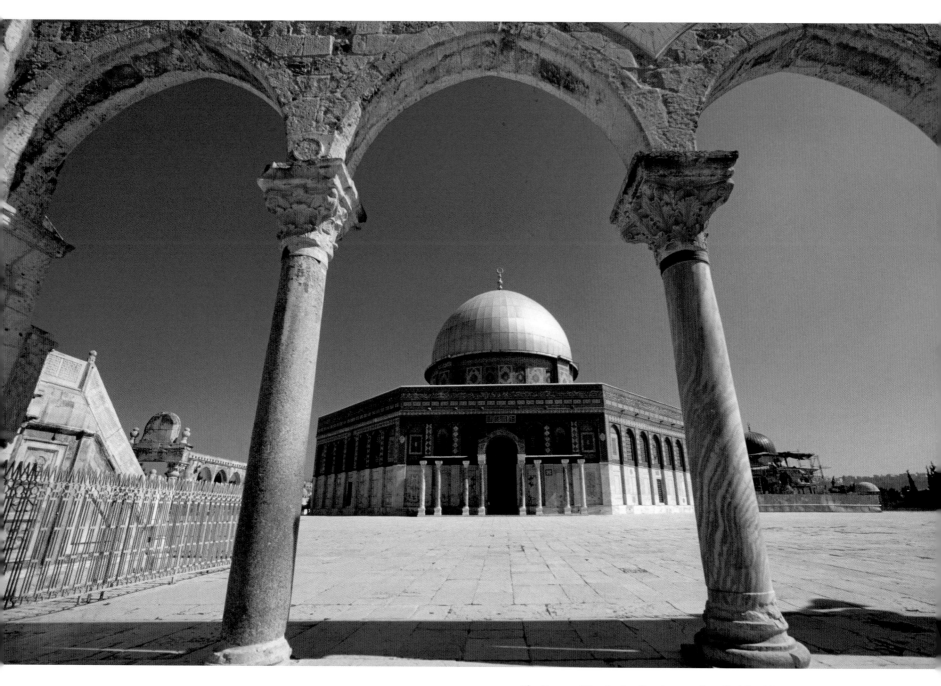

The Dome of the Rock, often incorrectly called the Mosque of Umar, is not a mosque for public worship but a shrine for pilgrims, a *mashhad*. Adjacent to the Dome is the Al-Aqsa Mosque, where Muslims make their prayers.

DOME OF THE ROCK

Jerusalem, Israel

MAP SITE 5

Jerusalem was captured in 638 CE, six years after the death of Muhammad, by the Muslim caliph Umar. Soon after his occupation of the city, Umar cleared the Temple Mount, built a small mosque, and dedicated the site to Muslim worship. The most imposing structure that the Muslims found in Jerusalem was the Church of the Holy Sepulchre. The Arab conquerors undertook to build a more spectacular edifice nearby, the Dome of the Rock. The chosen site was on the same rock where the Roman Temple of Jupiter had previously stood and, before that, the two temples of the Jews. There was also another reason for the Muslim veneration of Jerusalem. A certain passage in the Koran, the "Night Journey," links the Prophet Muhammad with Jerusalem and the Temple Mount. According to the text, Muhammad and the archangel Gabriel rode on a winged steed named El Burak and alighted at the Temple Mount, where they encountered Abraham, Moses, and Jesus. Gabriel then escorted Muhammad to the pinnacle of the rock, which the Arabs call as-Sakhra, where a ladder of golden light materialized. Climbing this ladder, Muhammad ascended through the seven heavens into the presence of Allah (Arabic for God), from whom he received instructions for himself and his followers.

At this site, known in Arabic as Haram al-Sharif (Noble Sanctuary), the ninth caliph, Abd al-Malik, built the Dome of the Rock in 691. Designed by Byzantine architects hired by the caliph, the Dome of the Rock was the greatest monumental building in early Islamic history. The Muslims in power before and after the Dome's construction accepted Christianity and Judaism, welcoming pilgrims of both religions to freely visit the Holy City. This era of peaceful coexistence ended in 969 CE, however, when control of the city passed to the Fatimid caliphs of Egypt, who systematically destroyed all the synagogues and churches. In 1071 the Seljuk Turks displaced the Egyptians as masters of the Holy Land and closed the pilgrimage routes.

The prohibition of Christian pilgrimage by these less tolerant Muslim rulers angered Western Europe and became a contributing cause of the Crusades—a series of invasions that culminated in the capture of Jerusalem in 1099. The Christian kingdom lasted almost ninety years, during which time the Dome of the Rock was converted to a Christian shrine and named Templum Domini (Temple of the Lord), the Church of the Holy Sepulchre was rebuilt, and hospices and monasteries were founded. The city was recaptured by the Muslims in 1187 and ruled by them, with the exception of two very brief periods of Christian control, until the nineteenth century. Jews, who had been barred by the Christian crusaders, started returning during the thirteenth century, and by the middle of the nineteenth century nearly half the city's population was Jewish. In 1980, Jerusalem was officially made the capital of Israel.

Besides the sites discussed above, the following places are also much visited by pilgrims in the Holy City. For Jews, the most venerable locations are Mt. Zion, the traditional site of King David's tomb, and the Western Wall. Devout Christian pilgrims will visit the fourteen stations of the Via Dolorosa, or Way of Grief. Additionally, there are the shrine of the Ascension on the summit of the Mount of Olives, the garden of Gethsemane, and Mt. Zion, the site of the Last Supper. In the Dome of the Rock, beneath the ancient sacred stone, there is a cavelike crypt known as Bir el-Arweh, or Well of Souls. Here, according to ancient folklore, the voices of the dead may sometimes be heard, along with the sounds of the rivers of paradise.

The interior of the Dome of the Rock, showing the rock from which Muhammad is believed to have ascended to heaven.

Chapel of the Nativity

Bethlehem, Israel

Map site 6

South of Jerusalem, Bethlehem is considered the birthplace of Jesus according to the Gospels of Matthew and Luke. Various New Testament scholars believe parts of these Gospels to be later accretions and assert that Jesus was actually born in Nazareth, his childhood home. Christian belief, however, has sanctified Bethlehem as Christ's birthplace, since the cave was "identified" in the second century CE by St. Justin Martyr. Archaeological evidence indicates that this cave was a pre-existing sacred site dedicated to Adonis, an ancient Greek deity whose death and rebirth represented the cycle of nature. The first church at the site was built by Helena, the mother of the Byzantine emperor Constantine, sometime around 326 CE. The church was later destroyed, but it was rebuilt in its present form by Emperor Justinian I around 529 CE.

The birth date of Christ is not mentioned anywhere in the four Gospels, and there are no authentic scriptures or historical sources that give an indication of it. There is no reference until the Philocalian calendar was compiled by a Roman calligrapher named Furius Dionysius Philocalus in 354 CE, and December 25 was given as the birth of Jesus. This date was chosen by early Roman church leaders to absorb the pagan festivals of the winter solstice on December 21 and the Roman festival of Mithras, the god of light, on December 25. It is important to know that several earlier dying-and-rising gods also shared the birthday of Jesus. December 25 is believed to be the birth date of the pagan gods Osiris, Tammuz, Adonis, Dionysus, Attis, and Orpheus, each of whom was also born in a cave or other humble place and attended by wise men bringing expensive and symbolic gifts.

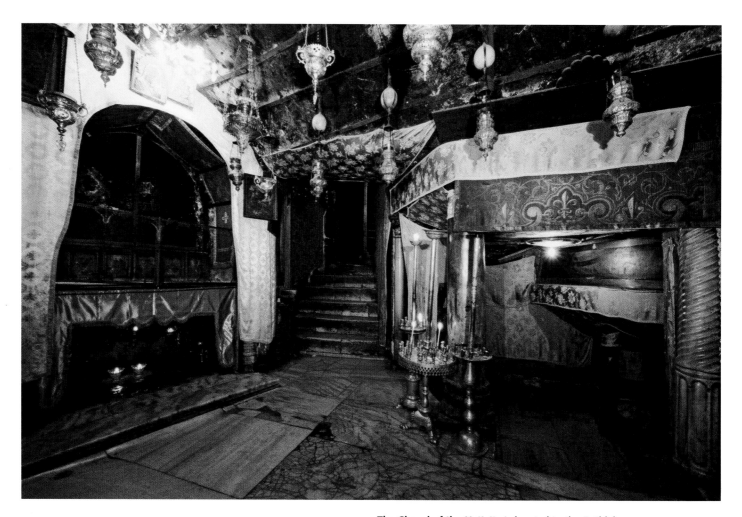

The Chapel of the Nativity is located in the Bethlehem cave where Jesus is believed to have been born.

The Quarantal Grotto in Jericho is the site of the temptation of Christ. This view shows the part of the cave where Jesus slept, prayed, and meditated.

QUARANTAL, THE HOLY GROTTO OF THE TEMPTATION OF CHRIST

Jericho, Israel

MAP SITE 7

Thirty-six miles (58 km) to the east of Jerusalem stands the ancient city of Jericho. A few miles northwest of Jericho, the Mount of Temptation is the traditional scene of the temptation of Christ. The Gospel of John omits the story, but the other Gospels (Mark 1:12–13, Matthew 4:1–11, and Luke 4:1–13) agree that Jesus, after being baptized by John, fasted in the mountains for forty days, during which time he was both enticed by the devil and directed by the spirit of God.

The Gospels of Matthew and Luke present a dramatic dialogue between Jesus and the devil, in which Jesus decisively rejects the devil's proposals. The Gospels are not true biographical historical records, but rather a compilation of beliefs and theories composed by numerous, often contradictory, writers over hundreds of years. The literary form of these stories indicates reflective thought about Jesus rather than reports by him.

In all probability, the narratives are devout, imaginative illustrations intended to show that Jesus endured a period of solitude and fasting during which time he considered his abilities and prepared himself for his public ministry.

The Arab name for the mountain is Quarantal, a corruption of *quarantena*, meaning a period of forty days. The actual site of the solitary meditations of Jesus is a small cave, 558 feet (170 m) up the steep side of the mountain. While earlier construction may have been done at the site, St. Chariton built the first known chapel there in 340 CE. The cave and chapel are rarely mentioned as a pilgrimage destination prior to the Crusades, yet during and following the Crusades, they were much visited. In 1874, the mountain was acquired by a Greek Orthodox sect, and in 1895 a small convent was built over the grotto.

The Chapel of the Holy Sepulchre, inside the Church of the Holy Sepulchre in Jerusalem, is the traditional site of Golgotha. The chapel's altar is a raised, marble block covering the stone Jesus's body was placed on.

CHAPEL OF THE HOLY SEPULCHRE

Jerusalem, Israel

MAP SITE 5

This chapel inside the Church of the Holy Sepulchre marks the traditional site of Jesus's Crucifixion at Golgotha, or Calvary, and of his burial and Resurrection. There is archaeological evidence that Golgotha was once a place of pagan sanctity, and it is traditionally claimed that the skull of Adam is buried there. Golgotha houses the cave shrine where some sources say Jesus was entombed. According to Christian tradition, its location was determined by Empress Helena in 326 CE. Helena believed that the Roman emperor Hadrian had constructed a pagan temple to Jupiter and Venus on the site in 135 CE. She sponsored excavations at Hadrian's temple that uncovered the tomb of Joseph of Arimathea and three crosses, which she assumed had been left after the Crucifixion. According

to the four Gospels, Joseph of Arimathea, a secret disciple of Jesus, had obtained the body of Jesus from Pilate and buried it in his own tomb site.

Emperor Constantine built a church over the tomb site in 335 CE. The remains of the original structure lie underneath the present church, built by the Crusaders in 1048. Inside the church is the Chapel of the Holy Sepulchre, the supposed burial place. I should mention the fascinating scholarly research that has discovered material that contradicts the Crucifixion story, such as the many legends from Asia that tell of how Jesus traveled in those areas *after* the supposed time of his Crucifixion and the belief that Christ died and was buried in the town of Srinagar in the Himalayan mountains of Kashmir.

KA'BA AT THE GREAT MOSQUE

Mecca, Saudi Arabia

MAP SITE 8

The center of the Islamic world and the birthplace of the Prophet Muhammad, Mecca is located in the mountains of central Saudi Arabia. According to legend, when Adam and Eve fell to earth from paradise, they wandered separately for two hundred years until God united them on Mt. Arafat, near present-day Mecca. Adam then built a shrine similar to the one he had used in paradise. Many generations later, Abraham and his son Ishmael were directed to rebuild this shrine. God gave Abraham instructions concerning the dimensions, the archangel Gabriel revealed the perfect location, and the Ka'ba was built from the stones of five sacred mountains. Upon completion of the shrine, Gabriel brought a magic stone for the sanctuary. With the passage of time, however, various pagan rituals were added to those of Abraham. The pilgrims of pre-Islamic times visited the house of Abraham and the sacred stone of Gabriel, but also a collection of 360 stone idols, including statues of Jesus and Mary, housed around the Ka'ba. The most important of all these statues was Allah, who would later become the sole God of the Muslims.

The city of Mecca achieved its major religious significance during the time of the Prophet Muhammad (570 to 632 CE). In 630 Muhammad took control of Mecca and destroyed the pagan idols, with the notable exception of the statues of Jesus and Mary. He then joined different Meccan rituals with the hajj pilgrimage to Mt. Arafat and declared the Ka'ba the centerpiece of the Muslim religion. The Ka'ba, along with the sacred Zamzam Well and the hills of Safa and Marwah, are enclosed in the vast Haram al-Sharif. Surrounded by eight towering minarets and sixty-four gates, this monumental building can hold more than 1.2 million pilgrims and is the largest mosque in the Islamic world. The cubical (the word *ka'ba* means cube), flat-roofed building rises fifty feet (15 m), and its corners are oriented toward the compass points. The east and west walls are aligned to the sunrise at the summer solstice and the sunset at the winter solstice. From the seventh century to the present, the structures surrounding the Ka'ba have undergone extensive rebuilding, yet the Ka'ba remains as it was in the time of Muhammad.

The hajj pilgrimage, one of the Five Pillars of Islam, is required of all Muslims. The pilgrimage takes place each year between the eighth and thirteenth days of Dhu al-Hijjah, the twelfth month of the Islamic lunar calendar. Nowadays about two million worshippers perform the hajj each year, and the pilgrimage serves as a unifying force in Islam by bringing together followers from diverse countries. After visiting the Great Mosque, the pilgrims walk a ritualized route to other sacred places in the Mecca vicinity, including Mina, Muzdalifah, and Mt. Arafat, and then return to the Ka'ba.

In a certain sense, Mecca is said to be visited by all Muslims every day, because five times each day (three times in the Shia, or Shiite, sect), hundreds of millions of believers kneel to pray. Wherever the place of prayer—an established mosque, a remote area in the wilderness, or a home—Muslims face Mecca and are connected to the Ka'ba by an invisible line of direction called the *qibla*. Colorful paintings of the Ka'ba often adorn the walls of houses in Egypt and other Islamic countries. These paintings show the various modes of travel to the holy shrine, including planes, trains, ships, and camels, and often depict the pilgrim on a prayer carpet. Mecca came to symbolize for Europeans the mysteries of the Orient and became a magnet for explorers, although entry is forbidden to persons not of the Muslim faith. A few daring travelers, such as the Swiss Johann Burckhardt and the English Sir Richard Burton, were able to impersonate Muslim pilgrims, gain entrance to Mecca, and write wonderfully of the holy city.

During the hajj, pilgrims walk seven times around the Ka'ba in a counterclockwise direction and then kiss the sacred stone, located in the southeast corner. This photograph shows one million pilgrims in the Great Mosque; another one to two million are in the surrounding streets.

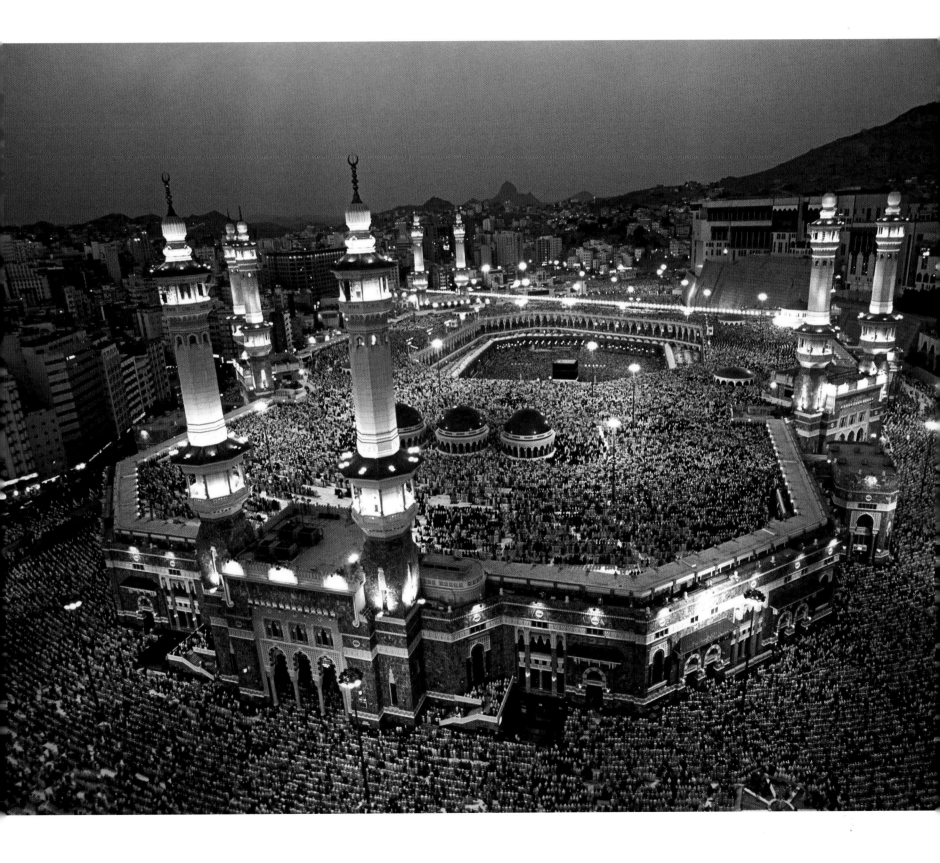

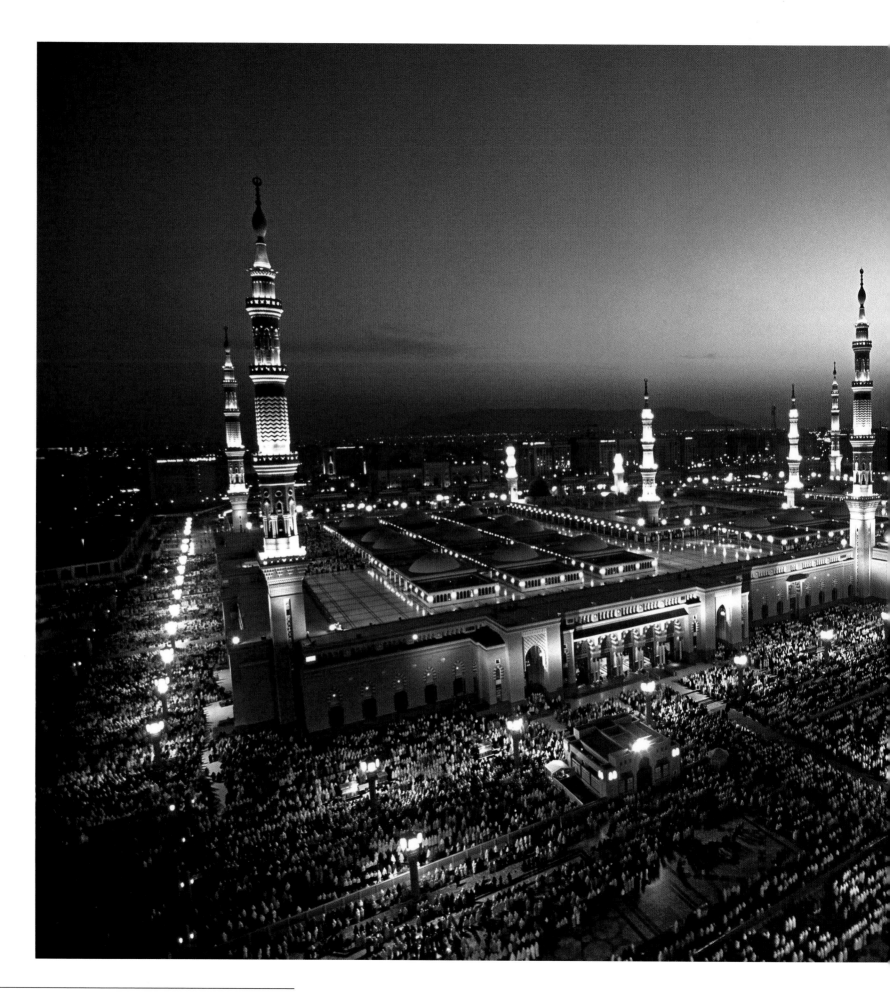

SACRED EARTH

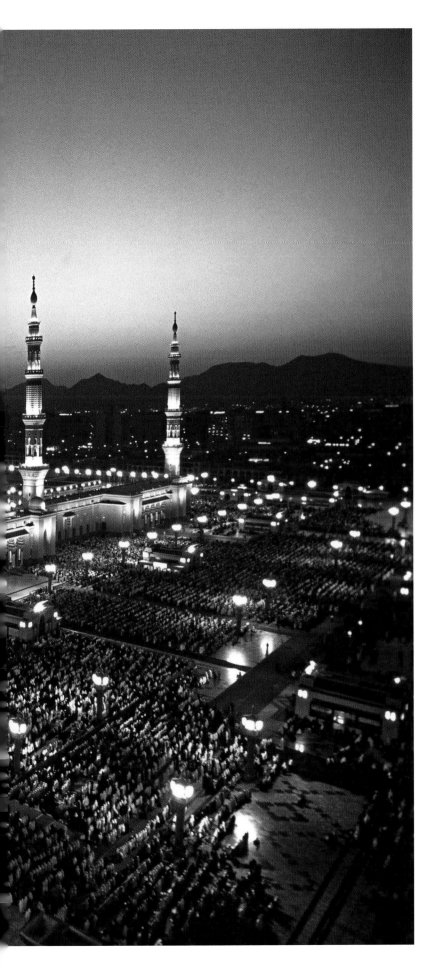

Mosque of the Prophet

Medina, Saudi Arabia

Map site 9

Known as the City of the Prophet, the Saudi Arabian city of Medina is the second holiest Islamic site after the city of Mecca. Medina first came to prominence in the year 622 CE, when Muhammad was invited to come and live there as a sort of governor. Medina in those times was a divided city with different clans and religions often quarreling. Muhammad was able to bring unity and peace to the city.

Medina's importance as a religious site derives from the presence of the Al-Masjid al-Nabawi, the Mosque of the Prophet. The first incarnation of the mosque was a relatively simple structure that Muhammad had built next to his house. After the death of the Prophet, the mosque was rebuilt and enlarged during the periods of the Umayyad caliphs and the Mameluke and Ottoman sultans, and again most recently in the 1980s by the royal family of Saudi Arabia.

As it stands today, the mosque has a rectangular plan on two floors, with the main prayer hall occupying the entire first floor. The roof, as well as the paved area around the mosque, is also used for prayer during peak times. The first mosque of Islam is also located in Medina and is known as Masjid al-Quba, the Quba Mosque.

The Mosque of the Prophet is lavishly decorated with marble and semiprecious stones, and is one hundred times larger than the first mosque built by Muhammad. It can accommodate more than half a million worshippers.

Great Mosque

Damascus, Syria

MAP SITE 10

Located in the heart of the teeming city of Damascus, the Umayyad, or Great Mosque, is known to be the oldest existing monumental architecture in the Islamic world. For millennia before the birth of Islam, however, the city of Damascus was a sacred site of other cultures. The recognized history of the temple site goes back to at least 1000 BCE, when the Aramaeans built shrines to Haddad, the god of storms and lightning, and the goddess Atargatis (Venus). Upon the foundations of these Aramaean sanctuaries, the Romans in the first century CE built a *temenos,* or sacred enclosure, with a temple of the god Jupiter.

Christians took possession of the Roman temple platform in the fourth century, and a church of St. John the Baptist was built in the exact place where the Jupiter temple stood. This church, an important pilgrimage site of early Byzantine Christianity, continued to function even after the Islamic conquest of Damascus in 636 CE. Following their occupation of the ancient city, the Muslims shared the great Roman temple platform with the Christians, the Christians retaining possession of their church and the Muslims using the southern part of the Roman *temenos* for their prayers. In 706 CE an Umayyad caliph demolished the church and constructed an enormous mosque upon the same site.

Inside the mosque is a small shrine of John the Baptist (Prophet Yahya to the Muslims), where tradition holds that the head of the saint is buried. This head is believed to possess magical powers and continues to be the focus of the annual pilgrimage of the Mandaeans, members of a small monotheistic religion practiced largely in parts of southern Iraq and Iran. Upon entering the holy place, Mandaeans press their foreheads against the metal grill of the shrine and reportedly experience prophetic visions. Adjacent to the prayer hall, along the eastern wall of the courtyard, is the entrance to another shrine chamber. According to legend, this shrine holds the head of Zechariah, the father of John the Baptist, or the head of Husayn, the son of Imam Ali, who was the son-in-law of Muhammad and the fourth of the Rightly Guided Caliphs.

Shrine of Lady Zeinab

Damascus, Syria

MAP SITE 10

There are several other important pilgrimage sites in the Damascus area, including the shrine of Ibn Arabi, the Cave of the Seven Sleepers on Mt. Qaysun, and the shrine of Lady Zeinab at the Sayedah Zeinab Mosque. Lady Zeinab was the granddaughter of the Prophet Muhammad through Fatima, and the sister of Imam Husayn and Imam Hasan. The site of the present mosque, built in 1990 after an earlier twentieth-century structure was razed, is believed to be the location of Lady Zeinab's grave site.

Lady Zeinab's shrine is an important pilgrimage site for the Shiite sect. Another shrine dedicated to Lady Zeinab is located in Cairo.

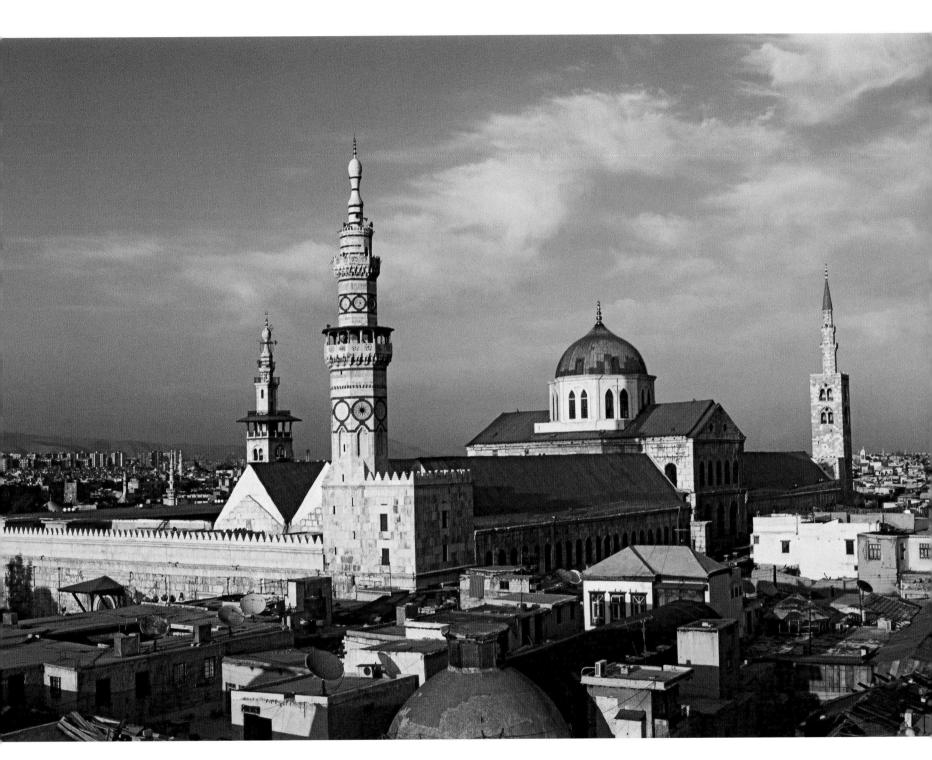

The Great Mosque of Damascus was built by Caliph Al-Walid I in 706 CE; thousands of craftsmen of Coptic, Persian, Indian, and Greek origin took ten years to construct the mosque, which includes a prayer hall, a large courtyard, and rooms for visiting pilgrims.

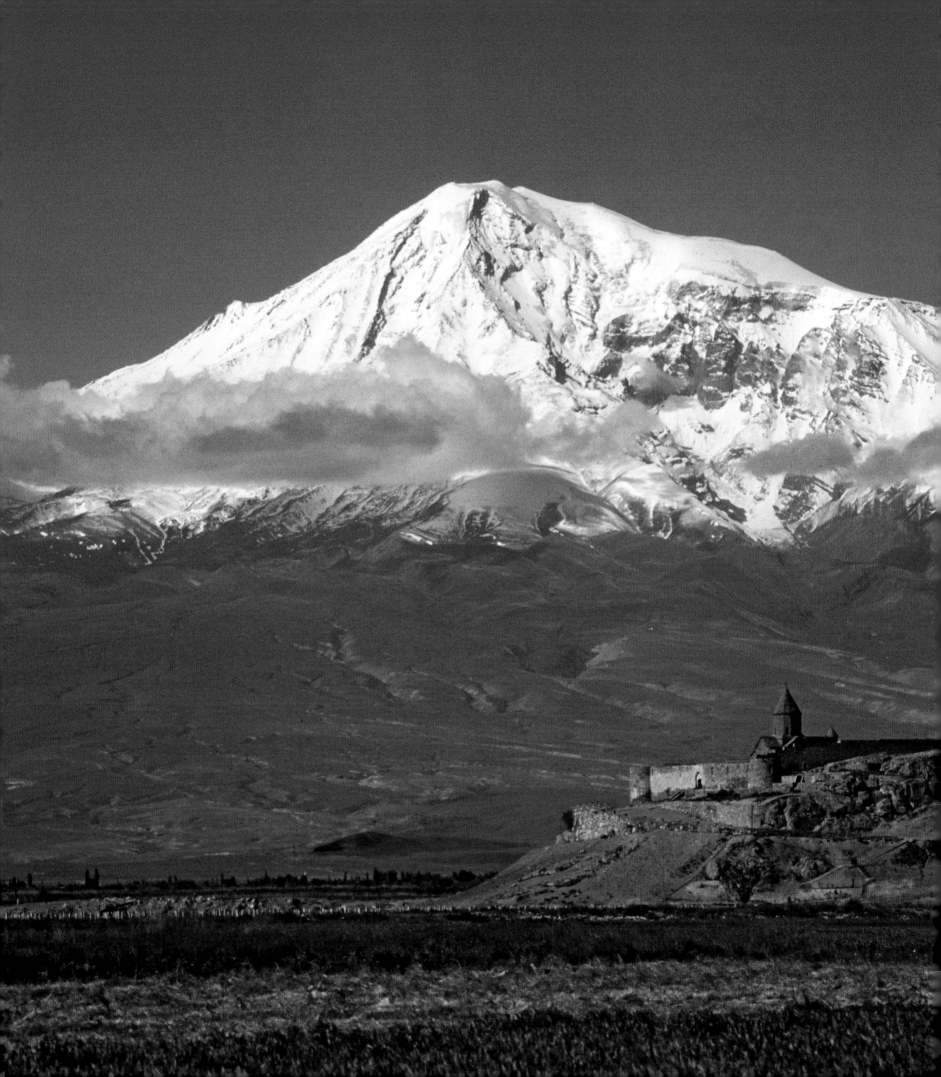

MT. ARARAT

Eastern Turkey
MAP SITE 11

Mt. Ararat, the traditional landing place of Noah's Ark, is located in eastern Turkey near the Armenian and Iranian borders. The summit of Ararat is 16,946 feet (5,165 m) above sea level. Also called Agri Dagi, Ararat is a dormant volcano; its last eruption was in 1840. Classical writers considered Ararat impossible to scale, and the first known ascent was by a German in 1829. Over the years, various groups have explored Ararat in the hopes of finding the remains of Noah's Ark. Both Josephus, in about 70 CE, and Marco Polo, in about 1300 CE, mention the ark's existence on the mountain, but their reports are based on other accounts. The story of Noah's Ark told in the Bible is a reworking of an earlier Babylonian myth recorded in the *Gilgamesh* epic, itself based on a devastating flood in the Euphrates River basin. The biblical references to a great flood and Noah's Ark have remarkable parallels in many other myths from around the world. These myths of great floods devastating human civilization are not the imaginative creations of ancient people, although they have been embellished and altered over the millennia, but reports of real events.

Mt. Ararat as seen from Armenia. There are numerous legends and eyewitness reports of Noah's Ark resting high on Mt. Ararat, but so far no real evidence has been found. Only the loftiest heights of the frozen peak would be capable of preserving the ark, and perhaps explorers will one day find the boat's remains beneath the snow and ice.

SHRINE OF RUMI

Konya, Turkey
MAP SITE 12

Occupied for nearly four thousand years, the city of Konya is famous for the shrine of the Sufi poet Rumi. Born in 1207 CE in the Persian city of Balkh (in what is now Afghanistan), Mevlana Jalaluddin Rumi was the son of an Islamic scholar. At the age of twelve, Rumi and his family made a pilgrimage to Mecca, and they settled in the town of Konya in 1228 CE. Initiated into Sufism, Rumi studied in Aleppo and Damascus, returned to Konya in 1240, and began teaching as a Sufi sheikh. Within a few years, a group of disciples gathered around him because of his eloquence, theological knowledge, and engaging personality.

In 1244 CE a strange event occurred that profoundly changed Rumi's life and gave rise to the extraordinary outpouring of poetry for which he is famous today. A wandering mystic known as Shams al-Din of Tabriz came to Konya and began to exert a powerful influence on Rumi. Despite Rumi's position as a teacher, he became devoted to Shams al-Din, ignored his own disciples, and departed from scholarly studies. Jealous of his influence on their master, a group of Rumi's students twice drove the dervish away and finally murdered him in 1247 CE.

Overwhelmed by the loss of Shams al-Din, Rumi withdrew from the world to mourn and meditate. During this time he began to manifest an ecstatic love of God that he expressed by writing beautiful poetry, listening to devotional music, and trance dancing. Over the next twenty-five years, Rumi's literary output was phenomenal. In addition to the *Mathnawi*, consisting of nearly 25,000 rhyming couplets, he composed 2,500 mystical odes and 1,600 quatrains. Virtually all of the *Mathnawi* was dictated to his disciple Husam al-Din in the fifteen years before Rumi's death. Rumi recited the verses whenever and wherever they came to him—meditating, dancing, singing, walking, eating, day or night—and Husam al-Din recorded them.

Rumi is also famous for the Sufi brotherhood that he established with its distinctive whirling and circling dance, known as Sema and practiced by the dervishes. The Sema ceremony represents the mystical journey of an individual toward union with the divine. Dressed in long white gowns, the dervishes dance for hours at a time. With arms held high, the right hand lifted upward to receive blessings and energy from heaven, the left hand turned downward to bestow these blessing on the earth, and the body spinning from right to left, the dervishes revolve around the heart and embrace all of creation with love.

Rumi passed away on the evening of December 17, 1273, a time traditionally known as his wedding night, or *urs,* for he was now completely united with God. In the centuries following his death, many hundreds of dervish lodges were established throughout the Ottoman domains in Turkey, Syria, and Egypt. Several Ottoman sultans were Sufis of the Mevlevi order. With the secularization of Turkey following World War I, the Mevlevi Brotherhood was seen as reactionary to the new republic and banned in 1925. While their properties were confiscated, members of the Mevlevi Brotherhood continued their religious practices in secret until their ecstatic dances were again allowed beginning in 1953.

A minaret at the shrine of Rumi soars into the Konyan sky. Each year on December 17, tens of thousands attend a religious celebration at the shrine. In the shrine there is a silver-plated step on which Rumi's followers rub their foreheads and place kisses. This area is usually cordoned off but is opened for these devotional activities during the December pilgrimage festivities.

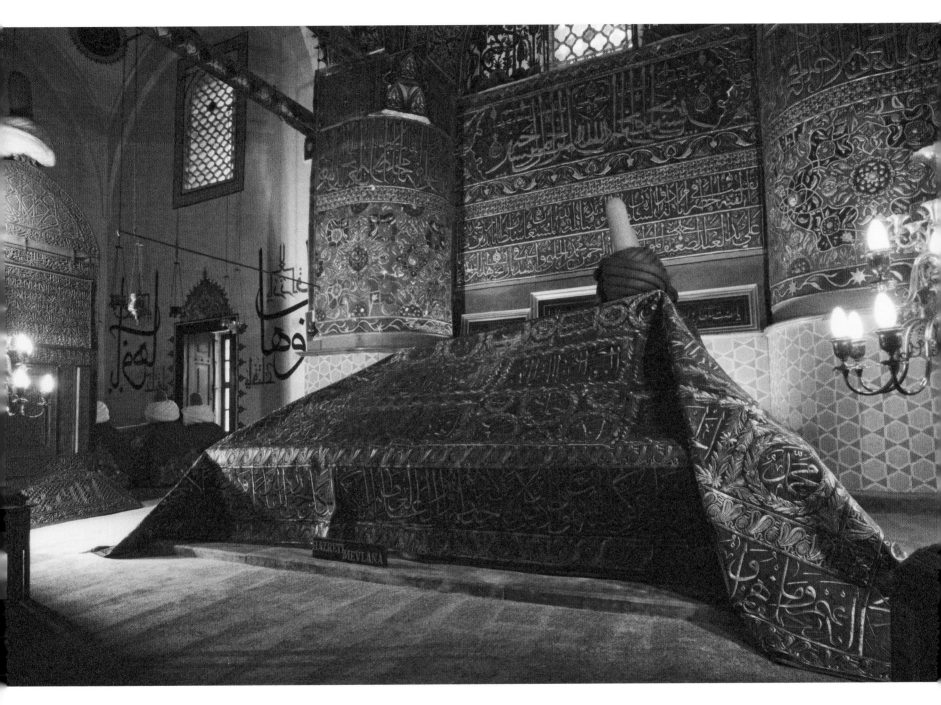

The burial cenotaph of Rumi lies in the main room of the former monastery of the whirling dervishes of Konya, which was converted into a museum in 1927. Here the tomb of Rumi lies covered with a large velvet cloth embroidered in gold. Adjacent to Rumi's burial are those of his father and sons and other Sufi sheikhs. The burials are capped with turbans, which are symbolic of the spiritual authority of Sufi teachers.

SHRINE OF IMAM REZA

Mashhad, Iran
MAP SITE 13

The existence of pilgrimage places, other than the Ka'ba in Mecca, is a controversial subject in Islam. Orthodox Sunni Muslims, following Muhammad's revelations in the Koran, state that there can be no pilgrimage site other than Mecca in Saudi Arabia. The reality, however, is that pilgrimage places dedicated to Muslim saints are popular throughout the Islamic world for both the Sunni and Shiite sects, particularly in Morocco, Tunisia, Pakistan, Iraq, and Shiite Iran. These sects, while quite similar in theological matters, differ in their understanding of who should have been the leader of Islam following the death of Muhammad. The Shiite, living mostly in present-day Iran, believe the Prophet designated his cousin and son-in-law Ali to be his successor. The Sunni, convinced that Muhammad had given no such indication, chose from among their group a series of caliphs.

A distinctive institution of Shiite Islam as practiced in Iran is the Imamate. The Shiites maintain that the only legitimate successor of Muhammad was Ali, both by right of birth and by the will of the Prophet. Shiites revere Ali as the First Imam, and his descendants, beginning with his sons Hasan and Husayn, continued the line of the Imams until the Twelfth Imam, who is believed to have ascended into a supernatural state to return to earth on judgment day. While none of the Twelve Imams, with the exception of Ali, ever ruled an Islamic government, the Shiites always hoped that they would assume the leadership of the Islamic community. Because the Sunni caliphs were aware of this hope, the Shiite Imams generally were persecuted, and often assassinated, throughout the Umayyad and Abbasid dynasties. A significant practice of Shiite Islam is that of visiting the shrines of the Imams. It is interesting to note that only one of the Imam shrines is located in Iran, that of Imam Reza in Mashhad, while the other Imam shrines are found in Sunni Iraq and Saudi Arabia. The Shiite shrines in Sunni Iraq have frequently been destroyed or desecrated by fundamentalist Sunnis, but each time, the shrines are reconstructed, ever more gloriously, by Shiite believers.

Mashhad, the second largest city in Iran, is best known for its beautiful pilgrimage shrine of Imam Reza, the Eighth Shiite Imam (765 to 818 CE). A person of extraordinary scholarship and saintly qualities, he was surprisingly appointed by the Sunni caliph al-Ma'mun to become his successor. Al-Ma'mun's actions, while welcomed by members of the Shiite sect, disturbed the rival Sunnis, resulting in violent uprisings and the death of Imam Reza, perhaps by assassination. Caliph al-Ma'mun, deeply mourning the death of Reza, built a mausoleum over the Imam's grave in 818 CE.

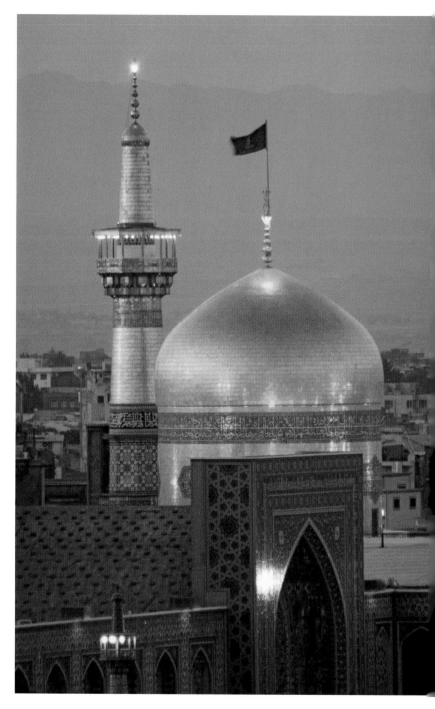

The shrine of Imam Reza has been frequently renovated and enlarged since its construction in the ninth century. Currently visited by more than twenty million pilgrims each year, it is the most beautiful mosque in all of Iran.

Jamkaran Mosque

Qom, Iran

Map site 14

Besides the highly visited shrine of Imam Reza, there are other Islamic pilgrimage sites in Iran. Among these are the Imamzadehs, or the tombs of descendants, relatives, and close friends of the Twelve Imams, and the mausoleums of revered Sufi saints and scholars. Saints, Imams, and the individuals enshrined in the Imamzadehs are viewed as having a close relationship with God and are therefore approached by pilgrims as intercessors. Pilgrims visit the shrine of a saint to receive some of his *baraka*, or spiritual power. Making a pilgrimage, or *ziyarat*, also brings religious merit. Near the holy city of Qom stands the Jamkaran Mosque, built in 1005 CE and visited by large numbers of pilgrims. Other important pilgrimage shrines in Iran are located in Shiraz, Rey, and Mahan.

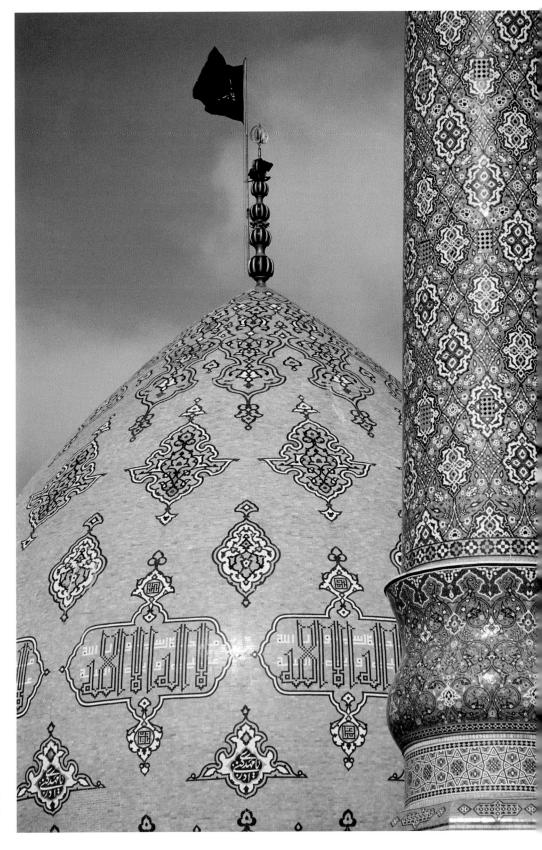

The minaret of Jamkaran Mosque, like many other mosques in Iran, is graced with verses of the Koran written in classical Arabic and with exquisitely laid tile work.

OLD CITY OF BAM

Bam, Iran

Map site 15

Located in southeastern Iran, the ancient ruined city of Bam is made entirely of mud bricks, clay, straw, and the trunks of palm trees. The city was originally founded during the Sassanian period (224 to 637 CE), and while some of the surviving structures date from before the twelfth century, most of what remains was built during the Safavid period (1502-1722). During Safavid times, the city occupied a little more than two square miles (5 sq km), was surrounded by a rampart with thirty-eight towers, and had between nine thousand and thirteen thousand inhabitants. Bam prospered because of pilgrims visiting its Sassanian-era Zoroastrian fire temple and because of its function as a major trading center

on the famous Silk Road. The Jame Mosque was built directly upon the site of the Zoroastrian temple during the Saffarian period (866 to 903 CE), and adjacent to this mosque is the tomb of Mirza Naim, a mystic and astronomer who lived three hundred years ago. Bam declined in importance following an invasion by Afghans in 1722 and another by invaders from the region of Shiraz in 1810. The city of Bam was used as a barracks for the Iranian army until 1932, and then it was completely abandoned until intensive restoration work began on the site in 1953. A massive earthquake destroyed much of the archaeological ruins of Bam in 2003.

Bam, the former World Heritage site, was at the epicenter of a massive and devastating earthquake in December 2003. Tragically, over 25,000 people lost their lives, and most of the ancient city, including the citadel—Arg-é Bam—seen here at the top right of the photograph—was reduced to rubble.

GREAT PYRAMID

Giza, Egypt

MAP SITE 16

The Great Pyramid is the most substantial structure of the ancient world and one of the most mysterious. Constructed from approximately 2.5 million limestone blocks weighing on average 2.6 tons each, its total mass represents more building material than is found in all the churches and cathedrals built in England. The Great Pyramid originally stood 481 feet (147 m) tall, covered an area of thirteen acres (5 hectares), and was encased in polished white limestone. Arab laborers forced their way into the Great Pyramid in 820 CE to find the inner chambers completely empty

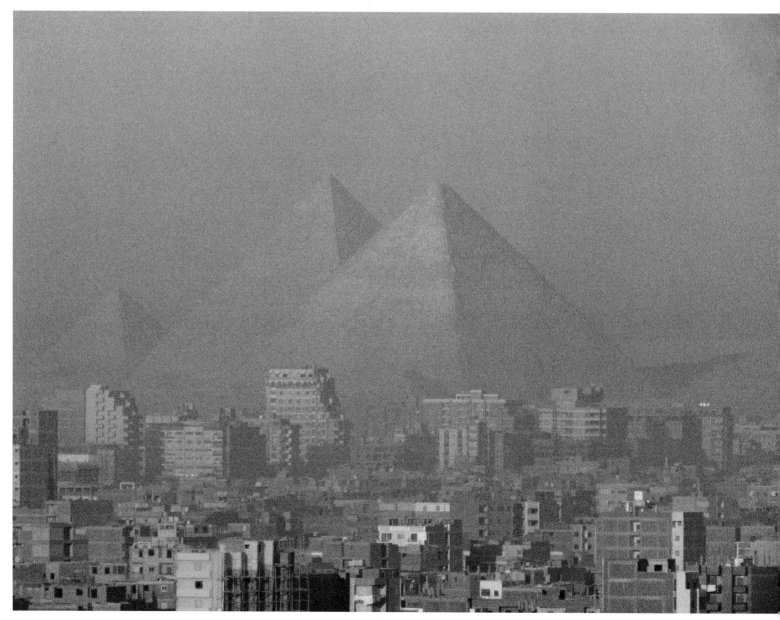

The pyramids shimmer in the lavender haze of the Giza sky. The Great Pyramid, attributed to Khufu, is on the right side of the photograph. In the center is the pyramid attributed to Khafra. The pyramid of Menkaura is on the far left.

except for a stone coffer. Traditional Egyptologists assume this coffer was for the burial of Khufu (Cheops in Greek), yet no embalming materials, hieroglyphic inscriptions, or other clues were found in the pyramid or its chambers to indicate that Khufu was buried there. An extraordinary example of geographic surveying, mathematical knowledge, and engineering brilliance far beyond the capacity of early Egyptian builders, the Great Pyramid continues to baffle researchers. What was the purpose of the structure? While no authoritative answer can presently be given, legend, archaeology, and mathematics seem to indicate that the Great Pyramid, and especially the main chamber, was a monumental device for gathering, amplifying, and focusing a mysterious energy for the spiritual benefit of human beings. The store coffer was the focal point of both celestial and terrestrial energies gathered and concentrated by the geographical location, celestial alignment, and construction mathematics of the pyramid. These energies were conducive to the awakening, stimulation, and acceleration of spiritual consciousness.

A man standing on one of the tiers of blocks that make up the Great Pyramid gives perspective on the vast size of the structure.

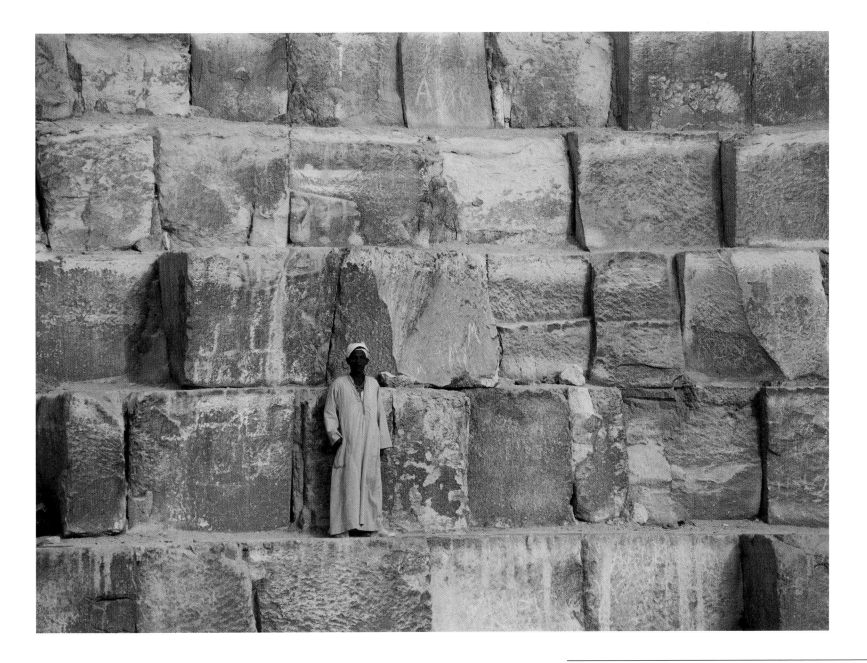

THE SPHINX

Giza, Egypt
MAP SITE 16

An unusual view: looking up from the giant paws of the Sphinx, one of the world's great mysteries.

The largest monumental sculpture in the ancient world, the Sphinx is carved from a ridge of stone 240 feet (73 m) long and 66 feet (20 m) high. Antiquarians previously assumed that the Sphinx was constructed in the Fourth Dynasty by Pharaoh Khafra, yet recent archaeological evidence proves that the Sphinx is far older and was only restored by Khafra during his reign. The Inventory Stele, for example, tells that Pharaoh Khufu, Khafra's predecessor, ordered a temple built alongside the Sphinx, which means that the Sphinx existed before Khafra's time.

Egyptologist R. A. Schwaller de Lubicz initially suggested a greater age for the Sphinx, which was confirmed by recent geological and climatological studies. The vertical erosion marks on the body of the Sphinx are not due to horizontally blown sand, as had been previously assumed, but are the result of long exposure to abundant rainfall, which occurred in the region many thousands of years before the dynastic Egyptians. Furthermore, most of the Sphinx was covered by sand dunes for nearly all of the past five thousand years, indicating that its surface erosion occurred prior to that time. Additional evidence for the great age of the Sphinx is seen in the astronomical significance of its lion form. Roughly every two thousand years, the sun rises against the background of a different constellation. Past constellations have been Pisces the Fish, Aries the Ram, Taurus the Bull, and, from 10,970 to 8810 BCE, Leo the Lion. Sophisticated computer programs show that during this period, especially on the morning of the spring equinox, the lion-bodied Sphinx would have looked directly at the constellation of Leo. These matters indicate that the Sphinx may have been built during a time when (according to conventional archaeological theory) humans had not yet evolved beyond a hunter-gatherer lifestyle. If the Sphinx is indeed that old, contemporary assumptions regarding the development of civilization must be entirely reworked.

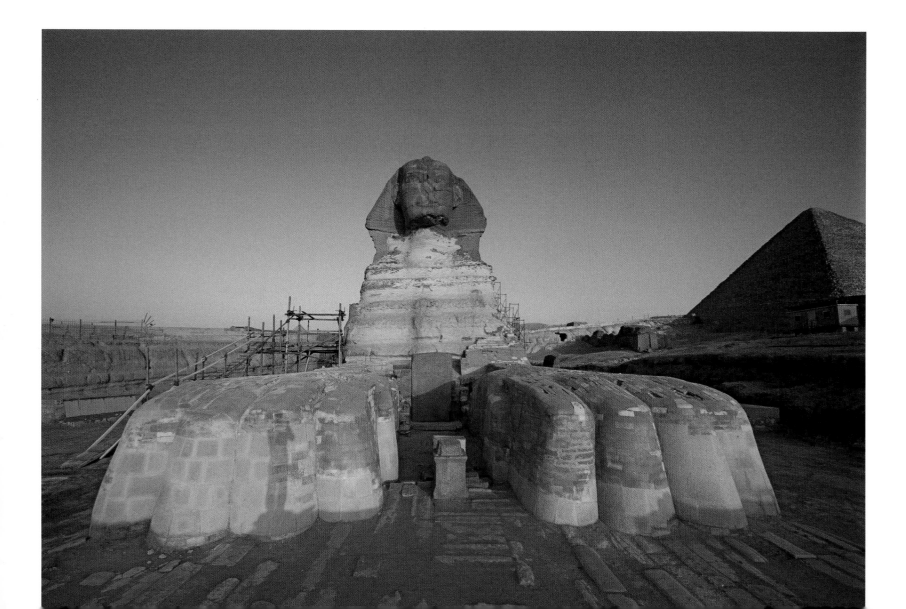

Obelisk of Queen Hatshepsut

Temple Complex of Karnak, Luxor, Egypt

MAP SITE 17

In the ancient city that the early Greeks called Thebes, there existed the most extensive religious complex of the dynastic Egyptians—and the largest temple complex in the world. Known to the Egyptians as Waset, it included the massive temples of Karnak and Luxor, the ruins of which still draw millions of tourists each year. Rather than being places for collective worship, the inner sanctums of these temples were considered to be abodes of the gods and could be entered only by temple priests and members of the nobility. The surrounding complex, however, functioned as a place for pilgrimage festivals and processions associated with the various deities enshrined in the temples. Some archaeologists consider the early founding of Karnak to have been around 3200 BCE, but the existing temple complex is mostly a Middle Kingdom (2040-1973 BCE) co-creation by several different pharaohs. The central temple at Karnak, dedicated to the state god Amon, is oriented to admit the light of the setting sun at the time of the summer solstice.

In one area of the temple stands the obelisk of Queen Hatshepsut (1473 to 1458 BCE): ninety-seven feet (30 m) tall and weighing perhaps 350 tons. Obelisks were carved from single pieces of stone, usually pink granite brought from hundreds of miles away, but how they were transported and erected is a mystery. The use of the obelisks is another mystery, and it has been suggested that they symbolized the Djed pillar, found throughout Egypt, the Osiris symbol for the backbone of the physical world and the channel through which the divine spirit rose to rejoin its source. Obelisks were often erected in pairs, and their dimensions were calculated according to geodetic data pertaining to the exact latitude and longitude where they were set. The shadows cast by the pair of unequal obelisks would enable the astronomer-priests to make precise astronomical observations and determine the "earth spirit" periods. Curiously, if the base of an obelisk is struck with a large wooden mallet, a particularly low sound is created. Perhaps before the world's collection of obelisks suffers further losses from time and human depredations, a grand symphony of many instruments could be played—the sacred geometry of the obelisks creating the sacred geometry of musical notes and scales.

An inscription at the base of the obelisk of Queen Hatshepsut indicates that the work of cutting the monolith out of the quarry required seven months. Nearby stands a smaller obelisk erected in the fifteenth century BCE by Thutmose I. Hatshepsut raised four obelisks at Karnak, only one of which still stands.

Colonnade of Amenhotep III

Temple of Luxor, Luxor, Egypt

Map site 17

Built upon the site of a Middle Kingdom sanctuary in Thebes, the Temple of Luxor was constructed by the Eighteenth and Nineteenth Dynasty pharaohs Amenhotep III and Ramses II during the second millennium BCE. The enormous asymmetric complex was built in stages upon three separate axes, and every wall, colonnade, and hall is perfectly aligned to one of these axes. Later additions by other pharaohs, Alexander the Great, and the Romans were all aligned according to the original axes, showing that the architectural guidelines of the temple were handed down through the generations. These three different axes, skewed as they are, seem to defy logical explanation, yet the mathematician, philosopher, and Egyptologist R. A. Schwaller de Lubicz saw within them a deliberate expression of harmony, proportion, and symbolism.

In 1952, following a fifteen-year on-site study of the Luxor temple complex, Schwaller de Lubicz challenged prevailing archaeological theories concerning the development, mathematical sophistication, and religious symbolism of the ancient Egyptians.

He did this by proving that the dynastic Egyptians possessed mathematics superior to the Pythagorean Greeks or the Europeans of the late medieval era, both of whom the Egyptians preceded by thousands of years. Furthermore, he demonstrated that Egyptian culture fused science, religion, philosophy, and art into a grand synthesis unequaled in the ancient or the modern world. Schwaller de Lubicz found in the Temple of Luxor a record of the Egyptians' understanding of the cosmic laws of creation and the manner in which spirit becomes manifest as matter. One central insight was that the various sections of the human body had been incorporated into the proportions of the temple. He found that specific locations within the temple correspond to the seven Hindu chakras (energy centers) in the human body. These locations actually stimulate experiences and feelings that dowsers and meditators are able to perceive consciously. It seems logical that such experiences are caused by the power of place inherent in the Luxor area, and by the amplification and focusing of that power at specific sites through the temple's extensive use of sacred geometry.

The stunningly beautiful double-colonnaded court was added to the temple by the Nineteenth Dynasty pharaoh Ramses II (1290–1224 BCE).

TEMPLE OF HATHOR

Dendera, Egypt

MAP SITE 18

Similar to other temple sites in Egypt, Dendera marks the location of a very old holy place. An indication of the antiquity of the site is given by the astronomical alignment of the main temple to the star Gamma Draconis before 5000 BCE. Early texts refer to a pre-Dynastic temple that was rebuilt during the Old Kingdom and further developed by New Kingdom pharaohs. The present structure dates to the Greek and Roman periods, with the sanctuary built by the Ptolemaic Dynasty in the first century BCE and the hypostyle hall by the Romans in the first century CE. Dendera was the primary shrine for the worship of Hathor, a patroness of earthly love, a goddess of healing, and a great feminine source of nourishment.

Recent studies indicate that the temple of Dendera had several interrelated functions. It was a venerated place of pilgrimage where miraculous cures were caused by the goddess; a hospital where different physiological, psychological, and magical therapies were practiced; and the scene of great processions and festivals throughout the astrological cycle. Enclosed within the Dendera complex are a sacred lake, a temple of the goddess Isis, and a sanatorium where divine healing was practiced. Within the main temple, it is interesting to study the beautiful and highly detailed astrological calendars carved and painted upon the ceilings. Visitors may wonder about the blackened condition of some of the ceilings in the temple. When Napoleon's scholars first visited Dendera, they found a centuries-old Arab village established inside the temple; the villagers' cooking fires had blackened the ceilings over the years.

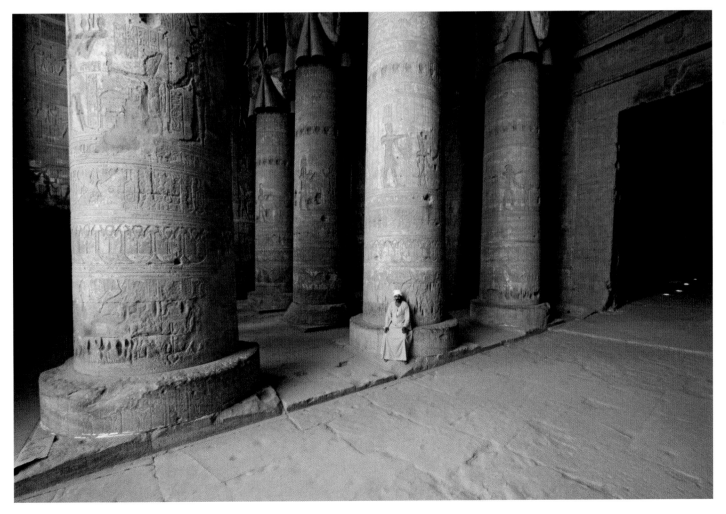

The huge columns that line the interior of the Temple of Hathor are carved with sculptural reliefs and hieroglyphics.

ST. CATHERINE'S MONASTERY

Mt. Sinai, Egypt

MAP SITE 19

Mt. Sinai (also called Mt. Horeb and Jebel Musa), or the Mountain of Moses, is a much-visited pilgrimage destination that includes St. Catherine's Monastery, the Burning Bush, and Elijah's Plateau. Moses was born in Egypt, the son of a Hebrew slave. Raised by the daughter of a pharaoh, he was later educated in the esoteric and magical traditions of the Egyptian mystery schools. At the age of forty, enraged by the Egyptian treatment of the Hebrews, he went into exile in the Sinai wilderness. Later, while grazing his flocks on Mt. Sinai, Moses came upon a burning bush and heard a voice commanding him to lead his people out of bondage from Egypt and return with them to the mountain. After taking the Hebrews out of Egypt, Moses twice climbed the mountain to commune with God. During his second ascent, lasting forty days and nights, Moses received two tablets upon which God had inscribed the Ten Commandments, as well as precise dimensions

for the Ark of the Covenant, a portable, boxlike shrine that would contain the tablets. Soon thereafter, the Ark was constructed, and Moses and his people departed from Mt. Sinai.

Early pilgrims to the mountain included Helena, the fourth-century empress who constructed the first church there; the Byzantine emperor Justinian I, who built a fortress around the church in 542 CE; and the Prophet Muhammad, who gave his personal pledge of protection, thereby ensuring the continued existence of the church. St. Catherine's Monastery is named after the fourth-century Christian martyr Catherine of Alexandria. During the twelfth to fourteenth centuries, thousands of pilgrims came annually to Mt. Sinai, the journey from Cairo lasting eight days by foot and camel. Currently there is no archaeological evidence that the 7,507-foot (2,288 m) peak of Jebel Musa is the actual Mt. Sinai of the Bible, and scholars have proposed alternative locations in the Sinai Peninsula.

St. Catherine's Monastery, at the base of Mt. Sinai, receives a hundred or more pilgrims and tourists a day. Currently Greek Orthodox monks tend the monastery and its extraordinary collection of Byzantine art.

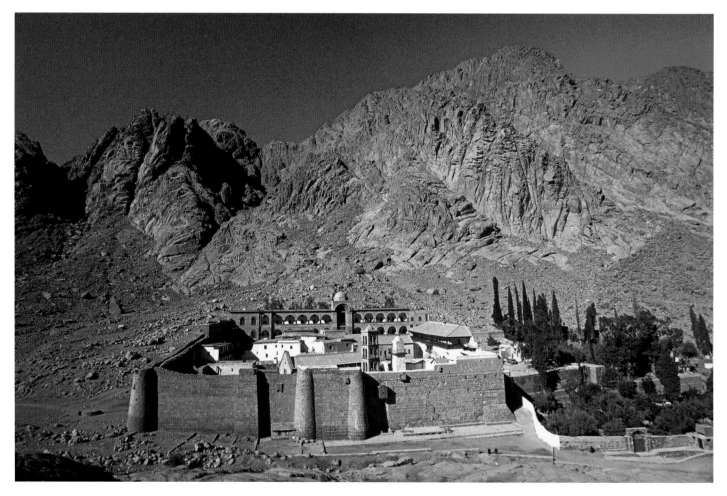

Church of St. Mary of Zion

Axum, Ethiopia

Map site 20

Ancient legends in Ethiopia (also called Abyssinia) describe the area of Axum as a swamp inhabited by evil spirits. God helped the local people by coming down to the nearby sacred hill of Makade Egzi to spread a miraculous dust from heaven that dried up the swamp, dispelled the evil spirits, and charged the region with a magical power. Over many centuries, shrines were set up on the sacred hill where the swamp had been. Around this holy place the cities of pre-Axumite and Axumite kingdoms developed. Between the fourth and seventh centuries CE, various kings of Axum erected the tallest granite obelisks in the ancient world, whose function is still unknown. A few hundred meters from a cluster of these towering obelisks is a walled compound containing the Church of St. Mary of Zion, built in 372 CE, and a fenced-off building said to contain the fabled Ark of the Covenant.

What factors explain this mysterious church isolated deep in the remote mountains of northern Ethiopia, far from the orbit of Christianity? Different legends offer contrasting answers. At some unknown date, the enigmatic Ark of the Covenant vanished from the Temple in Jerusalem. Ethiopian legends explain that Menelik I,

son of King Solomon and the Queen of Sheba, brought it to Axum. Scholarly research, however, suggests that during the sixth century BCE Jewish priests from Solomon's Temple transferred the Ark to a Jewish holy site on the Egyptian sacred island of Elephantine, where it remained for two hundred years. It was then hidden for eight hundred years on the island of Tana Kirkos in Lake Tana, Ethiopia, and finally brought by a Christian Axumite king to the Church of St. Mary of Zion sometime after the fourth century CE. The Ark remained in Axum until the early 1530s, when it was removed to a secret hiding place to protect it from approaching armies. With peace restored a hundred years later, the Ark was returned to Axum and St. Mary's church. There it remained until 1965, when Haile Selassie transferred it to a more secure chapel adjacent to the old church. Other scholars believe that the Ark was buried in secret tunnels beneath the Temple of Solomon in Jerusalem, only to be rediscovered and stolen seventeen hundred years later by the Knights Templar. Wherever the location of the true Ark, no one but the head priest of St. Mary of Zion is allowed to see the Ark of Axum.

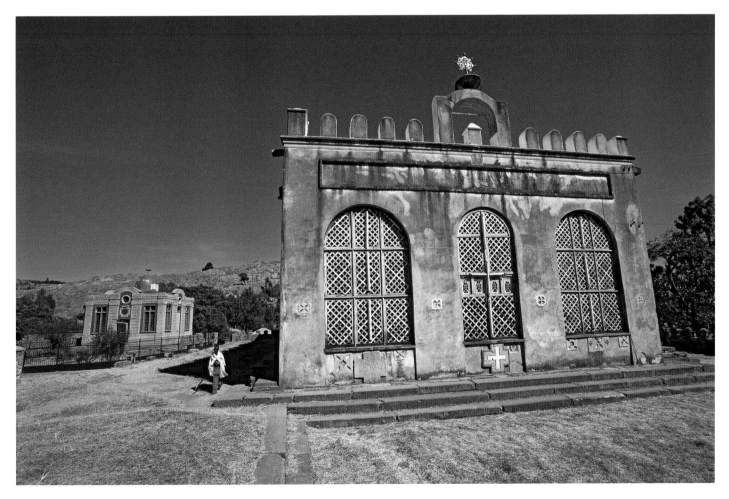

The Ark of the Covenant may be located at the building called the Treasury of the Ark of the Covenant, seen here to the left of the Church of St. Mary of Zion. It is privy only to the church priests.

CHURCH OF BET GIORGIS

Lalibela, Ethiopia
MAP SITE 21

Set into a hill and hewn entirely from rock, the Church of Bet Giorgis is a true engineering marvel. It was carved into an almost perfectly equilateral Greek cross with a roof decoration of additional Greek crosses nestled inside one another.

From the eleventh to the thirteenth centuries, Ethiopia was ruled by the Christian Zagwe Dynasty, and the most notable of its rulers was King Lalibela in the twelfth century. Legends tell that Lalibela had a three-day-long visionary experience during which he received divine communications instructing him to build several churches. Assisted by angels and St. Gabriel, the king built thirteen extraordinary churches over a period of twenty-five years. The churches of Lalibela are among the most unusual architectural creations of human civilization. Each church was sculpted, both inside and out, directly from the bedrock of the earth. No building materials of any kind were brought in. Narrow tunnels connect several of the churches, and the walls of the trenches and court-yards contain cavities and chambers filled with mummies of monks and pilgrims. The churches, many of them richly painted with biblical murals, are still used for worship today. The most remarkable of the Lalibela churches, is Bet Giorgis, dedicated to St. George, the patron saint of Ethiopia. Set in a deep pit with perpendicular walls, it can be entered only via a hidden tunnel carved into the stone.

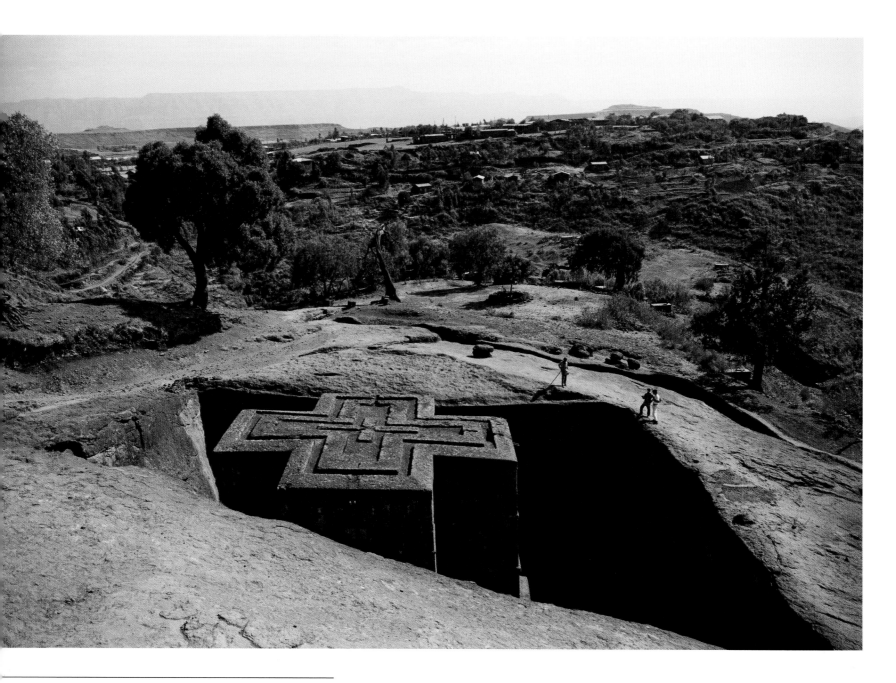

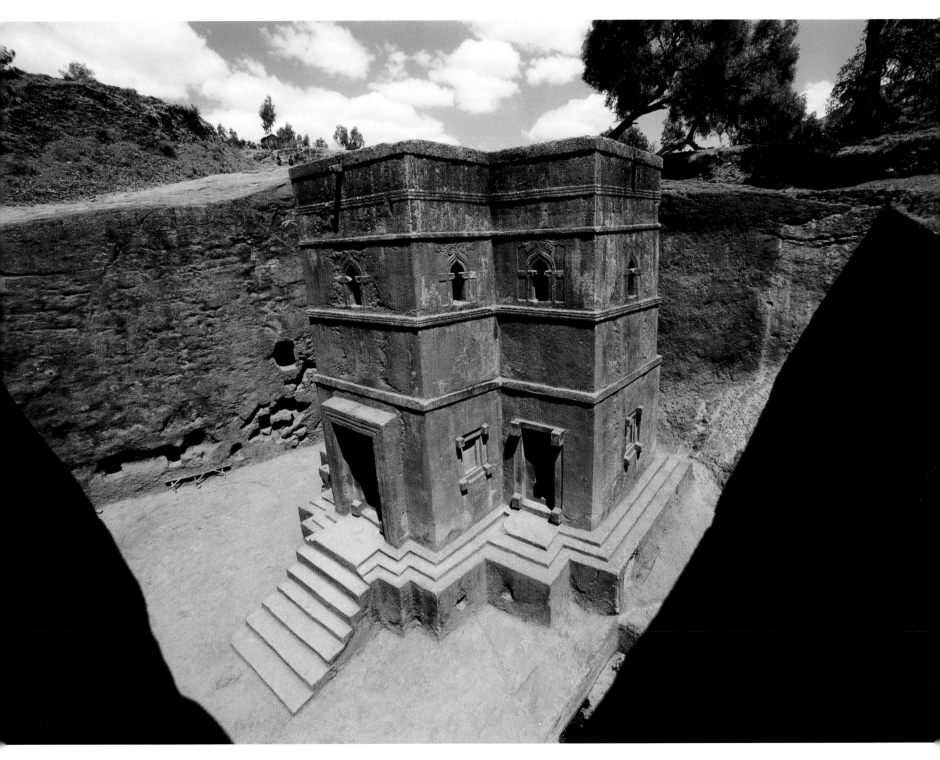

Bet Giorgis is perhaps the most beautiful of the thirteen rock-cut
churches of Lalibela, all of which have been used continuously
since they were carved in the twelfth century.

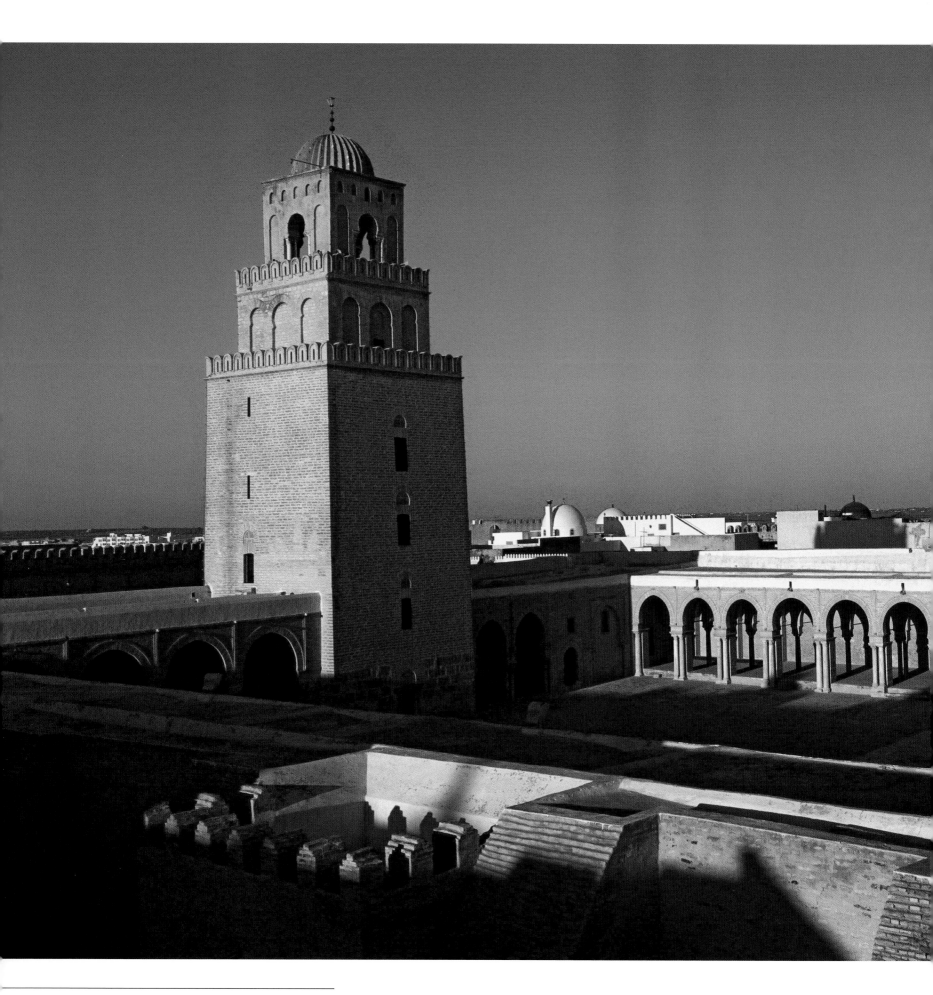

SACRED EARTH

Great Mosque of Kairouan

Kairouan, Tunisia

Map site 22

Historical records relate that in 670 CE the Arab conqueror Uqba ibn Nafi crossed the deserts of Egypt and began the first Muslim conquest of the Maghreb region of North Africa. Establishing military posts at regular intervals along his route, Uqba ibn Nafi came to the site of present-day Kairouan and there decided to camp with his soldiers for some days. Legends tell of a warrior's horse stumbling on a golden goblet buried in the sands, a goblet recognized to be one that had mysteriously disappeared from Mecca some years before. When the goblet was lifted from the sands, a spring miraculously appeared, and its waters were believed to issue from the same source that supplies the sacred Zamzam Well in Mecca.

By 698, the Arabs were masters of North Africa, and Kairouan was the capital of this vast province. During the ninth to eleventh centuries, the city became one of the most important cultural centers in the Arab world, witnessing a flowering of the sciences, literature, and the arts. From the eleventh century onward, Kairouan ceased to be the capital, as Tlemcen, Fez, Marrakech, and other cities usurped its political prominence. Yet as a holy city, Kairouan grew in importance with the passing centuries, and its splendid mosque became a magnet for pilgrims from Muslim territories throughout Northern and Saharan Africa. The Great Mosque, also known as the Sidi Oqba Mosque, was begun in 670 CE during the time of Uqba ibn Nafi and was frequently enlarged over time. Kairouan is the greatest Muslim city in North Africa and the fourth holiest city of Islam after Mecca, Medina, and Jerusalem.

The Great Mosque of Kairouan
contains a prayer hall, a courtyard filled with marble columns removed from more ancient Roman and Byzantine sites, and an early eighth-century minaret, the oldest in the world.

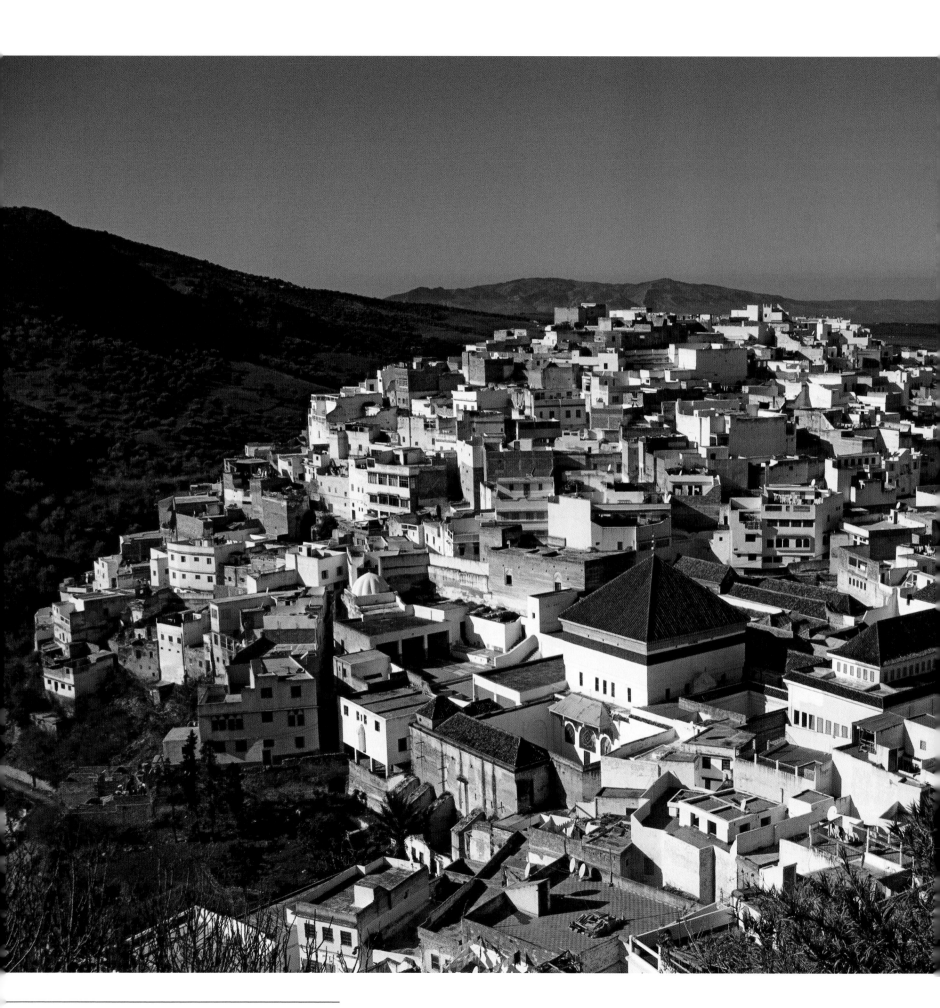

SACRED EARTH

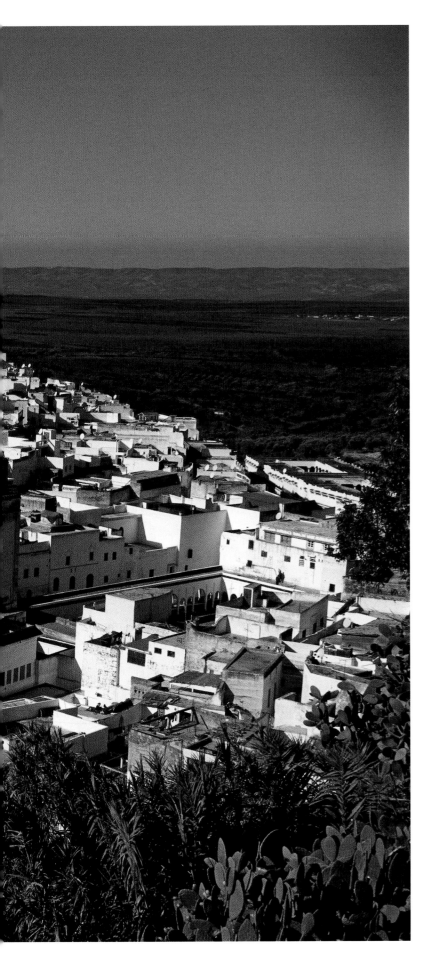

ZAWIYA OF MOULAY IDRIS I

Zerhoun, Morocco

MAP SITE 23

Scattered throughout Morocco are sacred sites and pilgrimage places of the ancient Berber culture and the Roman, Jewish, and Islamic people who settled in the northwest reaches of the African continent. The most notable immigrants were the Islamic Arabs, who began to enter the Maghreb region in 703 CE. In 788, Moulay Idris I, the great-grandson of the Prophet Muhammad, fled west from Baghdad and settled in Morocco. The heir to the Umayyad Caliphate in Damascus, Moulay had participated in a revolt against the Abbasid Dynasty and was forced to flee their assassins. Initially establishing himself among the ruins of the Roman shrine city of Volubilis, Moulay soon founded the town of Zerhoun, now the most venerated Islamic pilgrimage site in Morocco. The local Berber tribes, neophytes of Islam, were convinced of Moulay's power to lead as both king and Imam, and his exemplary conduct soon ensured his rule over many of the tribes.

The growing power of Moulay Idris I troubled the reigning Abbasid caliph, who sent an assassin to poison him in 791. Two months after Idris's death, a son was born to one of his concubines, and this child, Idris II, grew to be an extraordinary man who displayed astonishing memory, great intelligence, and immense physical strength. In the year 809, Idris II refounded the city of Fez on the left bank of the river Fez, directly opposite the right-bank site where his father had established the city twenty years earlier. Until he died in 828, Idris II worked to unify Morocco and establish its firm allegiance to Islam. For the next twelve hundred years, the monarchic tradition established by Idris I and II maintained its hold on Morocco. Throughout the centuries, the mausoleums of Moulay Idris I in Zerhoun and Moulay Idris II in Fez became the most visited pilgrimage shrines in Morocco.

The courtyard of the *zawiya* (mausoleum) of Moulay Idris I includes the two essential architectural features required in any religious building where Muslims pray: a *mihrab* set into a wall, indicating the direction of Mecca toward which prayers are made; and a fountain where one's hands must be washed prior to prayers. The *zawiya* is one of the most lavishly decorated religious buildings in all of North Africa and represents the great love that Moroccan Muslims had for Idris I.

Zawiya of Moulay Idris II and Kairouyine Mosque

Fez, Morocco

Map site 24

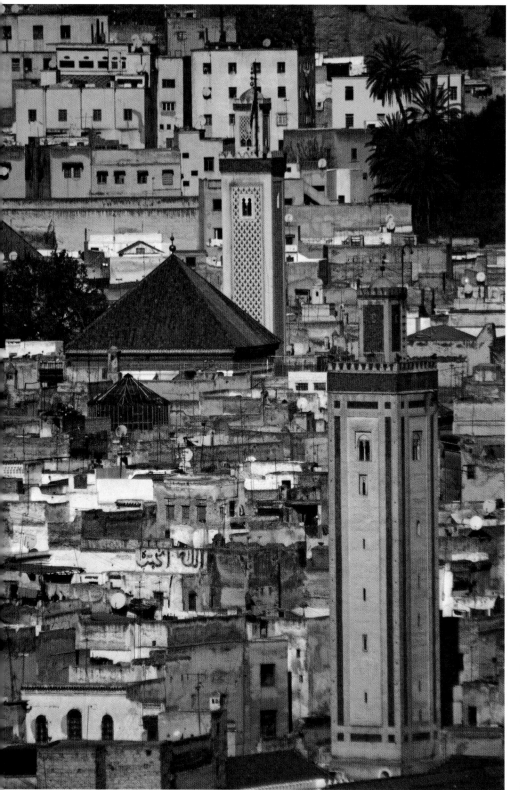

As discussed earlier, the existence of pilgrimage places, other than the holy shrine of the Ka'ba in Mecca, is a controversial subject in Islam. Orthodox Muslims, following the dictates of Muhammad's revelations in the Koran, will state that there can be no pilgrimage site other than Mecca. Likewise, they maintain that the belief in saints is not Koranic. The reality, however, is that saints and pilgrimage places are extremely popular throughout the Islamic world, particularly in Morocco, Tunisia, Iraq, and Shiite Iran. The cult of saints in Morocco and other parts of North Africa, called maraboutism (a marabout is either a saint or his tomb), developed from earlier traditions of Berber paganism and its belief in holy men and women whose *baraka*, or spiritual grace, extended to pilgrims visiting their shrines. The saint may be a figure of historical importance in Moroccan culture (such as Moulay Idris), or a Sufi mystic with sufficient piety or presence to attract a following. After a saint's death, his tomb would be visited by his followers, thus developing into a place of pilgrimage. Dozens of saints from ages past are still revered by Moroccans, and their *musims*, or feast days, are occasions for the gathering of large crowds at the *zawiya*, or mausoleum, of the saint. The two most important *musims* are those of Moulay Idris I in Zerhoun on August 17 and Moulay Idris II in Fez in mid-September.

Deep in the center of the oldest part of Fez, the great Kairouyine Mosque is entirely surrounded by narrow alleyways, clusters of markets, and barracks-like houses. Founded in 859 by Fatima, a woman from the city of Kairouan in Tunisia, the mosque underwent several renovations and additions during the tenth to thirteenth centuries. In addition to its splendid architecture, the Kairouyine Mosque is one of the oldest universities in the world. Among its students were the Jewish philosopher Maimonides, the brilliant Ibn al-Arabi, and the tenth-century Christian pope Silvester II, who encountered there the Arabic numerals and decimal system that he would later introduce to Europe.

The Kairouyine Mosque can be seen in the foreground at right, with the *zawiya* of Moulay Idris II in the background at left. Accommodating as many as twenty-two thousand worshippers, the Kairouyine Mosque is a treasure-house of beautiful and intricate inlaid tile work.

KOUTOUBIA MOSQUE

Marrakech, Morocco

MAP SITE 25

With the fall of the Idrisid Dynasty and the rise of the Almoravids, the seat of Moroccan government moved from the city of Fez south to Marrakech. The great mosque of Marrakech is called the Koutoubia, which derives its name from the *kutubiyin*, or booksellers, who originally clustered about the base of the mosque. Begun around 1150 and completed in 1199, with an impressive minaret soaring to 252 feet (77 m), the mosque can hold more than twenty-five thousand worshippers. Whereas the minarets of Islam's eastern regions are mostly white, built of brick, and covered with tiles, the Koutoubia minaret is made of huge blocks of local ocher-red stone that subtly changes its hue with the movement and angle of the sun.

Persian, Turkish, and Egyptian minarets are usually cylindrical or octagonal, but that of the Koutoubia is square, possibly inspired by the Umayyad minaret in Kairouan, Tunisia.

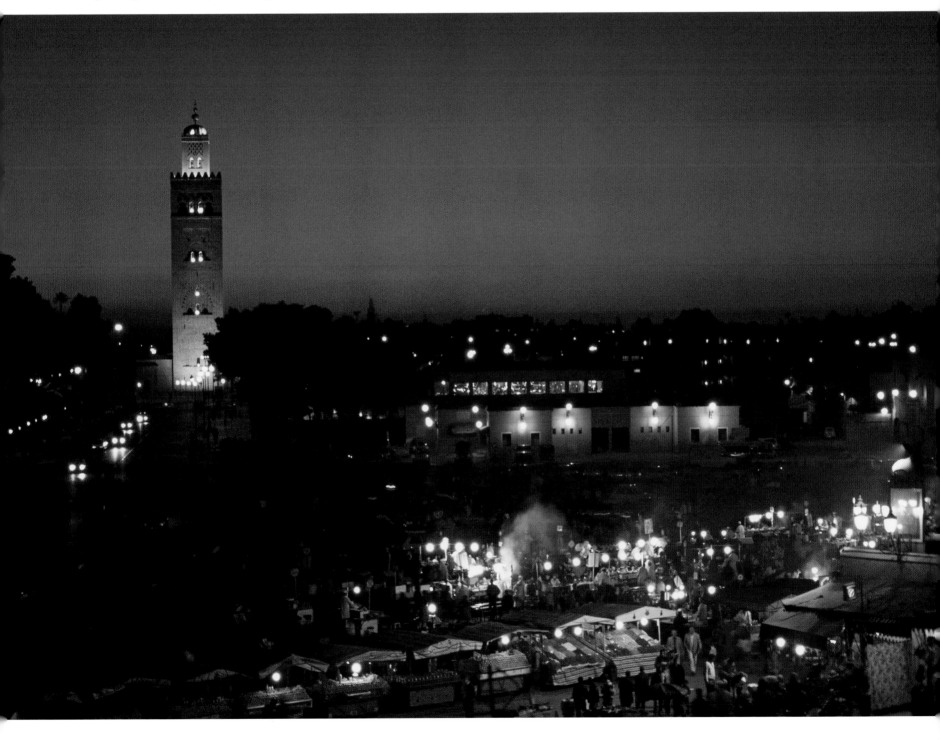

Great Mosque of Djenné

Djenné, Mali

Map site 26

The oldest known city in sub-Saharan Africa, Djenné is 220 miles (354 km) southwest of Timbuktu. Founded by merchants around 800 CE near the site of an older city dating from 250 BCE, Djenné flourished as a trading center between the deserts of Sudan and the tropical forests of Guinea. Controlled by Moroccan kings between 1591 and 1780, Djenné's markets expanded, featuring products from across the vast regions of North and Central Africa. In 1893 the city was occupied by the French, and its commercial functions were taken over by the town of Mopti.

In addition to its commercial importance, Djenné was also a center of Islamic learning and pilgrimage, attracting students and pilgrims from all over West Africa. The Great Mosque dominates the large market square of Djenné. Local legends tell that the first mosque was built in 1240 by the sultan Koi Kunboro, who converted to Islam and turned his palace into a mosque. The present mosque, begun in 1906 and completed in 1907, is built on a platform of sun-dried mud bricks and constructed entirely from mud and palm wood. Djenné's masons have integrated wood scaffolding into the building's construction, not as beams but as supports for the workers who apply plaster during the annual spring festival to replaster the mosque. Many of the citizens of Djenné work for weeks to prepare a mixture of mud and rice husks for this festive community event. The mosque's three towers are each topped with a spire capped by an ostrich egg, which symbolizes fertility and purity.

Although the Great Mosque incorporates architectural elements found in mosques throughout the Islamic world, it reflects the aesthetics and materials used for centuries by the people of Djenné. The use of local materials such as mud and palm wood, the incorporation of traditional architectural styles, and the structure's adaptation to the hot climate of West Africa are expressions of its elegant connection to the local environment.

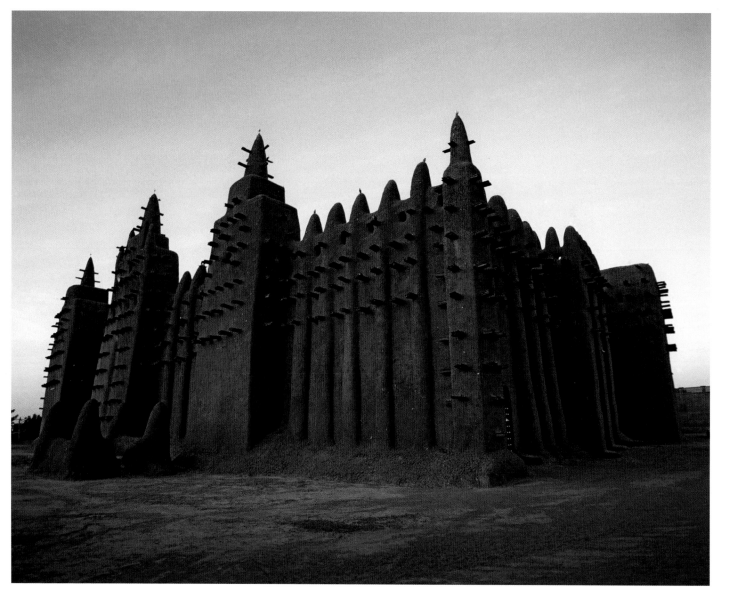

DOGON BINU SHRINES

Bandiagara Region, Mali

MAP SITE 27

Scattered across the cliffs of the Bandiagara region of Mali are hundreds of small Dogon villages. The origins of the Dogon are lost in the mists of time–their earlier name, Habe, means "stranger" or "pagan." Scholars believe the tribe to be of ancient Egyptian descent. Leaving their ancestral homelands, they wandered through Central Africa until the late fifteenth century, when they migrated to the cliffs of Bandiagara. But long before the Dogon arrived, these cliffs were used by other people—the Toloy of the third to second centuries BCE and the Tellem of the eleventh to fifteenth centuries CE.

Dogon religion is concerned with the ancestors and the spirits that the tribe encountered as it migrated from its obscure ancestral homelands. There are three principal cults among the Dogon: the Awa, the Lebe, and the Binu. The Awa is a cult of the dead. The earth god, Lebe, is concerned with the agricultural cycle. The Binu is a totemic practice dealing with Dogon sacred places used for ancestor worship, spirit communication, and agricultural rituals.

Binu shrines house the spirits of mythic ancestors who lived in the legendary era before the appearance of death among mankind. Binu spirits often make themselves known to their descendants in the form of an animal who interceded on behalf of the clan during its founding or migration, thus becoming the clan's totem.

In the late 1940s, Dogon priests surprised anthropologists by telling them secret Dogon myths about the star Sirius (8.6 light-years from earth). The priests said that Sirius had a companion star. The remarkable thing is that the companion star, Sirius B, which is invisible to the human eye, was discovered by European astronomers only in 1862 and wasn't photographed until 1970. The Dogon beliefs, on the other hand, are thousands of years old. In addition to their knowledge of the Sirius group, Dogon mythology includes Saturn's rings and Jupiter's four major moons. The Dogon have four calendars—for the sun, the moon, Sirius, and Venus—and have long known that planets orbit the sun.

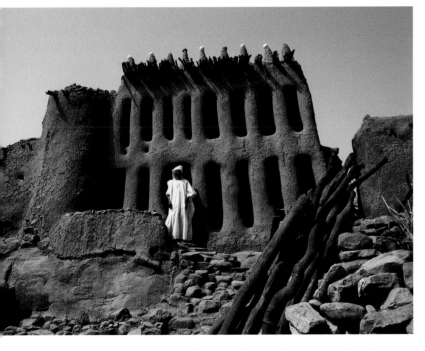

Ostrich eggs atop the roof spires of a Binu shrine at Arou-by-Ibi symbolize fertility and purity. The facades of the shrines are often painted with graphic signs and mystic symbols.

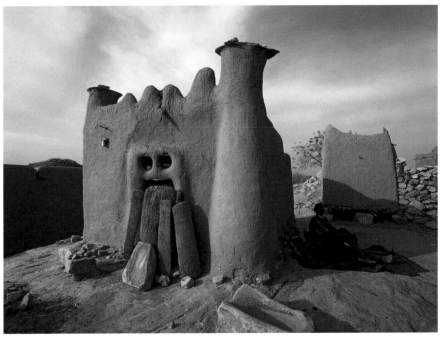

A Binu shrine near the Bandiagara escarpment. The priests of each Binu shrine maintain the sanctuaries. The Dogon believe that the benevolent forces of the ancestors are transmitted to them through their rituals.

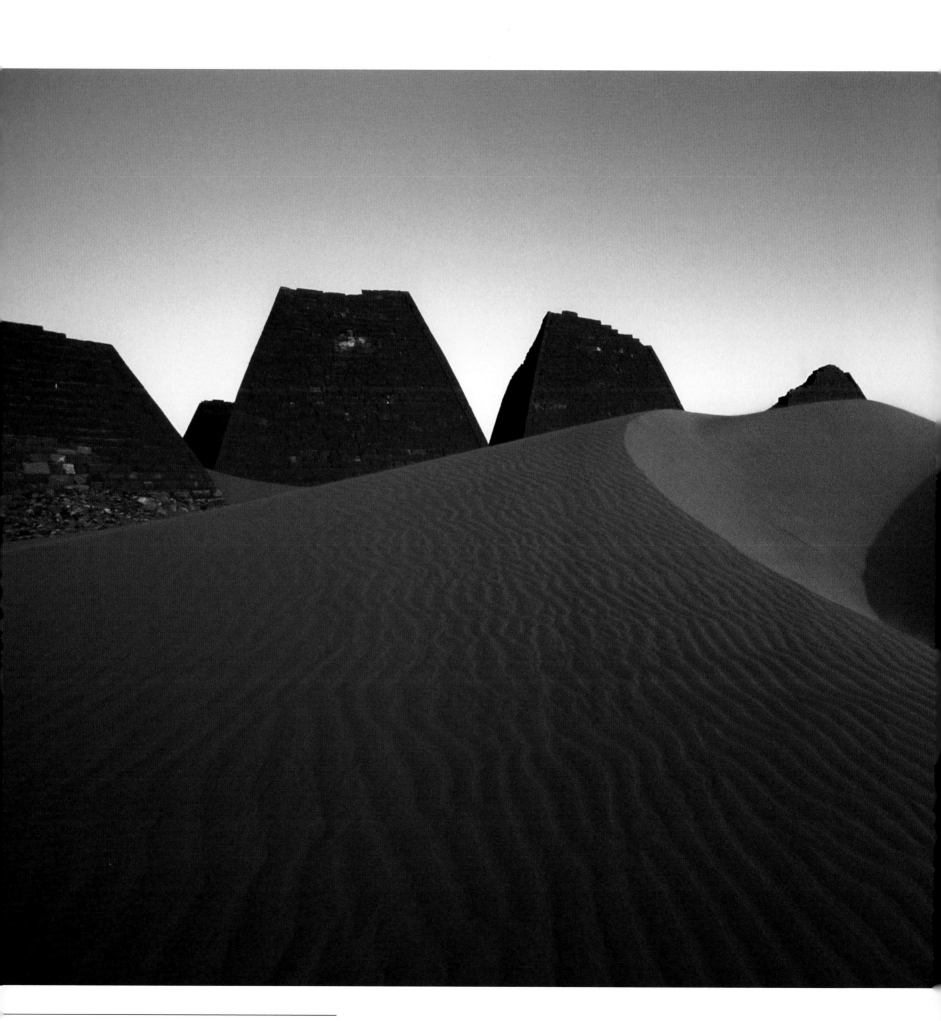

SACRED EARTH

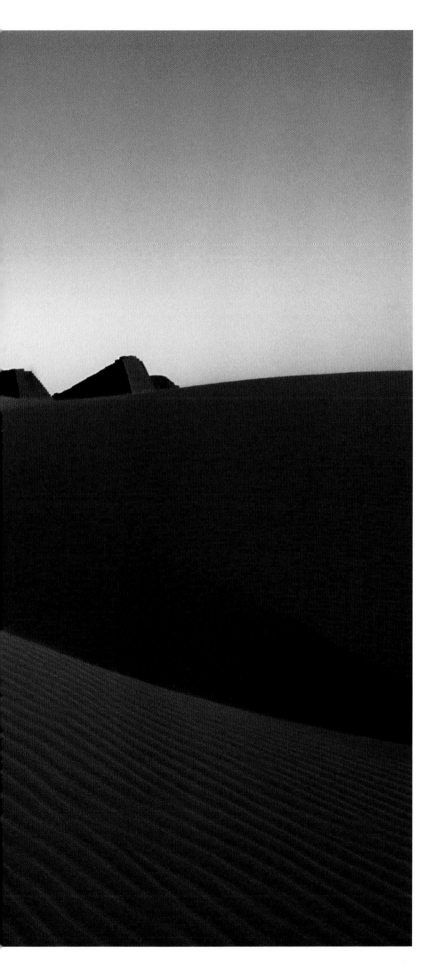

Pyramids of Meroë

Nile Province, Sudan
Map site 28

In approximately 1000 BCE, following the collapse of Egypt's Twenty-fourth Dynasty, the Nubian kingdom of Kush arose as the leading power in the region of the Middle Nile. By the first century BCE the Nubians had stopped writing in Egyptian and had begun using their own (currently undeciphered) script. Because of this, our historical knowledge of their civilization is based on archaeological findings and surviving Greek and Roman reports.

During the seventh century BCE the Kushite kings ruled much of Egypt. Around 300 BCE their capital and royal burial ground moved south from Napata to Meroë, located between the Fifth and Sixth Cataracts of the Nile. At the height of its power in the second and third centuries BCE, Meroë extended over a region from the Third Cataract in the north to Meroë, near present-day Khartoum. The rulers of Meroë were contemporaries of the Ptolemies of Egypt and the Romans, yet relations between them were not always peaceful. In 23 BCE, in response to Meroë's military advance into Egypt, a Roman army destroyed Napata, the religious center of the Kushite kingdom.

The major god of the Kushite religion was a divinity of regional origin. Known as Apedemak, and possibly having the lion form of the Egyptian god Amun, he was sometimes associated with the moon and also portrayed as an armored lion-headed man seated on an elephant or a throne while holding weapons and prisoners or lions and elephants.

The most visible remains at Meroë are its pyramids, which contained the tombs of more than forty kings, queens, and other important individuals. While these royal tombs were all plundered in ancient times, frescoes preserved in the tombs show that the rulers were either burned or mummified, then covered with jewelry and laid in wooden cases. Additional damage was done to the pyramids by the nineteenth-century Italian explorer Giuseppe Ferlini, who demolished the tops of more than forty pyramids in his search for treasures. Today, Meroë is a World Heritage site and the largest archaeological site in the Sudan. Situated about half a mile (805 m) from the Nile, the ruins extend over a square mile (2.6 sq km) in area.

The tomb pyramids of Meroë rise dramatically above the dunes of the Sudan. The tombs were once filled with the treasures of the kings and queens who were buried there.

SACRED SITES OF
ASIA
AND
THE
PACIFIC

Photograph of an Epiphany

In 1985, I was riding a bicycle through the mountains of Japan, from the north to the south, and visiting and photographing nearly fifty pilgrimage sites of Shintoism and Buddhism.

Months into the journey, I sailed across the Sea of Japan to South Korea and visited more holy places there. On a small island in the Korea Strait known as Jeju-do, I was cycling for a few days and was planning to climb the sacred mountain of Halla-san. In olden times the forests of Halla-san were known as the Yonghsil, or Enchanted Place Wilderness, which was considered to be the ritual gateway to the sacred peak. Also called Mountain of the Blessed Isle, Halla-san was believed by the ancient Chinese to form a sort of bridge between heaven and earth. In the middle of the volcanic crater atop Halla-san lies a small lake called Paengnoktam, or White Deer Lake. Legends mention this lake as the abode of angelic presences. The words *angelic presences* are not often found in Buddhism. These words indicated something that was pre-Buddhist, and I very much wanted to experience whatever it was.

In November of that year, I climbed Halla-san during a blizzard but was not able to reach the lake. Descending the mountain, I had a most incredible experience. Walking through the pine forests of the mountain's lower slopes, I began to feel a definite presence around me. Many times I stopped and looked around, expecting to see someone peering at me from behind a tree. While I did not see anything, the feeling of a presence increased until I felt I was completely surrounded by—I have no other appropriate words for this unique sensation—a bunch of hidden dwarfs or fairies. The feeling was angelic and extraordinarily peaceful. There does indeed seem to be a power or energy field surrounding Halla-san that may have given rise to the legend of angelic presences.

Farther down the mountain, near the southwest coast, is the cave temple of Sanbangsa, once a pagan shrine and now a Buddhist sanctuary. Inside the cave is a pool of water formed by drops falling from the ceiling. Various legends are told about this place. The water is believed to have a healing and prayer-granting power. Near the cave is a temple containing hundreds of old Buddha statues, which were brought by pilgrims to Jeju-do from many parts of Southeast Asia during the past thousand years.

The story of how the photograph on pages 198–199 was made is quite remarkable. The day before I arrived (when I had climbed Halla-san in a violent snowstorm), a lightning bolt had broken through the roof of the room containing the Buddha statues. The next morning, two craftsmen were repairing the damaged roof when I entered the shrine room. A radiant beam of dazzling white sunlight shone through the hole, directly illuminating one of the Buddha statues. The moment was an epiphany, and I realized that the picture being presented to me was a unique event. Such a beam of brilliant light had never before shone into the room and, within only minutes more of roof repair, would never again. With no time to set up a tripod, I used my trusty Nikon F3 with a 300 mm lens and took a light reading. Even at the widest lens aperture (f4.5), an exposure of one full second was needed. Professional photographers know it is virtually impossible to handhold a heavy 300 mm lens for a one-second exposure and not have a blurred image. But you can see that somehow, magically, it worked. It is one of my very favorite photographs from all my travels, and I like to think of it as a gift from the angelic spirits of sacred Halla-san.

Bagan temple complex, Bagan, Myanmar.

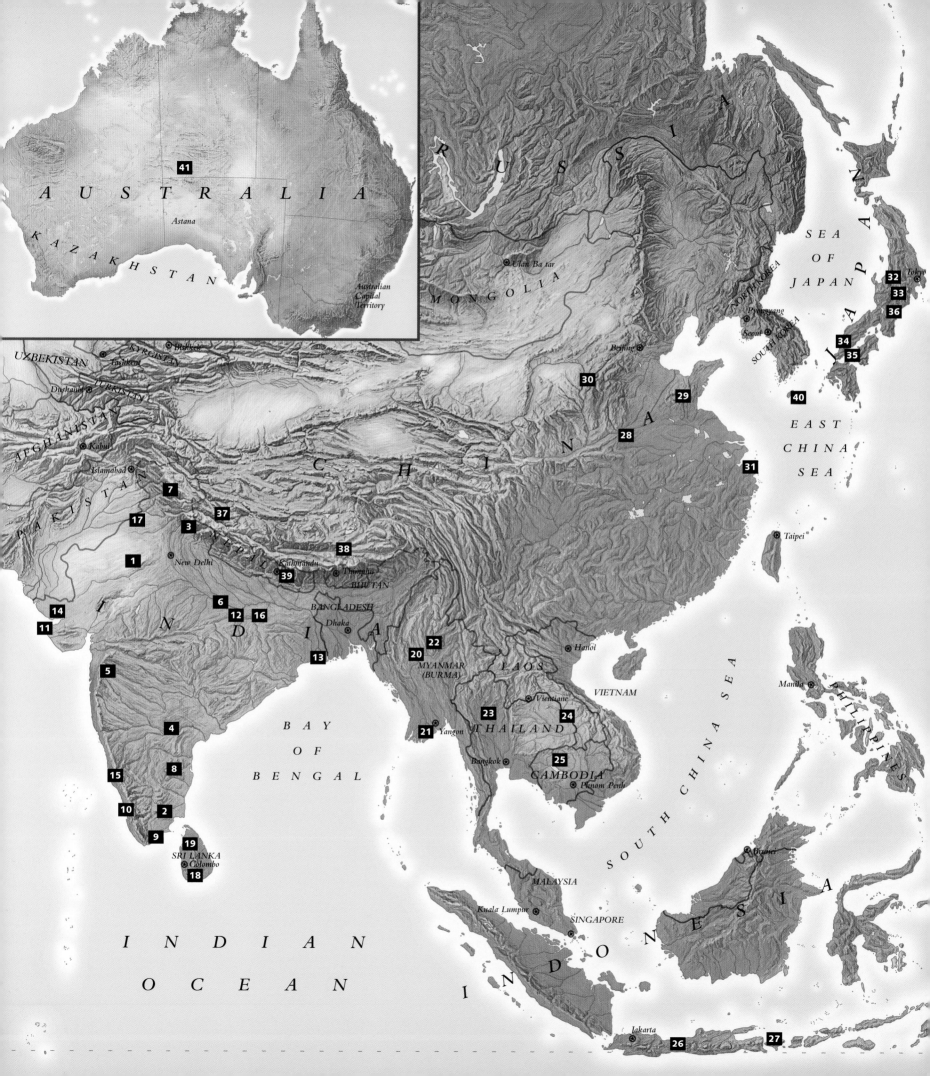

PACIFIC OCEAN

Sacred Sites of Asia and the Pacific

1. Pushkar, India

2. Tiruchchirappalli, India

3. Badrinath, India

4. Andhra Pradesh, India

5. Ellora, Maharashtra State, India

6. Varanasi, India

7. Hardwar, Uttar Pradesh, India

8. Tiruvanamalai, Tamil Nadu, India

9. Rameswaram, Tamil Nadu, India

10. Kerala, India

11. Dwarka, India

12. Allahabad, India

13. Calcutta, India

14. Palitana, Gujarat, India

15. Karnataka, India

16. Bodh Gaya, Bihar State, India

17. Amritsar, India

18. Adam's Peak, Sabaragamuwa Province, Sri Lanka

19. Mt. Mihintale, Sri Lanka

20. Bagan, Myanmar

21. Yangon, Myanmar

22. Mandalay, Myanmar

23. Phitsanulok, Thailand

24. That Phanom, Thailand

25. Angkor, Cambodia

26. Yogyakarta, Java, Indonesia

27. Mt. Agung, Central Bali

28. Hua Shan, Shaanxi Province, China

29. Tai Shan, Shandong Province, China

30. Wu Tai Shan, Shaanxi Province

31. Putuo Shan, Zhejiang Province, China

32. Honshu, Japan

33. Fuji-san, Shizuoka and Yamanashi Prefectures, Japan

34. Taisha, Japan

35. Miyajima Island, Hatsukaichi, Japan

36. Kyoto, Japan

37. Mt. Kailash, Kailash Range, Southwestern Tibet

38. Lhasa, Tibet

39. Kathmandu, Nepal

40. Jeju-do, South Korea

41. Uluru–Kata Tjuta National Park, Australia

HOLY HINDU PILGRIMAGE SITES

Pushkar, India
MAP SITE 1

The description of pilgrimage places in India's great epic, the Mahabharata, suggests a grand tour of the entire country. The pilgrimage begins in Pushkar, sacred to the god Brahma, and rambles through the subcontinent to end in Prayaga (modern-day Allahabad). As shown by the position of Pushkar as the starting point of the pilgrimage, the worship of Brahma was considered highly important at the end of the first millennium BCE. In historical times, the cult of Brahma was eclipsed by other deities. Pushkar is one of four pilgrimage shrine dedicated to Brahma in all of India, and fewer pilgrims visit the shrine relative to the great numbers at such celebrated sites as Varanasi, Tirupati, Chidambaram, and Rameswaram. It has been suggested that this waning of importance may be because the function of Brahma—creating the world—has been completed, while Vishnu (the preserver) and Shiva (the destroyer) still have relevance to the continuing order of the universe.

Mythological literature describes Brahma as having sprung from a lotus originating in the navel of Vishnu. Brahma then became the source of creation, the seed from which issued space, time, and causation. He is the inventor of theatrical art, and he revealed music and dance. He is sometimes depicted with four heads, representing the four Vedas and the four Yugas (great epochs of time), and at other times is depicted as Vishvakarma, the divine architect of the universe. His wife, Saraswati, was manifested out of him, and from their union were born all the creatures of the world. She is considered the personification of all knowledge—arts, sciences, crafts, and skills. She is the goddess of the creative impulse, the source of music, beauty, and eloquence. Artists, writers, and other individuals involved in creative endeavors have for millennia come on pilgrimage to Pushkar to request the inspiration of Brahma and Saraswati. According to the theory that shrine myths are often metaphorical expressions of the specific power of a pilgrimage place, the lake, hill, and area of Pushkar have a spirit or presence that awakens and stimulates human creativity.

There are five principal temples in Pushkar, all of relatively recent construction, since the earlier buildings were destroyed by the Mughal emperor Aurangzeb in the late seventeenth century.

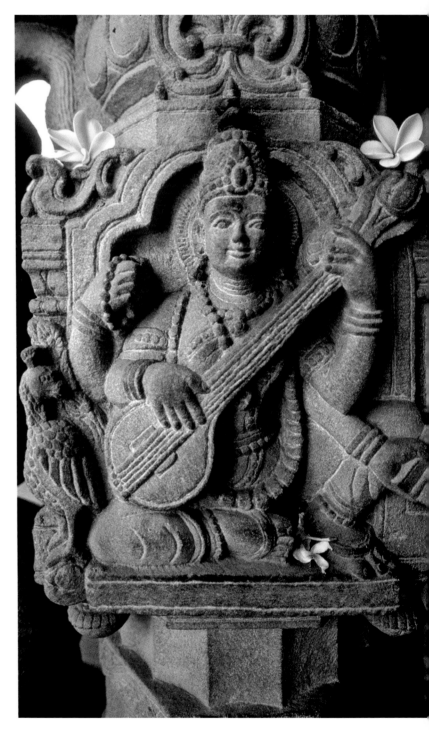

A stone carving of Saraswati at the Srisailam Temple of Andhra Pradesh. Saraswati holds a lutelike object that is probably a tamboura, an ancient Indian stringed instrument.

The sacred lake and pilgrimage Temple of **Brahma** in Pushkar is surrounded by numerous bathing areas, known as ghats, and pilgrims immerse themselves in the holy waters for a cleansing of both body and soul. During most of the year, Pushkar is a quiet town. Each November, however, more than 200,000 people arrive with 50,000 cattle for several days of pilgrimage, horse dealing, camel racing, and colorful festivities.

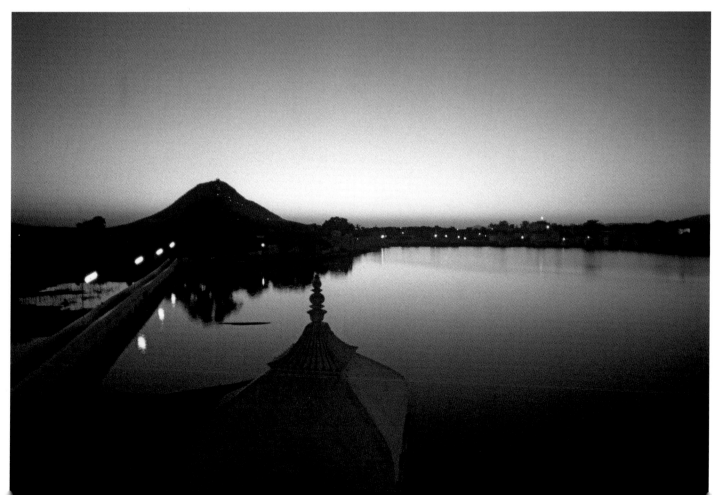

The hill of the goddess Saraswati, whose name means the "flowing one," stands out against the Pushkar sunset. In the *Rig Veda*, she represents a river deity and is connected with music, eloquence, and art.

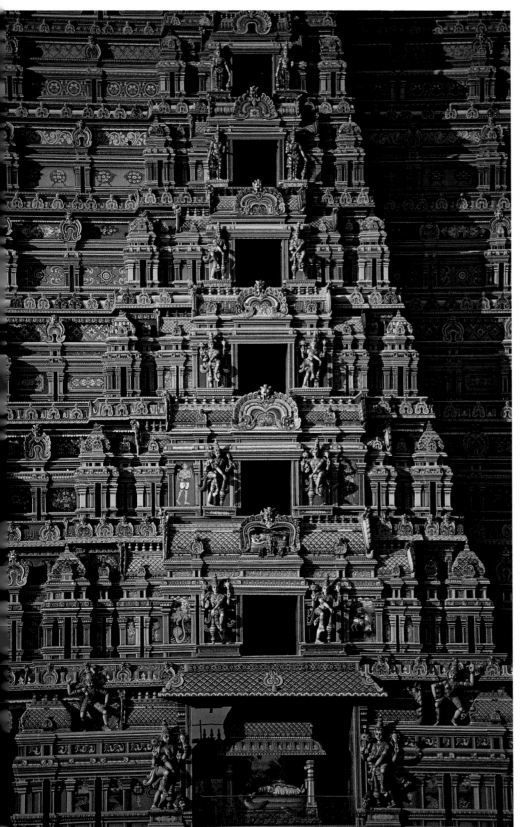

VISHNU TEMPLE COMPLEX OF SRIRANGAM

Tiruchchirappalli, India

MAP SITE 2

In the city of Tiruchchirappalli in Tamil Nadu State, on a small island between the branches of two rivers, stands the massive temple of Srirangam. The most revered of the 108 pilgrimage shrines of Vishnu and the largest temple complex in all of India, it is surrounded by seven concentric walls and twenty-one towers called *gopurams*. Srirangam enshrines a statue of Vishnu reclining on a great serpent. A legend tells that this idol, known as Sri Ranganatha, was being transported across India to Sri Lanka by the sage Vibhisana. Resting from his efforts, he set the statue upon the ground, but when he was ready to continue his journey, he found that the statue had magically bound itself to the earth. A hundred hands could not move the idol, and a small temple was built over it. The temple complex that has since grown around the statue has been rebuilt and enlarged many times over thousands of years, and its original date of founding is unknown to archaeology.

Vishnu, the second deity of the trinity of Hindu gods, is responsible for the protection and maintenance of the created universe. A gentle, loving god representing the heart, he is the focus of devotional worship by a large percentage of the Indian population. To ward off the extraordinary perils that threaten creation, Vishnu frequently incarnates himself. He has appeared as Rama, Krishna, the Buddha, and other incarnations. The Naanmugan Gopuram, shown in the photograph, is thirteen stories tall and covered with intricately carved, brightly painted statues of the many incarnations of Vishnu. More than being simply an extraordinary expression of art, these sculptures function as three-dimensional storybooks of Hindu mythology.

Most of the Srirangam temple complex standing today, including a grand hall of one thousand beautifully sculptured pillars, was constructed between the fourteenth and seventeenth centuries.

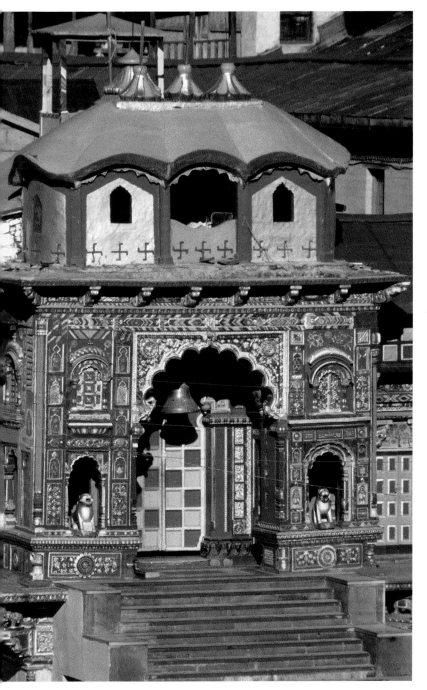

TEMPLE OF VISHNU

Badrinath, India

MAP SITE 3

There are several ways in which pilgrimage sites are categorized in Hinduism. One of these concerns the four Dhamas, or Four Divine Abodes of the gods at the four compass points of India. While no specific legend explains the grouping of these four sites together, they were each highly regarded by the time of the Mahabharata in 500 BCE. The four Dhamas are the Krishna Temple of Jagannath in Puri, Orissa; the Vishnu Temple in Badrinath, Uttar Pradesh; the Shiva Temple of Rameswaram in Tamil Nadu; and the Krishna Temple of Dwarka in Gujarat.

The temple of Badrinath, perched above a headstream of the Ganges in the Himalayan Mountains, is at 10,248 feet (3,124 m). Because of the extreme cold of the high mountain winter, the shrine is open only in the summer months. With the first snowfalls, the sacred statue of Vishnu is covered in a woolen blanket, the temple is closed and locked, and the priests move down the mountain to the town of Joshimath for the winter. Adjacent to the shrine is the hot spring pool of Taptakund, in which pilgrims take a dip before worshipping Sri Badrinatha.

Badrinath has been a well-known pilgrimage site for more than two thousand years, and Buddhist architectural influence in the shrine indicates that Badrinath has also been venerated by Buddhists since early times.

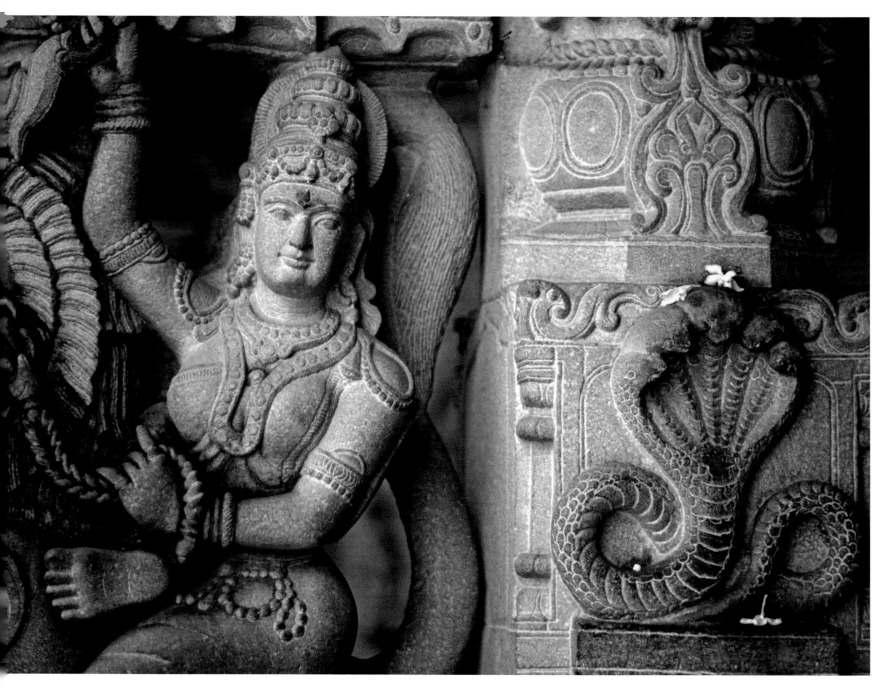

SRISAILAM TEMPLE

Andhra Pradesh, India

MAP SITE 4

A stone carving of the goddess Shakti and the serpent form of Shiva adorn the Srisailam temple complex.

Located on Rishabhagiri Hill on the bank of the sacred river Krishna is the exotic Temple of Srisailam. The temple complex, whose existing buildings date from the second century CE, is one of the twelve Jyotir Linga Shiva shrines. (Among India's most ancient temple sites, the Jyotir Lingas are worshipped as containing the creative power of Shiva.) Srisailam is also one of the eighteen most sacred goddess shrines, or Shakti Pithas. This unique combination of major god and goddess shrines at the same site makes Srisailam

one of India's most holy sites. Shiva is worshipped here in his form of Lord Mallikarjuna, and Shakti, his consort, as Sri Bharamaramba Devi. The images of these deities, both extremely old, are enshrined in the more recent temple built by the Vijayanager king Harihara Raya around 1404 CE. The temple, whose popular name is Sriparvata, is decorated with fine relief carvings depicting scenes from Hindu mythology. The sages Chaitanya and Sankaracharya both visited Srisailam.

ELLORA CAVE TEMPLES

Maharashtra State, India

MAP SITE 5

The complex of thirty-four temples at Ellora in the state of Maharashtra represents the greatest example of cave-cut architecture in the world. Built during the Gupta Period of the sixth to eighth centuries CE, the caves were constructed by carving into a mountainside and removing thousands of tons of rock, leaving only the temple structures behind. At Ellora, there are twelve Buddhist, seventeen Hindu, and five Jain temples. The construction and use of these temples by three different religions is a wonderful indication of the extraordinary spiritual maturity of ancient India.

In the cave temple of Sita-ki-Nahani (cave twenty-nine), Shiva is depicted killing the blind demon Andhakasura.

Although showing significant motion, this particular Shiva form is not a representation of dancing. During his divine dancing, Shiva never has fangs or a fearsome expression, but displays a radiant calm. Mythologically, Shiva is regarded as the great master of dance, and all 108 modes of dance came from him. Shiva's dancing manifests the Panchakryta, or five acts of God: creation, preservation, destruction, embodiment, and release. It is said that he dances every evening to relieve the suffering of creatures and entertain the gods and goddesses who gather upon Mt. Kailash in Tibet. Shiva is believed to have manifested in the Nataraja dancing form at the celebrated pilgrimage shrine of Chidambaram in the state of Tamil Nadu.

In cave twenty-nine at Ellora, a relief carving shows Shiva slaying the demon Andhakasura, who had lusted after Shiva's wife, Parvati. The goddess Kali crouches below to catch the demon's blood in a bowl.

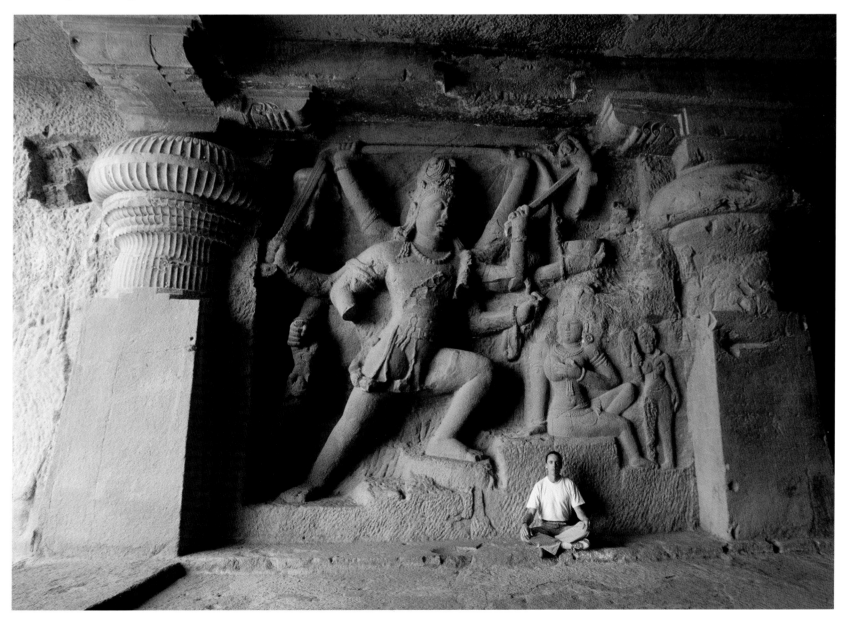

River Ganges and Holy City of Varanasi

Varanasi, India

Map site 6

Varanasi, the most visited pilgrimage destination in India, is one of seven sacred cities, one of twelve Jyotir Linga sites, and a Shakti Pitha (goddess) site. Myths and hymns speak of the waters of the Ganges as the fluid medium of Shiva's divine essence, and a bath in the river is believed to wash away all of one's sins. Known in different eras as Benares and Kashi (and sometimes called Banaras today), this great center of Shiva worship has had more than three thousand years of continuous habitation. The city's primary Shiva shrines, the Jyotir Linga Vishwanatha, or Golden Temple, and the Jnana Vapi, or Well of Wisdom, are the ritual center of Varanasi.

In Varanasi, it is said there are millions of shrines and deities. Since a pilgrim would need a lifetime to visit each of these shrines, it is considered wise to come to the holy city and never leave. Varanasi is traditionally called Mahashamshana, the "great cremation ground." Hindus believe that cremation at the holy city insures *moksha*, or final liberation of the soul from the endless cycle of birth, death, and rebirth. Encircling the holy city at a radius of five miles (8 km) is the sacred path known as the Panchakroshi Parikrama. Pilgrims take five days to circumambulate Varanasi on this fifty-mile (80 km) path, visiting 108 shrines along the way. This is a favored hermitage site for many of India's most venerated sages. Buddha, Mahavira, Kabir, Tulsi Das, Shankaracharaya, and Patanjali all meditated here.

Today a crowded and noisy city, Varanasi was in antiquity an area of rolling hills, lush forests, and natural springs bordered by the magical waters of the river Ganges. Here, the city and river are shrouded by early morning fog.

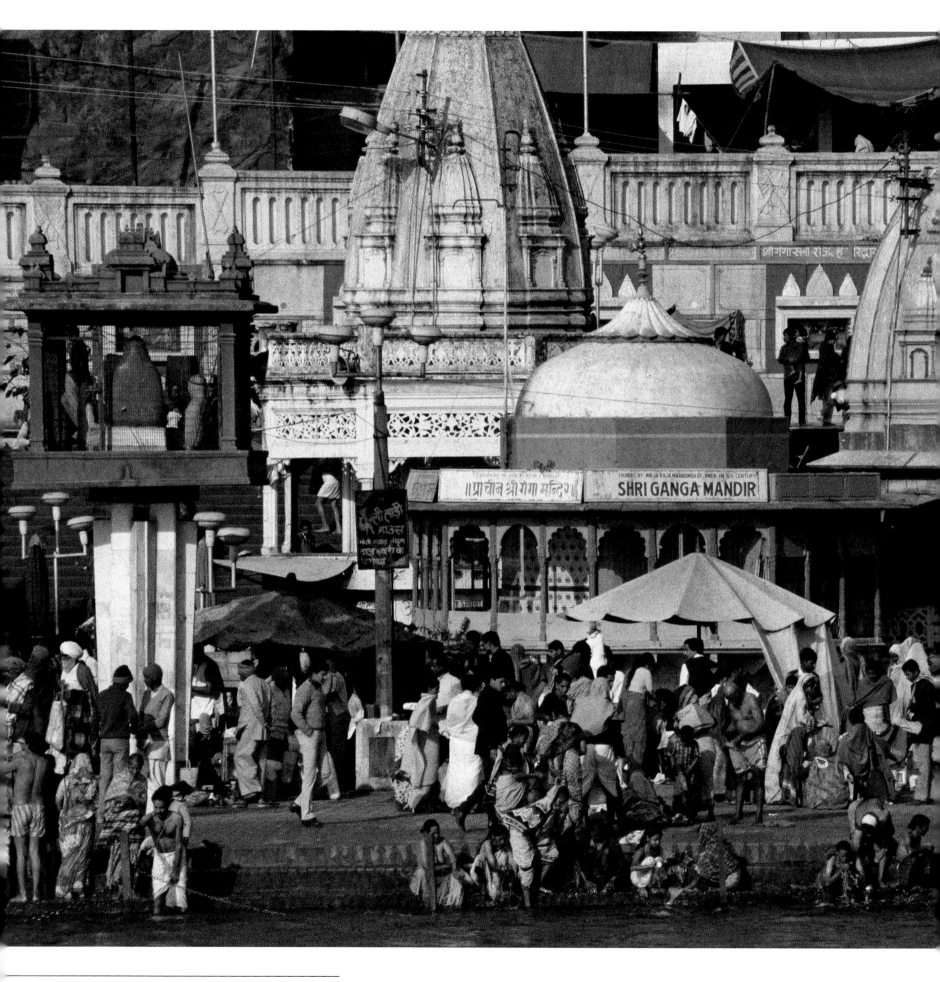

SACRED EARTH

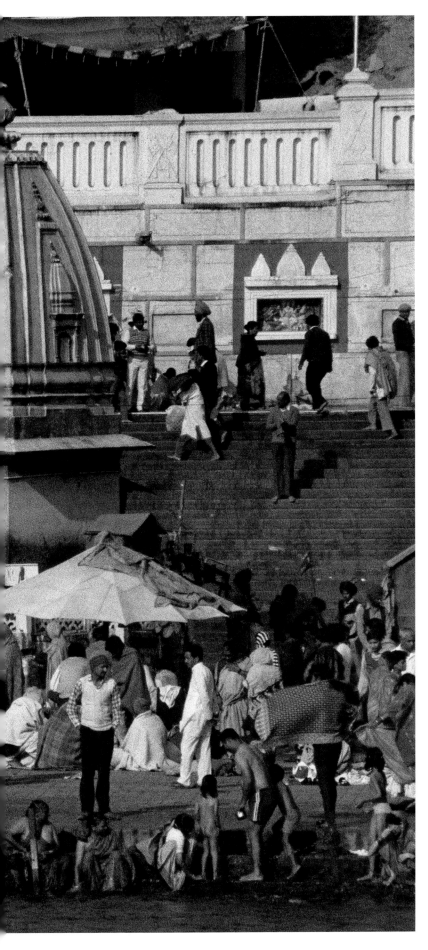

Hardwar

Uttar Pradesh, India

Map site 7

Hardwar (also known as Haridwar) is one of the holiest places for Hindus in India. It is significant that pilgrims often go from Hardwar to the two great Himalayan shrines of Kedarnath and Badrinath, as *Har* means Shiva (the deity of Kedarnath), *Hari* means Vishnu (the deity of Badrinath), and *Dwar* means gate. Hardwar is thus the gateway to the two holy shrines of Shiva and Vishnu. The town has also been called Gangadvar, meaning Door of the Ganga, as it is here that the sacred river Ganges leaves the mountains to flow out upon the Indian plains. Throughout the year large numbers of pilgrims come to bathe in the Ganges, especially at the Hari-ka-charan ghat, where they worship a footprint of Vishnu.

A large pilgrimage festival is held every year in April at the beginning of the Hindu solar year. Every twelve years, the great festival of Kumbha Mela is held, and every six years an Ardh Kumbha, or half of Kumbha. During these important festivals, millions of pilgrims throng to Hardwar from all parts of India. Fifteen miles (24 km) north of Hardwar is another holy town named Rishikesh, meaning Abode of the Mystic Sages. These two places, Hardwar and Rishikesh, have names that indicate their spiritual rather than secular attributes. Nowadays both towns are bustling social centers, yet in ancient times they were quiet forest groves, nestled along a rushing mountain river—the perfect places for contemplation and a life in harmony with the ways of nature.

Hardwar is one of India's Moksapuris, or seven sacred cities, where *moksha*, or spiritual liberation, may be attained.

ARUNACHALESWARA TEMPLE

Tiruvannamalai, Tamil Nadu, India

MAP SITE 8

The tallest *gopuram* at Arunachaleswara Temple is more than 197 feet (60 m) tall, or thirteen stories high. The central temple enshrines images of Shiva as Lord Annamalai and his consort as Unnamalai.

There are three categories of Shiva Lingam sites in India: the Jyotir Lingas, the Swayambhu Lingas, and the Bhuta Lingas. Located in five southern Indian temples, the Bhuta Lingas are places where Shiva manifested himself as the natural elements. The temples and their respective elements are Chidambaram (ether), Sri Kalahasti (wind), Tiruvanaikka (water), Kanchipuram (earth), and Tiruvannamalai (fire).

The Shiva Temple in Tiruvannamalai, its founding date unknown, is situated at the foot of Arunachala Hill. Sprawling over twenty-five acres (10 hectares), the complex grew over millennia; the large towers, or *gopurams*, were erected between the tenth and

sixteenth centuries. Every year during the Hindu month of Kartikai, from November to December, the great Deepam festival is held to celebrate Shiva's manifestation as the light of Arunachala. For ten days the city of Tiruvannamalai is alive with celebration, processions, dancing, and singing. On the final day of the festival, the eve of the full moon, a huge beacon fire is ignited atop the hill in commemoration of the fire left by Shiva. Arunachala Hill is considered a miraculous healing place, especially for addressing ailments of the lungs and female infertility. Arunachala Hill is also a symbol of spiritual knowledge, and several great sages have lived here, including Sri Ramana Maharshi (1879–1950).

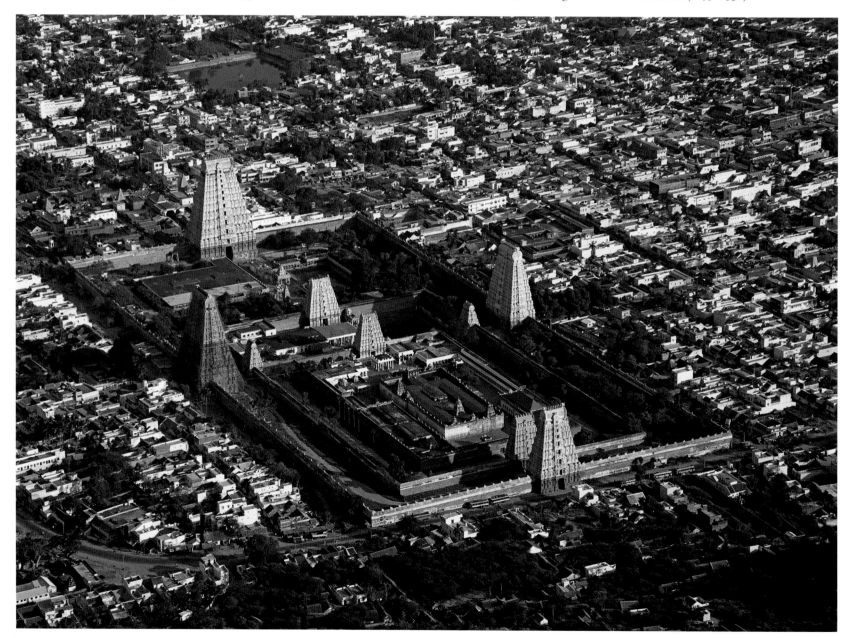

Rameswaram Temple

Tamil Nadu, India

Map site 9

The temple at Rameswaram, in addition to being one of the four holy Dhama sites, is also one of the twelve sacred Jyotir Lingas. Unique among the twelve Jyotir Lingas, Rameswaram has two sacred lingams, or symbolic objects of worship: one of stone brought by the deity Hanuman from Mt. Kailash, and the other of sand fashioned by Sita, the wife of Rama.

The enormous temple of the two Shiva Lingams lies near the seashore at the tip of India. Besides the one-hundred-foot-tall (30 m) *gopuram* towers shown in the photograph, the temple is renowned for its magnificent corridors with massive stone pillars.

Decorating the sides of the towers and throughout the interior of the temple are thousands of exquisite sculptures depicting mythic events from the Ramayana, a great Indian epic. There are also twenty-two sacred bathing pools within the temple complex. Fully clothed pilgrims will immerse themselves in each of these pools— known for their miraculous healing cures—before praying at the two Shiva Lingams. More than ten thousand pilgrims pass through the temple each day, making Rameswaram one of the most visited and vital sacred sites in all of Asia.

Perhaps the finest example of Dravidian architecture in southern India, the present Rameswaram Temple dates from the twelfth century and is the composite work of several different kings.

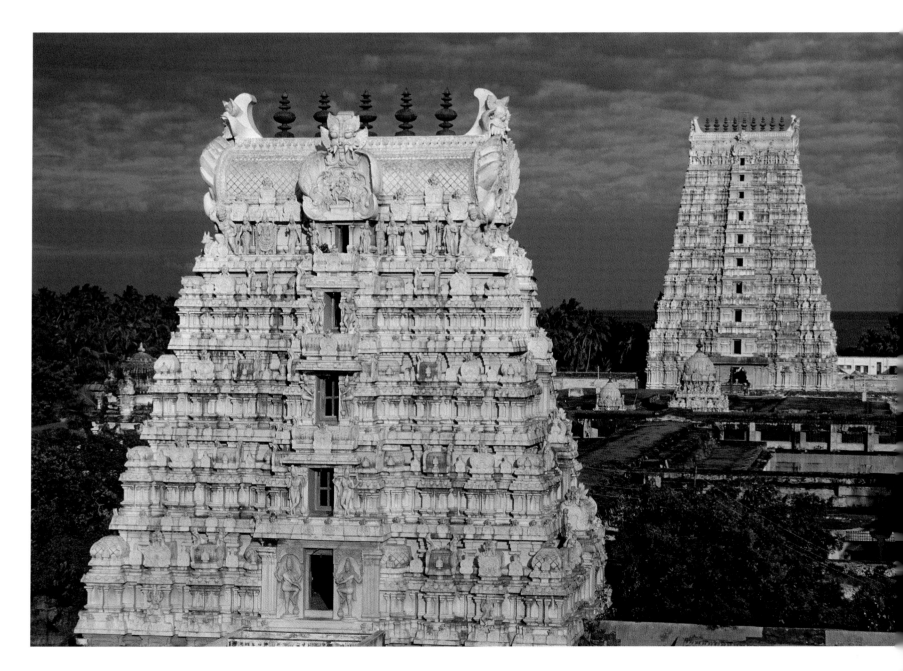

SHRINE OF SABARIMALA

Kerala, India
MAP 10

The shrine of Sabarimala is one of the more remote shrines in southern India, yet it still draws three to four million pilgrims each year. Before beginning the multiday walk through the mountain jungles to get to Sabarimala, pilgrims prepare themselves with weeks of fasting, celibacy, meditation, and prayer. When they finally arrive at the shrine, the pilgrims wait in line for hours, even days, to have a few seconds in front of the golden statue of Ayyappan, the resident deity of the site. After seeing the deity, many pilgrims will complete a vow called Shayana Pradakshinam. In the Malayalam language of Kerala, *shayana* means "body" and *pradakshinam* means "revolution," so Shayana Pradakshinam means "revolution with the body."

The Sabarimala shrine is open only a few times each year: for forty-one days during a festival in November and December; for another festival in January; on the day of the vernal equinox in April; and during smaller festivals in May and August. The shrine, unlike many in southern India, is open to persons of all religious callings, and there are no caste restrictions during the pilgrimage. However, women—unless they are younger than six or older than sixty—are not allowed to come to Sabarimala. This is explained by referring to the celibacy of Ayyappan and the concern that he might be lured away from his shrine by a woman his age. Ayyappan, one of the most fascinating of Hindu deities, is said to be the son of both Shiva and Vishnu, who had appeared as a woman to seduce a local demon. Mystics living in the deep forests surrounding the Sabarimala Mountains have for a thousand years reported seeing Ayyappan riding through the jungles upon a majestic tiger.

Pilgrims perform the Shayana Pradakshinam devotional practice at the Sabarimala shrine in Kerala.

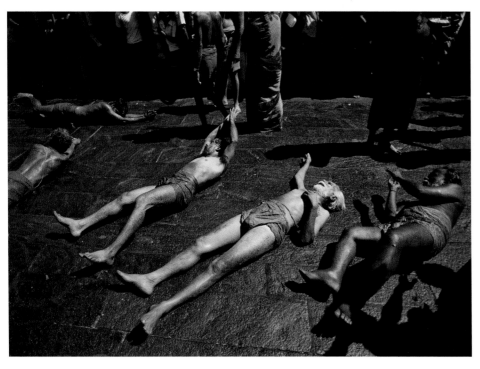

JAGATMANDIR KRISHNA TEMPLE

Dwarka, India
MAP SITE 11

Among the numerous categories of sacred sites in India are the Sapta Puri, or seven sacred cities of Ayodhya, Mathura, Hardwar, Varanasi, Kanchi, Ujjain, and Dwarka. Known as *mokshada*, meaning Bestower of Liberation, these sites are believed to confer liberation upon all persons who die within their boundaries. Dwarka is also one of the Dhamas, or Four Divine Abodes. Seldom visited by Westerners because of its remote location in the state of Gujarat, the beautiful five-story Jagatmandir Krishna Temple graces the center of Dwarka. Though it is one of India's oldest and most venerated pilgrimage sites, Dwarka's archaeological background is shrouded in mystery. Mythologically, Dwarka was the site chosen by Garuda, the Divine Eagle, who brought Krishna there when he departed Mathura. After founding the oceanside city of Dwarka, Krishna lived there until he died, in 3102 BCE, according to legend. Scholars believe that the oldest parts of the Jagatmandir Temple may date only to the reconstructions of the Gupta Period in 413 CE.

Dwarka is also visited by large numbers of pilgrims because of its association with the saint Mira Bai. One of India's most popular saints, Mira Bai renounced her life as the wife of a powerful sixteenth-century king to dedicate her days to the worship of Lord Krishna. Mira Bai followed the spiritual path known as Bhakti Yoga, a practice characterized by a devotional love of God. The path of the Bhakti yogi is concerned with invoking the presence of the divine through adoration of a statue or painting of a deity. In Mira Bai's case, as with many other saints in India's long history, it is believed that this invocation called forth not only the sense of the deity but actually a living, moving form of Krishna.

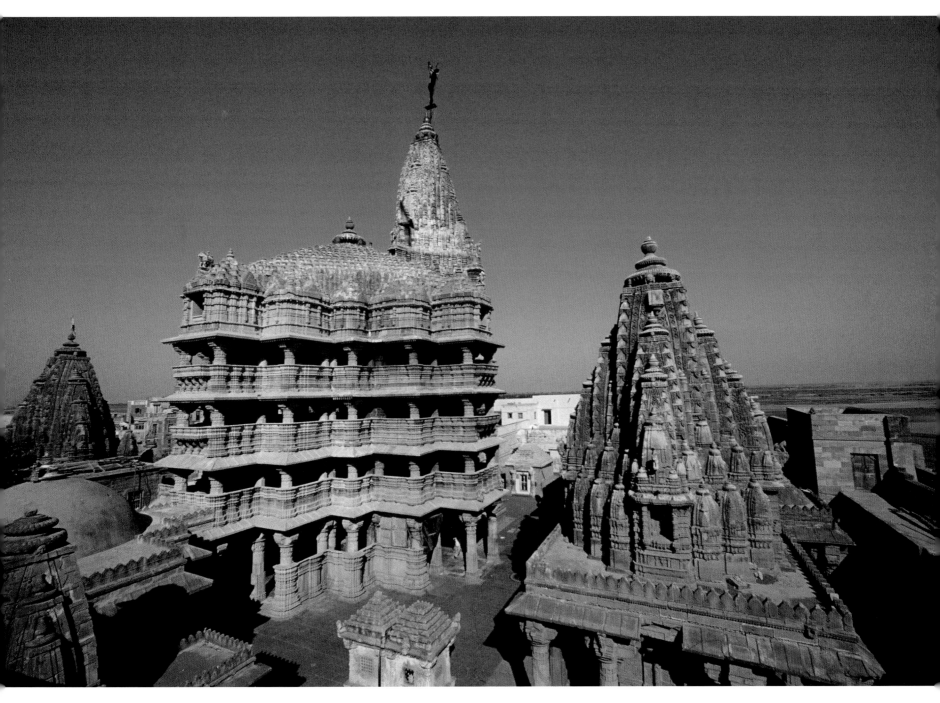

Legions of Bhakti yogis such as Mira Bai have infused the Jagatmandir Temple with a power of love; it is thus highly charged with the quality or energy of devotion and will awaken and amplify that quality in visiting pilgrims.

Portraits of sadhus at Tiruvannamalai in Tamil Nadu (left) and at Hardwar in Uttar Pradesh (right).

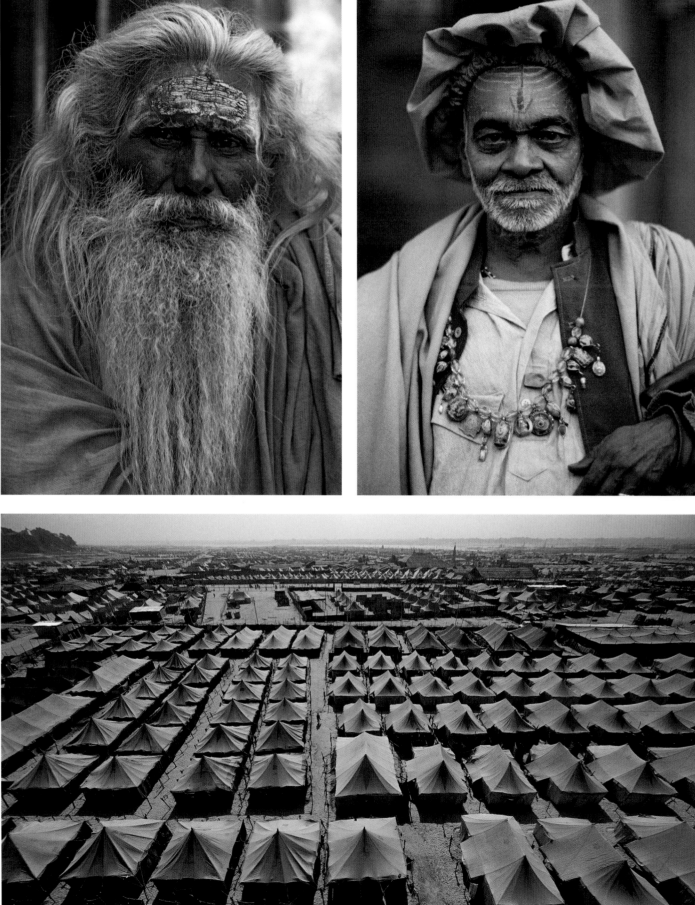

SADHUS

Tamil Nadu and Uttar Pradesh, India

MAP SITES 7 AND 8

Each year millions of men and women go on pilgrimages in India. Most of these pilgrims take a short break, a few days or weeks, from their normal affairs and then return home following the completion of their journey. Other pilgrims spend years, perhaps the remainder of their lives, wandering between the hundreds of sacred sites strewn across India. These lifetime pilgrims generally fall into two distinct groups. First, and quite visible, are the sadhus, the renunciate ascetics who are members of different semi-monastic orders. Second are those elder men and women, finished with the responsibilities of family life, who choose to lead their final years practicing Bhakti Yoga at the shrines of the deities.

According to Hindu beliefs, Bhakti is the most effective yogic method for achieving enlightenment in the present age, the Kali Yuga, or Age of Darkness. Bhakti Yoga on the pilgrimage trail is a splendid life. There are shrines scattered throughout the subcontinent, so pilgrims may travel the country from the high mountains of the Himalayas to the moist jungles of the south to the sandy beaches of the coasts. Because there are so many shrines and because they are never far from one another, the walking pilgrim has easy days of travel between shrines. At the shrines there are often free or inexpensive lodgings, simple but healthy food, and the companionship of other wandering pilgrims. The pilgrims rise early in the morning for the first *puja*, or devotional worship of the deity of the shrine. Different at each site, the *puja* ceremonies may consist of chanting, drumming, and singing or silent prayer, and there are always dimly lit corners of the temple where one may go to practice meditation. Next will be a meal, then some simple service such as cleaning up around the shrine, perhaps a nap during the heat of the day, and later in the evening another *puja* and a final meal. I have spent many months in southern India living such a life and can attest to its enchanting qualities.

ALLAHABAD KUMBHA MELA FESTIVAL

Allahabad, India

MAP SITE 12

Sacred site festivals in India, called *melas*, are a vital part of the pilgrimage tradition of Hinduism. Celebrating a mythological event in the life of a deity or an auspicious astrological period, the *melas* attract pilgrims from around the country. The greatest of these, the Kumbha Mela, is a riverside festival held four times every twelve years, rotating between the cities of Allahabad, Nasik, Ujjain, and Hardwar. The Allahabad festival, the largest religious gathering in the world, attracts vast numbers of pilgrims; thirteen million came in 1977, eighteen million in 1989, and more than twenty-five million in 2001.

The Allahabad Kumbha Mela festival is traditionally known as the gathering of the sadhus. At the most auspicious hour of the monthlong festival, thousands of naked holy men immerse themselves in the river, ritually cleansing both mind and spirit. Following the immersion of the sadhus, millions of other people enter the river. To participate in the Kumbha Mela during this auspicious time is considered an opportunity of great significance. Many Hindus also consider the Kumbha Mela sites to be the most favored places at which to die, and ritual suicide, though discouraged by the government, is still practiced.

To understand the spiritual magnetism of the festival, it is important to know its origin myth. During a battle between the gods and various demons in mythological time, four drops of a potion of immortality fell to Earth at the Kumbha Mela sites. At rare astrological periods, these four sites are believed to function as portals to everlasting union with God. These periods occur when Jupiter is in Aries or Taurus and the sun and moon are both in Capricorn (January to February). Perhaps there is some energy, some mysterious spirit or power manifest at these places and times, that assists people in experiencing spiritual awakening and enlightenment. The fact that hundreds of millions of people for thousands of years have believed this to be true suggests that an awesome power is indeed present at the Kumbha Mela sites.

A temporary tent city houses millions of pilgrims attending the Kumbha Mela festival in Allahabad.

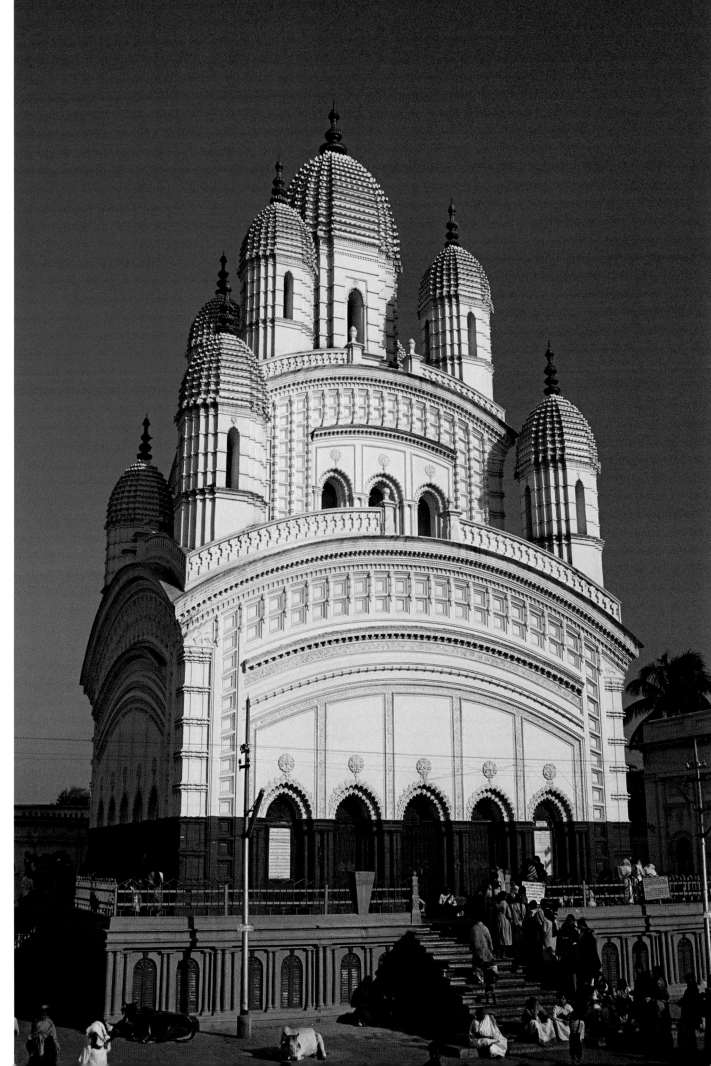

The large Kali temple complex at Dakshineswar in Calcutta has as its centerpiece a shrine of the goddess Kali, but the temples are also dedicated to the deities Shiva and Radha-Krishna.

Kali Temple of Dakshineswar

Calcutta, India

Map site 13

Following a dream of the goddess Kali, the wealthy widow Rani Rashmoni had the temple complex of Dakshineswar built between 1847 and 1855. A scholarly sage was chosen as the head priest, but within the year he died and his responsibilities passed to his younger brother, Ramakrishna. From the first days of his service in the shrine of the goddess Kali, Ramakrishna was filled with a rare form of the love of God known in Hinduism as *maha-bhava*. Worshipping in front of the statue of Kali, Ramakrishna would be overcome with such ecstatic love for the deity that he would fall to the ground and, immersed in spiritual trance, lose all consciousness of the external world. These experiences of God intoxication became so frequent that he was relieved of his duties as temple priest but allowed to continue living within the temple compound. During the next twelve years, Ramakrishna journeyed ever deeper into this passionate and absolute love of the divine. His practice was to express such intense devotion to particular deities that they would physically manifest to him and then merge into his being. Various forms of gods and goddesses such as Shiva, Kali, Radha-Krishna, Sita-Rama, Christ, and Muhammad frequently appeared to him, and his fame as an avatar, or divine incarnation, rapidly spread throughout India. Ramakrishna died in 1886 at the age of fifty, but his life, his intense spiritual practices, and the Temple of Kali where many of his ecstatic trances occurred continue to attract pilgrims from all over India and the world.

Jain Temple Complex of Shatrunajaya

Gujarat, India

Map site 14

While the majority of pilgrimage places in India are sacred to the Hindus, there are holy sites of other religions such as Jainism, Buddhism, and Islam. A religion and philosophy native to India, Jainism was founded in the sixth century BCE by the sage Mahavira. Born in 599 BCE, Mahavira began the life of an ascetic at the age of twenty-eight. After years of meditation, he attained enlightenment and thereafter taught until he died in 527 BCE.

Jainism, which does not espouse belief in a creator god, has as its ethical core the doctrine of Ahimsa, or non-injury to all living creatures, and as its religious ideal the perfection of human nature, to be achieved predominantly through monastic and ascetic life. According to Jain beliefs, their faith is eternal and has been revealed through the successive ages of the world by twenty-four Tirthankaras. Tirthankara, a title given to the (mostly mythical) enlightened sages of Jainism, means "ford maker" and indicates a being or deity who has bridged, or forded, the mundane and spiritual worlds and can thereby assist human beings in the same realization. Similar to the avatars of Hinduism, the Tirthankaras instruct and inspire humankind while protecting the world from demonic forces. Like the Hindu avatars, the Jain Tirthankaras have also sanctified specific places on earth by their birth, great miracles, or attainment of enlightenment.

Those places where the Tirthankaras and other holy persons have attained nirvana are called Siddha-kshetra. The primary Siddha-kshetras are the five sacred mountains of Shatrunajaya in Gujarat, Girnar in Saurashtra, Sametshikhar in eastern Bihar, Mt. Abu in Rajasthan, and Astapada, a mythical mountain at the center of the universe.

Shatrunajaya, meaning the Place of Victory, is considered the most holy of the Jain sacred mountains because nearly all of the Tirthankaras are believed to have attained nirvana while meditating atop it.

Shatrunajaya is the scene of a great pilgrimage festival on the full moon of each Karttika (October to November). Groups of pilgrims from all over the country flock here, and part of the celebration consists of processions carrying huge pictures of the sacred mountain through the streets of Palitana, the city on the mountaintop.

The rounded peak of Shatrunajaya rises two thousand feet (610 m) above the town of Palitana and is capped with a complex of 863 beautiful temples. While some of the temples are as old as the eleventh century (although the religious use of the site is far older), most date from the 1500s, after Muslim invaders destroyed the earlier shrines.

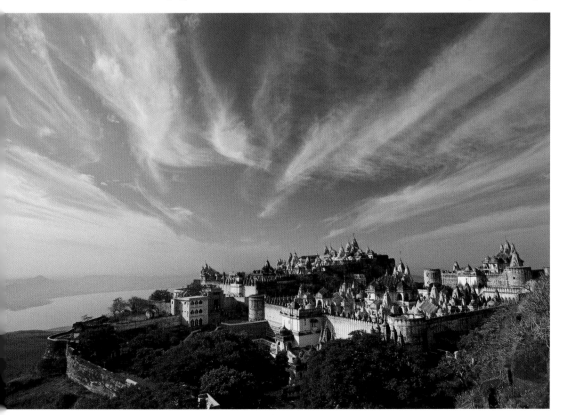

Within the ornately fashioned temples of Shatrunajaya are hundreds of exquisitely sculpted marble statues of the twenty-four Tirthankaras. These statues are the supreme object of Jain veneration, and although they may be worshipped by some uneducated Jains, they are intended as objects for philosophical inspiration rather than for worship.

SRAVANABELAGOLA

Karnataka, India

MAP SITE 15

The hill of Sravanabelagola, seventy-five miles (120 km) west of Bangalore in the state of Karnataka, is a noted place of pilgrimage in the religion of Jainism. A flight of 614 steps, finely chiseled into the granite of the mountain, leads to the summit, where there are an open court and the great statue of Sri Gomatheswar. Sravanabelagola means the "monk on the top of the hill," and hermits, mystics, and ascetics have resided here since at least the third century BCE. In those early times, the hill was thickly wooded, and hermits could feed themselves from the vegetation of the forest. Near the middle of the tenth century CE, temples began to be constructed upon the hill, and since that time the place has become one of the most important pilgrimage sites of the Jain religion.

The nearly fifty-nine-foot (18 m) statue of Sri Gomatheswar, carved between 978 and 993 CE out of the granite bedrock of the mountain, is the tallest freestanding statue in the world. Sri Gomatheswar, also known as Bahubali, was the son of the legendary first Tirthankara, Adinatha. The chief festival of Sravanabelagola is called Maha Masthaka Abhisheka, or the Head-Anointing Ceremony. Prior to the festival, an enormous wooden scaffolding is built around the huge statue of Sri Gomatheswar, and more than one million pilgrims assemble upon the slopes of the sacred hill. During the climax of the festival, priests and devotees standing atop the scaffolding chant holy mantras and ritually pour thousands of gallons of milk, honey, and precious herbs over the head of the statue. While flowing downward over the body of the statue, these sacred offerings are believed to acquire a powerful charge of spiritual energy from the great deity. Collected at the statue's feet and distributed to the waiting pilgrims, the magical libations are considered to assist individuals in their quest for enlightenment. The festival is performed only once every twelve to fourteen years during periods of particular astrological significance. Recent festivals occurred in 1981, 1993, and 2006.

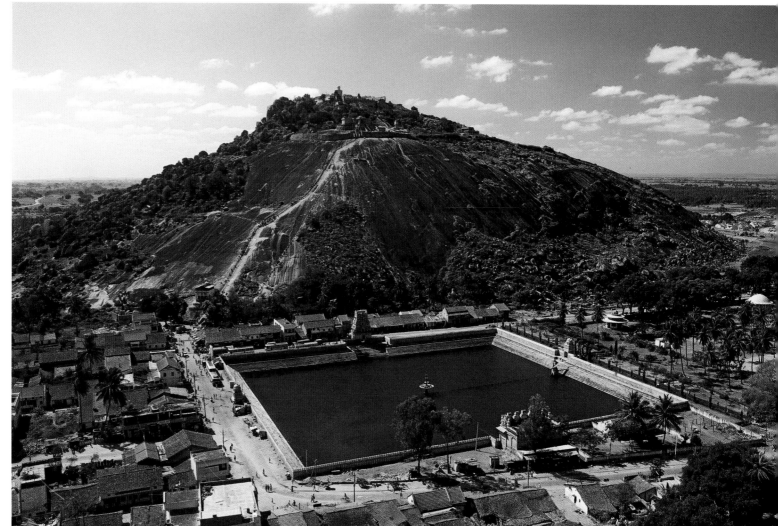

The Jain sacred hill of Sravanabelagola, also called Vindhyagiri or Per-kalbappu, rises 3,347 feet (1,020 m) above sea level. In front of the hill is a lake that is also sacred to the Jains.

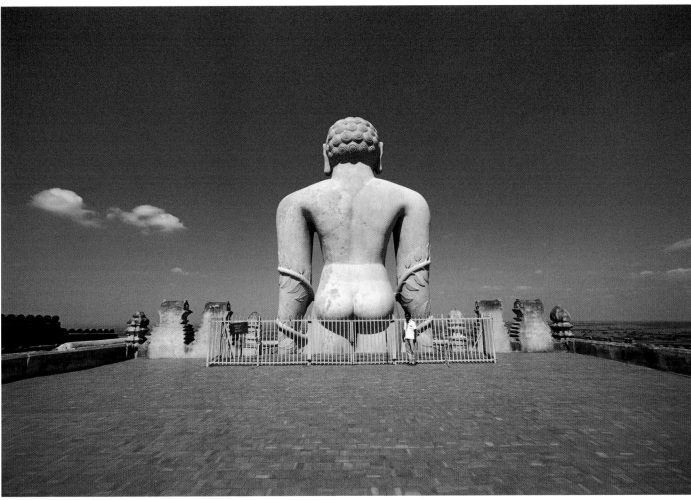

A view from behind the statue of Sri Gomatheswar atop the hill of Sravanabelagola; it is the world's tallest freestanding statue.

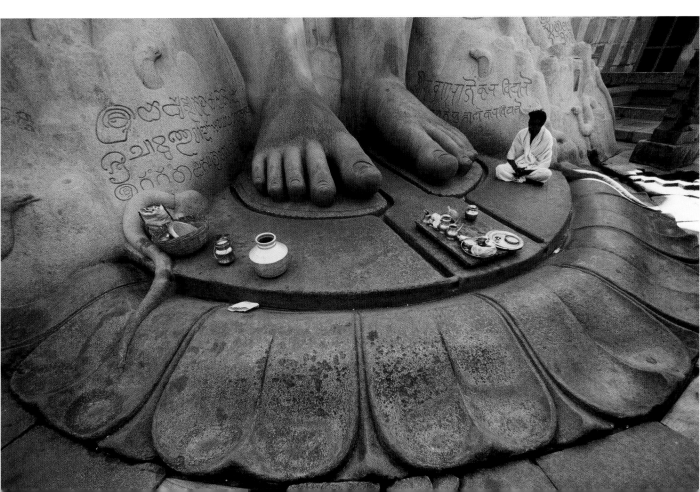

A temple priest sits at the holy feet of the statue, giving one an idea of the statue's immense scale.

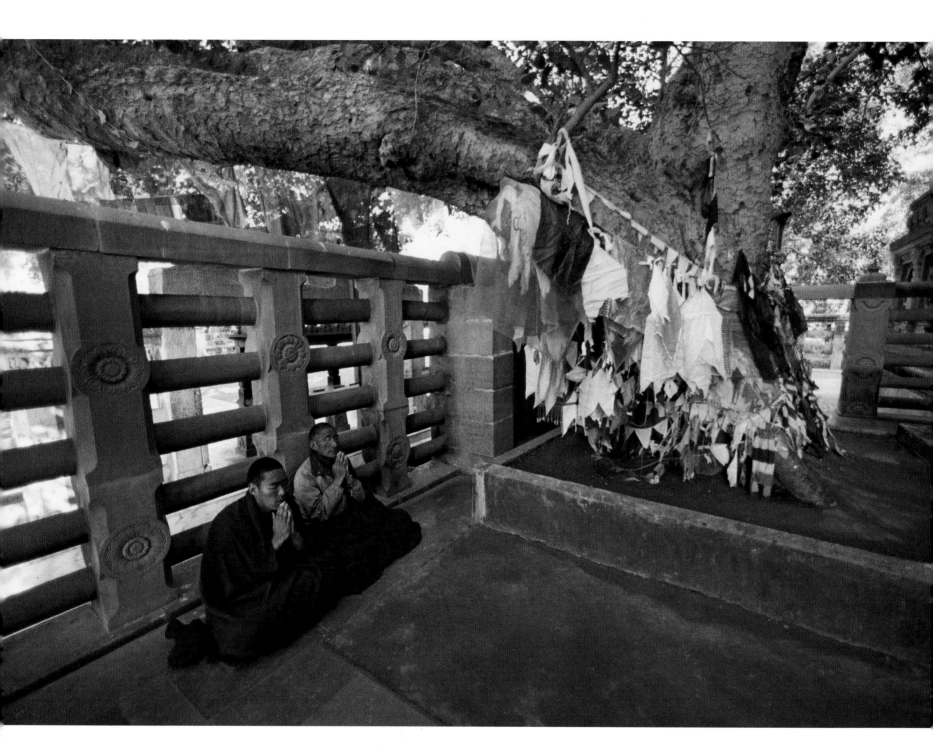

Tibetan monks meditating by the Bodhi Tree, the place of the Buddha's enlightenment, in Bodh Gaya. The tree standing today is a descendant of the tree from the Buddha's time. The environs of Bodh Gaya have attracted yogis and sages since the time of the Buddha. Great spiritual figures such as Padmasambhava, Nagarjuna, and Atisha have meditated beneath the Bodhi Tree.

Bodh Gaya

Bihar State, India

MAP SITE 16

Siddhartha Gautama, a royal prince of the sixth century BCE, lived his early years never having seen old age, sickness, poverty, or death. At the age of twenty-nine, he renounced his opulent lifestyle and began his search for truth. Following the traditions of Hinduism, Siddhartha had spiritual teachers, practiced yoga, and deeply explored the ascetic path. After several years, Siddhartha was guided by visionary dreams to meditate beneath the Bodhi Tree, where he attained the ultimate knowledge of spiritual enlightenment. His first discourse, given at Saranath, presented the Four Noble Truths and the Noble Eightfold Path for which Buddhism is so famous.

The Four Noble Truths assert that human beings suffer because of the clinging nature of the mind. There is a way out of suffering through the meditative practices of the Noble Eightfold Path. Through these practices, one gains insight into how suffering is caused by identification with the mind's processes. Letting go of such identification, one discovers—and increasingly resides in—a pre-existing state of inner peace.

The Buddha spent the remainder of his life traveling and teaching in northeastern India. He died at the age of eighty; his body was cremated, and the ashes were placed in ten reliquary shrines whose locations are now unknown.

The origins of the practice of pilgrimage in Buddhism are obscure. Scholars believe that Buddhist pilgrimage was initially imitative of the practice among Hindus but later became an integral part of the Buddhist tradition, assuming its own distinct features. Buddhists quote passages from the Mahaparinibbana Sutta in which the Buddha tells his disciple, Ananda, that there are four places "that a devout person should visit and look upon with reverence." These four places are Lumbini, where the Buddha was born; Bodh Gaya, where he attained enlightenment; Saranath, where he gave his first teachings; and Kushinager, where he passed away. These places became known as the Four Great Wonders, and monks and pilgrims began visiting them. Other places associated with the Buddha's life, such as Rajagraha, Sravasti, Vaisali, and Samkasya, also became pilgrimage destinations, and all eight sites are known as the Eight Great Wonders.

Other places became pilgrimage centers as Buddhism extended its influence across Asia. In general, there were three types of Buddhist sacred sites that arose in the centuries following the Buddha's death. One category concerned those places considered sacred prior to the arrival of Buddhism, which were then incorporated into Buddhist sacred geography. This was especially true in Tibet, where numerous Bönpo sacred sites were taken over by the Buddhists (Bön is a shamantic antecedent to Buddhism indigenous to Tibet), and in China, where particular Taoist sacred mountains became the abodes of Buddhist bodhisattvas. The second category included places associated with the lives or relics of various sages, saints, and teachers in the Buddhist tradition. A third category concerned those sacred sites that had their origin in the manifestation or apparition of various deities.

Pre-eminent among all these pilgrimage sites is Bodh Gaya, the place where the Buddha attained enlightenment. No archaeological remains exist of structures from the time of the Buddha. The earliest temple was constructed by Emperor Ashoka around 250 BCE, and this shrine was replaced in the second century CE by the Mahabodhi Temple. The Mahabodhi, with shrines for ritual practice and meditation, is crowned by a stupa (monument) containing relics of the Buddha. Inside the temple is a statue of the Buddha and also a Shiva Lingam. The Hindus believe that the Buddha was one of the incarnations of Vishnu; therefore, the Mahabodhi Temple is also a pilgrimage site for Hindus. Behind the temple are the two most venerated objects in the Buddhist world: the Bodhi Tree and, beneath it, the Vajrasana, or seat of the Buddha's meditation.

Following pages:
The beautiful Golden Temple of Amritsar, India, is mirrored in a shimmering reflection on the sacred Amritsar Lake.

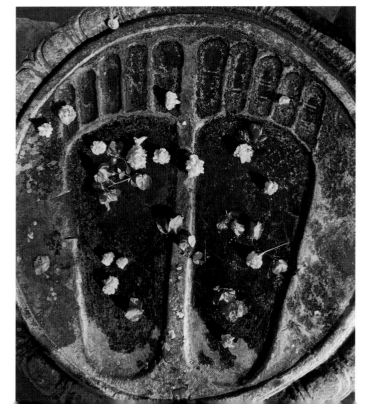

The Buddha's footprints, enshrined at Bodh Gaya, are strewn with flowers.

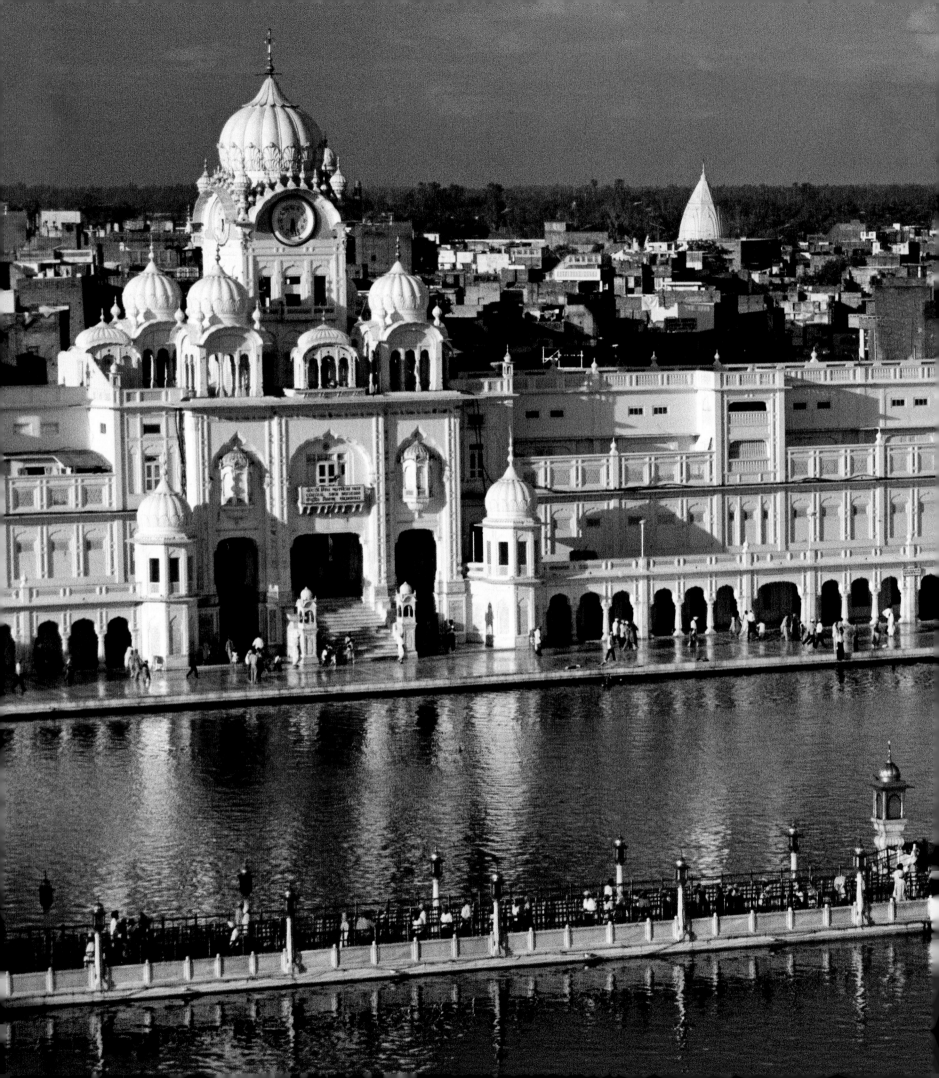

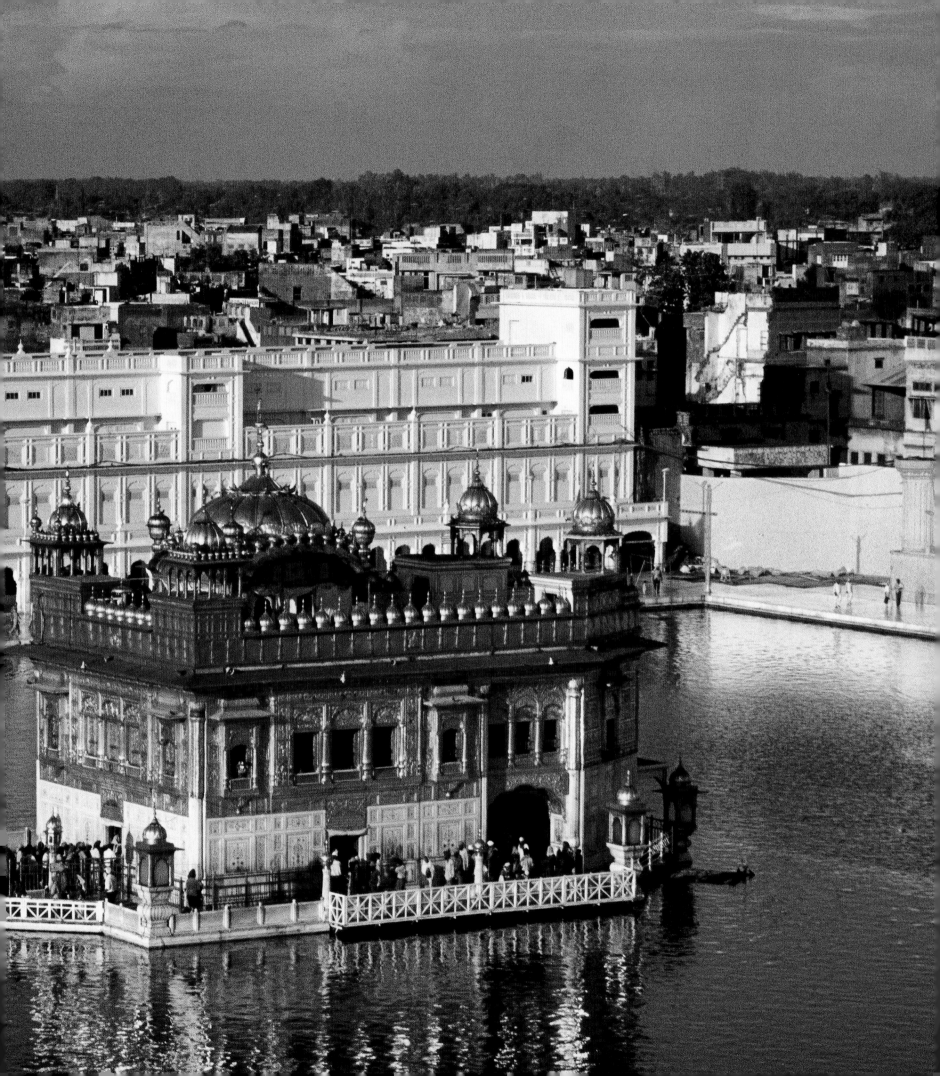

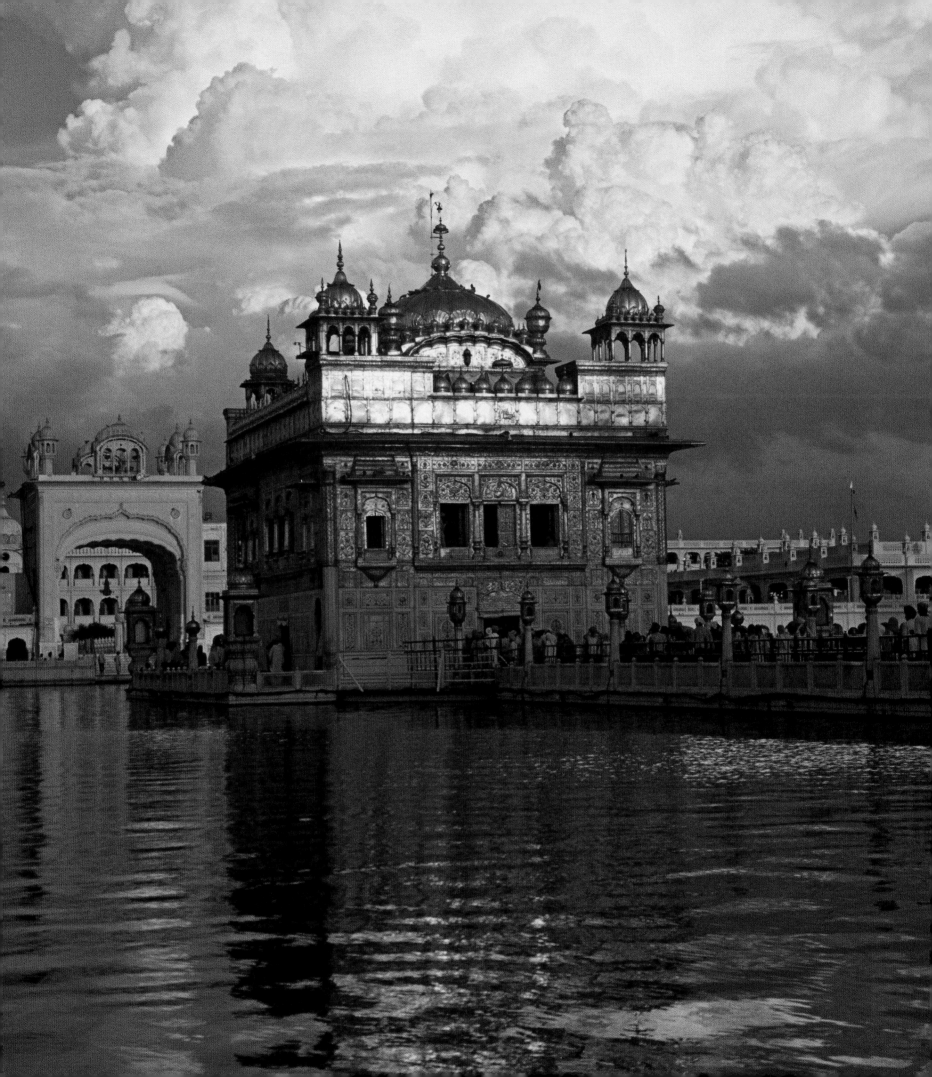

GOLDEN TEMPLE

Amritsar, India

MAP SITE 17

Pilgrims take a stroll on the marble concourse at the Golden Temple.

Located in northwestern India, in the city of Amritsar, the Golden Temple is the most sacred place of the religion of Sikhism. What was once a small lake in the midst of a quiet forest has been a meditation retreat for wandering sages since deep antiquity. Amritsar, originally the name of the lake, means "pool of ambrosial nectar" and refers to a drink of the gods, a rare and magical substance that catalyzes euphoric states of consciousness and spiritual enlightenment. An underground spring feeds the sacred lake, and throughout the day and night pilgrims immerse themselves in the water, as a symbolic cleansing of the soul. Guru Nanak (1469–1539 CE), the founder of the Sikh religion, deeply loved the holy lake, and after his death, his disciples continued to venerate the site.

The Golden Temple, called Hari Mandir (meaning Temple of God), was constructed during the leadership of Arjun, the fifth Sikh Guru, between 1581 and 1606. From the early 1600s to the mid-1700s, the Sikh Gurus were constantly involved in defending both their religion and their temple against Muslim armies. On numerous occasions the temple was damaged, but each time it was rebuilt more beautifully by the Sikhs. During the reign of Maharaja Ranjit Singh (1780–1839), Hari Mandir was gilded, richly ornamented with marble sculpture, and inlaid with large quantities of precious stones. Beginning early in the morning and lasting until long past sunset, musicians within the Golden Temple chant hymns to the accompaniment of flutes, drums, and stringed instruments. Echoing across the serene lake, this enchantingly beautiful music induces a delicate yet powerful state of trance in the pilgrims strolling leisurely around the marble concourse encircling the pool and temple.

The Golden Temple's architecture draws on both Hindu and Muslim artistic styles, yet represents a unique co-evolution of the two.

ADAM'S PEAK

Sabaragamuwa Province, Sri Lanka

MAP SITE **18**

Jutting sharply skyward from the lush jungles of southwestern Sri Lanka is the 7,362-foot (2,244 m) peak of Sri Pada, the Holy Footprint. Also called Adam's Peak, the mountain has the unique distinction of being sacred to the followers of four of the world's major religions: Hinduism, Buddhism, Christianity, and Islam. Long before the development of these religions, however, the mountain was worshipped by the aboriginal inhabitants of Sri Lanka, the Veddas. Their name for the peak was Samanala Kanda, Saman being one of the four guardian deities of the island. For Hindus, the name of the mountain is Sivan Adi Padham, because it was the world-creative dance of the god Shiva that left the giant footprint—slightly less than six by three feet (2 by 1 m). According to Buddhist traditions from as early as 300 BCE, the real print is actually beneath this larger marking. Imprinted on a huge sapphire, it was left by the Buddha during the third and final of his legendary visits to Sri Lanka. When Portuguese Christians came to the island in the sixteenth century, they claimed the impression to be the footprint of St. Thomas, who, according to legend, first brought Christianity to Sri Lanka. Finally, the Arabs record it as being the solitary footprint of Adam, where he stood on one foot for a thousand years of penance . Visited by many early world travelers, among them the Venetian Marco Polo (1254–1324) and the Arab Ibn Battuta (1304–1368), Adam's Peak attained a legendary status as a mystical pilgrimage destination.

MIHINTALE BUDDHA

Mt. Mihintale, Sri Lanka

MAP SITE **19**

Situated about seven miles (11 km) east of the ruins of the great city of Anuradhapura, the sacred mountain of Mihintale is considered to be the location where Buddhism was first introduced to the island of Sri Lanka. There are two stories, one historical and one mythological, that explain the arrival of Buddhism at Mihintale. According to historical sources, in the middle of the third century BCE, the Indian emperor Ashoka sent his son Mahinda to Sri Lanka to spread the teachings of the Buddha. Mahinda and his group of Buddhist monks were camped upon the sides of Mt. Mihintale when King Devanampiya Tissa of Anuradhapura encountered them during a royal hunting expedition. Mahinda spoke to the king of Buddhism and recited the Culahastipadopama and other sutras. The date of this meeting is believed to have been on the full moon of June in 247 BCE. Soon thereafter, the king (and forty thousand inhabitants of Anuradhapura) converted to Buddhism. An alternate story of the arrival of Buddhism in Sri Lanka tells that the Buddha himself journeyed to the island on the back of the winged demigod Garuda, but there is no historical evidence that the Buddha himself ever visited the island. Today the peak of Mihintale, approached by a grand stairway of 1,840 granite steps, has many temples, lodgings for monks, and several splendid statues of the Buddha. Each June on the full moon, a pilgrimage commemorates the date when Mahinda first preached the Buddhist doctrine in Sri Lanka, and thousands of people flock from all over Sri Lanka to meditate at the holy peak.

A Buddhist monk venerates the Holy Footprint on Adam's Peak. Votive offerings are made here, especially of a coil of silver the length of the donor's height, for recovery from sickness, and rainwater taken from the footprint is known to have a wonderful healing power as well.

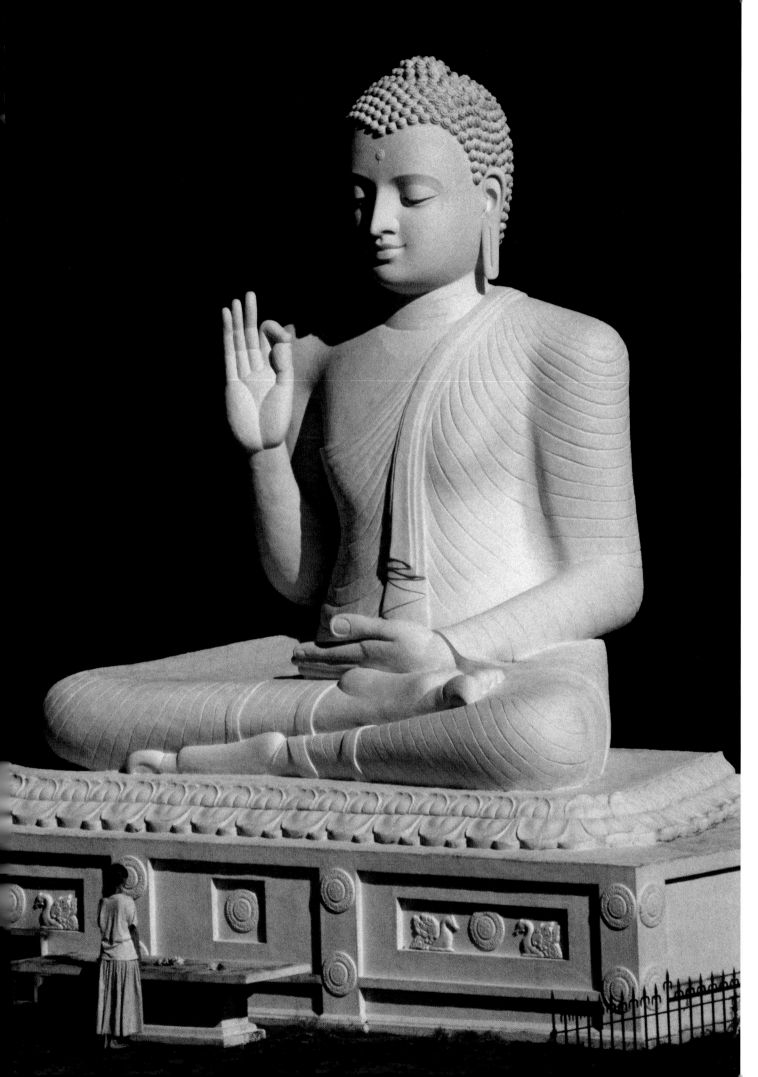

This photograph of the Mihintale Buddha, taken with a 1,200 mm lens, was made during the brightest part of the day but was underexposed by several f-stops to turn the background black—thereby simulating the view of the great Buddha as seen during the night of the full-moon pilgrimage.

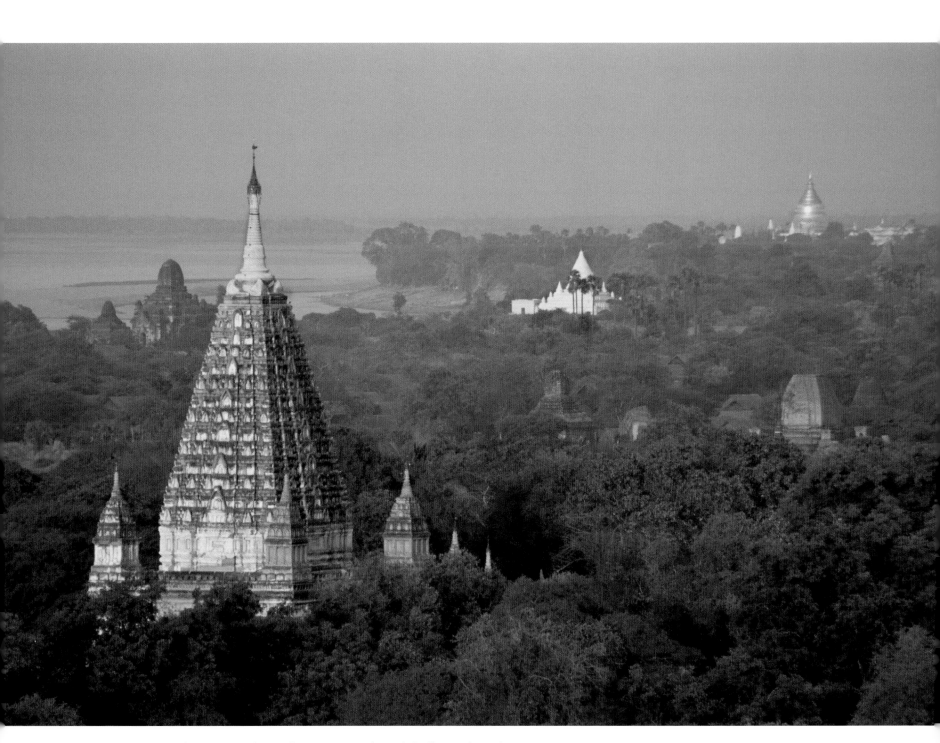

At the Bagan temple complex in Myanmar, the Mahabodhi Temple can be seen in the left foreground. The temple is covered with niches containing seated Buddha figures. In the far right background, the golden pagoda of Shwezigon can be seen; the most important reliquary shrine in Bagan, it was built in the eleventh century and contains several bones and hairs of the Buddha.

The majestic Gawdawpalin Temple at Bagan stands 197 feet (60 m) tall.

BAGAN TEMPLE COMPLEX

Bagan, Myanmar

Map site 20

There are two enormous ancient temple complexes in Southeast Asia: Bagan in Myanmar and Angkor in Cambodia (see pages 168-171). Both sites are remarkable for their expanse of sacred geography and the number and size of their individual temples. For many visitors, Bagan is the more extraordinary because of its wonderful views. Scattered across a vast dusty plain may be seen scores of exotic Buddhist temples. The kingdoms of Bagan date to the early second century CE, yet the region entered its golden age much later, during the reign of King Anawrahta in 1057. From that time, until it was overrun by Kublai Khan's forces in 1287, more than thirteen thousand temples, pagodas, and other religious structures were built. Today, seven centuries later, approximately twenty-two hundred temples remain standing. The river Irrawaddy has washed away nearly one-third of the original city area, and thieves in search of treasures have torn apart many temples, while earthquakes and the ravages of time have reduced hundreds of other temples to piles of crumbling stones. Two of the loveliest temples are the Mahabodhi and Gawdawpalin. The Mahabodhi, a smaller replica of the famous Bodhi Temple in Bodh Gaya, India (where the Buddha attained enlightenment), was built during the thirteenth-century reign of King Nantaungmya. The Gawdawpalin Temple, built in the twelfth century by King Narapatisithu and completed in the thirteenth century by his son, was badly damaged in a 1975 earthquake but has since been reconstructed. Many of the temples of Bagan are still functioning, and large numbers of pilgrims visit the ancient holy place.

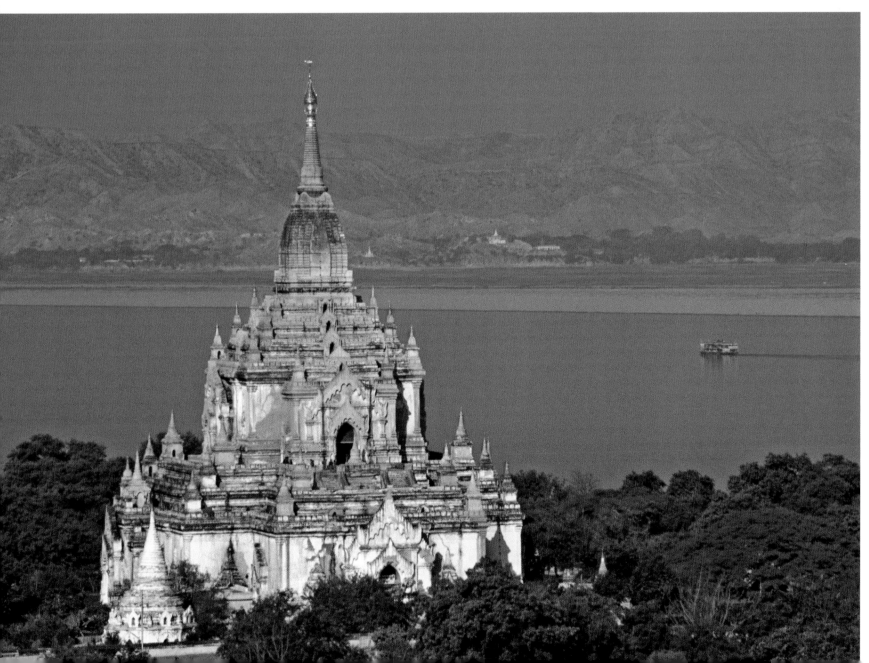

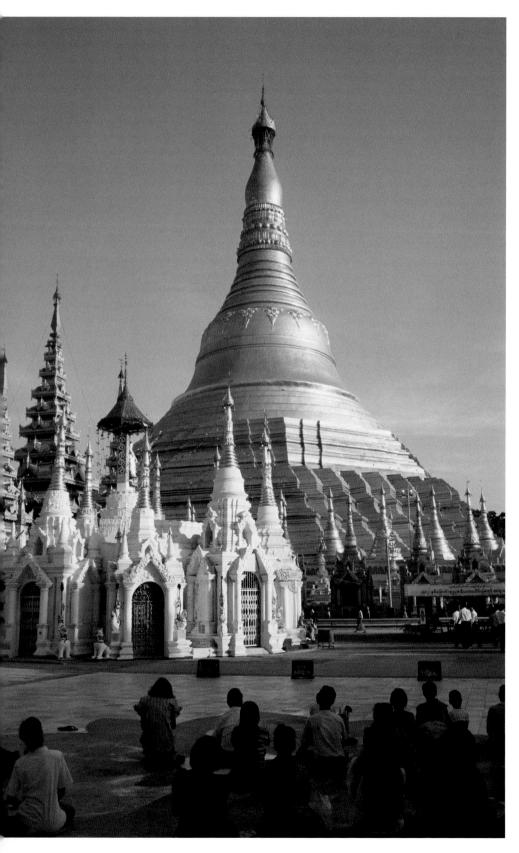

SHWEDAGON PAGODA

Yangon, Myanmar
MAP SITE **21**

The origins of Shwedagon are lost in antiquity, its age unknown. Long before the pagoda was built, its location on Singuttara Hill was already an ancient sacred site because of the buried relics of the Buddhas of the three previous ages. According to one legend, nearly five thousand years had elapsed since the last Buddha walked the earth, and Singuttara Hill would soon lose its blessedness unless it was reconsecrated with relics of a new Buddha. In order that such new relics might be obtained, King Okkalapa of Suvannabhumi spent time atop the hill, meditating and praying. A series of miracles ensued, and eight hairs of the Buddha of this age were, somewhat magically, brought to the hill. To enshrine the relics, multiple pagodas of silver, tin, copper, lead, marble, iron, and gold were built one on top of the other to a height of sixty-six feet (20 m). During the following centuries, passing from myth to historical fact, the pagoda more than quadrupled in size. Some of the development of Shwedagon is also attributed to reconstruction following disastrous earthquakes.

While much of the pagoda's beauty derives from the complex geometry of its shape and surrounding structures, equally mesmerizing is its golden glow. Surrounding the pagoda are a plenitude of smaller shrines housing pre-Buddhist spirits called *nats*, miracle-working images, and even a wish-granting stone. The entire temple complex radiates a palpable sense of beauty and serenity.

The lower stupa at Shwedagon is plated with 8,688 solid gold bars, an upper part with another 13,153. The tip of the stupa, far too high for the human eye to discern in any detail, is set with 5,448 diamonds; 2,317 rubies, sapphires, and other gems; 1,065 golden bells; and, at the very top, a single 76-carat diamond.

Mahamuni Buddha

Mandalay, Myanmar
Map site 22

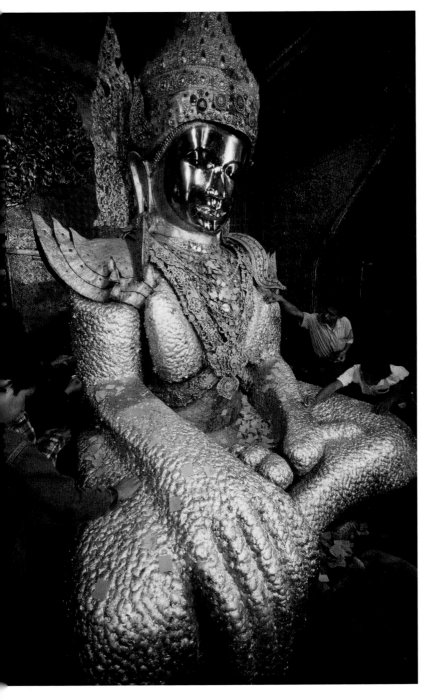

Legends tell that the Buddha once went to teach among the people of northern Myanmar. The local king asked the Buddha to leave an image of himself for the benefit of the people. The Buddha sat for a week of meditation under a tree while Sakka, a king of the gods, created a lifelike image of great beauty. Pleased with the image, the Buddha decided to imbue it with his spiritual essence for a period of five thousand years.

According to ancient tradition, only five likenesses of the Buddha were said to have been made during his lifetime: Two were in India, two were in paradise, and the fifth is the Mahamuni, or Great Sage. Archaeologists believe the image was probably cast during the reign of King Chandra Surya, who ascended the throne in 146 CE, some six hundred years after the Buddha actually passed away. Little is known of the Mahamuni over the next fifteen hundred years. It was stolen, moved around by various kings, and once buried beneath a crumbling temple in the jungle. Brought to Mandalay in 1784 and placed within a specially built shrine, it is the most venerated Buddha image in all of Myanmar.

The Mahamuni statue, thirteen feet (4 m) tall and originally cast of metal, is now entirely coated with a layer of gold leaf two inches (5 cm) thick. So much gold leaf has been applied by so many different hands that the figure has developed an irregular outline. Many thousands of pilgrims visit the shrine each day, and a great festival in early February draws hundreds of thousands of people.

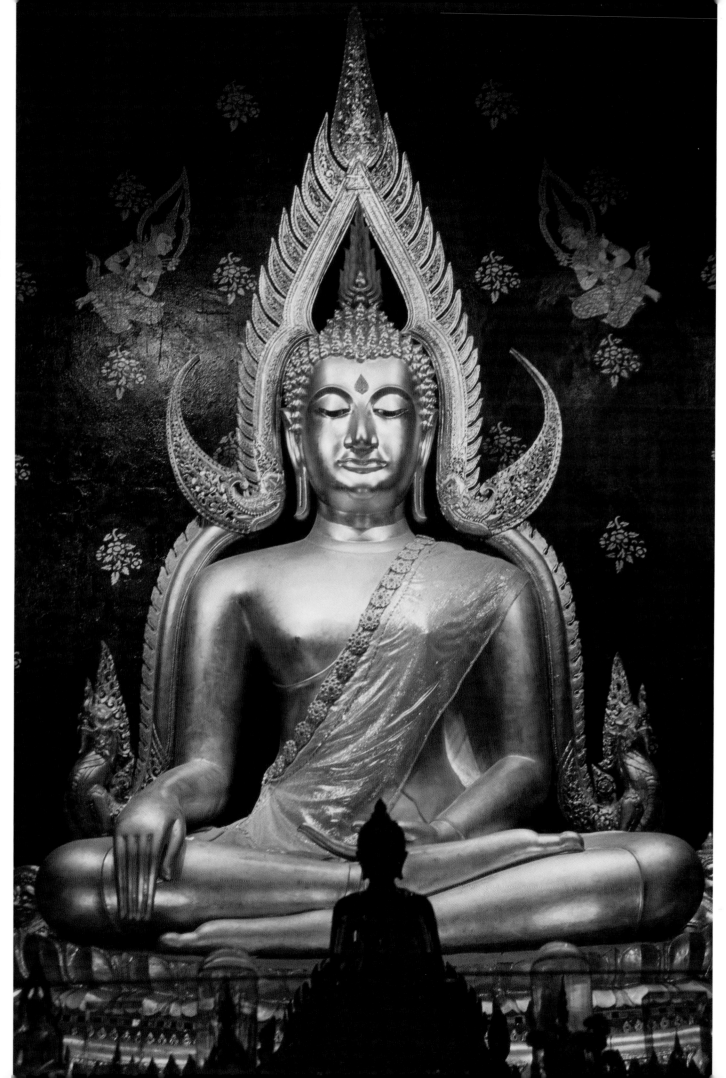

One of the most revered Buddha images in Southeast Asia, the gold-plated Phra Phuttha Chinnarat Buddha has a flamelike halo.

Phra Phuttha Chinnarat Buddha

Phitsanulok, Thailand

Map site 23

Buddhist sacred places may be grouped in various categories: places directly connected with the life of the Buddha; places where relics of the Buddha are kept; and places with highly venerated Buddha images. The Wat (Temple) Phra Si Ratana Mahathat in Phitsanulok is in the third category. Its stunningly beautiful image of the Buddha is venerated in Thailand and throughout Southeast Asia. Locals often shorten the long name of the temple, simply calling it Wat Phra Si or Wat Yai. The bronze image of the seated Buddha is a superb example of late Sukhothai sculpture and was cast during the reign of King Li Thai in 1357 CE. While a bustling, noisy city has grown around the temple, and streams of pilgrims and tourists constantly pass through the shrine, there is nonetheless a palpable feeling of serenity that surrounds the Buddha statue.

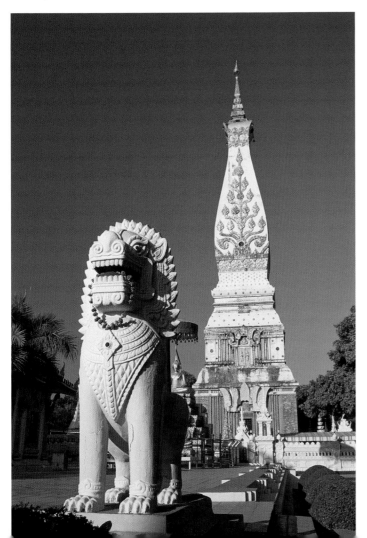

Wat That Phanom Chedi

That Phanom, Thailand

Map site 24

In northeastern Thailand, a little over half a mile (805 m) from the shore of the Mekong River, stands the exotic temple complex of That Phanom on the sacred hill of Phu Kamphra. According to legend, the original sanctity of the site derived from visits by the Buddhas of the three previous ages. Long after these mythical visits, it is believed that the Buddha of the sixth century made a pilgrimage to the sacred hill to venerate the relics of the earlier Buddhas. Accompanied by his chief disciple, Ananda, the Buddha journeyed from India to Phu Kamphra. While there, the Buddha telepathically communicated with another disciple, giving instructions that following his death the disciple should bring the Buddha's breastbone relic to the hill.

A collection of stories known as the *That Phanom Shrine Chronicles* tells that the first shrine was built shortly after the Buddha's demise. Archaeologists, however, date the earliest structures to between the sixth and tenth centuries CE, with the present form of the temple being established by the Lao kings of Vientiane in the fifteenth or sixteenth century. The centerpiece of the temple is a 187-foot-tall (57 m) *that*, or Lao-style *chedi* (pagoda-like reliquary), decorated with 243 pounds (110 kg) of gold. The *chedi* is known as a popular wish-fulfilling place, and there is a curious ritual associated with it whose origins are lost in time. Pilgrims will first purchase a small bird held captive in a finely woven bamboo cage. Carrying the caged bird with them while walking around the temple, the pilgrims will pray at various Buddha images and pre-Buddhist spirit stones. The bird is then freed to the skies in the hope that its release will speed the pilgrim's prayers to heaven. While pilgrims visit the shrine of That Phanom throughout the year, during the seven-day period of the annual festival held in late January or early February, the temple complex is especially alive with the energy of many thousands of people.

An imposing lion stands guard in front of the That Phanom Temple.

ANGKOR TEMPLE COMPLEX

Angkor, Cambodia

MAP SITE 25

The great temple complex of Angkor, crafted by the Khmer civilization between 802 and 1220 CE, represents one of humankind's most astonishing architectural achievements. From Angkor, the Khmer kings ruled over a vast domain that reached from Vietnam to China to the Bay of Bengal. The more than one hundred stone temples one sees at Angkor today are the surviving remains of a grand religious, social, and administrative metropolis whose other buildings—palaces, public buildings, and houses—were built of wood and have long since decayed and disappeared.

Conventional theories presume the lands where Angkor stands were chosen as a settlement site because of their strategic military position and agricultural potential. Some scholars, however, believe that the geographical location of the Angkor complex and the arrangement of its temples were based on a planet-spanning sacred geography from ancient times. Computer simulations have shown that the ground plan of the Angkor complex—the terrestrial placement of its principal temples—mirrors the stars in the constellation of Draco at the time of the spring equinox in 10,500 BCE. While the date of this astronomical alignment is far earlier than any known construction at Angkor, it appears that the purpose of the principal temples was to architecturally mirror the heavens to assist in the harmonization of the earth and the stars. Both the layout of the Angkor temples and the iconographic nature of much of its sculpture were also intended to indicate the celestial phenomenon of the precession of the equinoxes and the slow transition from one astrological age to another.

At the Temple of Phnom Bakheng, there are 108 surrounding towers. The number 108, considered sacred in both Hindu and Buddhist cosmologies, is the sum of 72 plus 36 (36 being half of 72). The number 72 is a primary number in the sequence of numbers linked to the earth's axial precession, which causes the apparent alteration in the position of the constellations over a period of 25,920 years, or one degree every 72 years. Another mysterious fact about the Angkor complex is its location: 72 degrees of longitude east of the Pyramids of Giza. The temples of Bakong, Prah Ko, and Prei Monli at Roluos, south of the main Angkor complex, are situated in relation to one another in such a way that they mirror the three stars in the Corona Borealis as they appeared at dawn on the spring equinox in 10,500 BCE. It is interesting to note that the Corona Borealis would not have been visible from these temples during the tenth and eleventh centuries, when they were constructed.

Angkor Wat, built during the early years of the twelfth century by Suryavarman II, honors the Hindu god Vishnu and is a symbolic representation of Hindu cosmology. In the fourteenth century, Angkor Wat became a Theravada Buddhist shrine.

The five towers of Angkor Wat are reflected at sunrise in the moat that surrounds the temple. Consisting of an enormous temple symbolizing the mythic Mt. Meru, Angkor Wat's five nested rectangular walls and moats represent chains of mountains and the cosmic ocean. The short dimensions of the vast compound are precisely aligned along a north-south axis, while the east-west axis has been deliberately diverted 0.75 degrees south of east and north of west, seemingly to give observers a three-day anticipation of the spring equinox.

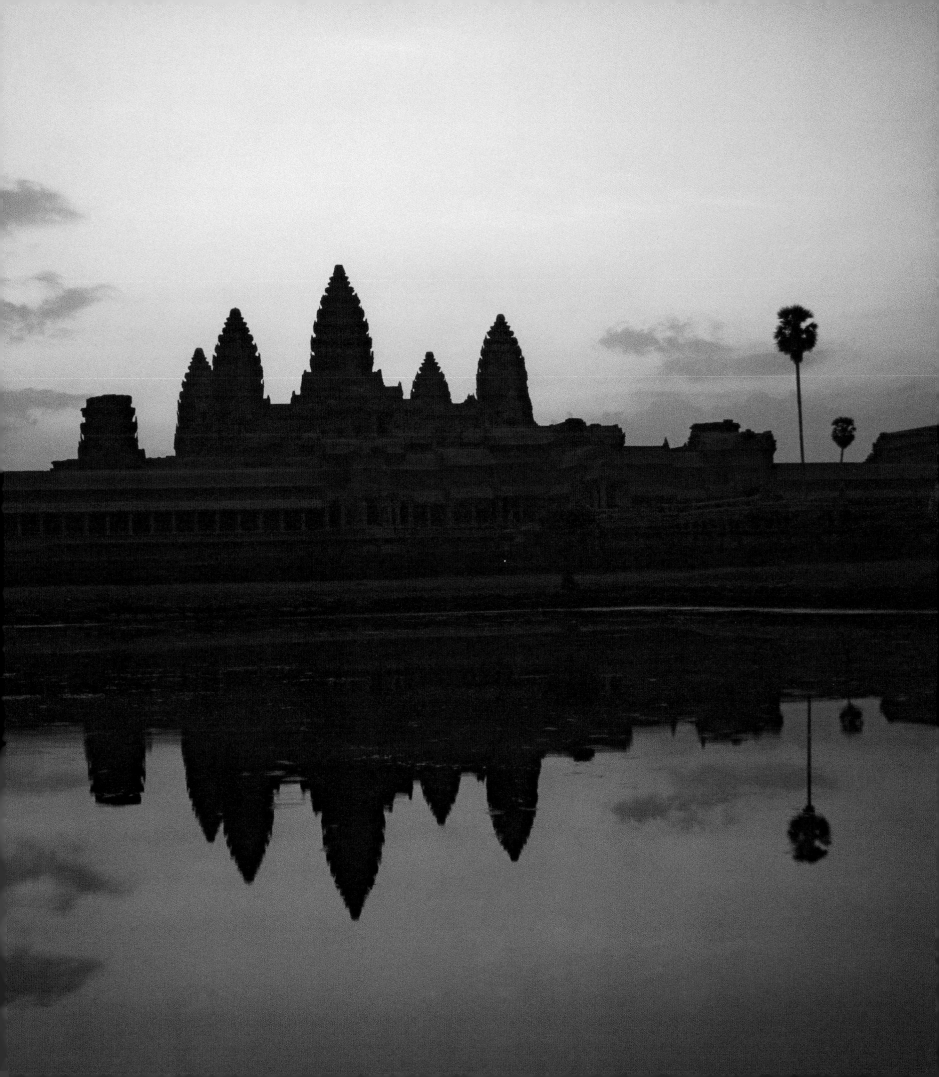

TA PROHM TEMPLE

Angkor, Cambodia

MAP SITE 25

Unlike other temples at Angkor, Ta Prohm has been left as it was found, preserved as an example of what a tropical forest will do to an architectural monument when the protective hands of humans are withdrawn. Ta Prohm's walls, roofs, chambers, and courtyards have been sufficiently repaired to stop further deterioration, and the inner sanctuary has been cleared of bushes and thick undergrowth. But the temple itself has been left in the stranglehold of trees. Having embedded their roots in the stones centuries ago, the trees' serpentine roots have pried apart the ancient stones, and their immense trunks straddle the once bustling Buddhist temple. Built in the later part of the twelfth century by Jayavarman VII as part of a grand reconstruction of the city of Angkor, Ta Prohm is in the same position, relative to other temples in the Angkor temple complex, as Eta Draconis is, in the Draco constellation. In that sense, it is its terrestrial counterpart. Jayavarman also built the Bayon Temple, whose architecture contains both Hindu and Buddhist features.

During the half-millennium of Khmer occupation, the city of Angkor became a pilgrimage destination of importance throughout Southeast Asia. Sacked by the Thais in 1431 CE and abandoned in 1432 CE, Angkor was forgotten for a few centuries. Wandering Buddhist monks passing through the dense jungles occasionally came upon the awesome ruins. Recognizing the sacred nature of the temples but ignorant of their origins, the monks invented fables about the mysterious sanctuaries, saying they had been built by the gods in a far ancient time. Centuries passed, these fables became legends, and pilgrims from the distant reaches of Asia sought out the mystic city of the gods. A few adventurous European travelers knew of the ruins, and stories circulated in antiquarian circles of a strange city lost in the jungles. Most people believed the stories to be nothing more than legend, however, until the French explorer Henri Mouhot brought Angkor to the world's attention in 1860. The French people were enchanted with the ancient city and, beginning in 1908, conducted an extensive restoration project. The restoration has continued to the present day, except during the 1970s and '80s when military fighting prevented archaeologists from living near the ruins.

Orthodox archaeologists sometimes interpret the temples of the Angkor complex as tombs of megalomaniacal kings, yet in reality those kings designed and constructed the temples as a form of service to both God and their own subjects. The temples were places not for the worship of the kings but rather for the worship of God. Precisely aligned with the stars, constructed as vast three-dimensional meditational forms, and adorned with stunningly beautiful religious art, the Angkor temples were instruments for assisting humans in their realization of the divine.

Jayavarman VII spoke of his intentions in erecting temples as being "full of deep sympathy for the good of the world, so as to bestow on men the ambrosia of remedies to win them immortality.... By virtue of these good works would that I might rescue all those who are struggling in the ocean of existence."

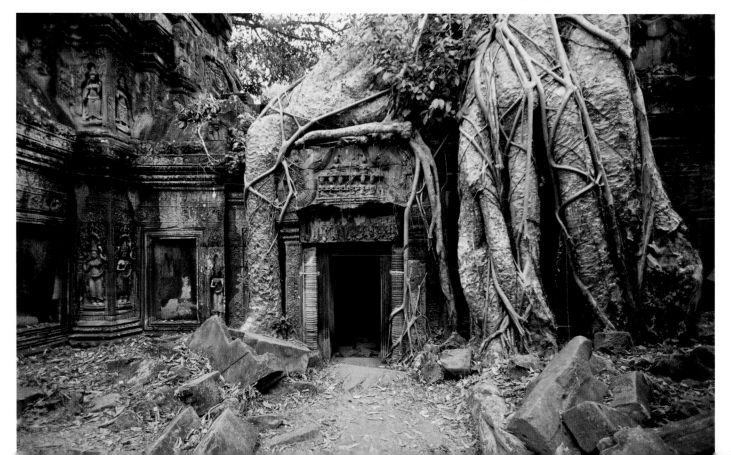

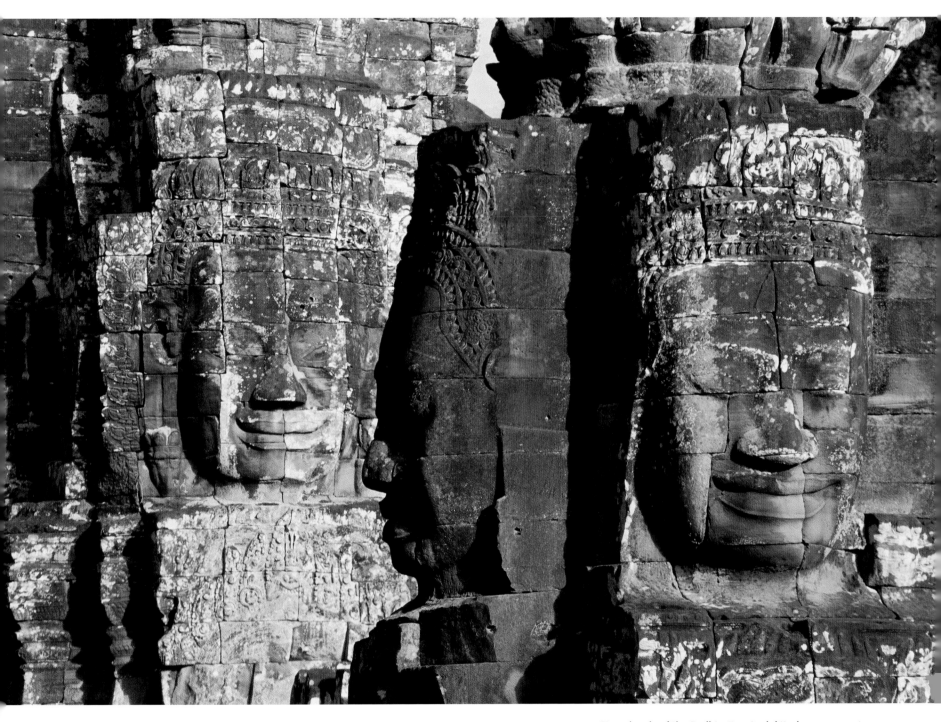

The relentless grip of the jungle; enormous banyan tree roots grip the walls of a temple at the ruins of Ta Prohm.

Stone heads of the Bodhisattva Avalokiteshvara grace stone walls at the Bayon Temple, the principle temple built by Jayavarman VII at Angkor.

Borobudur Stupa

Yogyakarta, Java, Indonesia
Map site 26

Sometime before the fifth century CE, Hinduism and Buddhism spread from Southeast Asia to the islands of the Indonesian archipelago. The first stone temples, Hindu shrines of the eighth century, are found on the Dieng plateau of Java. The greatest concentration of Javanese sacred architecture, however, lies near the city of Yogyakarta. Here stand the Hindu temple complex of Prambanam and the Hindu-Buddhist Temple of Borobudur.

Borobudur is commonly considered a Buddhist structure, yet its first and second terraces were Hindu constructions begun in 775 CE. From 790 to 835 CE, the Buddhist Sailendra Dynasty completed the great stupa. Soon thereafter, the Hindu Sanjaya Dynasty took over the Buddhist monuments of the Sailendra. Although the Sanjaya were Hindu, they ruled over a Buddhist majority, and Borobudur remained a Buddhist site. During the tenth and eleventh centuries, the great stupa fell into decline and lay forgotten, buried under volcanic ash and jungle growth. Europeans cleared the site in 1815, the Dutch began restoration in the early 1900s, and a U.S. project begun in 1973 completed the work.

Borobudur is a massive, symmetrical monument, 2,150 square feet (200 sq m) in size, that sits upon a low hill. The stupa represents a Buddhist cosmological model of the universe organized around the axis of mythical Mt. Meru. Beginning at the eastern gateway, pilgrims circumambulate the stupa in a clockwise direction. Walking through three miles (5 km) of open-air corridors while ascending six square terraces and three circular ones, the pilgrims symbolically spiral upward from the everyday world to the nirvanic state of absolute nothingness. The first six terraces are decorated with panels showing Buddhist doctrines and a panorama of ninth-century Javanese life. Crowning the entire structure is a great central stupa. Representing nirvana, it is empty.

Upon the three upper terraces of Borobudur are seventy-two smaller stupas, each of which once contained a statue of the Buddha, such as the one seen here.

SACRED MOUNTAINS OF BALI

Mt. Agung, Central Bali

MAP SITE 27

Bali is a relatively small island in the Indonesian archipelago, one of hundreds, with an area of only 2,147 square miles (5,560 sq km). Originally inhabited by aboriginal peoples of uncertain origin, Bali was colonized by a seafaring people, called the Austronesians, some four or five thousand years ago. Since the seventh century CE, the animistic Balinese have absorbed diverse elements of Mahayana Buddhism, Hindu Shivaism, and Tantrism. Today, the island is the only remaining stronghold of Hinduism in the archipelago, and the Balinese religion is a fascinating amalgam of Hinduism, Buddhism, Malay ancestor cults, and animistic magical beliefs and practices.

A range of towering volcanic mountains divides the island into the northern and southern parts. For the Balinese, these mountains are the homes of the gods. The range includes four primary sacred mountains: Agung, Batur, Batukao, and Abang. Of these, Gunung Agung, Bali's highest mountain at 10,308 feet (3,142 m), is the most sacred to the island's Hindus, while Gunung Batur is considered most holy by the Aboriginal people in the remote jungles around Lake Batur. Mt. Agung is the abode of Batara Gunung Agung, also identified as Mahadewa, the supreme manifestation of Shiva. Mt. Batur and Lake Batur are sacred to Dewi Danu, the Goddess of the Lake, who is regarded as the provider of those waters bubbling from natural springs around the lower slopes of Mt. Batur. The enormous freshwater sacred lake of 4,240 acres (1,717 ha) is considered by farmers and priests to be the ultimate source of the springs and rivers that provide irrigation water for the whole of central Bali.

SACRED TEMPLES OF BALI

Pura Besakih, Mt. Agung, Central Bali

MAP SITE 27

In Bali there are six most holy temples, Sad Kahyangan, or the Six Temples of the World. They are Besakih, Lempuyang Luhur, Gua Lawah, Batukaru, Pusering Jagat, and Uluwatu. Balinese temples are not closed buildings but rectangular courtyards open to the sky, with rows of shrines and altars dedicated to various deities. The shrines themselves are not considered sacred but rather exist as residences for holy spirits—either ancestors or Hindu deities. The gods are said to be present in the temples only on the dates of the temples' festivals, and therefore the temples are usually empty. On Hindu festival days, the congregation of each temple assembles to pray to and entertain the visiting deities.

The most famous temple in all Bali is the triple shrine located in the courtyard of the Pura Penataran Agung at Pura Besakih. At this shrine three *padmasanas* (a type of shrine) are arranged side by side. Although it is often said that the three shrines are for Brahma, Vishnu, and Shiva, all are fundamentally dedicated to Shiva. The elaborate tiered shrine is called a *meru* and symbolizes the world mountain, Gunung Maha Meru. Something like a Chinese pagoda, a *meru* is constructed of an odd number of thatched tiers. If, for some reason, a shrine must be moved to another location, the spirit of the shrine is first transferred to a *daksina,* a special offering, which is then placed nearby in a temporary shrine. The original shrine is then completely destroyed. None of its components may be reused for any purpose. Often the materials are dumped into the sea to ensure that they are not unwittingly used again. This practice is in contrast to certain other religious traditions where the reuse of the remains of earlier temples is considered to actually increase the sanctity and power of newer temples.

Other important Balinese temples are Ulun Danu Batur, the Temple of the Crater Lake, dedicated to the Lake Goddess Dewi Danu, and Tirta Empul, where the holiest waters of Bali flow, believed to possess magical curative powers.

The tiered *merus* at the Temple of Pura Besakih are built according to the laws of traditional Balinese architecture, which carefully specify the dimensions of a *meru*, the way it must be constructed, the type of wood appropriate for each part, and the ceremonies involved in its dedication.

Mt. Agung is sacred to Bali's Hindus as the supreme manifestation of Shiva.

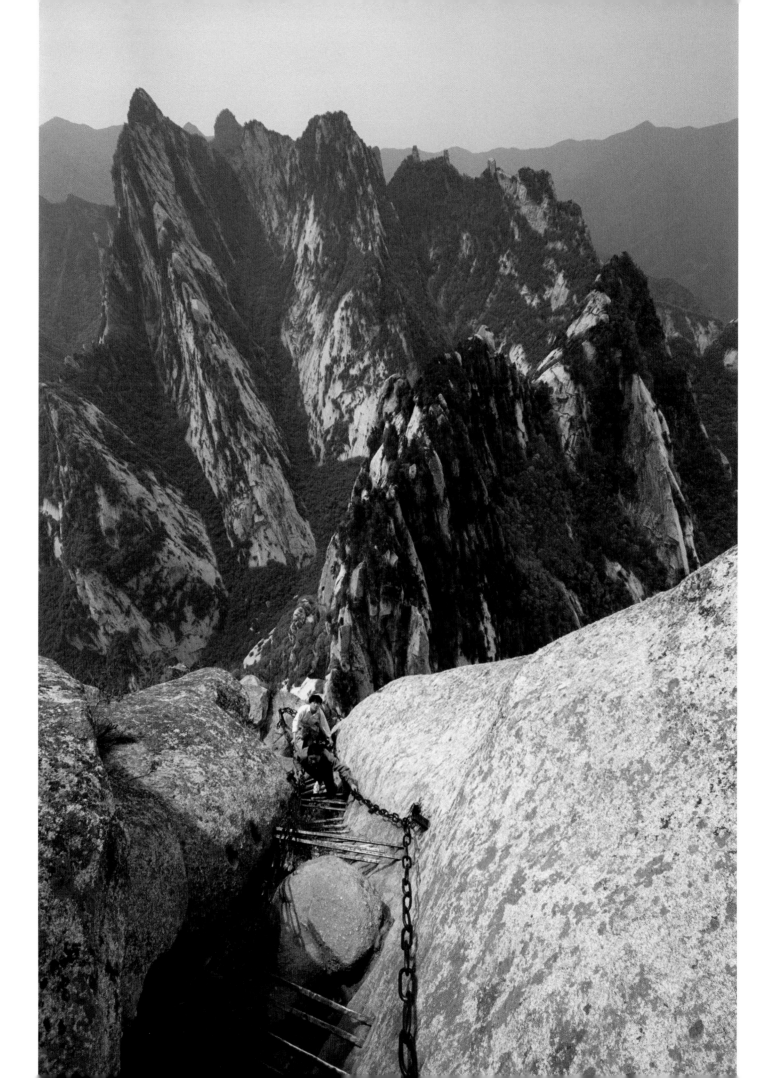

SACRED MOUNTAINS OF CHINA

Shaanxi, Shandong, and Zhejiang Provinces, China

MAP SITES 28 – 31

Possessing records of events that occurred three thousand years ago, China has the oldest recorded history of any region on earth. It is through legends, however, from long before written records were compiled, that we get the first stories of sacred mountains. Mountains were regarded as holy places because of the belief that they were earthly pillars supporting heaven. Other myths speak of mountains as the abodes of powerful nature spirits who created storms, bolts of lightning, and life-giving rain. Another reason for the sanctification of particular mountains were the legends of shamanism and early Taoism. These legends speak of sages and mystics, sometimes called immortals, who lived deep in the forested mountains, existed on diets of rare herbs and exotic elixirs, who lived to be five hundred years old. The mountain areas where the sages had lived came to be regarded as sacred places, as portals to the heavenly realm.

The *Shu-ching,* a fifth-century BCE classic of traditional history, tells that in the second millennium BCE, Chinese ruler Shun went on a pilgrimage every five years to the four mountains that marked the limits of his realm. These peaks then became some of the holy mountains of early Taoism. Other sources indicate that the following five mountains were highly venerated by the Taoists in ancient times: Tai Shan, Heng Shan Bei, Hua Shan, Heng Shan Nan, and Song Shan. It is important to note that the Chinese phrase for pilgrimage—"*ch' ao-shan chin-hsiang*"—means "paying one's respect to a mountain."

In the first century CE, traders returning from India via the Silk Route began the introduction of Buddhism into China. Over the next few centuries, adventurous Chinese pilgrims traveled to India to visit the sacred places of the Buddha's life. Some of these pilgrims returned with an affinity for the Buddhist tradition of monastic life. Like Taoist hermits, Buddhists monks favored quiet mountains for their meditative practices. Each of the Buddhist sacred mountains was considered to be the home of a particular bodhisattva, a spiritual being dedicated to the service of helping sentient creatures transcend suffering and attain enlightenment. Hermitages and monasteries were established at certain peaks, some previously considered sacred by the Taoists, and over the centuries the Chinese Buddhists began to regard four peaks as having primary sanctity: Putuo Shan, in the east—sacred to the Bodhisattva Guan Yin; Wu Tai Shan, in the north—sacred to the Bodhisattva Manjushri; Emei Shan, in the west—sacred to the Bodhisattva Samantabhadra; and Jiu Hua Shan, in the south— sacred to the Bodhisattva Ksitigarbha.

These Buddhist sacred mountains, along with the Taoist peaks, became the primary pilgrimage destinations of both China's masses and the ruling elite.

Hua Shan

The five peaks of Hua Shan resemble the petals of a flower— hence its common name, the Flowery Mountain. A difficult ten-mile (16 km) path leads to the Green Dragon Ridge and other trails to the five peaks. Formerly the mountains held numerous temples, but now few remain.

Tai Shan

Tai Shan is not merely the mountain home of the gods; it is considered a deity itself and has been venerated by the Chinese as their most sacred peak since at least the third millennium BCE. The emperors of ancient China regarded Tai Shan as the actual son of the Emperor of Heaven, from whom they received their own authority to rule the people. The mountain functioned as a god who looked after the affairs of humans and who also acted as a communication channel for humans to speak to God. Seventy-two legendary emperors are said to have come to Tai Shan, but the first known

Pilgrims scale Hua Shan. Today Hua Shan is a popular hiking destination for Chinese youth on vacation, yet the mountain routes are still trekked by devout pilgrims and wandering monks. In order to reach certain caves of the sages, pilgrims must scale cliffs with only a linked chain for protection from a fall to certain death.

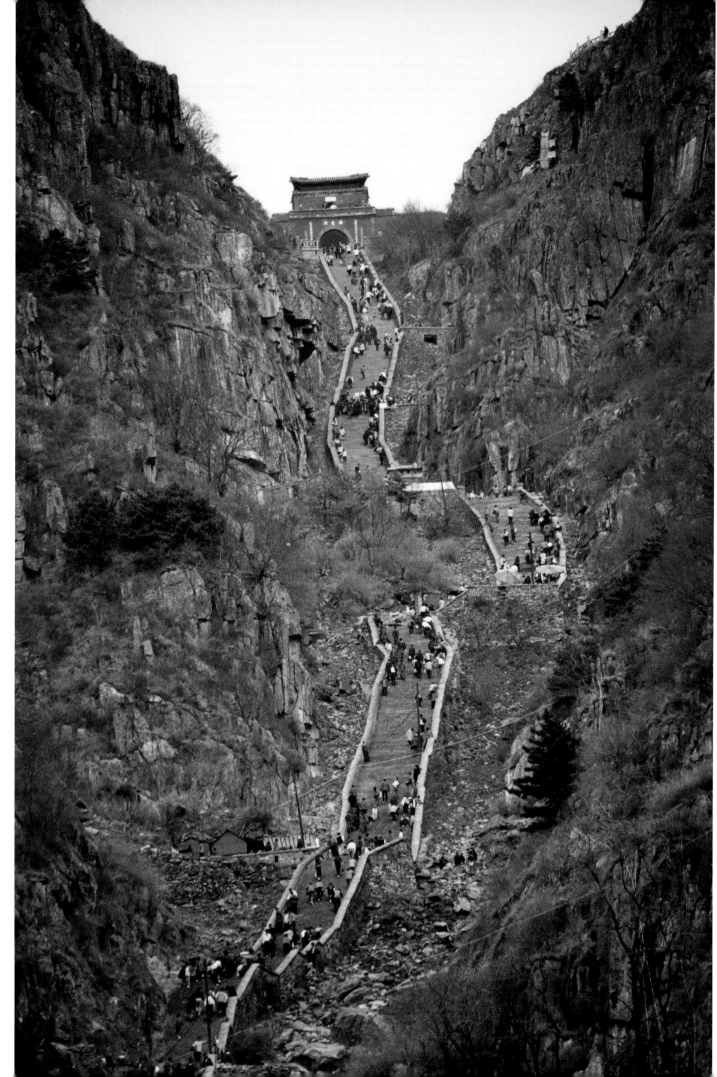

Consisting of more than seven thousand steps, the Stairway to Heaven leads to the summit of Tai Shan, which is dotted with numerous temples, inns, small restaurants, and shops for the millions of annual pilgrims.

evidence dates from a rock carving left on the mountain in 219 BCE by Emperor Shih Huang-ti, who is also remembered for having begun construction of the Great Wall. Historical record tells of the sometimes enormous retinues that would accompany an emperor on his pilgrimage to Tai Shan; lines of people might stretch from the bottom to the top of the mountain, a distance of more than six miles (10 km). Besides royalty, artists and poets have also favored the holy peak. The walls lining the path up the mountain are covered with poems and tributes carved in stone, proclaiming the importance and beauty of the surroundings. Confucius and the poet Dufu both wrote poems expressing their respect, and legend tells that those who climb the mountain will live until they are one hundred years old.

Temples of Wu Tai Shan

The center of Chinese Buddhism for two thousand years, Wu Tai Shan was originally the Taoist sacred mountain of Tzu-fu Shan and was believed to be the abode of Taoist immortals. At few other places in China can such an abundance of traditional temple architecture be found. The first known temples were built during the reign of Emperor Ming Di in the first century CE. Fifty-eight temples built after the seventh century Tang Dynasty still stand, as well as the oldest wooden temple in all of China, the Nan Chan Si Temple, built in 782 CE. There are forty-eight temples of Chinese Buddhism and ten Tibetan lamaseries. The peaks of Wu Tai and

the surrounding temples are sacred to Manjushri, the Buddhist bodhisattva of wisdom and virtue. Manjushri is believed to reside in the vicinity of Wu Tai Shan, and numerous legends speak of apparitions of the bodhisattva riding a blue lion high in the mountains above the monasteries.

Puji Temple, Putuo Shan

Putuo Shan, the lowest of China's sacred mountains, is located on a small island in Zhejiang Province. A holy place long before the arrival of Buddhism, the island is now considered sacred to the Bodhisattva Avalokiteshvara, the goddess of compassion who attained enlightenment upon the island. The temples of Avalokiteshvara on Putuo Shan, many built in the eleventh century, are among the most elaborate in all of China. Chinese legends tell that Avalokiteshvara, also known as Guan Yin, was born on February 19 of the lunar calendar, and achieved enlightenment on June 19, and nirvana on September 19. On these dates, thousands of pilgrims from around the country congregate at Putuo Shan to celebrate the goddess. Avalokiteshvara, was originally a male bodhisattva in India but changed gender after reaching China. In Putuo Shan, she is sometimes depicted holding a vase in her hand and pouring holy water to ease the suffering of people. This bodhisattva, in either of its gender forms, is a deity of mercy and gentleness, and the association with Putuo Shan indicates that the energetic character of this sacred place is conducive to the development of compassion in the human heart.

Following pages: **The Puji Temple** on China's sacred Putuo Shan is dedicated to the goddess Guan Yin, a feminine version of the male bodhisattva known in India as Avalokiteshvara.

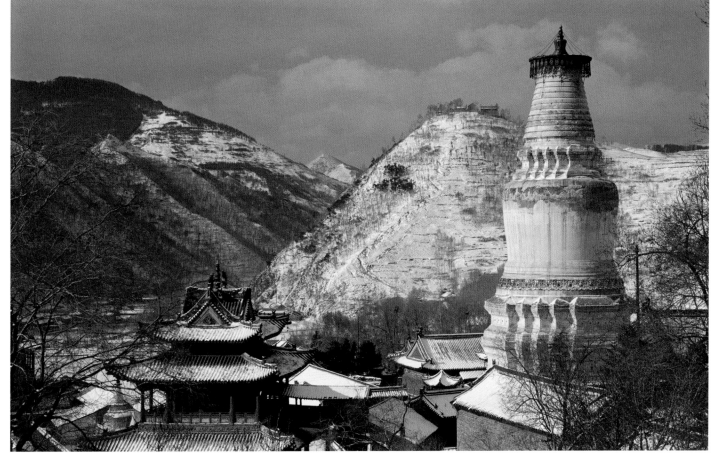

Two important temples are situated on the peak of Wu Tai Shan: the Temple of the Jade Emperor and the Temple of the Princess of the Azure Clouds. The latter is one of the most venerated places of pilgrimage for Chinese women— thousands make the long climb each day.

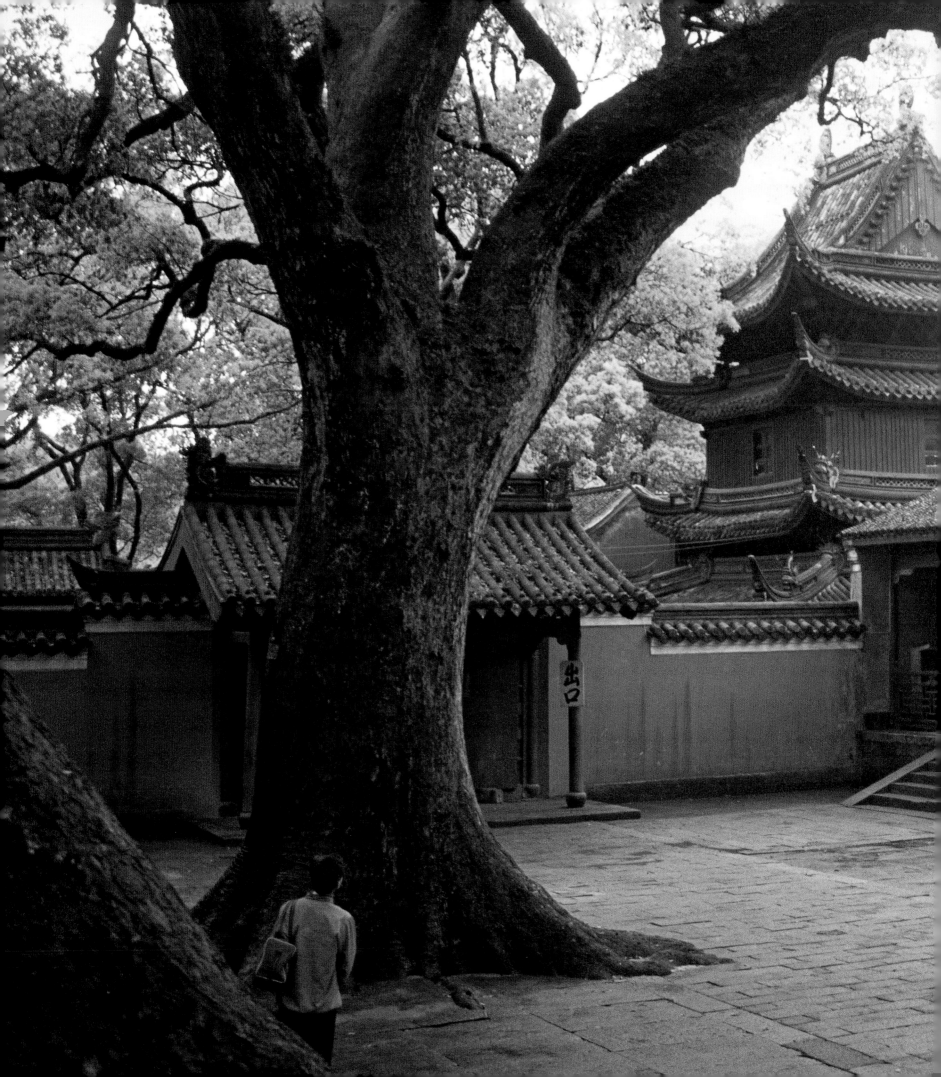

SACRED EARTH

NANTAI–SAN

Honshu, Japan

MAP SITE 32

The sacred places and pilgrimage traditions of Japan have been conditioned by geographical features as much as by religious and cultural factors. More than 80 percent of the Japanese countryside is hilly or mountainous terrain. This physical characteristic led to a unique and enduring tradition in ancient times of religious beliefs and practices focused on mountains. This tradition was so widespread that Japanese scholars have termed it Sangaku Shinko, meaning "mountain beliefs" or "mountain creed."

Soaring above beautiful Lake Chuzenji and the ancient temple town of Nikko is the sacred mountain of Nantai-san. Also known as Kurokiyama and Futaarasan, the 8,149-foot (2,484 m) peak has been a place of Shinto pilgrimage since at least the fourth century CE. Local legends tell of a powerful mountain spirit that assisted hermits and monks in spiritual realization, and by the eighth century, Nantai-san was a favored site for Buddhist practitioners on solitary retreats. I spent some days living on the mountaintop. Besides finding the place highly conducive for the practice of meditation, I received visionary information indicating that Nantai-san had an energy field that would awaken and stimulate the capacity of human creativity. This particular energy field is highly concentrated during the time of August 1 to 7, when thousands of pilgrims climb the mountain, starting from behind the Chugushi shrine in Nikko.

The sacred mountain of Nantai-san has been revered in Japan for more than sixteen hundred years. The appellation *san* is an indication of deep respect.

Fuji-san as seen from Tokyo; more than 400,000 people climb this mountain annually.

Fuji-san

Shizuoka and Yamanashi Prefectures, Japan

Map site 33

Fuji-san is frequently, but mistakenly, spoken of as the most sacred mountain in Japan. While there is no such thing as a most sacred mountain in Japan, Fuji-san has become famous as a national symbol because it is the highest peak in the country at 12,388 feet (3,776 m); it is one of the most symmetrical volcano cones in the world; and it is visible from Tokyo, only sixty miles (97 km) away. Younger than many Japanese mountains, Fuji-san began to rise only twenty-five thousand years ago and probably assumed its general form by 8000 BCE. There is an ancient body of myths regarding the mountain's divine origins, resident deities, and spiritual powers. Occasionally smoking since its last major eruption in 1707, the beautiful peak has been venerated as the home of a fire god, then the dwelling of a Shinto goddess of flowing trees, and, since Buddhist times, as the abode of Dainichi Nyorai, the Buddha of All-Illuminating Wisdom. While scholars debate the origin of the various names of the mountain, one of the most commonly used means "everlasting life." According to early myths, the mountain was first climbed by the wizard-sage En no Gyoja around 700 CE, but it is more likely that the first ascents began in the twelfth or thirteenth centuries.

Izumo Taisha Temple

Taisha, Japan

Map site 34

Situated at the foot of the sacred Yakumo and Kamiyama hills, the beautiful temple complex of Izumo Taisha is the oldest and most important Shinto shrine in Japan. According to the *Kojiki* (*Legendary Stories of Old Japan*) and the *Nihon Shoki* (*Chronicles of Japan*), the main shrine was the largest wooden structure in the country prior to 1200 CE. The height of the main shrine was then about 164 feet (50 m), surpassing the 151 feet (46 m) of the Todaiji Temple in Nara, which is the largest wooden structure in the world today. Sometime around 1200, following a great fire, the main shrine was rebuilt to about half of its original size. The present shrine dates from 1744.

The Izumo Taisha shrine is dedicated to the Shinto deity Okuninushi-no-kami. Legends tell that Okuninushi's father courted and married his mother at Izumo Taisha. Because of this divine marriage, the shrine has from ancient times been a special place for marriage ceremonies for the Japanese people. Okuninushi is also the deity who is traditionally credited with the introduction of medicine and the art of farming. Izumo Taisha hosts at least fifteen major festivals each year. The November festival of Kamiarizuki, or Time When the Spirits Gather, is an especially fascinating celebration attended by thousands of pilgrims. During Kamiarizuki, it is believed that the Kami nature spirits of lakes, rivers, and mountains come from around the country to gather for one month at Izumo Taisha.

Shinto priests welcome Kami spirits during a Kamiarizuki festival at the shore of the nearby ocean. There was a definite and palpable sense of a mysterious energy at this time. Following the beachside greeting, pilgrims installed the Kami spirits in wooden boxes, danced as they carried them through town, and then took the boxes to the shrine.

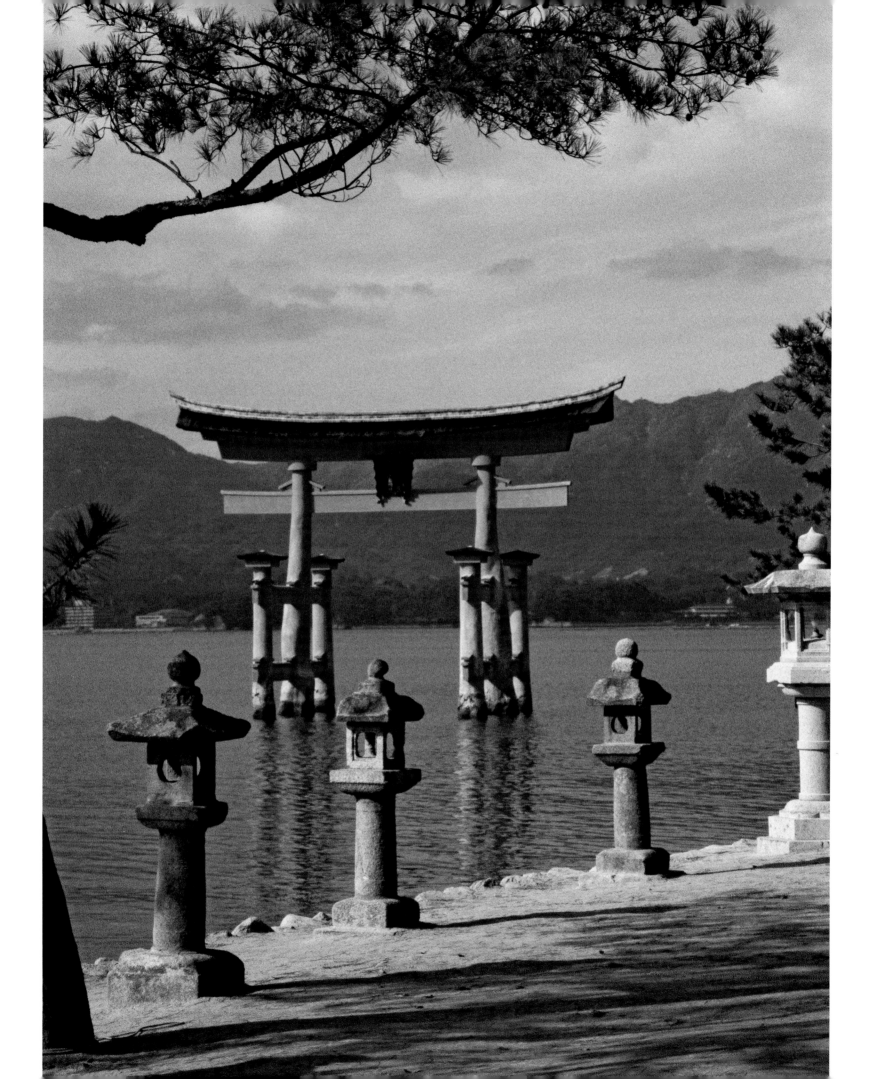

HOLY ISLAND OF MIYAJIMA

Hatsukaichi, Japan

MAP SITE 35

Located several miles off the coast of Hiroshima city, the holy island of Miyajima is a sacred site of both Shintoism and Buddhism and one of the most enchantingly beautiful places on earth. To come by boat in the early morning across the mist-enshrouded sea, slowly approaching the island and its sacred mountain of Misen-san, is to enter a fairy-tale realm. Long before Buddhism came to Japan in the fifth century CE, Shinto sages lived as hermits in the mountain's forested hills. Today the small island of only twelve square miles (31 sq km) is much visited by pilgrims and tourists yet still retains its extraordinary sense of serenity and magic.

Blanketed with luxuriant primeval forests, Misen-san is the highest peak on Miyajima, rising to 1,739 feet (530 m). Its lofty summit gives a panoramic view of many other islands in the Seto Inland Sea and the distant mountain ranges of Shikoku. Near the summit are a few small temples, including the Gumonjido, a temple founded in the early ninth century CE by the great sage Kobo Daishi on his return from China. A flame within the temple has burned consistently from the time of the temple's dedication to the present. There is a cable car that goes to the summit, but it is more enjoyable to walk along one of the three paths through the forests. The Omoto path is the most beautiful and the least used; strolling here, you feel yourself transported back to the semi-mythical days of Kobo Daishi and the Shinto mountain mystics. The peaceful forests of Misen-san are also home to some two thousand domesticated deer.

Miyajima's primary temple, the Itsukushima Shrine, was first constructed in 593 CE and enlarged to its present size in 1168. The complex of buildings includes the main shrine, several subsidiary temples, a Noh drama and dance stage, and many bridges and walkways linking the various parts of the temple. Built on tidal land that during high tide gives the structure the appearance of floating on the sea, the shrine is dedicated to three Shinto goddesses of the sea: Ichikishima, Tagori, and Tagitsu, each of whom is believed to live within the inner sanctum of the shrine. Metal nails were not used in the construction of the buildings, and there are precisely calculated crevices between the floor slabs to alleviate the pressure of high tidal waves caused by typhoons. Some of the ancient wooden planks used for flooring are five feet (1.5 m) wide and more than thirty-three feet (10 m) long, and these enormous boards were laboriously transported to Miyajima from northern Japan, hundreds of miles away.

Following pages: **The Itsukushima Shrine,** listed as a National Treasure with the government of Japan, is one of the world's most extraordinary examples of sacred architecture. Associated with the Itsukushima Shrine, and considered a part of its sacred geography, are seven smaller shrines positioned around the island. There are no roads to most of these shrines; pilgrims use small boats to approach the rocky shores where the temples are located.

The lovely Otorii gate, which stands in the sea and leads to the Itsukushima shrine, is the symbol of Miyajima Island. The present Otorii, the eighth constructed since the Heian Period (794–1185), was built in 1875 from camphor wood. It is fifty-two feet (16 m) tall, the roof is seventy-nine feet (24 m) wide, and the main pillars are made from single trees. The Otorii is self-supporting and has no parts buried in the ground. During the mid-July Kangensai music festival, colorfully decorated boats sail through the giant gate while dancers aboard the boats perform sacred dances.

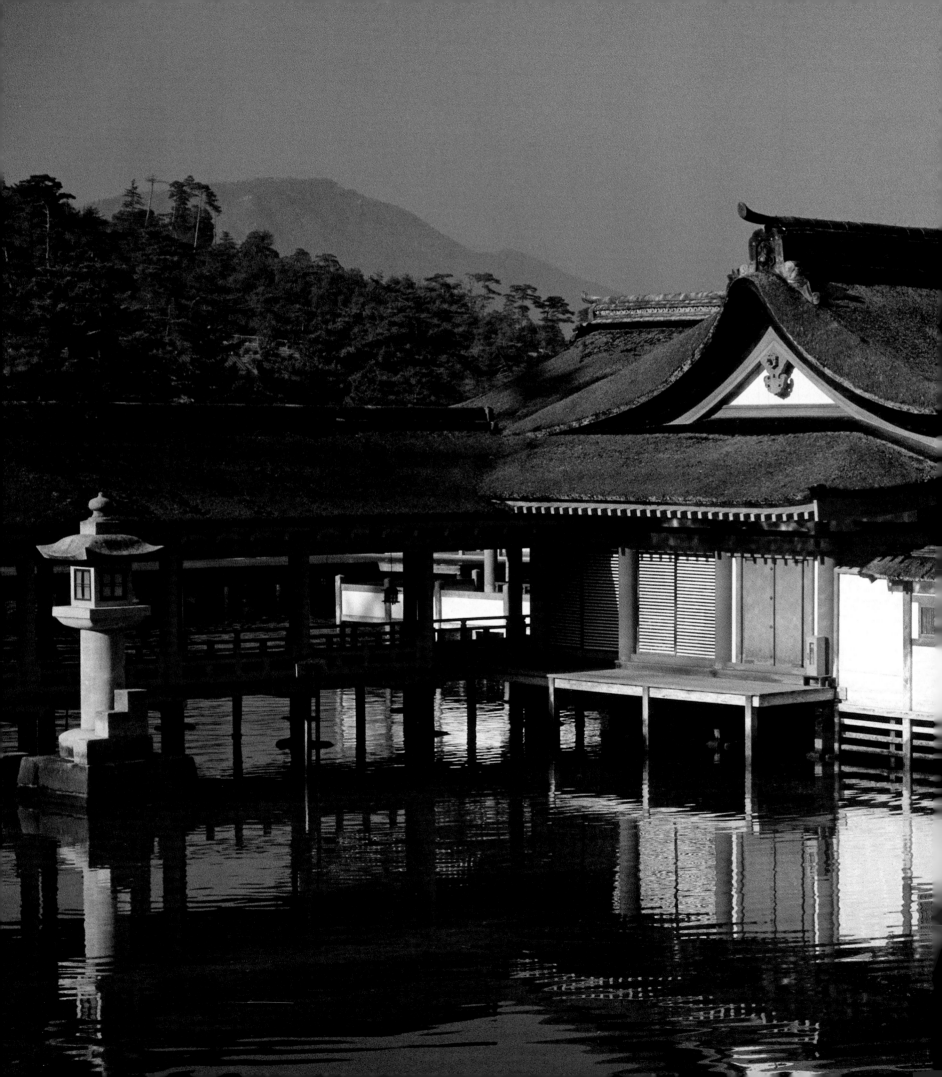

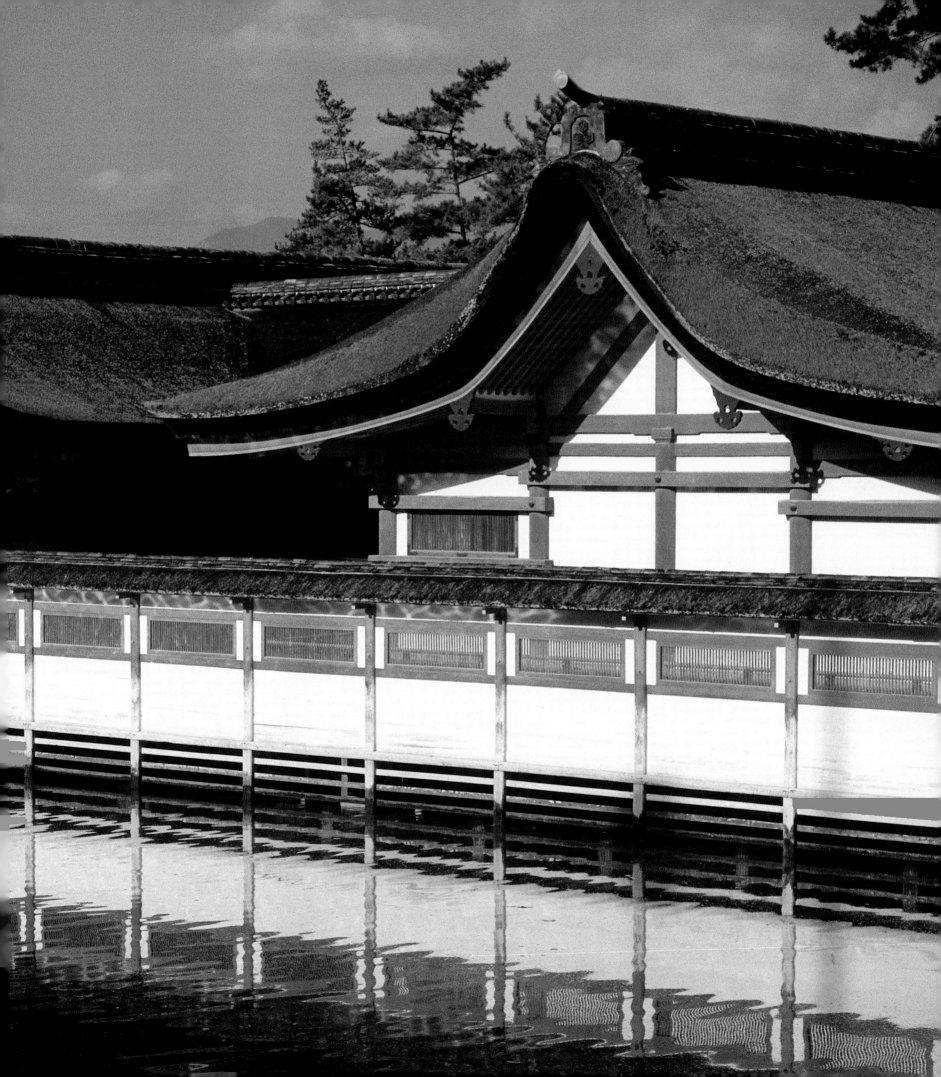

Adjacent to the Itsukushima Shrine on Miyajima Island is the Hokoku Shrine; a detail of the shrine is shown in the photograph at right. The fifteenth-century structure was left partly unfinished after its builder, the fabled Japanese warrior Hideyoshi Toyotomi, died. An inner part of this shrine, known as the Senjokaku, was constructed by Toyotomi for the repose of the souls of war dead. The five-storied pagoda, ninety feet (27 m) tall, represents a harmonious combination of Chinese and Japanese architectural styles. Within the pagoda, painted in full color, is a beautiful image of the Buddha.

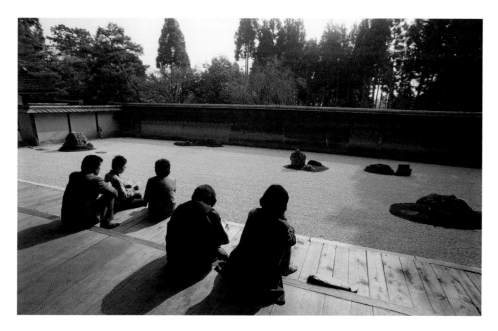

Pilgrims meditate at the Zen garden of Ryoan-ji in Kyoto.

ZEN GARDEN OF RYOAN-JI

Kyoto, Japan
MAP SITE 36

Ryoan-ji, the Temple of the Peaceful Dragon, was founded in 1473 CE by Katsumoto Hosokawa. Within the precincts of the beautiful temple is the Zen garden of Soami, completed in 1499. The garden is extremely simple, composed of fifteen stones set in a small field of white gravel. The stones are arranged in five groupings of five, two, three, two, and three, and are so placed that when viewed from any vantage point there is always one rock hidden from sight. Fondly called the Garden of Emptiness, Ryoan-ji is a sublime place to meditate on the transitory nature of all worldly phenomena. The best times to visit are in the winter months, during the weekdays, in the snow or pouring rain.

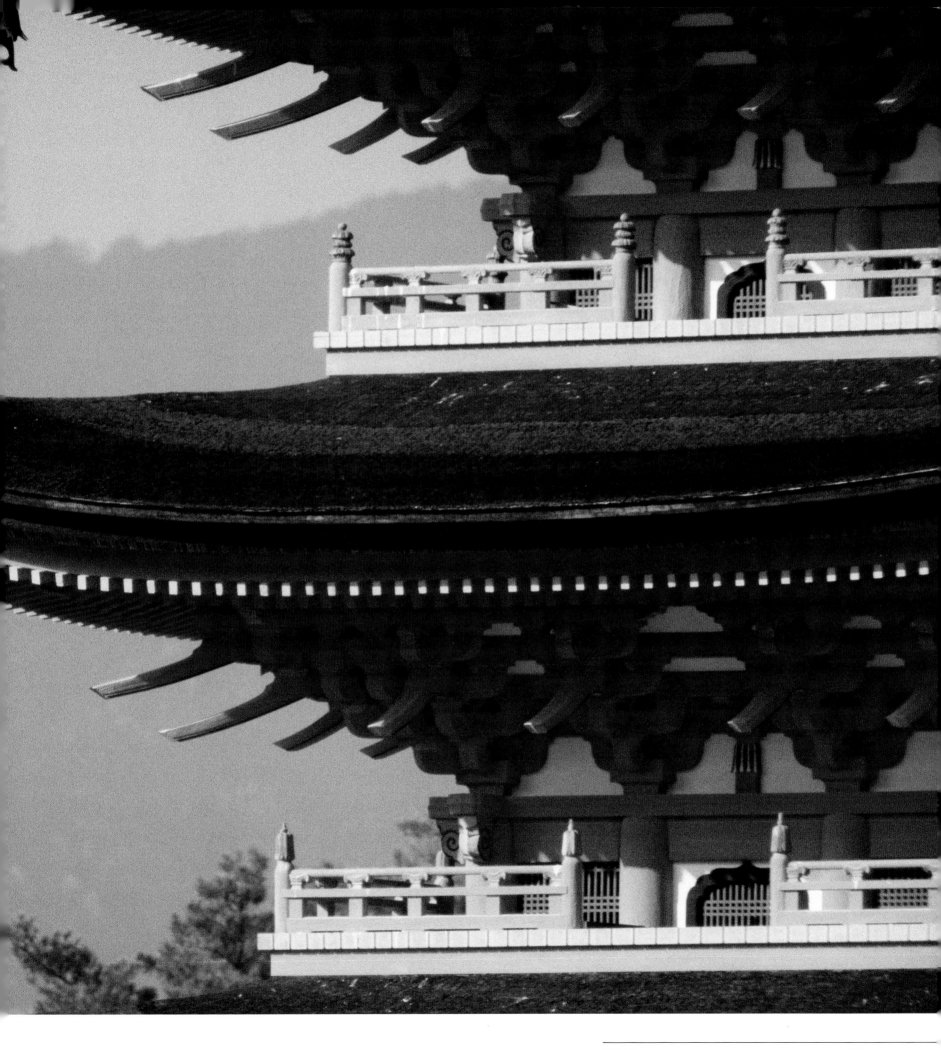

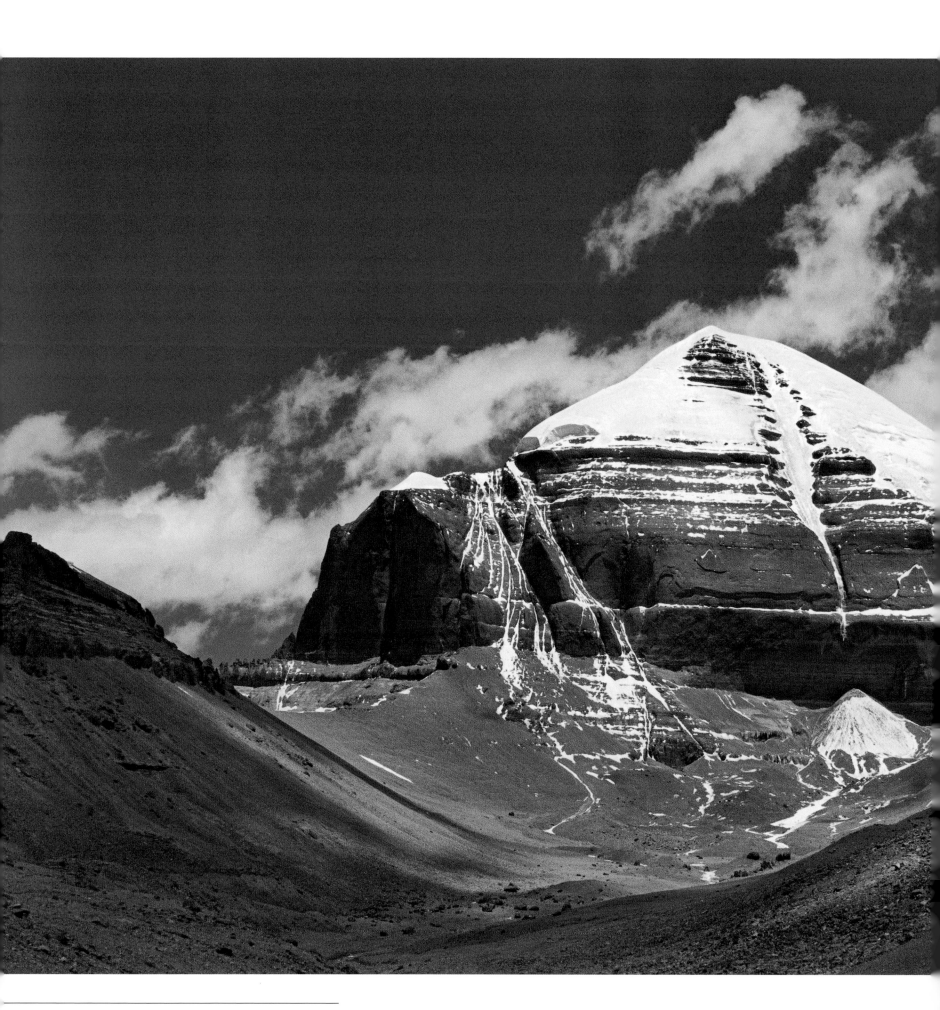

SACRED EARTH

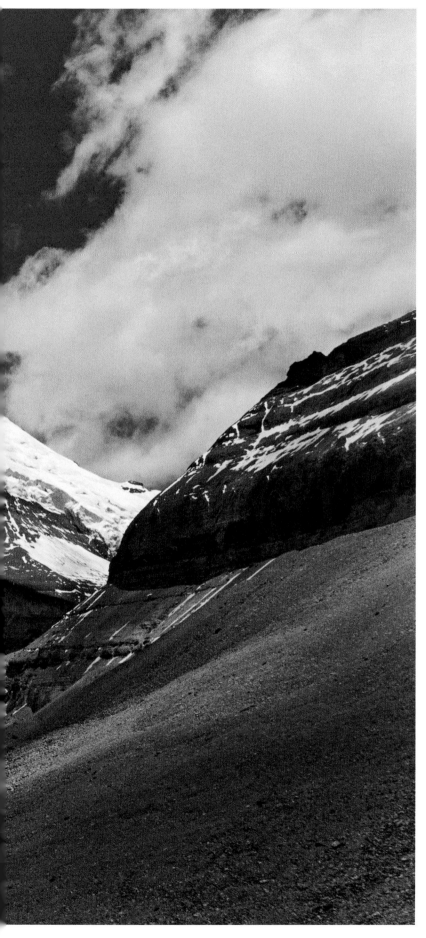

MT. KAILASH

Kailash Range, Southwestern Tibet

MAP SITE 37

Soaring to 22,027 feet (6,714 m), Mt. Kailash is one of the world's most venerated holy places but also one of the least visited. A sacred site of four religions and for billions of people, Kailash is visited by only a few thousand pilgrims each year. This curious fact is explained by the mountain's remote location in far western Tibet. Hindus believe Kailash to be the abode of Shiva, the Lord of Yoga and the divine master of Tantra. According to legend, immortal Shiva lives atop Kailash practicing yoga, making love with his consort, Parvati, and smoking ganja, the sacred herb marijuana. Kailash is sacred to other religions as well. The Jains call the mountain Astapada and believe it to be the place where Rishaba, the first of the twenty-four Tirthankaras, attained liberation. Followers of Bön, Tibet's pre-Buddhist shamanistic religion, call the mountain Yungdrung Gu Tse and believe it to be the home of the sky goddess Sipaimen. Tibetan Buddhists call the mountain Kang Rinpoche, the Precious One of Glacial Snow, and regard it as the dwelling place of the Tantric deity Demchog and his consort, Dorje Phagmo.

Pilgrims to Kailash, after the difficult journey there, have the arduous task of circumambulating the sacred peak. Known as a *kora* or *parikrama*, this circuit normally takes three days. For some it will take two to three weeks, while making full-body prostrations the entire way. Most pilgrims to Kailash will also take a short plunge in nearby Lake Manasarovar, the Lake of Consciousness and Enlightenment. How long have people been coming to this sacred mountain? The answer is lost in antiquity, before the dawn of Hinduism, Jainism, or Buddhism. The origin myths of each of these religions speak of Kailash as the mythical Mt. Meru, the axis mundi, the center and birthplace of the entire world. Indeed, Kailash is so deeply embedded in Asian mythology that it was perhaps a sacred place of another era, another civilization, now long gone and forgotten.

Mt. Kailash, in Tibet, is one of the world's most sacred but least visited sites. No planes, trains, or buses journey anywhere near the region, and even in all-terrain vehicles, the trip still requires travel through difficult, often dangerous, terrain. The weather, always cold, can be unexpectedly treacherous, and pilgrims must carry all the supplies they will need for the entire journey.

Potala Palace

Lhasa, Tibet

Map site 38

Perched upon Marpo Ri Hill, 426 feet (130 m) above the Lhasa valley, the Potala Palace rises a further 558 feet (170 m) and is the greatest monumental structure in all of Tibet. Early legends concerning the rocky hill tell of a sacred cave, considered to be the dwelling place of the Bodhisattva Chenrezig (Avalokiteshvara, or Guan Yin), which was used as a meditation retreat by King Songtsen Gampo in the seventh century CE. In 637 CE, Gampo, who is considered an emanation of Avalokiteshvara, built a palace on the hill. This structure stood until the seventeenth century, when it was incorporated into the foundations of the buildings still standing today. From as early as the eleventh century, the palace was called Potala. This name probably derives from Mt. Potala, the mythological mountain abode of the Bodhisattva Avalokiteshvara in southern India.

The Potala is an immense structure, its interior space being in excess of 1.4 million square feet (130,000 sq m). Fulfilling numerous functions, the Potala was the residence of the Dalai Lama and his large staff until he fled Tibet, in 1959. Until that time, it was also the seat of the Tibetan government. Additionally, it housed a school for training monks, and it was one of Tibet's major pilgrimage destinations because of the tombs of past Dalai Lamas. Within the Potala are two small chapels, the Phakpa Lhakhang and the Chogyal Drubphuk. Dating from the seventh century, these chapels are the oldest surviving structures on the hill and also the most sacred. The Potala's most venerated statue, the Arya Lokeshvara, is housed inside the Phapka Lhakhang and draws thousands of Tibetan pilgrims each day.

Jokhang Temple

Lhasa, Tibet

Map site 38

Before the arrival of Buddhism, the locations of the Jokhang Temple and the Potala Palace were holy places of Bön, the indigenous religion of Tibet. Both sites are also associated with King Songtsen Gampo. When Gampo's wife, the Chinese princess Wencheng, arrived in Lhasa in 641 CE, she brought two statues: the Akshobhya Vajra depicting the Buddha at age eight, and the Jowo Shakyamuni depicting the Buddha at age twelve. At a Bönpo site, the Paradise of the Water Divinities, the Ramoche Temple was constructed to house the Jowo Shakyamuni statue.

A second temple, the Rasa Trulnang Tsuglag Khang, was constructed to house the Akshobhya Vajra statue. The site of this temple, in the middle of Lake Wothang, was determined through geomantic divination, yet work done each day was mysteriously undone that evening. By further divinations, the king learned that Tibet was situated upon the back of a sleeping female demon. The demon was inhibiting the introduction of Buddhism and could be pacified only by the construction of twelve temples at specific geomantic locations in the countryside. King Gampo attended to this work—which can be clearly seen as the Buddhist usurpation of pagan sacred sites—and then completed the Rasa Temple and installed the Akshobhya Vajra statue. This temple, called the House of Mysteries, was erected upon the heart of the demon and was also considered to be a gateway to the underworld.

In 649 CE the statues were switched between the two temples, and the Rasa Temple was renamed Jokhang, the Shrine of the Jowo. Because the temple is not controlled by any particular sect of Tibetan Buddhism, it attracts adherents of all the sects as well as followers of Bön. Consisting of three floors and many chapels, the Jokhang has undergone many reconstructions since the seventh century. Housed in the Jowo Lhakhang shrine, the Jowo Shakyamuni, or Wish-Fulfilling Gem, is cast from precious metals and decorated with glittering jewels. Three pilgrimage circuits exist in Lhasa: the Lingkhor, which encircles the city's sacred district; the Barkhor, which encloses the Jokhang Temple; and the Nangkhor, a ritual corridor inside the Jokhang.

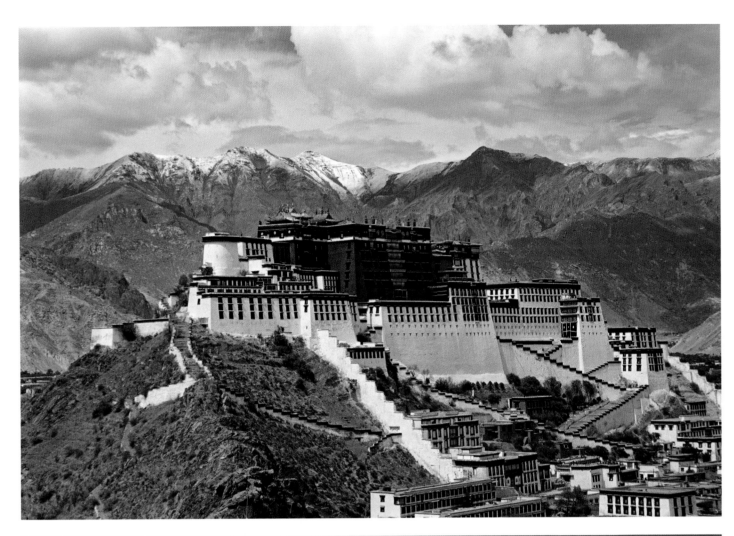

The Potala Palace, twelve thousand feet (3,658 m) above sea level, contains more than one thousand rooms. The palace was only slightly damaged during the Tibetan uprising against the invading Chinese in 1959. As a result, all the chapels and their thousands of artifacts are well preserved. Today it is operated as a museum by the Chinese government.

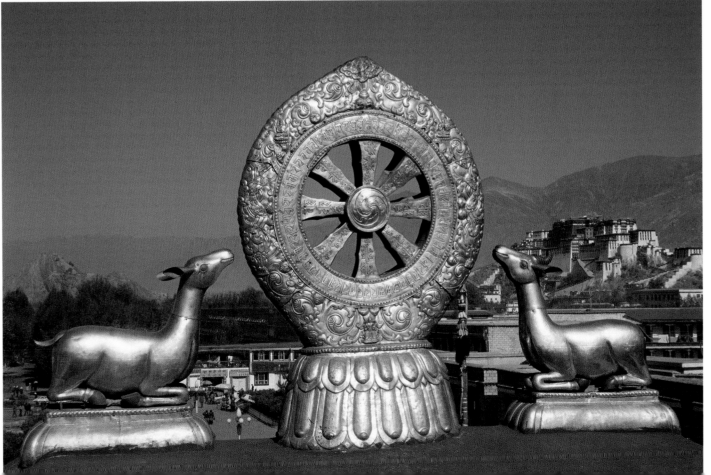

On the roof of the Jokhang Temple, a golden Wheel of Dharma is flanked by two deer, which are symbolic of the Buddha's first teaching in Deer Park in Sarnath, India. The Potala Palace can be seen in the distance.

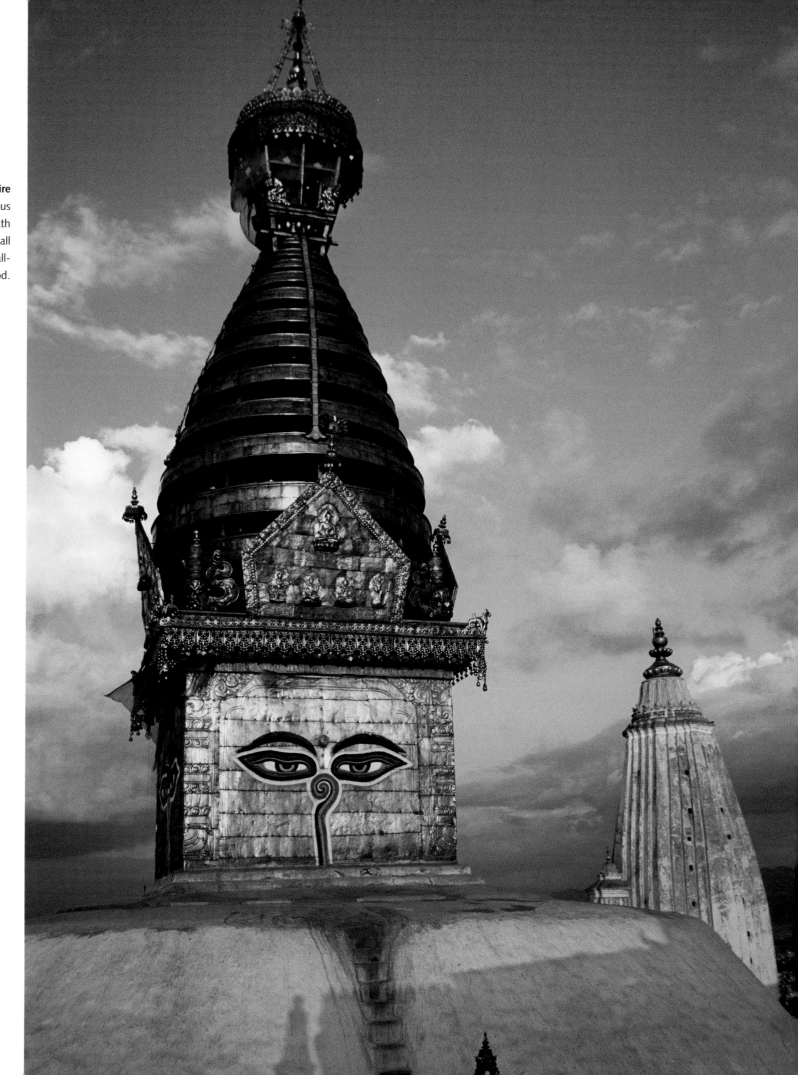

The golden spire of the mysterious Swayambhunath Stupa; painted on all four sides are the all-seeing eyes of God.

SWAYAMBHUNATH STUPA

Kathmandu, Nepal

MAP SITE 39

A golden temple crowning a wooded hill, Swayambhunath Stupa is the most ancient and enigmatic of all the holy shrines in Kathmandu valley. Historical records found on a stone inscription give evidence that the stupa was already an important Buddhist pilgrimage destination by the fifth century CE. Its origins, however, date to a much earlier time, long before the arrival of Buddhism into the valley. Swayambhunath's worshippers include Hindus, Vajrayana Buddhists of northern Nepal and Tibet, and the Newari Buddhists of central and southern Nepal. Each morning before dawn, hundreds of pilgrims ascend the 365 steps leading up the hill and begin a series of circumambulations of the stupa. On each of the stupa's four sides is a pair of large eyes. These eyes are symbolic of God's all-seeing perspective. There is no nose between the eyes but rather a representation of the number one in the Nepali alphabet,

signifying that the single way to enlightenment is through the Buddhist path. Above each pair of eyes is another eye, the third eye, signifying the wisdom of looking within. No ears are shown because it is said the Buddha is not interested in hearing prayers in praise of him. Atop Swayambhunath Hill is another fascinating, though smaller and less visited, temple. This is Shantipur, the Place of Peace, inside of which, according to legend—in a secret and always locked underground chamber—lives the eighth-century Tantric master Shantikar Acharya. Practicing meditation techniques that have preserved his life for centuries, he is a great esoteric magician who has complete power over the weather. Swayambhunath Stupa is also called the Monkey Temple because of the many hundreds of monkeys that scamper about the temple at nighttime after the pilgrims have departed.

Pilgrims ascend the stairs to the Swayambhunath Stupa in Kathmandu, Nepal. The stupa is also called the Monkey Temple, and several monkeys are visible, sitting atop the yellow Buddha statue at the base of the stairs.

CAVE TEMPLE COMPLEX OF SANBANGSA

Jeju-do, South Korea
MAP SITE 40

Sixty miles (97 km) off the southern tip of South Korea stands the small island of Jeju-do, dominated by the extinct volcano peak of Halla-san, which rises 5,850 feet (1,783 m). Neither mythology nor anthropology indicates the origins of the ancestral stock of Jeju-do, and its people are probably a mix of indigenous Koreans, Chinese, Malayans, and Japanese. During Neolithic times, a unique culture developed on the island, and legends speak of the volcanic peak as the dwelling place of spirits and giants. By the end of the first millennium BCE, Jeju-do had entered the realm of Chinese mythology as one of the islands of Samshinsan, or Islands of the Blest. One of these holy islands was known as Yong ju-san, or Mountain of the Blessed Isle. According to the ancient Chinese, the island acted as a bridge between heaven and earth.

At a later date Yong ju-san became Halla-san, the Peak That Pulls Down the Milky Way, and this image of heavenly energy flowing down upon Jeju-do offers an explanation for the supernatural phenomena mentioned in the ancient myths of the island. In the middle of the volcanic crater atop Halla-san lies a small lake called Paengnoktam, or White Deer Lake. Legends mention this lake as the abode of angelic presences. The cave temple of Sanbangsa can be found on the lower part of the mountain, not far from the southwest coast. It was formerly a pagan shrine but is now a Buddhist temple and pilgrimage site. A pool inside the cave, formed by water droplets falling from the ceiling, is the subject of local legend; the pool water is thought to have healing and prayer-granting powers. Not far from the cave is the Sanbangsa Temple, which houses numerous Buddha statues brought to Jeju-do over the millennia by pilgrims from all parts of Southeast Asia.

Buddha statues at Sanbangsa Temple are illuminated by a rare ray of brilliant sunlight during repair of the temple roof following a lightning strike.

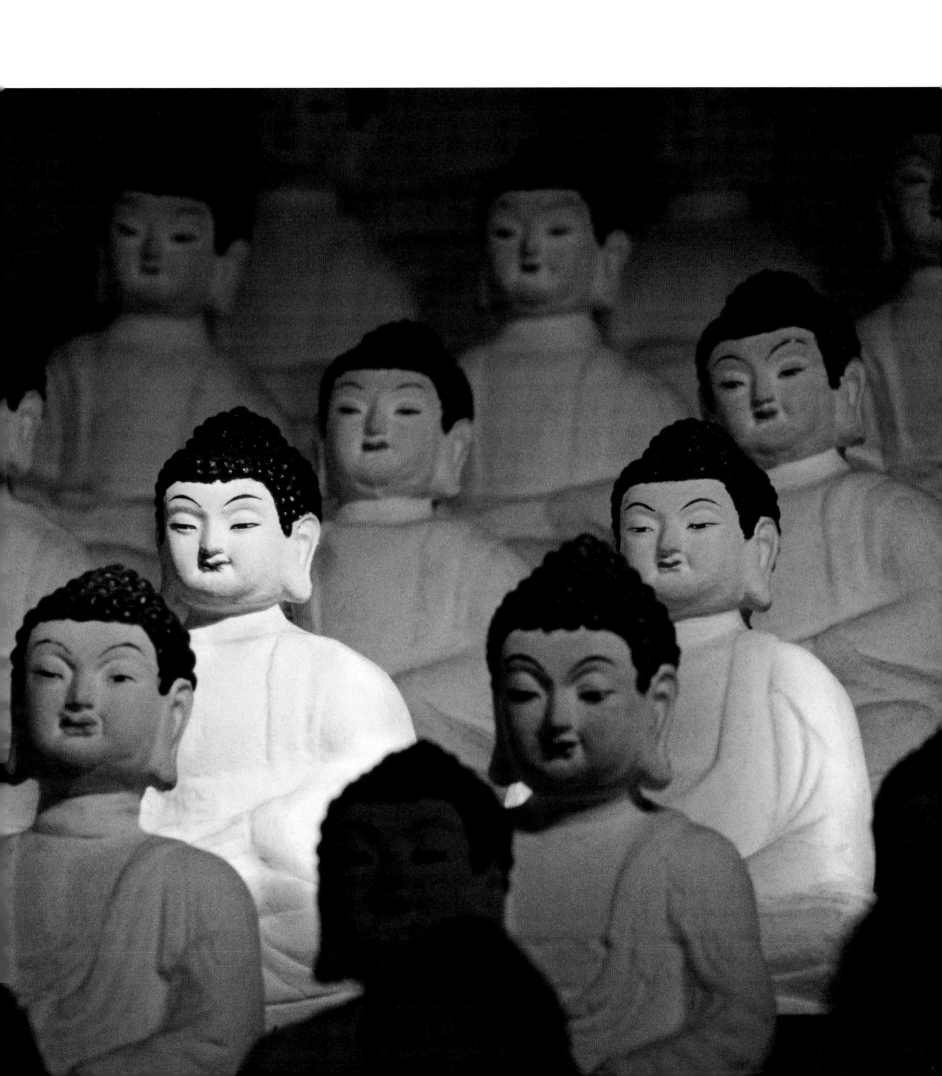

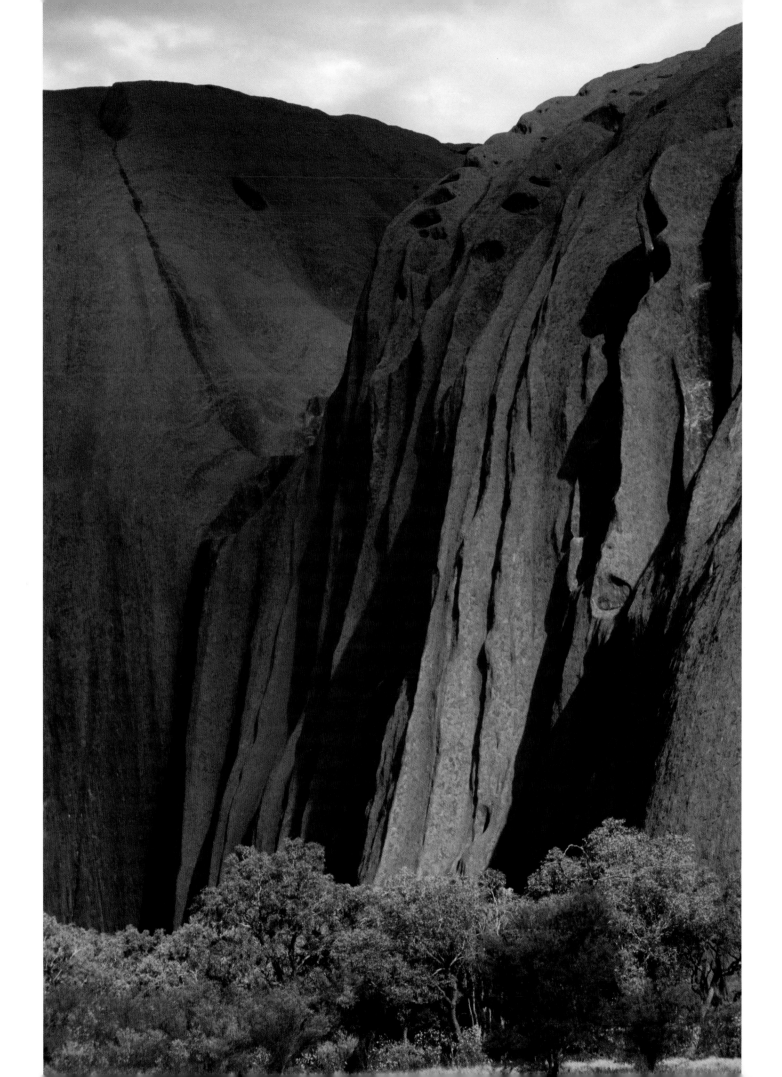

AYERS ROCK

Uluru–Kata Tjuta National Park, Australia

MAP SITE 41

The Aborigines of Australia were one of the earliest cultures to develop a form of sacred geography, a mythical conception of geographic space. Their legends, passed down over four hundred centuries, tell of the conception of the world during a time that different tribes call Alcheringa, Tjukurpa, or Wapar—known in the Western world as Dreamtime (see page 6). During the Dreamtime cycle, the totemic human and animal ancestors of the Aborigines wandered across the landscape, singing and creating the myriad geographic features of the earth. After the cycle was completed and the earth created, the ancestors themselves turned into bodies of water and unique landforms, such as Ayers Rock. The paths walked by the ancestors during their wanderings were called *iwara* (dreaming tracks, or songlines) by the Aborigines.

During the course of the yearly cycle, various Aboriginal tribes would make journeys called walkabouts along the songlines of various totemic spirits, and would return year after year to the same traditional routes. As people trod these ancient pilgrimage routes, they sang songs that told the myths of the Dreamtime and gave travel directions across the vast deserts to other sacred places along the songlines. At the totemic sacred sites, where the mythical beings of the Dreamtime dwelt, the Aborigines performed various rituals to invoke the *kurunba,* or spirit power of the place. This power could be used for the benefit of the tribe, the totemic spirits of the tribe, and the health of the surrounding lands. For the Aborigines,

walkabouts along the songlines of their sacred geography were a way to support and regenerate the spirits of the living earth, and also a way to experience a living memory of their ancestral Dreamtime heritage.

Located in the center of Australia, the massive rock formations of Uluru (Ayers Rock) and Kata Tjuta (the Olgas) are the most prominent and known sacred sites of the Aboriginal people. The beginning of Aboriginal settlement in the Uluru region has not been determined, but archaeological findings to the east and west indicate a date more than ten thousand years ago, though some archaeologists estimate that human settlement in the region actually dates from at least twenty-two thousand years ago. The name *Uluru* applies to both the rock and the waterhole on top of the rock. The thirty-six rounded rocks of Kata Tjuta (or Many-Headed Mountain) are located in the same national park as Uluru. By Aboriginal tradition, only certain elderly males may climb the rock, but despite this tradition, the Australian government allows tourists to make the climb using a metal chain installed in 1964. The Aboriginal tribes also request that visitors do not photograph certain sections of Uluru, mostly to honor traditional gender-related beliefs and customs. Uluru was made a national park in 1950 and, in 1958, was combined with the Olgas to form the Uluru–Kata Tjuta National Park. Uluru is listed as a World Heritage site for its natural and man-made attributes.

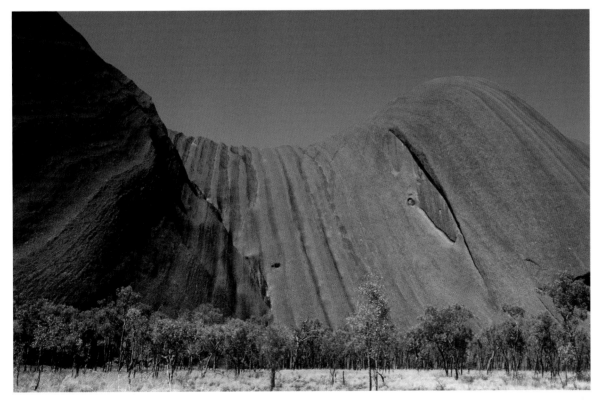

Uluru rises 1,135 feet (346 m) high, has a circumference of six miles (10 km), and covers an area of 1.3 square miles (4 sq km). It is the single largest rock outcropping in all of Australia. This photo and the ones on the previous and following pages give a perspective of the massive size of this rock formation, which is sacred to the Aborigines.

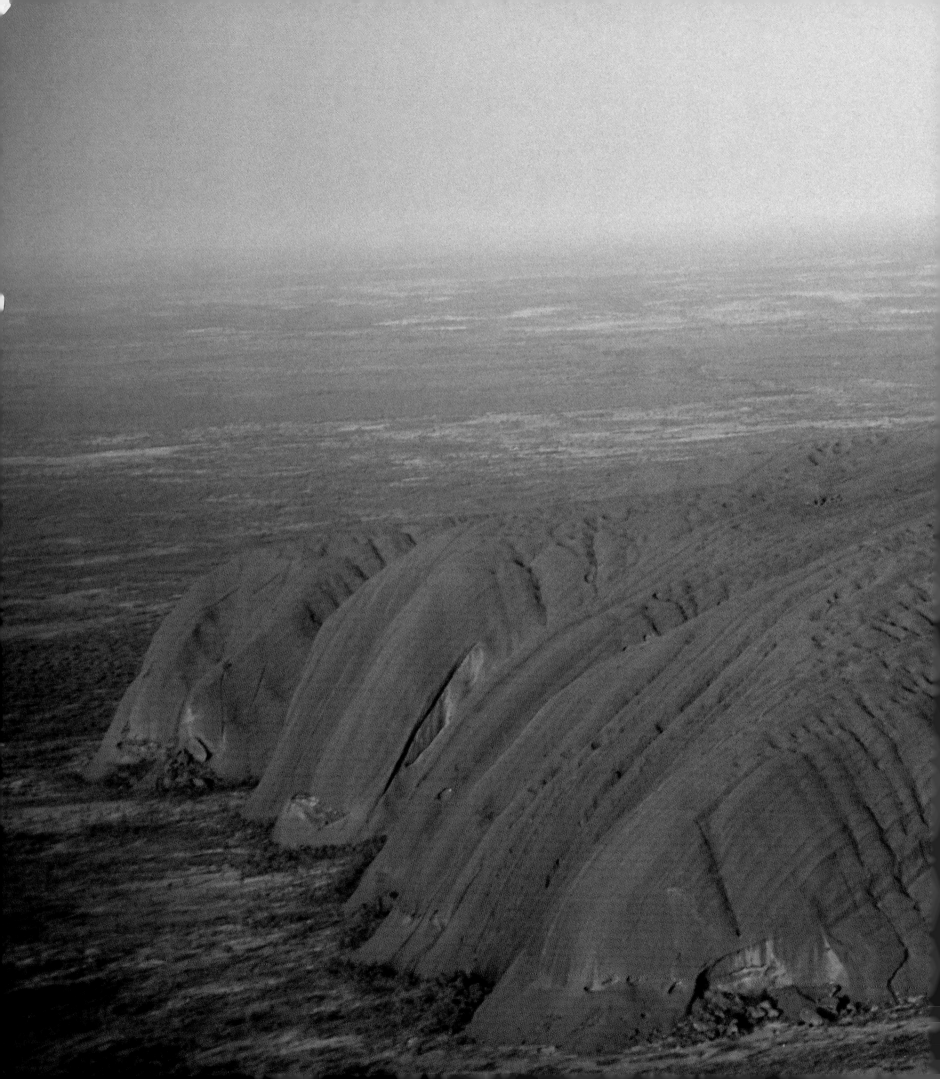

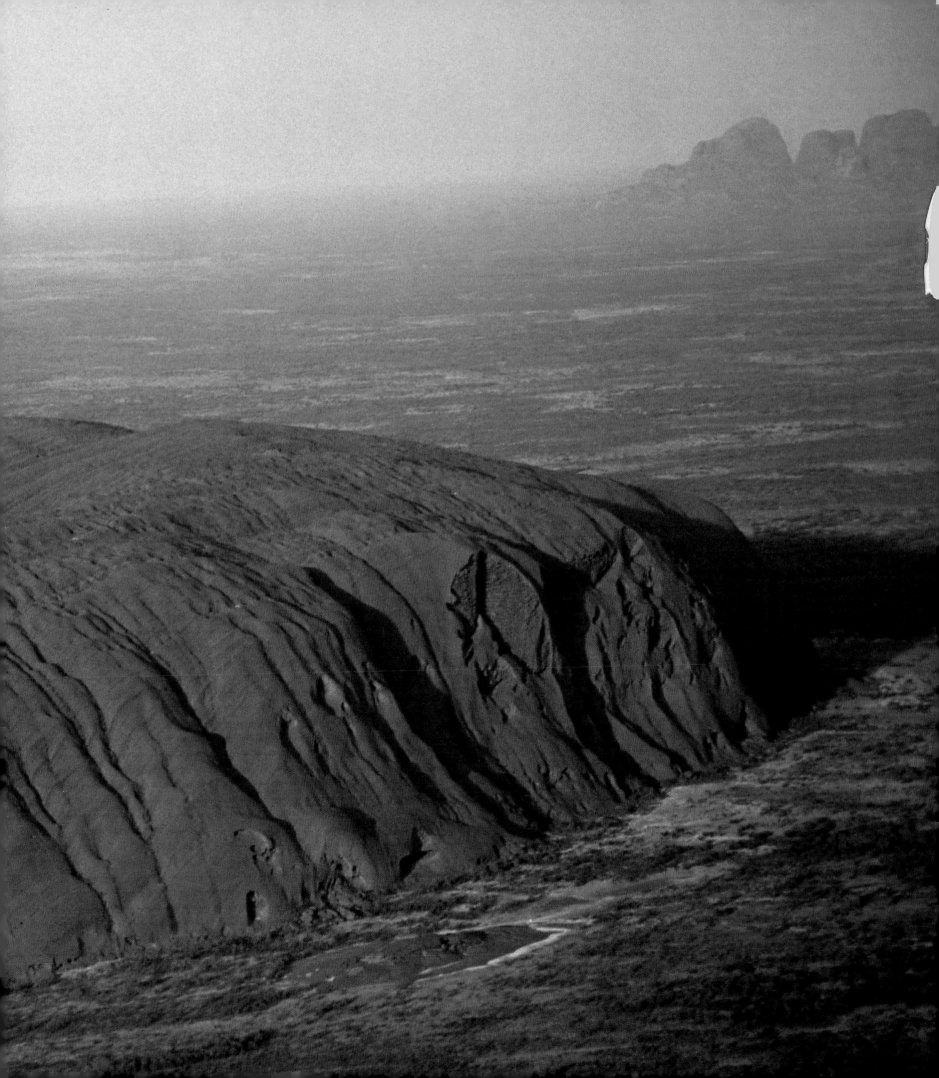

SACRED SITES OF

SOUTH AMERICA

A Pilgrimage Journey in the Magic Bus

Crossing the border from Arizona to northern Mexico in early January 1997, I began one of the most magical and exciting journeys of all my years of pilgrimage. During a year of travel, I drove slowly south through the countries of Mexico, Guatemala, Honduras, Nicaragua, Costa Rica, Panama, Colombia, Ecuador, Peru, Bolivia, Chile, and Argentina, and then flew to Brazil and Venezuela. Fourteen countries, twenty-two thousand miles (35,400 km), five robberies, and 365 days later, I returned to the United States. My means of transportation was an old Volkswagen bus, which I also slept in on more than 250 nights while passing through mountainous terrain. Along the way, I visited and photographed several dozen sacred sites of numerous pre-Columbian cultures, as well as almost all of the major Christian pilgrimage shrines. Traveling mostly alone, I read extensively, meditated daily, climbed a number of high mountain peaks, and generally had a stunningly good time. Even the robberies, in which I lost all my photographic equipment (two cameras and eight lenses), my passport, money, credit cards, and some valued personal items, did not deter me from continuing my pilgrimage.

The VW bus I used, purchased in California from a skilled VW mechanic, was in nearly pristine condition, which meant its original paint still shined as if the car had just come off the assembly line. I was experienced enough in international travel to know the importance of blending in as best I could, but the bright yellow paint was simply too lovely to paint over with a duller color. What to do? My solution (which turned out to be the cause of both difficult and rewarding experiences) was to adorn the sides of the bus with eight beautiful color paintings. I chose two images that were well known to Latin American Christians—Nuestra Señora de Guadalupe and San Martín de Porres—and others that were a combination of Egyptian pyramids, shamanic drummers, flying angels, mythical animals, and even a UFO. Everywhere I drove, across deserts, around soaring mountains, and through crowded cities, the Magic Bus attracted the attention of admiring pilgrims, but it also stimulated the greed of scheming thieves. Some of the most surprising moments occurred when the bus was parked alongside different Christian holy places. Pilgrims would gather around, sometimes in greater numbers than were in the churches, to stare, wide-eyed, at my lovely paintings. And the Magic Bus brought me other gifts; its paintings, my pilgrimage stories, and my somewhat humorously spoken Spanish attracted dozens of invitations for meals and places to stay.

Besides my photography of sacred sites, I also presented slide shows throughout Latin America. From the beginning, I gave these shows in Spanish, and by the end of my journey, I felt comfortable (almost) speaking like a native. Along the way, and because I had extra space in the bus, I gave rides to other travelers for days and weeks at a time. Two of the travelers I met had gone on long journeys and had spent years backpacking in more than one hundred countries.

My sacred quest in Latin America was a time of beauty, inspiration, and excitement, and I hope someday to travel there again. My recommendations for anyone who yearns to explore Latin America? Take the time to really experience the beauty of the region and know the extraordinary kindness of its people.

Basilica of El Cisne, Ecuador.

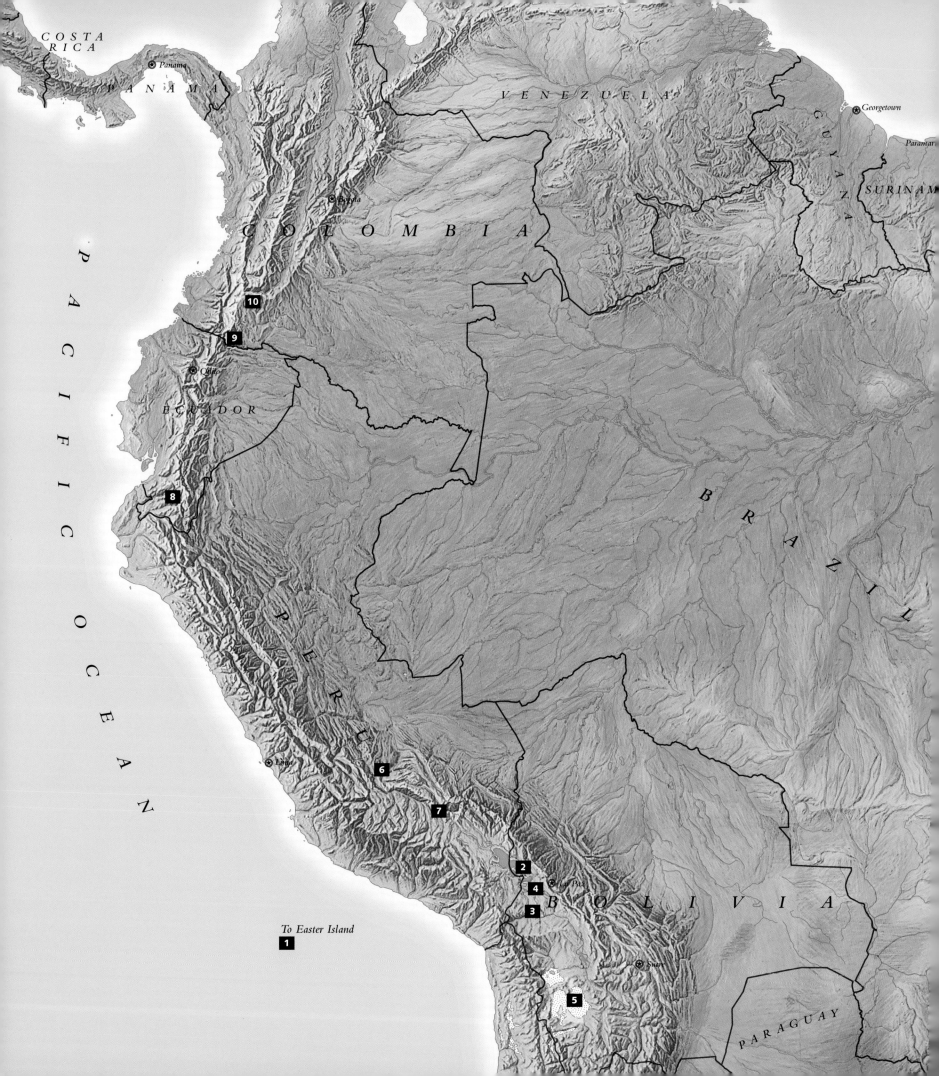

Sacred Sites of South America

1. **Easter Island, Chile**

2. **Lake Titicaca, Mt. Ancohuma, and Mt. Illampu, Bolivia**

3. **Tiwanaku, Bolivia**

4. **Copacabana, Bolivia**

5. **Salar de Uyuni and Mt. Tunupa, Bolivia**

6. **Machu Picchu, Peru**

7. **Mt. Ausungate, Peru**

8. **El Cisne, Ecuador**

9. **Sanctuary of Las Lajas, Colombia**

10. **San Augustín, Colombia**

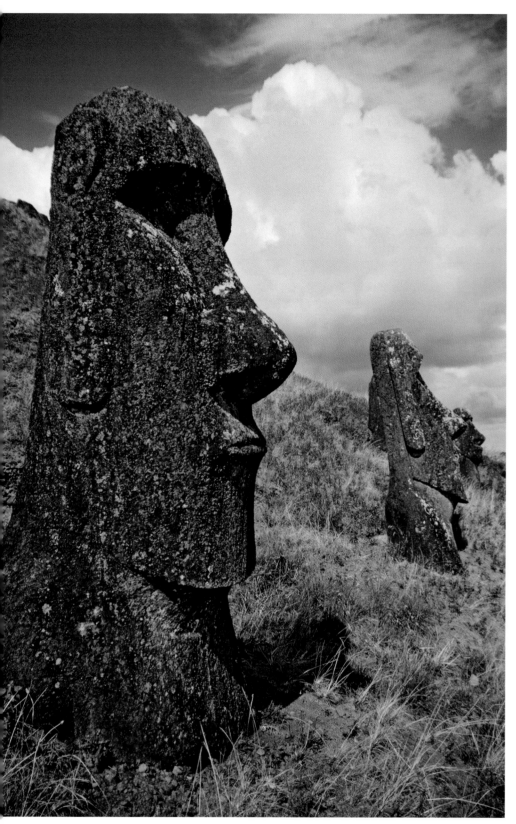

Rapa Nui (Easter Island)

Chile

Map site 1

One of the world's most famous yet least visited archaeological sites, Easter Island is sixty-three square miles (163 sq km) in size and located twenty-two hundred miles (3,540 km) off the coast of Chile. The oldest known name of the island is Te Pito o Te Henua, the Center of the World. In the 1860s, Tahitian sailors gave the island the name Rapa Nui, Great Rapa, due to its resemblance to another island in Polynesia called Rapa Iti, or Little Rapa. The island received its most well-known name, Easter Island, from a Dutch sea captain, Jakob Roggeveen, the first European to visit, on Easter Sunday, in 1722. In the early 1950s, the Norwegian explorer Thor Heyerdahl suggested that Easter Island had been originally settled by people from the coast of South America. Archaeological, ethnographic, and linguistic research has shown this hypothesis to be inaccurate. It is now believed that the original inhabitants of Easter Island were of Polynesian stock, arrived by canoes in the fourth century CE, and numbered fewer than one hundred. At the time of their arrival, much of the island was forested, teemed with land birds, and was perhaps the most productive breeding site for seabirds in the Polynesia region. Because of the plentiful bird, fish, and plant food sources, the human population grew and gave rise to a rich religious and artistic culture.

Easter Island's most famous features are its enormous stone statues called *moai,* at least 288 of which once stood upon stone platforms called *ahu.* Nearly all the *moai,* averaging fifteen feet (4.5 m) tall and weighing fourteen tons, are carved from stone of the Rano Raraku volcano. The *moai* and *ahu* were in use as early as 500 CE, but the majority were erected between 1000 and 1650.

Scholars assume that the carving and erecting of the *moai* derived from an idea rooted in similar practices found elsewhere in Polynesia. Archaeological and iconographic analysis indicates that the statues represented an ideology of male, lineage-based authority. Yet the statues had more than mere iconic function. To the people who erected and used them, they were repositories of sacred spirit. Carved stone and wooden objects in ancient Polynesian religions, when ritually prepared, were believed to be charged by a magical spiritual essence called *mana.* The *ahu* platforms of Easter Island were the sanctuaries of the people of Rapa Nui, and the *moai* statues were the ritually charged sacred objects of those sanctuaries.

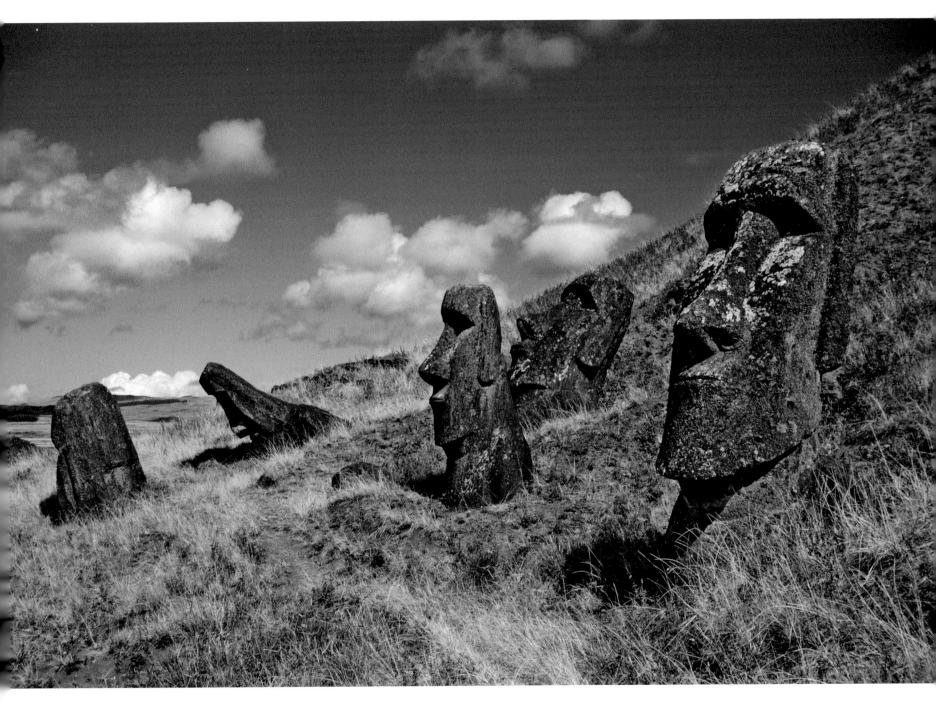

***Moai* statues stand sentinel** on Easter Island, Chile. Between 50 and 150 people were needed to drag a *moai*—depending upon its size and weight—across the countryside on sleds and rollers made from the island's trees.

Lake Titicaca, Mt. Ancohuma, and Mt. Illampu

Bolivia

Map site 2

Soaring majestically 20,957 feet (6,388 m) above Lake Titicaca, and often cloaked by ethereal mists, are the sacred mountains of Ancohuma and the slightly lower Illampu. Archaeological remains found on the summit of dozens of mountains throughout Peru and Bolivia reveal that pre-Columbian people regularly ascended peaks in excess of 18,000 feet (5,486 m) to perform ceremonies asking the spirits for life-giving rain. Today, people from throughout the Andes still ascend these mountains to continue an ancient ritual of communion with the nature spirits and the weather gods. Great condors, traditionally regarded as messengers of the mountain spirits and able to communicate through shamans, also watch over the sacred peaks.

Far below these resplendent mountains is Lake Titicaca. Situated at 12,507 feet (3,812 m) and covering 3,200 square miles (8,288 sq km), the lake is more than one thousand feet (305 m) deep and has more than thirty (mostly uninhabited) islands. Three of its main islands—Amantani, Isla de la Luna (Island of the Moon), and Isla del Sol (Island of the Sun)—figure richly in Andean myths, and ruins of enigmatic temples are scattered throughout their hills. Legends say that long ago in a forgotten time, the world experienced a terrible storm with tremendous floods. The lands were plunged into a period of absolute darkness and frigid cold. Humankind was nearly eradicated. Sometime after the deluge, the creator god Viracocha arose from the depths of Lake Titicaca. Journeying to the islands of Amantani, Luna, and Sol, Viracocha commanded the sun (Inti), the moon (Mama-Kilya), and the stars to rise. Next he went to Tiwanaku, to fashion new men and women out of stones, and sending them to the four quarters, he began the repopulation of the world.

The holy mountains of Ancohuma and Illampu rise majestically above Lake Titicaca and the Island of the Moon, in the foreground.

SACRED EARTH

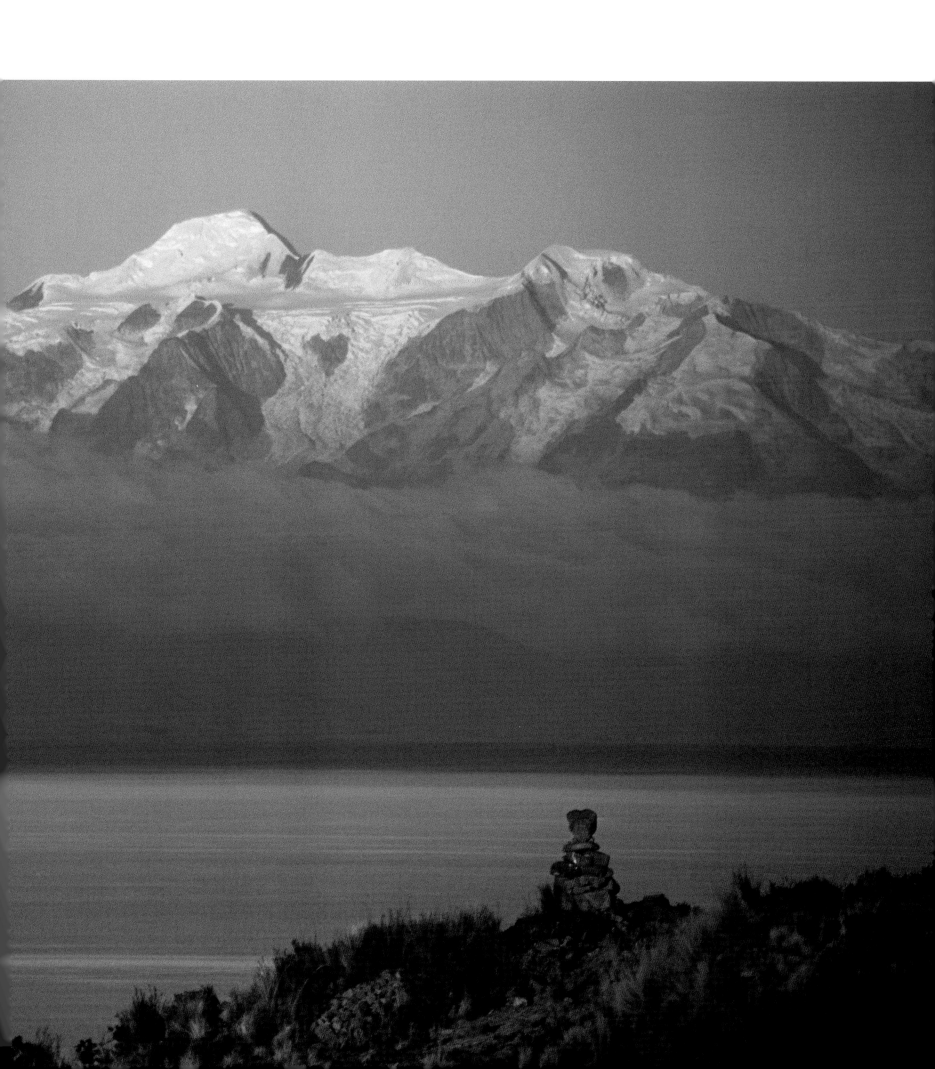

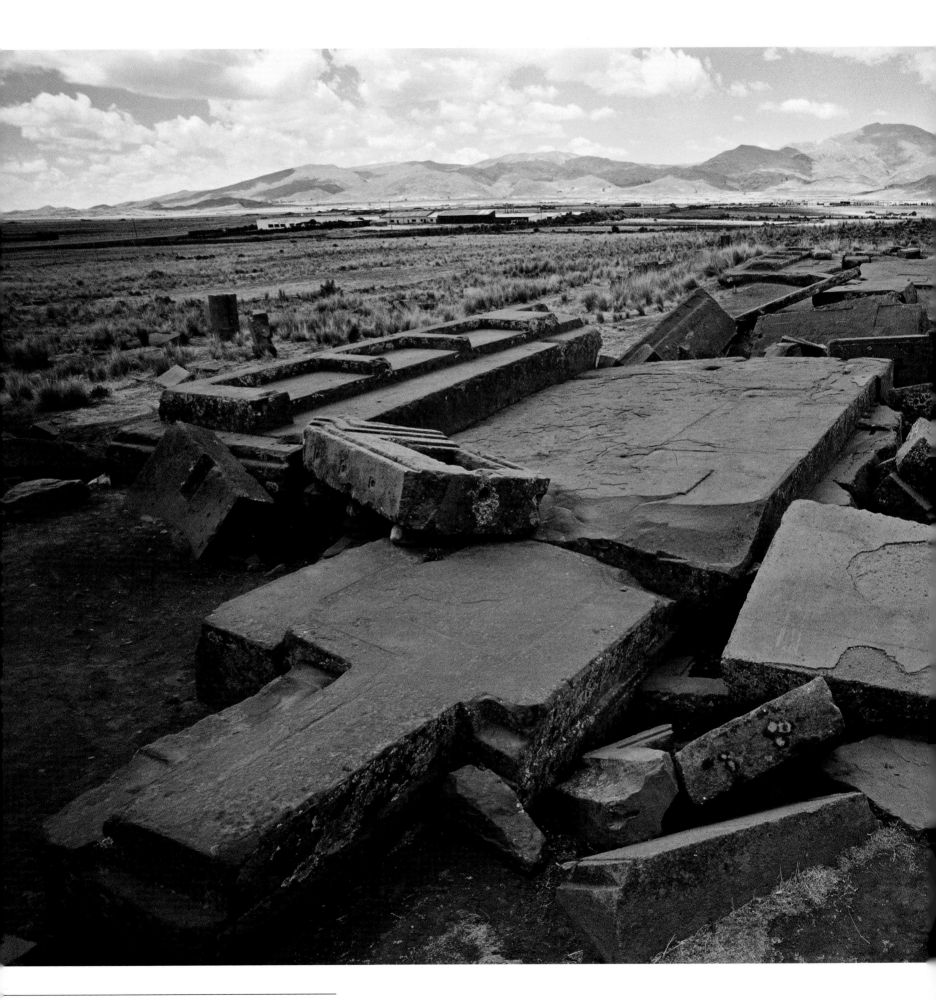

SACRED EARTH

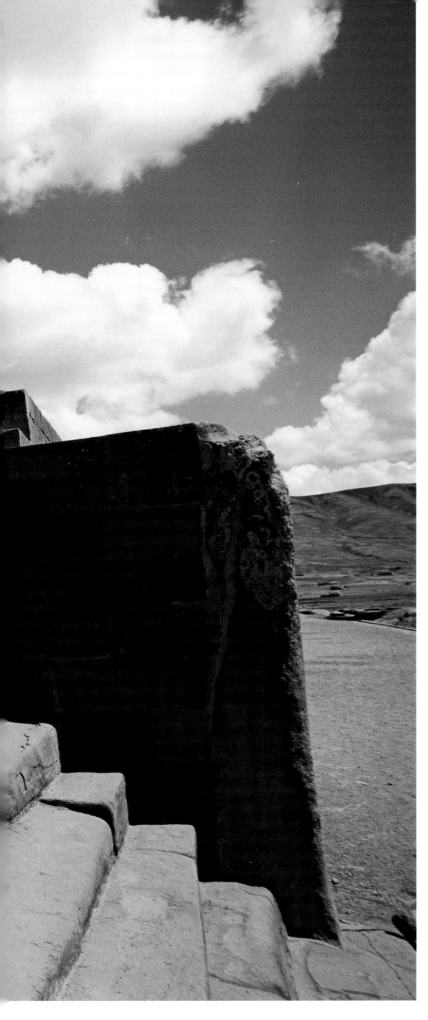

KALASASAYA TEMPLE COMPOUND

Bolivia

MAP SITE 3

Near the Akapana Pyramid is the Kalasasaya compound, a structure whose design and celestial alignment suggest a great antiquity for Tiwanaku. Arthur Posnansky, a German-Bolivian scholar, exhaustively studied Tiwanaku for almost fifty years. Posnansky conducted precise surveys of all the principal structures of Tiwanaku, including the Kalasasaya compound, which is delineated by a series of vertical stone pillars. Utilizing his measurements of sight lines along these pillars, the celestial orientation of the Kalasasaya, and its intended deviations from the cardinal points, Posnansky was able to show that the alignment of the structure was based on an astronomical principle called the obliquity of the ecliptic (a measurement based on Earth's axial tilt). His findings strongly suggest that initial construction was around 15,000 BCE. This date was later confirmed by a team of four astronomers from various universities in Germany. Equally astonishing, the spatial arrangement of Tiwanaku's four main structures—relative to one another and to the stars above— indicates that the engineers of the initial site had an advanced knowledge of astronomy, geomancy, and mathematics.

Adding to this mystery are the ancient myths of Tiwanaku, which tell of its founding and use in a time before great floods. Scientific research has proved that a cataclysmic flood did indeed occur some twelve thousand years ago. Mixed in with the deepest layers of flood alluvia at Tiwanaku are human bones, utensils, and tools, showing human use of the site prior to the great flood. There is also the intriguing enigma of the strange carvings of bearded, non-Andean people found around the site, replete with sculptural and iconographic details that are unique in the Western Hemisphere. All of this evidence seems to indicate that the original Tiwanaku civilization flourished many thousands of years *before* the period assumed by conventional archaeologists. Rather than rising and falling during the two millennia around the time of Christ, Tiwanaku may have existed during a vastly older period, some fifteen thousand years ago. The implications of this are truly stunning. Tiwanaku may be, along with Teotihuacán in Mexico, Baalbek in Lebanon, and the Great Pyramid in Egypt, a surviving fragment of a long-lost civilization.

The entrance to the Kalasasaya Temple; the temple complex was built perhaps as long as fifteen thousand years ago by a civilization with a sophisticated knowledge of astronomy, geomancy, and mathematics.

BASILICA OF THE VIRGEN DE LA CANDELARIA

Copacabana, Bolivia

MAP SITE 4

The Basilica of the Virgen de la Candelaria of Copacabana, the most visited pilgrimage shrine in Bolivia, can be seen at the left of the photograph.

On the southern shore of Lake Titicaca, the town of Copacabana is widely known for its Christian pilgrimage shrine to the Virgen de la Candelaria, also called the Dark Virgin. Before the Christian use of the site, there was an Incan Temple of the Sun there, from which native pilgrims boated to the sacred islands of the sun and the moon, the Isla del Sol and Isla de la Luna, respectively. According to Christian legends, in 1576 a few Incan fishermen were caught in a raging storm on Lake Titicaca. When they prayed for divine assistance, Mary appeared and led them to safety. In gratitude they decided to build a shrine and install a statue of Mary. The native Incan craftsman, Tito Yupanqui, sculpted the four-foot (1.2 m) image out of dark wood. The statue was placed in a chapel in 1583 and soon became famous throughout Bolivia and Peru as a miracle-causing icon. The present cathedral, completed in 1805, is the most visited pilgrimage site in Bolivia with hugely attended festivals on February 1 to 3 (Mary's Day), May 23 (San Juan's Day), and the first few days of August. The celebration in August is extremely popular, and native groups perform traditional dances accompanied by drums, flutes, and pipes. During the festival periods, a copy of the statue of Mary is adorned with colorful robes and precious jewels and escorted on processions around the town of Copacabana. The statue is also taken by boat onto Lake Titicaca in order to bless its waters. The original statue is never taken outside because of fears that great storms may arise. Called La Coyeta by the indigenous Aymara and Quechua people, the Virgen de la Candelaria is Bolivia's patron saint.

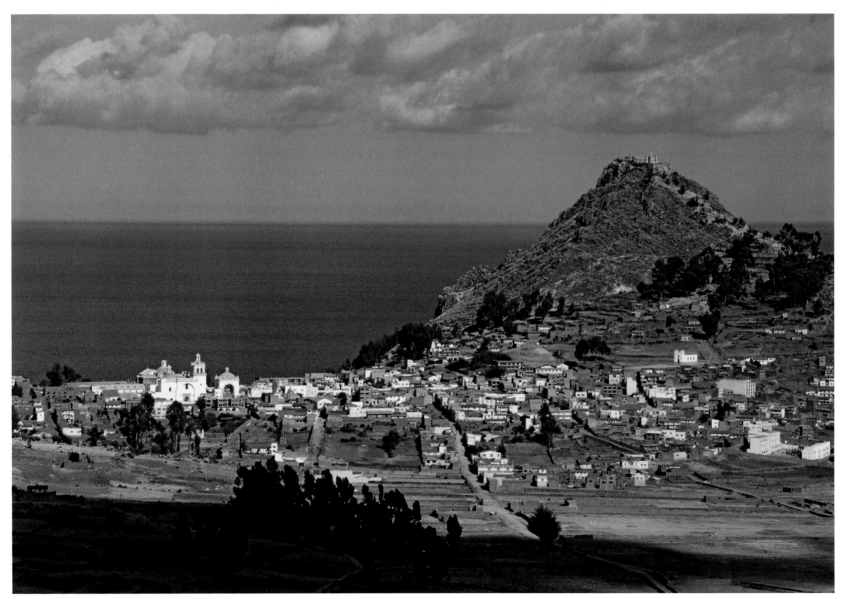

Salar de Uyuni and Mt. Tunupa

Uyuni, Bolivia

Map site 5

Covering an area of 4,680 square miles (12,121 sq km), Salar de Uyuni is the world's largest salt flat. At an elevation of 11,970 feet (3,648 m), it is filled with an estimated 10 billion tons of salt. Contemporary maps usually name the salt flats Salar de Uyuni, for near their southeastern border is the small town of Uyuni. Local people, however, whose ancestors have lived nearby for hundreds of years, say its true name is linked not to Uyuni but to the sacred mountain of Tunupa. Rising like a mirage from the northern extremes of the Salar, the long-extinct volcano of Mt. Tunupa is 17,700 feet high (5,395 m). There are no roads across the vast salt flats, only tracks left by the occasional jeeps that take travelers to view the otherworldly place. In the middle of the Salar, piercing the blazing white, is the small island of Isla Inkahuasi. Also called Isla de Pescadores, its sharp crags of volcanic rock are as black as ink. The only evidence of island life is a profusion of tall, green cacti and dozens of shy rabbits with long, cartoonlike ears. Every November, Salar de Uyuni is the breeding ground for three types of South American flamingos. There is something inexplicably magical about this unique place, and simply being there brings on a state of inner peace. No effort need be made to reach this state; the environment gives it freely.

The surreal salt flats of Salar de Uyuni give the impression of an enormous ocean, with sacred Mt. Tunupa a stark contrast in the background.

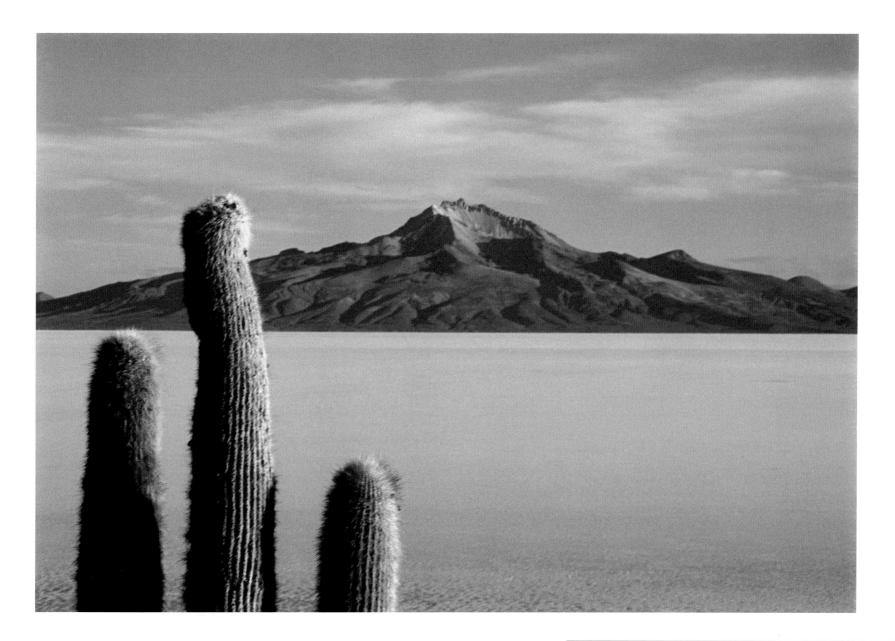

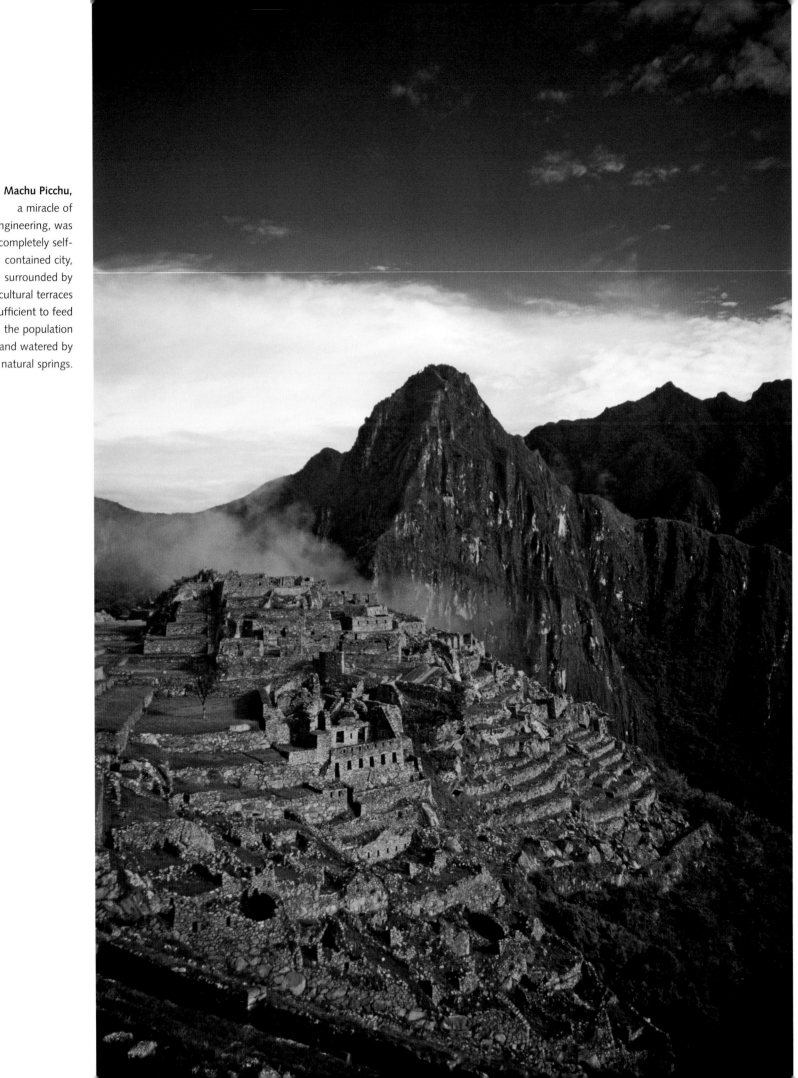

Machu Picchu, a miracle of engineering, was a completely self-contained city, surrounded by agricultural terraces sufficient to feed the population and watered by natural springs.

MACHU PICCHU

Peru

MAP SITE 6

The ruins of Machu Picchu, rediscovered in 1911 by Yale archaeologist Hiram Bingham III, comprise one of the most beautiful ancient sites in the world. While the Incas utilized the 9,060-foot-tall (2,761 m) Andean mountaintop from the early 1400s and erected massive stone structures, legends and myths indicate that Machu Picchu (Old Peak, in the Quechuan language) was revered as a sacred place from a far earlier time. Whatever its origins, the Incas turned the site into a small but extraordinary city. Invisible from below, Machu Picchu seems to have been utilized by the Incas as a secret ceremonial city. The structures, carved from the gray granite of the mountaintop, are wonders of both architectural and aesthetic genius. Many of the building blocks weigh fifty tons or more, yet they are sculpted so precisely and fitted together with such exactitude that the mortarless joints

will not permit the insertion of even a thin knife blade. One of Machu Picchu's primary functions was as an astronomical observatory, and several stone structures around the site have been shown to record the exact dates of key periods in both solar and lunar cycles. One particularly fascinating astronomical sighting device is called the Intihuatana stone, the Hitching Post of the Sun, and shamanic legends say that when a sensitive person touches his forehead to this stone, the Intihuatana opens that person's vision to the spirit world. When an Intihuatana stone was broken at an Inca shrine, the Incas believed that the deities of the place died or departed. The Spanish conquistadors never found Machu Picchu; the Intihuatana stone and its resident spirits remain at the site. The mountaintop sanctuary fell into disuse and was abandoned some forty years after the Spanish conquered Cuzco in 1533.

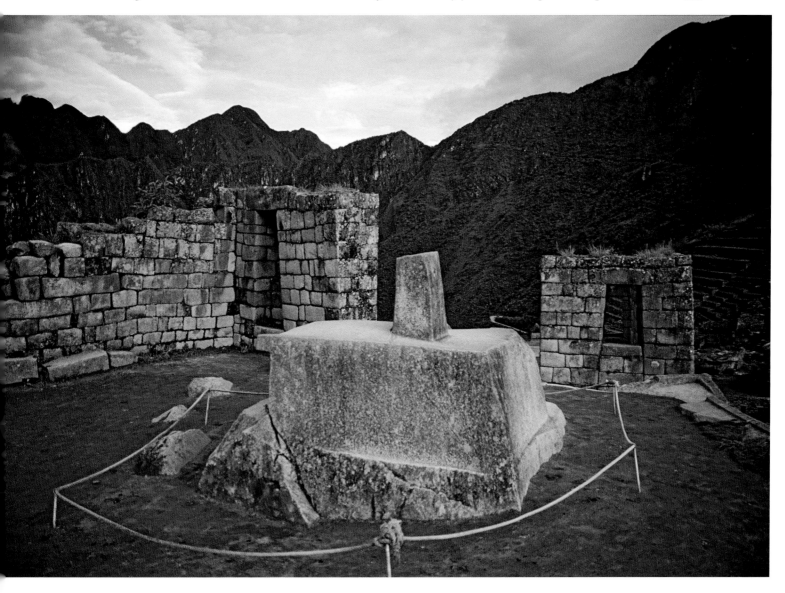

The Intihuatana stone at Machu Picchu is designed to "hitch" the sun at the two equinoxes. At midday on March 21 and September 21, the sun stands almost directly above the pillar, creating no shadow at all. At this precise moment it is said that the sun "sits with all his might upon the pillar" and is for a moment "tied" to the rock. During these periods, the Incas held ceremonies at the stone in which they "tied the sun" to halt its northward movement in the sky.

Church at Qoyllur Rit'i

Mt. Ausungate, Peru

Map site 7

The veneration of high mountains is of great antiquity in the Andes, where certain peaks were considered to be the abodes of deities who controlled the weather and, thereby, the fertility of the crops. Archaeological excavations have revealed more than fifty ceremonial sites on or near mountain summits in Colombia, Ecuador, Peru, Bolivia, and Chile. While most of the remains found at these sites indicate construction by the Incas (between 1470 and 1532 CE), the mountains were worshipped for thousands of years before the Incan era. Of widespread importance in the Andes was a weather god, known as Tunupa to the Aymara of Bolivia and Illapa to the Incas of Peru. Andean peoples also venerated mountains as the mythical places where their cultures began, the abodes of ancestor spirits, the haunts of shamans, and the link between the three worlds of the Underground, Earth, and Sky.

Two *apus*, or sacred peaks, Salcantay and Ausungate, dominate the mountains of southern Peru. Current use of these *apus* reflects a fascinating mix of pagan and Christian influences, clearly observable at the mountain shrine of Qoyllur Rit'i. Twenty miles (32 km) to the south of Ausungate peak, which is 20,905 feet (6,372 m) high, lies the shrine of Qoyllur Rit'i. The shrine marks the place where pre-Colonial era legends tell of a mountain deity who appeared to local peasants as a white-skinned boy with blond hair. Similar Christian legends speak of a shepherd who encountered a mysterious Caucasian-appearing youth, assumed to be the child Jesus. The transformation of the indigenous holy site into a Catholic pilgrimage shrine began in 1783, when the cult of Señor de Qoyllur Rit'i was launched by the clergy's declaration of Christ's appearance. The shrine of Qoyllur Rit'i, requiring a long climb, is seldom visited by nonreligious pilgrims.

Pilgrims worship in a small church at the festival site of Qoyllur Rit'i. On two particular days, June 21 (the summer solstice) and September 14, pilgrims arrive by the thousands to participate in traditional dances and devotional acts, such as gathering chunks of ice from the nearby Qollqepunku glacier.

BASILICA OF EL CISNE

El Cisne, Ecuador

MAP SITE 8

Forty miles (64 km) from the city of Loja in the mountains of southern Ecuador is the town of El Cisne, the site of a much-venerated Marian shrine. The Basilica of El Cisne was built in 1742 and modeled after a similar basilica in Harlungenberg, Germany. In 1594 the inhabitants of the El Cisne region desired their own religious relic, similar to the Nuestra Señora de Guadalupe in Mexico City. Representatives of the local people traveled to the capital city, Quito, where they asked the sculptor Don Diego de Robles to create the Virgen de El Cisne statue, which he did out of the wood of a *cedro* (Spanish cedar) tree. Upon arriving in El Cisne, the Virgin performed her first miracle, which was a much-needed rainstorm after a prolonged drought. Since then, the statue has been a focal point of devotion for the deeply religious inhabitants of the area. On August 17 of each year, thousands of pilgrims gather in El Cisne to begin a three-day religious procession to Loja. The lifesize statue of Mary is carried to the Cathedral of Loja, where it is the focus of a great festival on September 8. The statue remains in the cathedral until it is returned to El Cisne on November 3.

SANCTUARY OF LAS LAJAS

Colombia

MAP SITE 9

In the remote mountains of southwestern Colombia, Las Lajas is one of the most enchantingly beautiful pilgrimage shrines in all the world. A scene of fairy-tale splendor, the cathedral clings to the side of a cliff above a swiftly running river in a mountain gorge. Two waterfalls surge from the jungle-covered cliffs and plummet a hundred feet (30 m) to the river below. Rains come and go, and lingering mists hide the church with the deftness of a magician's hands. In concert with the rumbling of flowing waters, church bells echo across the mountain valleys.

According to local legends, in 1754 a woman named Maria Meneses used to walk from her home to the nearby town of Ipiales. One day a storm arose, and Maria sought shelter in a cave above the Guaitara River, where she began to pray. An image of Mary, as the Virgin Santísima, appeared on a rock. Over time, this cave and image became the site of numerous miraculous healings. The Sanctuary of Las Lajas, a Gothic-style structure built between 1915 and 1952, is much visited by pilgrims from throughout Colombia and Ecuador, especially on its primary holy day of September 16. The cathedral was designed so that the rock with the image of Mary is the high altar.

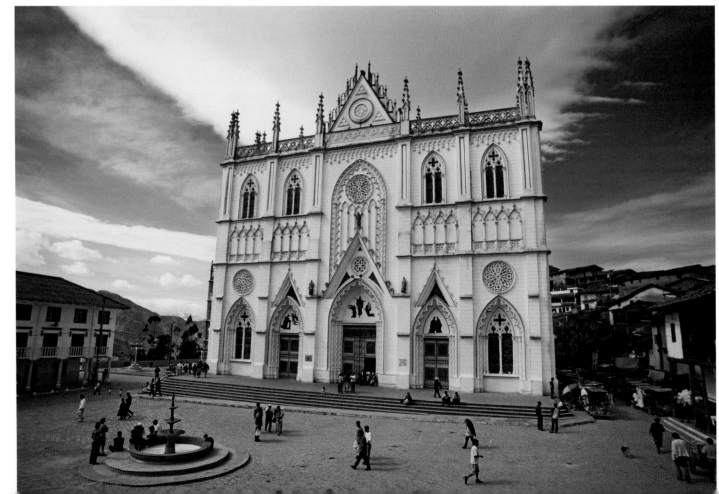

The beautiful Basilica of El Cisne is the site of a great Marian festival held in the mountainous town every August.

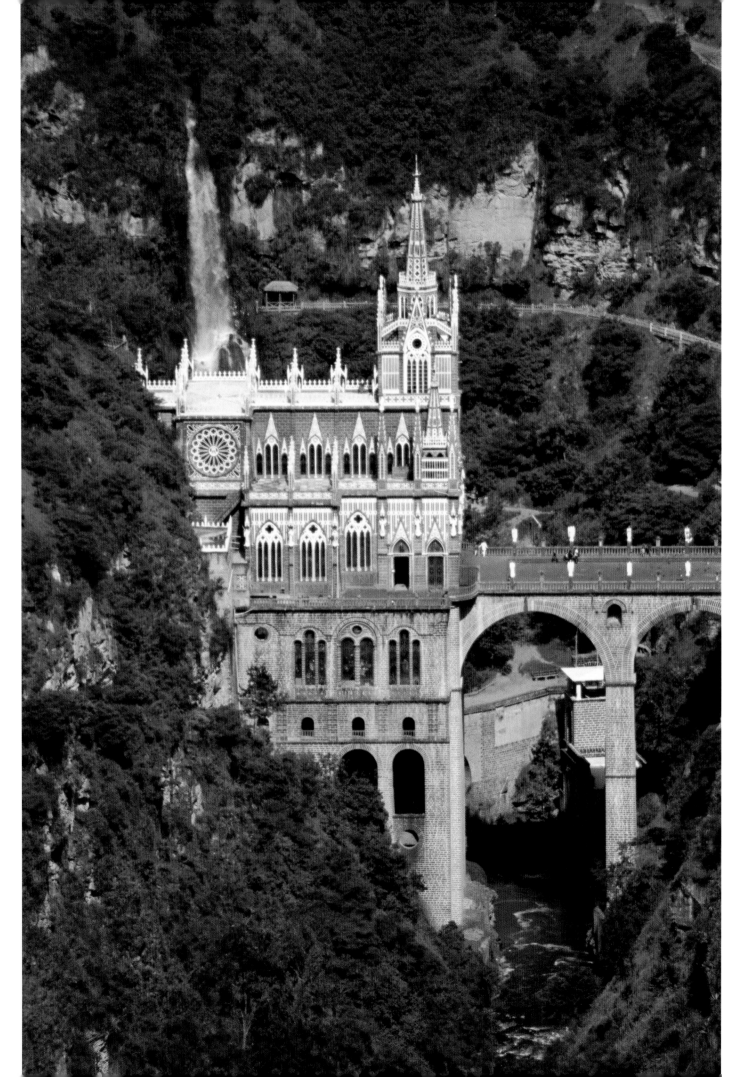

The breathtaking Las Lajas was built into the side of the gorge where Maria Meneses experienced a vision of the Virgin Mary.

SAN AUGUSTÍN

Colombia

MAP SITE 10

San Augustín, considered to be one of the most significant archaeological sites in South America, is actually a collection of ceremonial and burial sites scattered over an area of 250 square miles (647 sq km). Little is known of San Augustín. Who were the people who lived there? Where did they come from? When did they arrive? And what was the purpose of the stone figures they so expertly carved? None of these questions can be answered with any degree of certainty. Scholars have hypothesized that an ancient people settled in the forested hills as early as 3300 BCE. These

shadowy people may have been the ancestors of the stone carvers who produced more than five hundred monolithic statues, sarcophagi, and petroglyphs sometime between the sixth and fourteenth centuries CE.

Regarding the purpose of the fantastic stone statues, neither archaeology nor local folklore provides any clues. Reaching heights of fifteen feet (5 m), the statues depict a variety of anthropomorphic and zoomorphic figures. Certain scholars interpret the sculptures as metaphors indicating shamanic associations. Yet these figures also

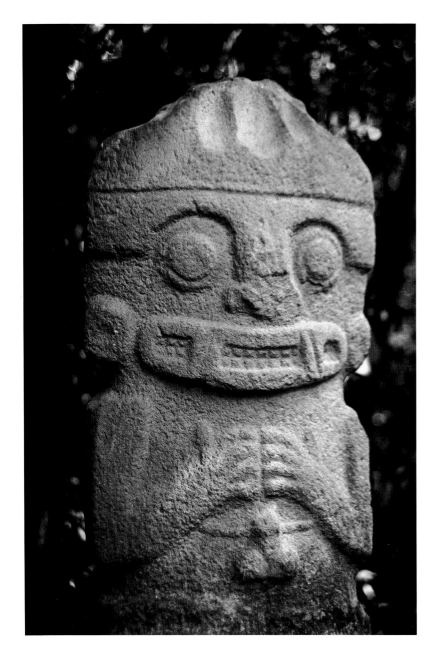

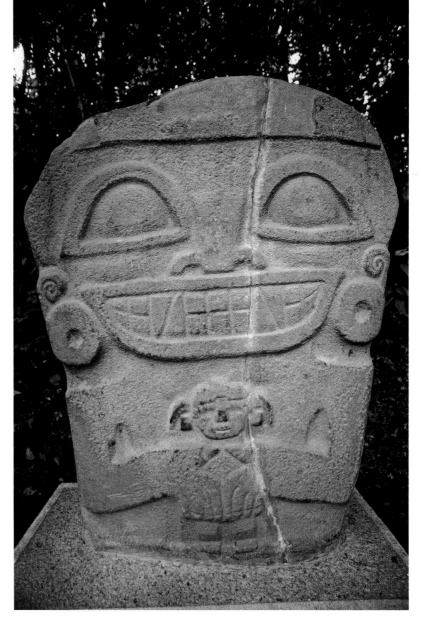

seem to have an additional power beyond their visual appearance and metaphoric message. Studying similar iconic objects from around the world, one learns of talismanic qualities inherent in such sculptures; of how they were charged with spiritual powers through ritual and ceremony. These sculptures actually function as batteries, or memory banks, recording the particular powers that were directed into them. While nothing is known of the preparation or use of the San Augustín statues, it seems that they too are objects charged with—and still containing—mystic powers from a long-forgotten age.

The mythical statues at San Augustín represent an astounding array of human figures; smiling, frowning, and sneering monsters; and various animals such as jaguars, snakes, frogs, and great birds. Some of the faces of the statues are somber, some are serene and wise, and still others are frightening and ominous.

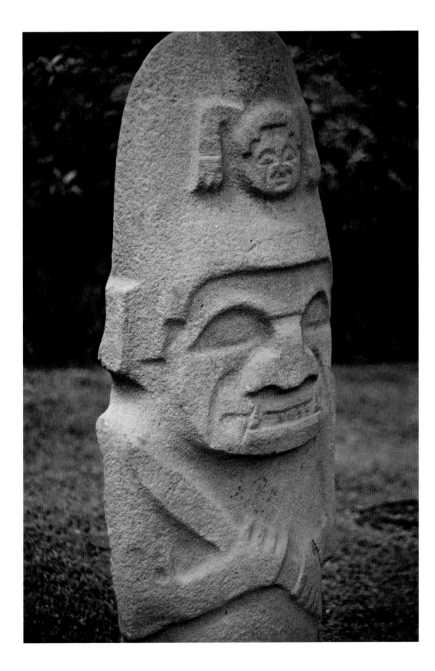

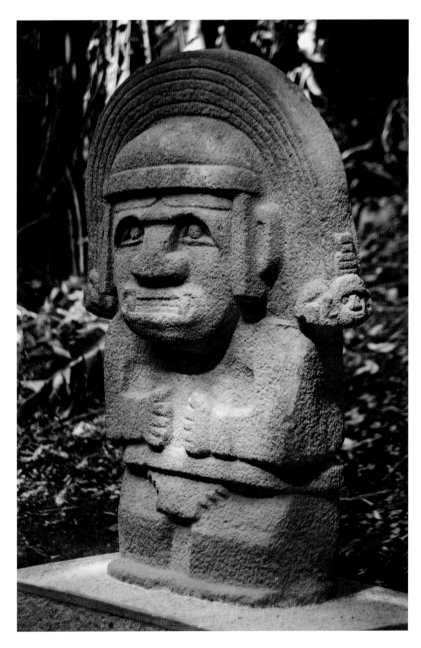

SACRED SITES OF

NORTH
AND
CENTRAL
AMERICA

The Beginning of My Love Affair with Power Places

From an early age I was enchanted with Tarzan, the character created by Edgar Rice Burroughs. I first came upon Tarzan by finding a treasure in the state of Illinois. That treasure was buried not in the ground but high above it: in a lofty tree fort, in a wooden box, in the colorful pages of dozens of Tarzan comic books. Gazing at those Tarzan comic books, and later reading the actual books, I was mesmerized by the noble deeds he did and the magical and powerful places he discovered. Thus began my love of travel, power places, and the adventurous life.

Soon after that momentous discovery, my father was transferred to Holloman Air Force Base in New Mexico. Our family—my parents, my sister, and I—lived on the base for eighteen months. During that time, my father and mother enjoyed traveling around the state in search of rocks, old pottery, and Indian rugs. Happily, I went along. Near the air force base there were some dunes known as White Sands. Those dunes were the first power place I visited, the first to touch my soul.

Situated in south-central New Mexico, west of Alamogordo, White Sands are the planet's largest dune fields of pure gypsum sand. The brilliant white sands cover an area of nearly 230 square miles (596 sq km), and many dunes rise to more than sixty feet (18 m). It is important to understand that the *pure* sands of such landlocked dunes as White Sands, in contrast to the *mixed* sands of coastal beaches, emanate the energy of a single mineral type. The unique energy emanation of the dunes of White Sands derives from the atomic frequency of a mineral known as selenite. The dunes of White Sands are the only place on the entire planet where that particular energy is found. Local legends indicate that the dunes were once a fabled site for Native American vision quests. Pilgrims journeyed there from the regions of what are now the southwestern United States and northern Mexico. The power of the dunes was believed to promote clarity of insight and the ability to know one's life purpose.

Years later—after living for four years in India, three years at a strict military school, ten years as a monk in the ashram of an Indian guru, and twenty years conducting the travels photographically chronicled in this book—I came to White Sands once again. It was after sunset on a cool, early autumn day, and a full moon had risen in the pale blue-tinted purple sky. I had already planned to stay the night. I drove my car to the far end of the National Park Service parking lot, locked it, and promptly walked into the dunes. I was dressed in light khaki-colored clothes that would be difficult to see in the dark of the night. Hidden this way, I was free to wander at will. At the beginning of my trek, I had ingested a psychotropic plant agent that resulted in my having a stunningly beautiful experience of my own divinity. Several delightful hours passed this way. Then, sometime after midnight, I heard the sounds of a human voice, far away but amplified by some sort of loudspeaker. I could barely make out the faint words, but they seemed to be saying, "Come out of the dunes and return to the parking lot." I laughed and remained where I was—upon the dunes, under the brilliant full moon, enraptured by the surreal beauty of that holy place.

Toltec Sanctuary of Tollan, Tula, Mexico.

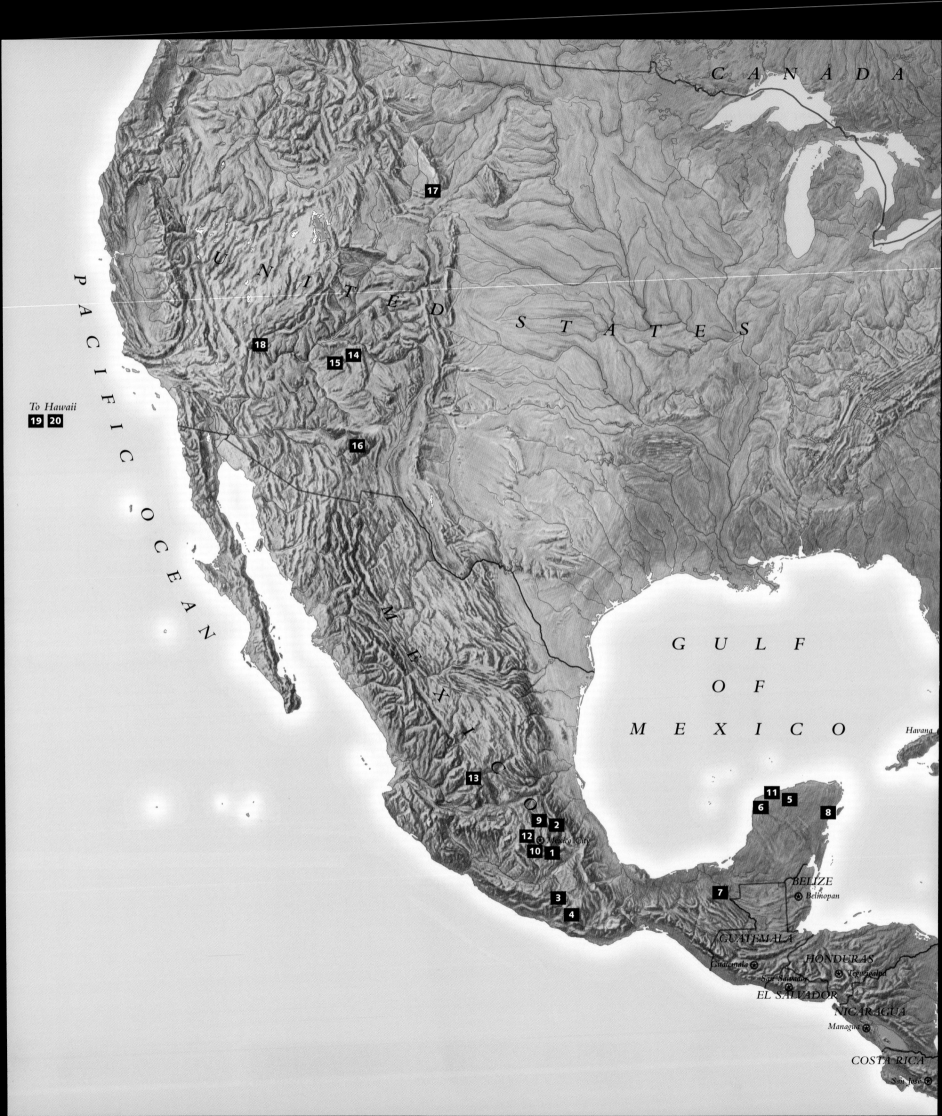

Sacred Sites of North and Central America

1. Mt. Popocatepetl and Mt. Iztaccihuatl, Puebla, Mexico

2. Teotihuacán, Mexico

3. Monte Albán, Mexico

4. Mitla, Mexico

5. Chichén Itzá, Mexico

6. Uxmal, Mexico

7. Palenque, Mexico

8. Tulum, Mexico

9. Tula, Mexico

10. Mexico City, Mexico

11. Izamal, Mexico

12. Chalma, Mexico

13. San Juan de los Lagos, Jalisco, Mexico

14. Chaco Canyon National Monument, New Mexico, United States

15. Shiprock, New Mexico, United States

16. White Sands National Monument, New Mexico, United States

17. Devils Tower National Monument, Wyoming, United States

18. Red Rocks of Sedona, Arizona, United States

19. Mauna Kea, Hawaii, United States

20. Haleakala Crater, Maui, Hawaii, United States

Mt. Iztaccihuatl is seen in the distance from the slopes of Mt. Popocatepetl; in Aztec culture, the mountains represented two heartbroken lovers—a warrior and a princess.

MT. POPOCATEPETL AND MT. IZTACCIHUATL

Puebla, Mexico

MAP SITE 1

Southeast of Mexico City stand the two great sacred mountains of Popocatepetl and Iztaccihuatl. In Nahuatl, the language of the Aztecs, Popocatepetl translates as Smoking Mountain; the 17,833-foot (5,435 m) volcano has erupted on and off over the centuries and frequently emits large plumes of ash and vapor. Iztaccihuatl, Sleeping Lady or White Lady in Nahuatl, is an extinct volcano almost as tall as Popocatepetl. Ruins of shrines, found as high as 12,000 feet (3,658 m) on both peaks, show that the mountains served important religious functions for the Aztecs and perhaps earlier cultures. A romantic legend that dates from pre-Conquest times relates how the warrior Popocatepetl was in love with the maiden Iztaccihuatl, daughter of a tribal king. The lovers went to the king, who told them he would allow the marriage only if Popocatepetl was victorious in battle with a rival tribe. Popocatepetl went off to battle and was victorious, but he was kept away longer than expected. A rival suitor to the hand of Iztaccihuatl spread the rumor that Popocatepetl had died in battle, and the young

maiden soon died of grief. When Popocatepetl returned, he placed her body atop a mountain range that assumed the shape of a sleeping woman—the form that is evident in the western view of Iztaccihuatl today. Overcome with sadness, Popocatepetl climbed the adjacent peak, where, standing sentinel with a smoking torch, he eternally watches over his lost love.

Legends relate that the Aztec emperor Montezuma once sent ten of his warriors to climb Popocatepetl to discover the source of the mysterious smoke. The first recorded ascent in 1522 CE seems to have been accomplished by soldiers in the army of Cortés, making Popocatepetl the highest peak climbed by Europeans up to that time. Nowadays, during the winter months when the snow is hard and the skies clear, many climbers scale the towering mountains. In the vicinity of central Mexico are three other sacred mountains: Tlalocatepetl, the abode of the powerful Aztec rain god; Citlaltépetl (or Pico de Orizaba), the tallest peak in Mexico; and Nevado de Toluca.

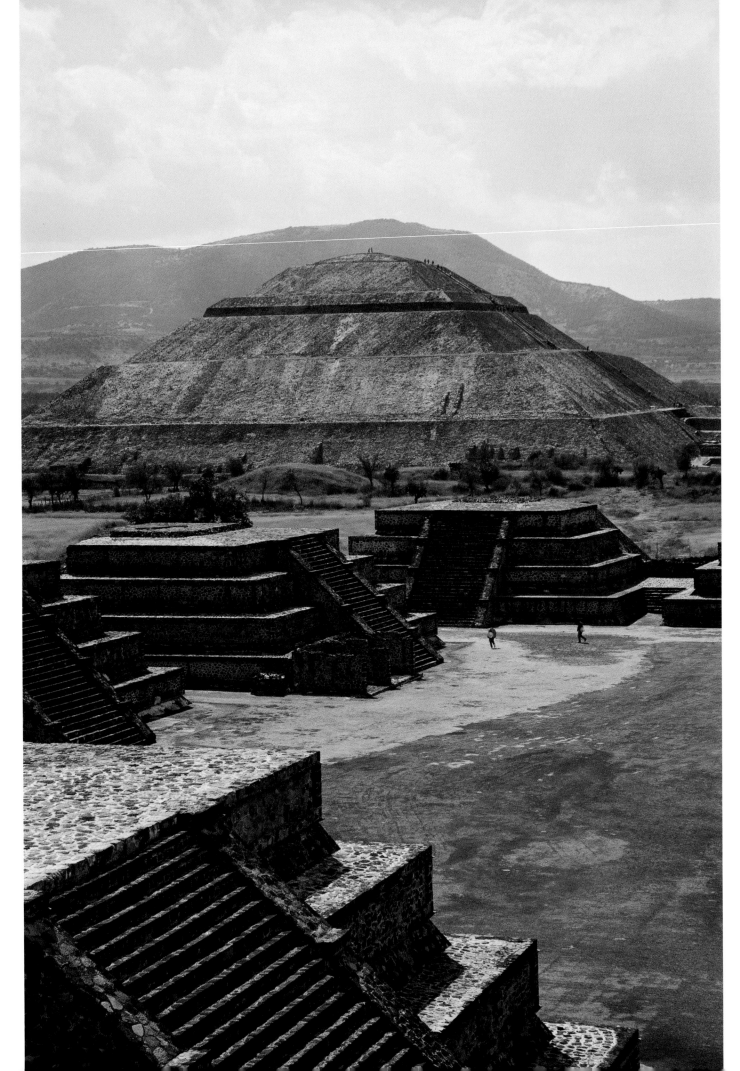

Before Teotihuacán grew into an enormous sacred city, its origins as a place of worship likely began in a small natural cave now hidden beneath the Pyramid of the Sun. Even though the city is in ruins, and the strange cave beneath the pyramid is locked, visitors may still tap into the powerful energy field of Teotihuacán.

Pyramid of the Sun

Teotihuacán, Mexico

Map site 2

Near Mexico City stand the ruins of Teotihuacán, the largest city of Mesoamerica in pre-Columbian times. Orthodox archaeologists are divided concerning the dating of the site, some believing it flourished from 1500 to 1000 BCE and others stating a later period of 100 BCE to 700 CE. There are also scholars studying the mythology and archaeology of the region who suggest that Teotihuacán may be far older. One intriguing matter is that the original name of the place is unknown. Its current name, Teotihuacán, (Place of the Gods), was given to the city by the Aztecs after the city's decline and abandonment. Various Mesoamericans before the Aztecs—Mayans, Zapotecs, and Toltecs—were equally mystified by the vast ruins, seeing in them shadowy traces of an even earlier people.

The most striking architectural structure of Teotihuacán is the towering Pyramid of the Sun, a man-made sacred mountain whose original name and function are unknown. From atop this pyramid, whose base is nearly equal in size to that of the Great Pyramid of Egypt, numerous other pyramids may be seen along the Avenue of the Dead, the main street of Teotihuacán. There are several unsolved riddles about the Pyramid of the Sun, such as that concerning the sheet of granulated mica, one-foot (30 cm) thick, which once covered its uppermost level. Illegally removed and sold in the early 1900s, the mica had been transported from South America thousands of miles away. How had the great quantity of mica been brought from such a distance, and why had the pyramid been covered with the rare stone? One suggestion is that mica, being an efficient energy conductor, was used as part of a receiving device for long-wavelength celestial radiations. The incoming celestial energy would have been collected by the pyramid, whose sacred geometrical design would focus it into the cave beneath the pyramid. This energy, available for use at any time of the year, would be especially concentrated at certain periods during solar and lunar cycles. These specific periods were determined by using astronomical observation structures positioned in different places around the geomantically aligned city.

Mound J

Monte Albán, Mexico

Map site 3

High above the city of Oaxaca, the ruins of Monte Albán are the second largest ceremonial site in Mesoamerica, exceeded in size only by Teotihuacán. The first known buildings were constructed around 1000 BCE, but most of these are now buried beneath later Zapotec structures. While the Zapotec occupation of the site dates from 500 BCE, most of the existing structures date from 200 to 800 CE when Monte Albán became the principal ceremonial site of the Zapotec Empire. The temple complex was abandoned as a functioning ceremonial center during the tenth century, though it continued to be used as a burial place by the Mixtecs. Traditional archaeological theory is unable to explain why this particular site was chosen and used. Upon a steep plateau with no source of water and never used for habitation or military purposes, Monte Albán was laboriously constructed with massive blocks of stone carried from far away. How are we to explain this immense human endeavor? Perhaps the ancient name of the site, Sahandevui, meaning "at the foot of heaven," provides a mythological explanation.

Built sometime between 100 BCE and 200 CE, Mound J is a sophisticated astronomical observatory positioned at an angle of forty-five degrees relative to the main axis of Monte Albán. The elaborate and still undeciphered hieroglyphs at Monte Albán are among the most ancient writings in all of Mesoamerica. Equally mysterious are the strange rock carvings known as *danzantes,* which depict human figures with Negroid facial features. Similar to carvings found at Olmec sites in other parts of Mexico, these decidedly non-Mexican figures and the hieroglyphic writings seem to indicate the possibility of contact with and influence by cultures far from the Western Hemisphere.

Mound J, a sacred astronomical observatory at Monte Albán, has celestial alignments with the Southern Cross, Alpha and Beta Centauri, the rising position of Capella, and the setting position of Alnilam, the center star of Orion's Belt.

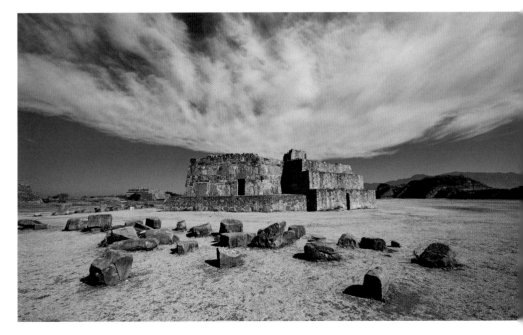

Main Sanctuary

Mitla, Mexico

Map site 4

Near the city of Oaxaca, the ruins of Mitla are one of Mexico's
most fascinating and enigmatic sacred places. Archaeological
excavations indicate that the site was occupied as early as 900 BCE.
Mitla's visible structural remains, however, date from between 200
and 900 CE when the Zapotecs were present, from 1000 CE when
the Mixtecs took over of the site, and from 1200 CE when the
Zapotecs were back in control. Mitla comes from the word
mictlan, a Nahuatl term meaning "place of the dead." The earlier
Zapotec name of Lyobaa means "tomb" or "place of rest."

Mitla includes five main groups of structures, among which is
the Hall of Columns, with its entrance to the main sanctuary.
It is not known what these structures were called by their builders;
the name Hall of Columns comes from the first Spanish explorers
who visited the site. The hall, 120 by 21 feet (37 by 6 m), has six
monolithic columns of volcanic stone that originally supported a
roof covering the entire hall. The darkened doorway leads
through a narrow passageway to the interior of another enclosure,
now roofless but also covered in ancient times. This chamber is
one of the most astonishing artistic artifacts of pre-Columbian
America. Its walls are covered with panels of inlaid cut-stone
mosaic known as stepped-fret design. The motif of these intricate
geometric mosaics is believed to be a stylized representation of the
Sky Serpent and therefore a symbol of the pan-regional
Mesoamerican deity Quetzalcoatl, who was typically represented
as a feathered serpent. Many archaeologists are mystified regarding
the use of this chamber, but according to ancient lore, it was used
for the final initiation of shamans who had been trained in the
healing arts at the school of Mitla. In the Patio of Tombs, adjacent
to the Hall of Columns, is a tall stone column known as the Pillar
of Death. Legend says that if you hold your arms around this
pillar and feel it move, your death is imminent.

**The entrance to the main
sanctuary** at Mitla; past the
darkened doorway lies a
chamber that may have
been used in pre-Columbian
times to initiate shamans
trained in healing.

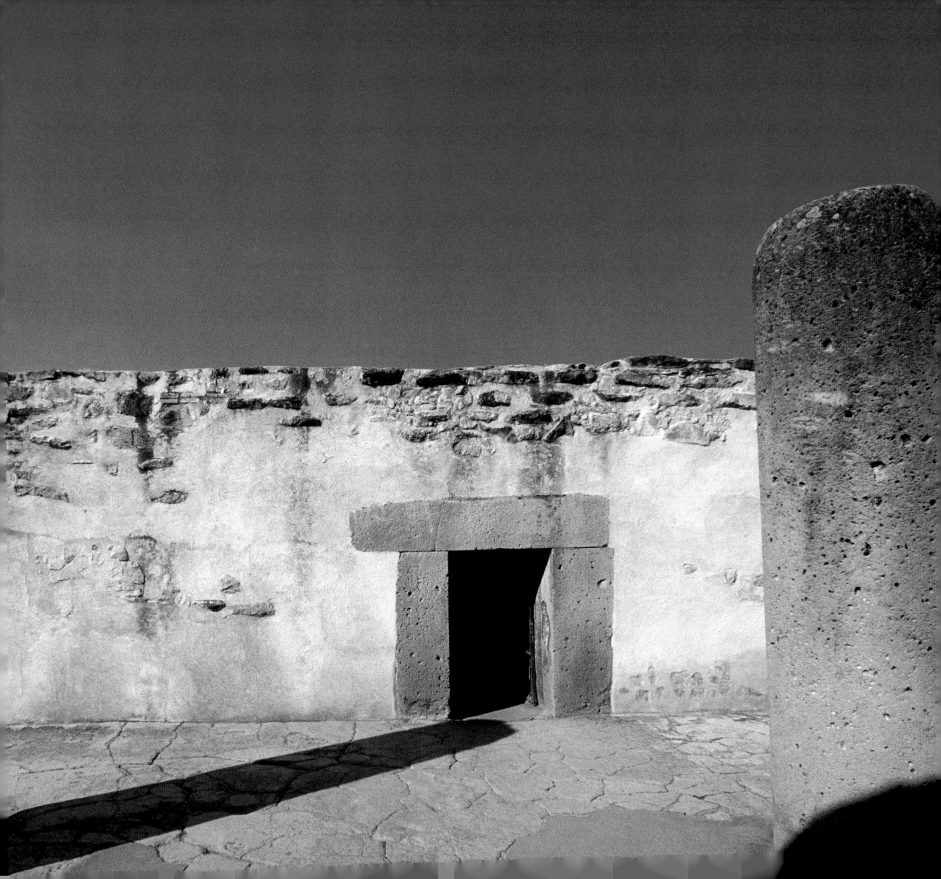

Chichén Itzá, Mexico

MAP SITE 5

Each face of the four-sided Temple of Kukulcan has a stairway with ninety-one steps, which together with the shared step of the platform at the top add up to 365, the number of days in a year. These stairways also divide the nine terraces of each side of the pyramid into eighteen segments, representing the months of the Mayan calendar.

The earliest archaeological remains found at Chichén Itzá date from the first century CE, yet by then the Yucatán Peninsula had been inhabited for at least eight thousand years. After their conquest of the holy city of Izamal in the eighth century, the seafaring Itzá people settled at the enormous natural well, known as Wuk Yabnal, Abundance Place. Their city became known as Chichén Itzá, which translates as Mouth of the Well of the Itzá. From this site, the Itzá Maya rapidly became the rulers of much of the Yucatán Peninsula. Contrary to popular belief, the Maya were not an empire. Rather, they were a collection of autonomous city-states in frequent communication with other city-states in their region.

The Temple of Kukulcan, the Feathered Serpent (also known as Quetzalcoatl to the Toltecs and Aztecs), is the largest and most important ceremonial structure at Chichén Itzá. This ninety-foot-tall (27 m) pyramid was built during the eleventh to thirteenth centuries directly upon the foundations of previous temples. The

architecture of the pyramid encodes precise information regarding the Mayan calendar and is directionally oriented to mark the solstices and equinoxes. Studies by archaeoastronomers have revealed that other structures at Chichén Itzá also have significant astronomical alignments, such as the Caracol observatory, which indicates key positions of the planet Venus, particularly its southern and northern horizon extremes. If you study the ground plan of Chichén Itzá and the spatial relationships between its primary temples, you will see that the site was actually a mirror of the star positions in the night skies during the building and assembly of the temple complexes. This is an example of sacred geography, or terrestrial astrology, on a local scale. The Mayans also practiced sacred geography on a larger regional scale by siting their temple-cities so that their orientation mirrored the position of different celestial bodies in the sky.

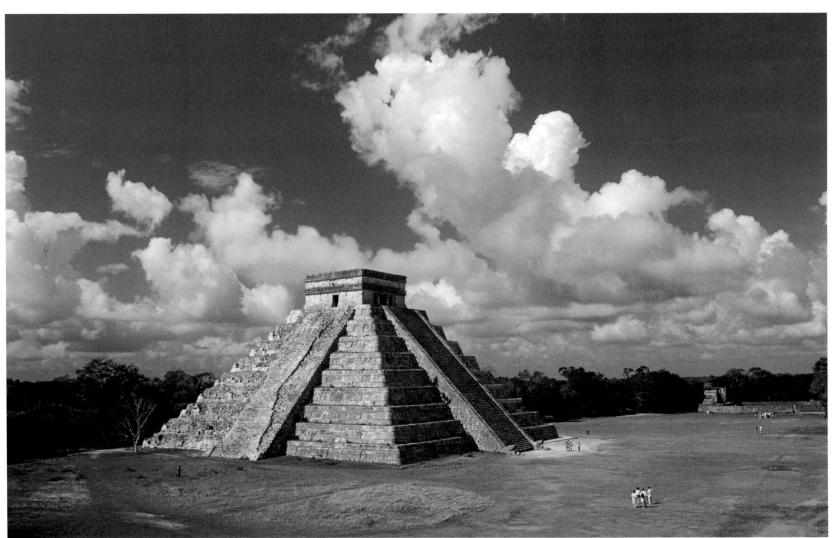

Pyramid of the Magician

Uxmal, Mexico

Map site 6

Uxmal was the greatest metropolitan and religious Mayan center in the Puuc hills of Yucatán during the late Classical Period, flourishing between the seventh and tenth centuries CE. Uxmal translates as "thrice built," and whatever the actual number, the numerous building phases are reflected in a variety of architectural styles. The city was abandoned in the tenth century after apparently coming under Toltec influence. The Pyramid of the Magician, soaring to one hundred feet (30 m), is the tallest structure in Uxmal.

According to ancient legend, a magician-god named Itzamna constructed the pyramid in one night. From archaeological excavation, however, we know that the pyramid was constructed in five superimposed phases over a period of many years. The legendary association of the pyramid with a magician may be understood as an indication that the structure, and indeed the entire sacred part of the Uxmal complex, had ancient and ongoing use as a mystery school and ceremonial center.

The entire city of Uxmal is aligned with the position of the planets known to the Maya, with Venus predominating; the Pyramid of the Magician is oriented so that the stairway on its west side faces the setting sun at the summer solstice.

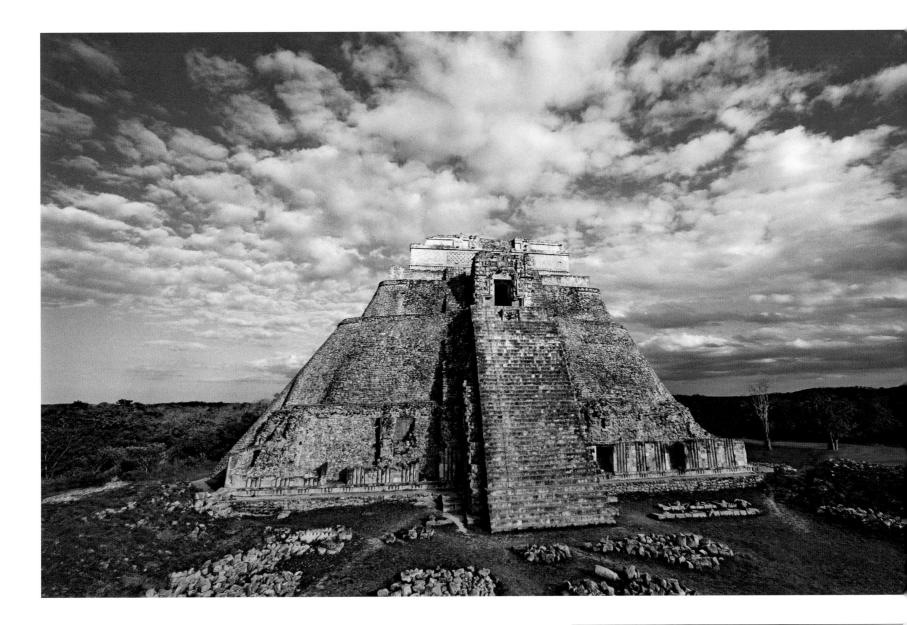

TEMPLE OF THE INSCRIPTIONS

Palenque, Mexico

MAP SITE 7

The Temple of the Inscriptions, in the breathtaking city of Palenque, was a temple, a burial tomb for the Mayan king Pacal Votan, and a pilgrimage site.

Vast, mysterious, and enchanting, the ruined city of Palenque is considered to be the most beautifully conceived of all the Mayan cities. Nestled amid steep and thickly forested hills, its temples and pyramids are frequently shrouded in lacy mists. During its period of cultural flowering, from the seventh through the tenth centuries, Palenque was even more beautiful, for then its limestone buildings were coated with white plaster and painted in a rainbow of pastel hues. Mysteriously, the great city was later abandoned and reclaimed by the jungle. Even the Mayan name of the city was lost, and the ruins received their current name from the nearby village of Santo Domingo de Palenque. Unknown until the nineteenth century, this jewel of Mayan architecture was introduced to the world through the evocative writings and splendid drawings of the explorers John Lloyd Stephens and Frederick Catherwood in 1841. While the ruins have received some of the most extensive reconstruction efforts of any Mayan site, only thirty-four structures have been excavated out of an estimated five hundred that are scattered around the area.

The Temple of the Inscriptions, erected in 692 CE, was a temple, a burial tomb, and a pilgrimage site. Beneath the floor of an inner room, a hidden stairway leads to a funerary crypt eighty feet (24 m) below, which contained a coffin and a skeleton covered with jade ornaments and other precious jewels. Inscriptions reveal the burial to have been of the priest-king Pacal Votan, who ruled the city from 615 to 683 CE. The thirteen corbeled vaults leading to the burial crypt replicate the thirteen levels of heaven in Mayan cosmology, and the nine stages of the pyramid symbolize the nine levels of the underworld. The ruins of Palenque, like so many other Mayan sites, were part of a vast regional sacred geography, itself a mirror of the night skies as viewed and understood by the Mayan astronomers.

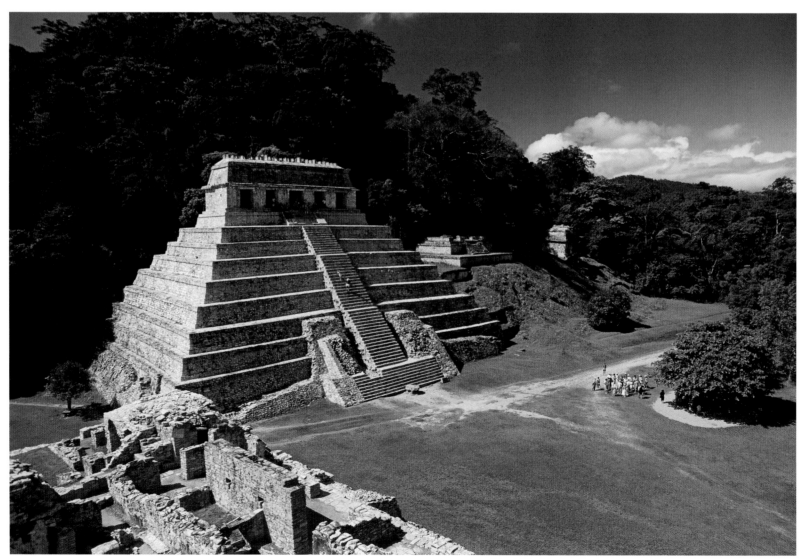

TEMPLE OF KUKULCAN (EL CASTILLO)

Tulum, Mexico

MAP SITE 8

Eighty miles (129 km) south of the tourist resorts of Cancún, in the Yucatán state of Quintana Roo, stand the ruins of the Mayan city of Tulum. Its original name is long forgotten; Tulum is a Nahuatl term meaning "walled city." Although occupied from as early as the Mayan pre-Classic period (300 BCE to 250 CE), nearly all the existing structures date from the late post-Classic period (1200 CE to the European conquest in 1521), when Tulum was a maritime trading center. Recent research has shown that Tulum was also a pilgrimage site for Mayan women on their way to the holy island of Cozumel, where there stood the sanctuary of the goddess Ix Chel (pronounced *eesh chel*). Ix Chel was the pre-eminent goddess of the Maya pantheon from 100 to 900 CE. Large numbers of women from the Mayan territories visited her shrine at Cozumel, making it one of the greatest pilgrimage sites in the pre-Columbian world. The goddess Ix Chel appears frequently in the Tulum temple murals, and the coastal region of Tulum was fascinatingly female, with a multitude of coastal towns having the feminine prefix *Ix* in their names.

Though architecturally somewhat crude compared to other classic Mayan sites such as Uxmal and Chichén Itzá, Tulum has one of the most beautiful settings of any city constructed by the Mayans. Perched on a cliff overlooking pristine beaches and an aquamarine sea, the Temple of Kukulcan dominates the ruins. This structure, called El Castillo (meaning "the castle") by the conquering Spaniards, was never a castle but rather a shrine and ceremonial center.

El Castillo, in Tulum, was a temple dedicated to the god Kukulcan. Tulum, with its coastal location, was an important Mayan maritime trading center and pilgrimage site for Mayan women.

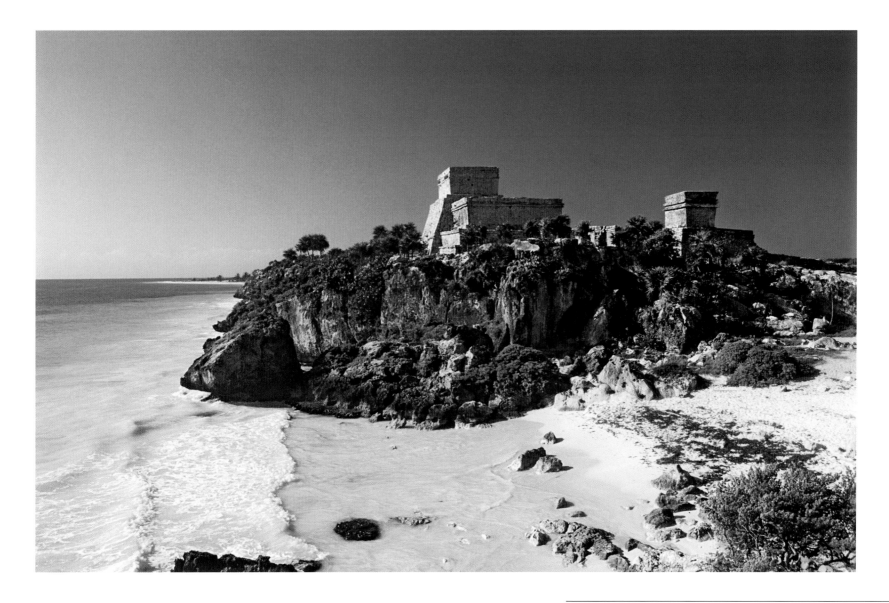

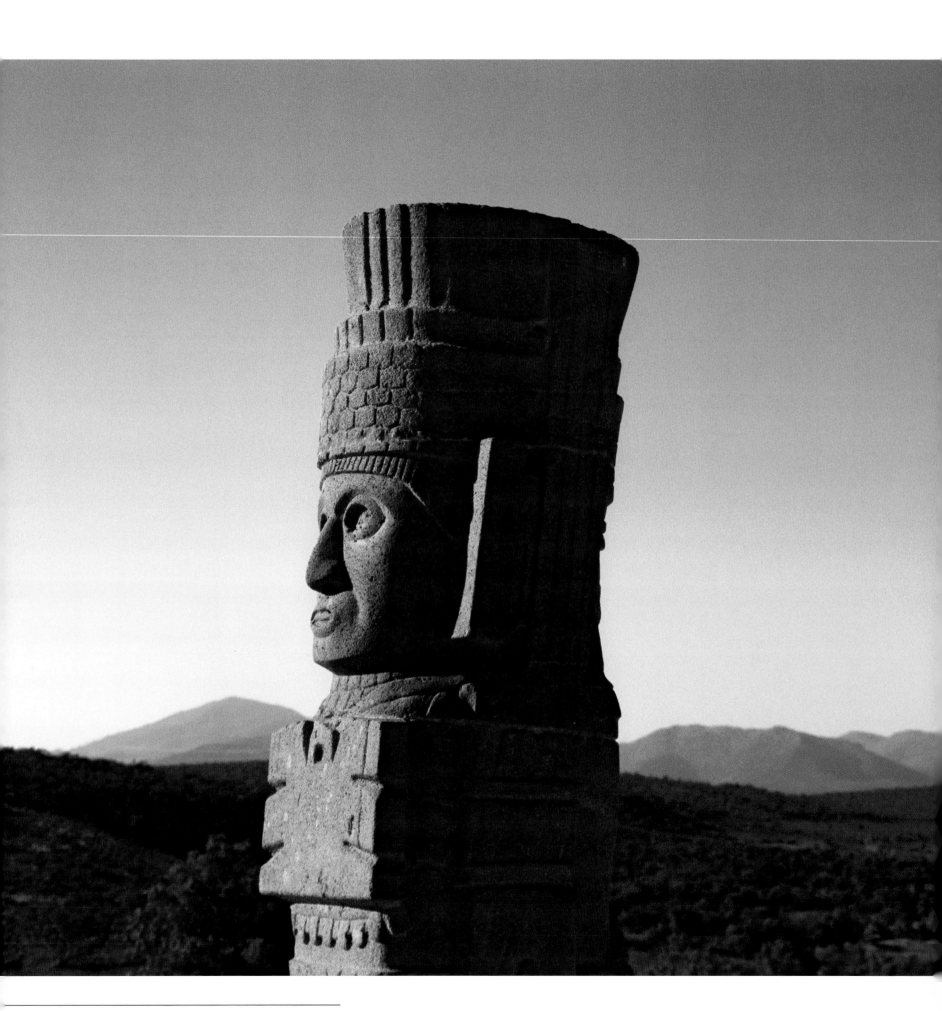

SACRED EARTH

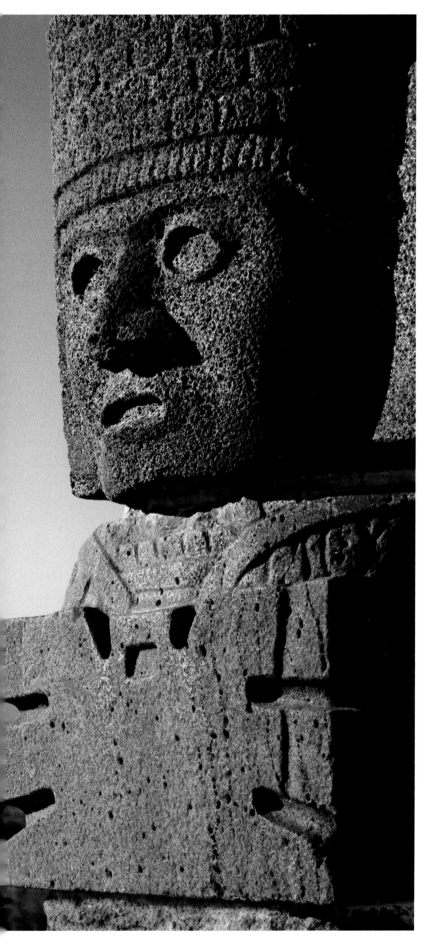

Toltec Sanctuary of Tollan

Tula, Mexico

Map site 9

The Toltec civilization developed in central Mexico, and by 1050 CE their city of Tollan had become the capital of a large empire. Mentioned in indigenous documents and post-Conquest sources, Tollan was said to be on the hill of Tzatzitepetl, but the ruins were lost until 1940, when archaeologists discovered them near the village of Tula de Allende. The ruined city contains a palace and three pyramid-shaped temples. Four tall stone statues called Atlanteans, believed to represent Quetzalcoatl, stood upon the largest of these temples. The Toltec civilization eventually declined as the twelfth-century Chitimecs and the fourteenth-century Aztecs attacked Tollan, plundering its pyramids in search of riches.

According to legend, Tollan was founded by the mythological Quetzalcoatl, the Feathered Serpent, an ancient deity whom the Toltecs had adopted from earlier cultures and worshipped as the god of Venus. Around 1000 CE, a rival Toltec deity named Tezcatlipoca drove Quetzalcoatl and his followers out of Tula. Quetzalcoatl then traveled to the Atlantic Ocean, where he disappeared beyond the eastern horizon. The legend of the victory of Tezcatlipoca over Quetzalcoatl probably reflects some historical fact. Indigenous historians and Spanish chroniclers had mentioned Quetzalcoatl as an actual priest-king of Tula. The early years of Toltec civilization had been influenced by Teotihuacán culture, with its ideals of priestly rule and peaceful behavior. Later pressures from northern immigrants brought about a social and religious revolution, with a military class seizing power from the priests. Quetzalcoatl's defeat symbolized the downfall of the priests.

The Aztec calendar was divided into cycles of fifty-two years (comparable to our centuries) divided into four parts. The years in the first part of the cycle were known as Reeds. The year One Reed was assigned to Quetzalcoatl as his astrological or calendar name. There was a belief among the Aztecs that Quetzalcoatl would return to them from the east in a One Reed year. This belief later caused the Aztec sovereign Montezuma II to regard the Spanish conqueror Hernán Cortés as a divine envoy because 1519 CE, the year in which he landed on the Mexican Gulf coast, was a One Reed year.

Toltec warrior statues eternally guard the Toltec sanctuary of Tollan, which is dedicated to Quetzalcoatl.

Basilica of Nuestra Señora de Guadalupe

Mexico City, Mexico

Map site 10

The Basilica of Nuestra Señora de Guadalupe is the most visited pilgrimage site in the Western Hemisphere. Located on the hill of Tepeyac, a sacred site long before the arrival of Christianity, it was the site of a temple dedicated to Tonantzin, the Mother of the Gods. Following the conquest of the Aztec city of Tenochtitlan by Hernán Cortés in 1521 CE, the shrine was demolished, and native people were forbidden to make pilgrimages to the sacred hill.

In 1531, a baptized Aztec named Juan Diego experienced a series of apparitions upon the hill of Tepeyac. In these apparitions a young woman revealed herself as the Holy Mary, Mother of God. The figure directed Juan Diego to speak with the local bishop and have him build a church on the hill. The bishop was skeptical and asked for a sign. Juan Diego returned to the hill, encountered the apparition again, and was told to climb to the peak, where he should gather a bunch of roses and return to Mary. Juan climbed the hill with misgivings, for it was winter and no roses could possibly be growing. Yet upon reaching the summit, Juan found a profusion of roses, and he wrapped an armful of them in his shawl and took them to Mary. Arranging the roses, Mary instructed Juan to take the shawl-encased bundle to the bishop, for this would be her sign. When the bishop unrolled the shawl, the presence of the roses was astounding. But truly miraculous was the image that had mysteriously appeared on the inside of Juan Diego's shawl. The image showed a young woman wearing a crown and a gown and standing on a half-moon. Soon thereafter the bishop began construction of the church.

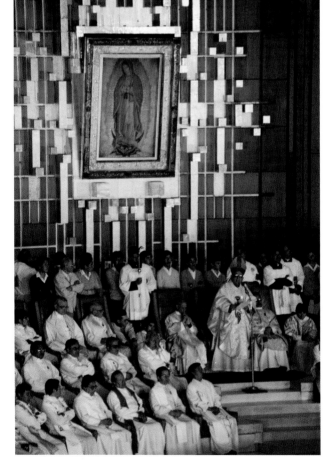

Convent of San Antonio de Padua

Izamal, Mexico

Map site 11

East of Mérida, the capital of Yucatán, is the colonial town of Izamal. In the center of town stands the Convent of San Antonio de Padua, which contains one of the most venerated Marian statues in all of Mexico. Thousands of miracles of healing are attributed to this statue. Examining Izamal's pre-Columbian history, however, shows another explanation for the healing miracles. Prior to the time of the Spanish conquest of Yucatán (1527-1547), Izamal was one of the most important cities on the peninsula. A Mayan pilgrimage site since as early as 1000 BCE, Izamal was considered to be the abode of Kinich Kakmo, a manifestation of the sun god, and of Itzam Na, a deity of healing and the arts. Itzam Na was also known by the title Ahaulil, or Lord, and was sometimes shown presiding over lesser deities.

Following the capture of Izamal by the Spanish, the local population was enslaved and forced to dismantle the top of an enormous pyramid in the center of the city. Upon the now-flattened pyramid, at the place where there previously had stood the sanctuary of the god Itzam Na, the natives were forced to erect a Franciscan convent and church in 1553 to discourage themselves from their "devil worship." Soon after the consecration of the church and the installation of a statue of Mary, miracles of healing began to occur. These miracles were explained by the Christian authorities as resulting from the grace of Mary. But were the miracles actually caused by the wooden statue of Mary inside the church, or might they be better explained by the Mayan beliefs regarding the healing power of the sacred site of Izamal? The town is much visited twice each year when thousands of pilgrims come for the Procession of the Black Christ on October 18 and the Procession of the Virgin of Izamal on December 8.

Juan Diego's shawl with the miraculous image of Nuestra Señora de Guadalupe is preserved behind glass above the main altar in the basilica. Yearly, an estimated ten million pilgrims come to venerate the image, and on major festival days such as December 12, the atmosphere of devotion created by the hundreds of thousands of pilgrims is truly electrifying.

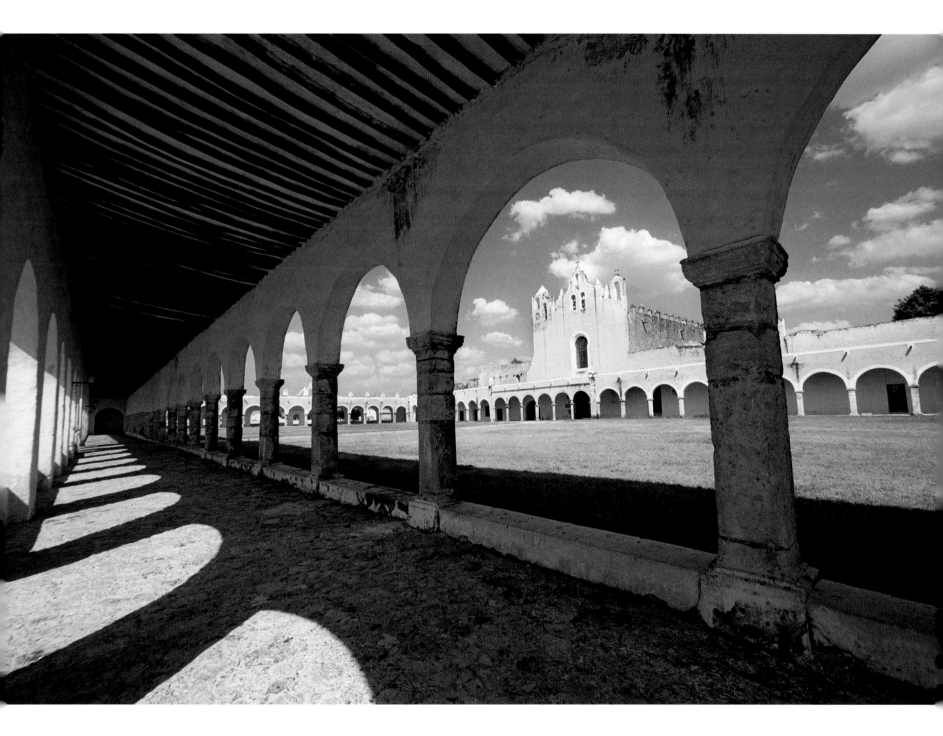

A view from underneath the huge colonnade at the sixteenth-century Convent of San Antonio de Padua, the site of a large Catholic festival in October that brings thousands of pilgrims to the small town of Izamal, previously a Mayan sacred site.

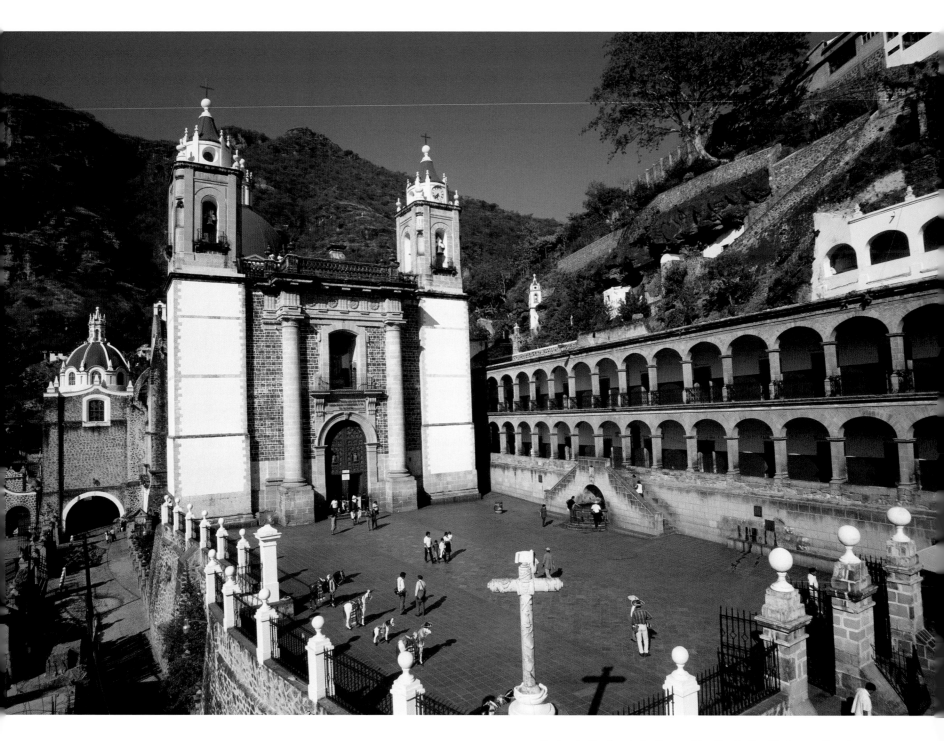

During festival periods, the road leading to the Pilgrimage Church of Chalma is filled with *peregrinos* (pilgrims), many of whom have traveled miles to seek healings and blessings. Behind the church there is a stream where the pilgrims bathe in water from the spring that feeds the cave that was long ago visited by Aztec pilgrims.

Pilgrimage Church of Chalma

Chalma, Mexico

Map site 12

Near the city of Cuernavaca is the pre-Columbian sacred site of Chalma. Though its early history is shrouded in myth, Chalma was long visited by Aztec pilgrims making offerings to a statue of Oztoteotl, the Dark Lord of the Cave. Pilgrims would walk for days through the surrounding mountains, wearing flowers in their hair, then bathe in a sacred spring and drink its holy water before entering the cave. The statue was a black cylindrical stone reputed to have magical healing powers, and Oztoteotl was identified as a deity of human destiny or a god of war. Various stories tell how two Christian friars, arriving at the cave soon after the Spanish invasion of Mexico, destroyed the Aztec idol and replaced it with a statue of Christ. Over time, the cave entrance was enlarged and the shrine was dedicated to St. Michael. The statue of Christ remained in the cave until 1683 CE, when it was brought down to a newly constructed church. The original statue was destroyed by fire in the eighteenth century, and the statue that is venerated there today was modeled after the original statue's remains.

Thousands of Catholic pilgrims flock to the site throughout the year, giving thanks for prayers answered or to make wishes. Today's pilgrims, often carrying flowers as their pagan ancestors did, walk traditional paths to Chalma. Many walk the last leg of their journey at night, the light from their torches and candles making a luminous trail up and down the deep ravines. Women carry small babies, old men hope for a miraculous cure, and young folk seek adventure. While some other Catholic pilgrimages involve suffering, pilgrims to Chalma pray through dancing. Upon entering the charming church, pilgrims light a candle and place a *milagro* (small metal talisman) in a box before the altar. In the shrine there is also a wall covered with simple paintings, photos, and other personal tributes displayed as thanks for miracles granted.

San Juan de los Lagos

Jalisco, Mexico

Map site 13

Located in central Mexico, northeast of the city of Guadalajara, the small town of San Juan de los Lagos is the second-most-visited pilgrimage shrine in Mexico. Founded by Fray Miguel of Bologna, the town was first called San Juan Bautista Mezquititlán, but its name was changed in 1623 CE. The miraculous image of the Virgin of San Juan was crafted in the year 1521 by the Tarasco Indians of Michoacán and represents the Virgin Santísima. A grand pilgrimage festival at the shrine occurs each year on February 2, when several hundred thousand pilgrims walk to the shrine from all over central Mexico. During a week of festivities, there are hundreds of temporary stalls with pilgrimage icons for sale, many bands of musicians playing around the great basilica, fireworks demonstrations in the evenings, and a feeling of spiritual joy throughout the town. A sense of holiness truly saturates and surrounds this shrine during the February festival.

A pilgrim visiting San Juan de los Lagos during the winter festival holds a crucifix.

PUEBLO BONITO, CHACO CANYON
New Mexico, United States
MAP SITE 14

In the desert of northwestern New Mexico stand the ruins of the greatest architectural achievement of the northern Native Americans. Known as Chaco Canyon, the site was the main ceremonial center of the Anasazi culture. It is not known what these people called themselves; the term *Anasazi* is a Navajo word meaning "ancient ones." The early Anasazi were nomadic hunter-gatherers who by 700 CE had begun to live in settled communities of which Chaco Canyon is the finest example. Intensive construction between 900 and 1100 CE resulted in the development of several sophisticated dwelling complexes. Pueblo Bonito (Pretty Village) had more than six hundred rooms, numerous two- and three-level buildings, several ceremonial structures called *kivas*, and a population of perhaps twelve hundred people. Tree-ring dating shows that a period of great drought came upon the Chaco area in 1150 CE, causing the abandonment of the site. Rediscovered in 1849 by U.S. Army soldiers, the site was made a national monument in 1907. The National Geographic Society began reconstruction of the site in 1920.

Radiating from the Chaco complex are many straight lines etched into the ground and extending twenty miles (32 km) or more into the desert. Conventional archaeologists explain these enigmatic lines as roads leading to outlying settlements, but this seems highly unlikely, as the lines are arrow straight regardless of terrain. They go up and down vertical cliffs that make them impractical for casual or commercial travel. Perhaps they had another purpose. Research indicates that the lines often lead to other structures where evidence of religious activity is found. More than five hundred miles (800 km) of these lines have so far been charted. Nowadays they are mostly visible only from the air in the early morning or late afternoon, when the sun casts deep shadows. Inspecting the lines at ground level, one can see that they have been acted upon by hundreds of years of natural erosion, which has obscured all but scarce remains. It seems reasonable to suggest that the lines once delineated a regional map of sacred geography.

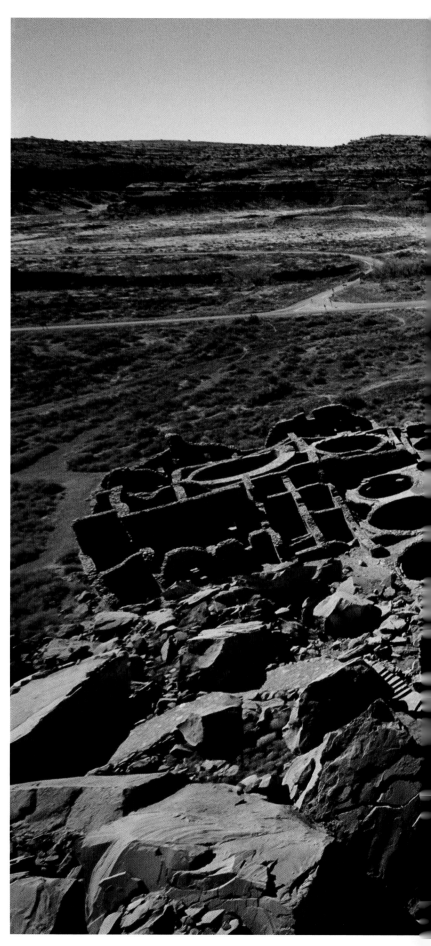

An aerial view of the Pueblo Bonito ruins shows the range of architectural features that made up this once-bustling Anasazi community. The circular structures known as *kivas* were used for ceremonial purposes.

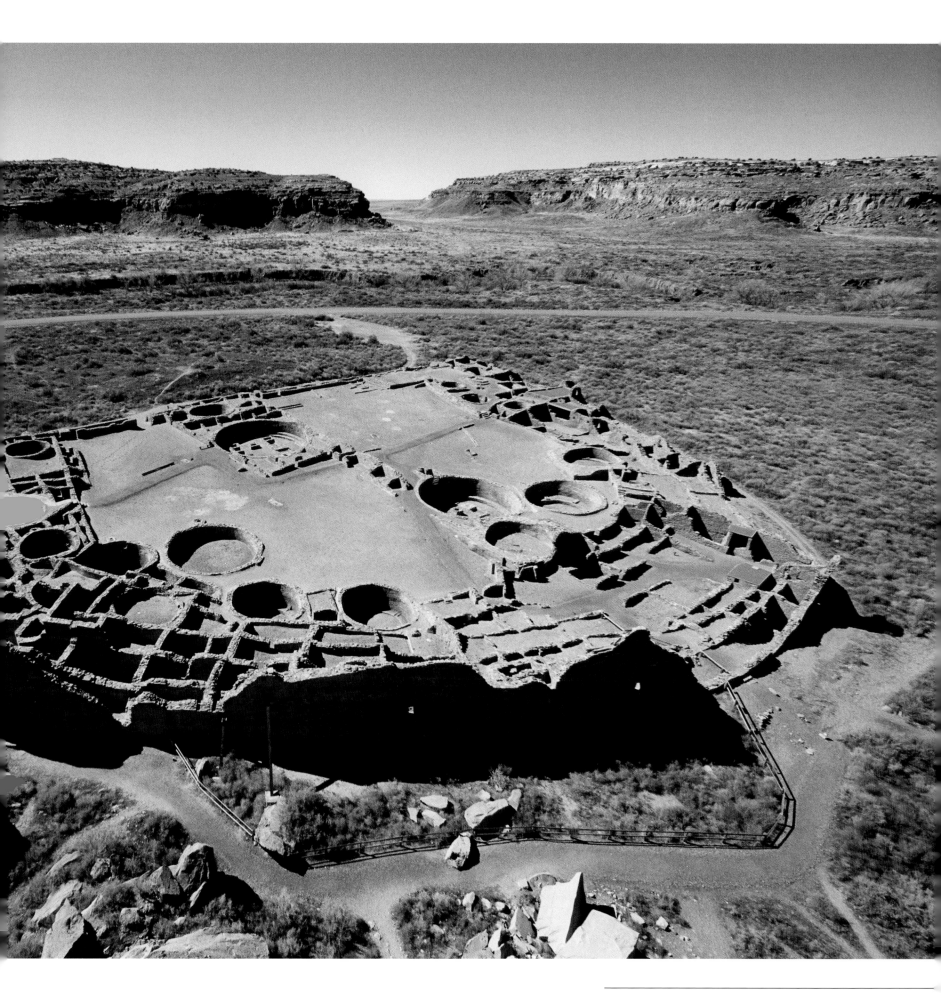

The craggy silhouette of Shiprock is described in Navajo mythology as the body of the great bird that rescued the Navajo people and brought them to their homeland.

SHIPROCK

New Mexico, United States

MAP SITE 15

Known today most commonly by the name Shiprock, the 1,700-foot-tall (518 m) eroded volcanic plume is sacred to the Navajo as Tse Bi dahi, or the Rock with Wings. This name comes from an ancient folk myth that tells how the rock was once a great bird that transported the ancestral people of the Navajo to their lands, in what is now northwestern New Mexico. The Navajo ancestors had crossed a narrow sea far northwest and were fleeing from a warlike tribe. Tribal shamans prayed to the Great Spirit for help. Suddenly the ground rose from beneath their feet to become an enormous bird. For an entire day and night, the bird flew south, finally settling at sundown where Shiprock now stands. Geologists have determined that the rock was formed twelve million years ago during the Pliocene era. The legend of the rock seems more likely to be a metaphor describing the site's magical power to lift the human soul above the problems of daily existence into an awareness of the Great Spirit. From ancient times to the more recent past, Tse Bi dahi was indeed a pilgrimage place of major importance, particularly for young men and women engaged in solitary vision quests. Technical climbers first scaled the rock in 1939. Since 1970, Shiprock has been off-limits to climbers, giving it once again the respect due a Navajo sacred place.

WHITE SANDS

New Mexico, United States

MAP SITE 16

Situated in south-central New Mexico are the world's largest dune fields of gypsum, stretching nearly 230 square miles (596 sq km), with sparkling white sand dunes that rise more than sixty feet (18 m). True sand dunes, as contrasted to beach sand—which is a mixture derived from many parts of the ocean floor—are places of a single energetic quality or frequency. Gypsum sand is from the mineral selenite, and there is no other place on earth with the feeling of White Sands.

The dunes were once a fabled site for vision quests by Native Americans from all parts of the region that is now the south-western United States and northern Mexico. The earth energies here promote an expansive sense of calmness, a childlike joy in the heart, and clarity in seeing one's life purpose. The best times to visit White Sands are on weekdays during the autumn, winter, or spring. At these times there will be few tourists, compared to the number during the summer months. Additionally, the winter light is absolutely beautiful on the shimmering sands. When visiting White Sands, take time to wander far out upon the dunes and spend hours playing and lying on the sand. For an even more magical experience, spend a full-moon night sleeping on the soft sand. The dunes seem to attract visitors from *very* far away. While National Park Service and government officials resolutely deny their existence, many hundreds of UFOs have been sighted at the White Sands National Monument during the past thirty years.

Energy fields at the pure gypsum dunes of White Sands promote powerful feelings of peace and mental clarity.

DEVILS TOWER

Wyoming, United States

MAP SITE 17

Brought to international attention by the movie *Close Encounters of the Third Kind,* Devils Tower has been a sacred place of numerous Native American tribes since prehistoric times. Various legends are told about the origin of the tower. One story, common to the Kiowa, Arapaho, Crow, Cheyenne, and Sioux tribes, concerns a group of seven girls who were pursued by a giant bear. One day the seven girls were playing in the forest when a great bear came upon them and gave chase. The girls fled swiftly through the trees, but the bear slowly gained on them. Recognizing the hopelessness of their situation, the girls jumped upon a low rock and prayed to the Great Spirit to save them. Immediately the small rock began to grow upward, lifting the seven girls higher and higher into the sky. The angry bear jumped up against the sides of the growing tower and left deep claw marks, which may be seen to this day upon the rock walls. The tower continued to soar toward the sky until the girls were lifted to the heavens, where they became the seven stars of the Pleiades.

Known by many different names to Native Americans, including Mateo Tepee (Grizzly Bear's Lodge), the tower is actually the remnant of a volcanic extrusion of sixty to seventy million years ago. Rising more than 1,200 feet (366 m), the tower was first seen by non-natives during a geological survey in 1875 CE. The surveyors called the rock Devils Tower, after an old Native American name, the Bad God's Tower. It was first climbed, using a long wooden ladder attached to the rock face, on July 4, 1893. Proclaimed the first U.S. National Monument by President Theodore Roosevelt in 1906, the tower is today a popular climbing site, and more than twenty thousand ascents have been made. Jutting magnificently out of the surrounding terrain, the tower was a much-venerated vision quest site of the Native Americans. Its use in this regard has continued to the present time by both natives and non-natives, and many visitors have reported seeing strange light phenomena and UFOs around the tower's summit.

Devils Tower, as viewed from an airplane. The giant rock is still a sacred site of worship for many Native American tribes.

The Red Rocks of Sedona were
colored red over the millennia by
iron-oxide deposits. Various local
tour guides speak about "vortexes"
or specific sites of concentrated
energy at different places in the
Sedona landscape, but geologists
and experienced dowsers strongly
refute these notions. The general
area of Red Rocks does seem to
have an inspirational effect upon
some people, including myself, but
this effect cannot be attributed to
particular places in the landscape.

Red Rocks of Sedona

Arizona, United States

Map site 18

Situated in northern Arizona at an elevation of 4,500 feet (1,371 m), the famous Red Rocks of Sedona are one of the most beautiful natural sites in the United States. Part of the eroding Mogollon Rim of the vast Colorado plateau, Sedona's canyon walls show nine layers of stone from different geological periods spanning hundreds of millions of years. There are six layers of sandstone, two thin layers of limestone, and, atop of all these, an igneous layer of basalt stone. The different sandstone and limestone layers were formed by sand from dunes or mud deposited by inland seas. The red colors of some of the sandstone layers are the result of iron oxide staining the rocks over great periods of time. The uppermost igneous layer was deposited by volcanic eruptions 14.5 million years ago that once covered the entire Verde Valley several meters deep in lava. The Verde Valley, or Green Valley, is so named because of the natural copper that had long been mined in the nearby hills, not because of the color of local vegetation.

Evidence of human presence in the Sedona region begins around 4000 BCE, when hunter-gatherers roamed through the Verde Valley. As early as 300 BCE, the dry desert soils were being farmed by the Hohokam people, who developed systems of irrigation canals by 700 CE but then mysteriously abandoned the area—perhaps because of a regional volcanic eruption in 1066 CE. Next to arrive were the agrarian Sinagua, whose Spanish name means "without water," an indication of their ability to farm in the dry environment. Settling in the area from about 1000 to 1400 CE, they built pueblos and cliff dwellings, perhaps influenced by the architecturally more sophisticated Anasazi, and made baskets, pottery, and jewelry. They also established trading relationships with tribes from the Pacific coastal regions and northern Mexico, and exported the high-grade copper that they mined west of Sedona. Traces of the Sinagua may be found in the remains of their ruined pueblos scattered around the Sedona area. Sites such as Palatki, Honanki, and Wupatki contained many two-story buildings with dozens of rooms decorated with intriguing pictographs and petroglyphs depicting clan affiliations, mythological beings, and astronomical observations. Archaeologists theorize that the Sinagua may have conducted religious celebrations during particular periods determined by their celestial observations. Early in the fifteenth century, the Sinagua disappeared from the area for reasons that remain a mystery, and the Yavapai and Apache tribes began to settle along the sides of Oak Creek Canyon.

Europeans first arrived in the region in 1583, when a group of Spanish explorers came in search of gold and silver. Following the end of the Civil War and the creation of the Territory of Arizona in 1863, homesteaders began to settle in the Verde Valley and along Oak Creek. Growth was slow at first because of the remoteness of the region. In 1902 the small town was named Sedona, after the name of the local postmaster's wife. The first spurt of development came during the 1940s and '50s, when Hollywood began filming westerns amid the Red Rocks, such classics as *Billy the Kid, Apache,* and *Broken Arrow.* In the 1960s and '70s, the beauty of the Red Rocks began attracting retirees, artists, and an increasing number of tourists. Currently more than four million visitors pass through Sedona each year. While there is no evidence that this area was a venerated sacred place in antiquity, it has become the most visited New Age pilgrimage destination in the United States since the late 1980s.

Mauna Kea

Hawaii, United States
Map site 19

Mauna Kea, the most sacred mountain to native Hawaiians, was the site of ongoing religious ritual practice.

Mauna Kea, at 13,796 feet (4,205 m), is the tallest mountain in Hawaii and all of the Pacific Ocean. If measured from its base at the ocean's floor, 16,000 feet (4,877 m) down, it is the tallest in the world. Due to its great weight, it has also subsided an estimated 35,000 feet (10,668 m) into the crust. Adjacent to Mauna Kea is the cone of Mauna Loa, lower by only 115 feet (35 m). Mauna Kea comprises 23 percent of the island of Hawaii and is its fourth most active volcano. The age of Mauna Kea is estimated to be one million years. There seem to be on-and-off eruptions every few hundred years, followed by quiet periods of a few thousand years. Mauna Kea is currently dormant, but it is believed that the mountain last erupted about 4,500 years ago.

Earthquakes occur every so often on Mauna Kea, and this seems to be the result of tectonic faulting, rather than the movement of magma. Winter snow falls on the heights, accumulating to many feet, and this has given the peak its indigenous name of Mauna Kea, or White Mountain. Glaciers have existed on Mauna Kea an estimated three times in the past 100,000 years. Since humans first came to the Hawaiian Islands, Mauna Kea has exerted a powerful spiritual magnetism, and pilgrims have often made the long climb up its steep slopes. Early Hawaiian legends speak of Mauna Kea as a revered elder ancestor. From its peak, which was believed to be the abode of the supreme creator of the world, the view is as lovely as any in the world.

HALEAKALA CRATER, MAUI

Hawaii, United States

MAP SITE 20

Haleakala is the name of the crater that forms the summit of East Maui Volcano. Maui, one of the younger islands in the Hawaiian chain, began as two separate volcanoes on the ocean floor about two million years ago. Over geologic ages, the volcanoes erupted, adding layer upon layer of lava, until their peaks emerged above the surface of the sea. The larger eastern peak has a height of 10,023 feet (3,055 m) above the ocean and approximately 30,000 feet (9,144 m) from its base on the ocean floor (97 percent of Haleakala's volume is actually below sea level). Haleakala is often, and incorrectly, said to be the largest dormant volcanic crater in the world, but there are larger volcanic craters, called calderas. Haleakala is not truly dormant, having last erupted around 1790 CE (it has erupted at least ten times since the year 1000), and it is also not a true crater, but rather the remnant of two erosional valleys partially refilled with lava from more recent volcanic activity. Still, the "crater" of Haleakala is a vast place, large enough to contain all of the island of Manhattan. From the rim of the crater, paths lead 3,000 feet (914 m) down to miles of hiking trails and cabins available for overnight stays. Haleakala, which means the House of the Sun, got its name because according to Polynesian legend the demigod Maui captured the sun here and forced it to slow its journey across the sky in order to give his people more daylight hours. Before then, the sun had moved too rapidly and there had been little time to do anything during the day. Archaeological studies of several small temples and altars within the crater indicate that Hawaiian peoples venerated Haleakala since at least 800 CE. Originally applied only to the eastern peak, the name Haleakala today refers to the entire mountain.

Rainbow-colored sunbeams magically touch the volcanic crater of sacred Haleakala.

Global Sacred Sites: An expanded listing of over five hundred sites

Sites marked with an asterisk are discussed or appear in photographs in this book.

Left: **The entrance to the Kalasasaya Temple**; Tiwanaku, Bolivia
Below: **Icon seller**, Rishikesh, India.

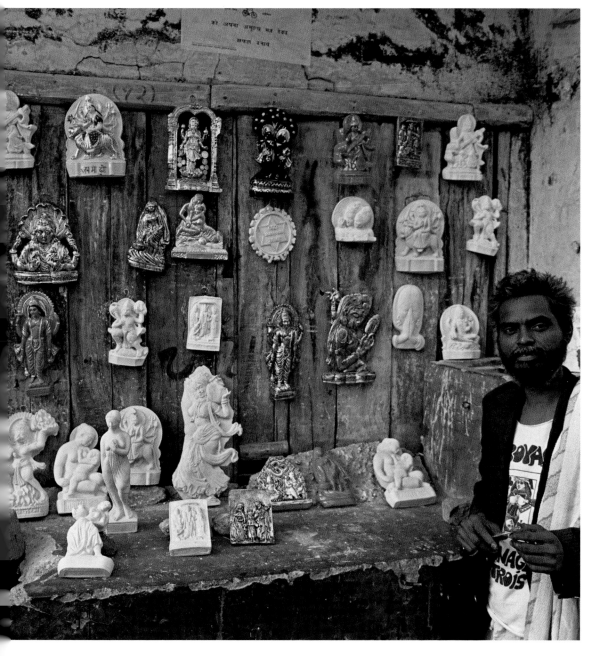

Europe

Andorra
Meritxell: Shrine of the Virgin

Armenia
Echmiadzin: St. Echmiadzin Cathedral
Garni: Garni Pagan Temple
Goght: Geghard Monastery

Austria
Hallstatt: Pilgrimage Church of Mariahilf★
Klagenfurt: Peak of Magdalensberg
Mariazell: Basilica of the Mariä Geburt

Belgium
Banneux: Shrine of the Virgin of the Poor
Beauraing: Shrine of Our Lady of Beauraing (Lady with the Golden Heart)
Bruges: Basilica of the Holy Blood
Oostakker, Ghent: Oostakker-Lourdes, Shrine of the Blessed Virgin
Scherpenheuvel-Zichem: Our Lady of Scherpenheuvel
Wéris: Megalithic site

Bosnia and Herzegovina
Medjugorje: Shrine of the Queen of Peace
Rijeka: Trsat Sanctuary, temporary location of the Virgin Mary's house in 1291 CE

Bulgaria

Chepelare River Valley: Bachkovo Monastery

Mt. Rila: Rila Monastery and the Seven Rila Lakes

Crete

Knossos: Minoan Palace ruins

Lato: Dorian ruins

Mt. Ida

Czech Republic

Mt. Hostyn: Basilica of the Ascension of the Virgin Mary and healing spring

Prague: Shrine of the Infant Jesus of Prague

Denmark

Bornholm Island: Round Templar churches of Bornholm★

England

Bath: Bath Abbey and the Roman Baths (hot springs)

Canterbury: Canterbury Cathedral★, St. Martin's Church

Cerne Abbas: Cerne Abbas Giant★

Durham: Durham Cathedral

Glastonbury: St. Michael's Tower at Glastonbury Tor★; Chalice Well; numerous other megalithic, pagan, and medieval sites

Keswick: Castlerigg Stone Circle

Lindisfarne: Holy Island; St. Cuthbert Priory ruins

London: St. Alban Tower; St. Paul's Cathedral; Westminster Abbey

Penzance: St. Michael's Mount★; numerous megalithic sites

Salisbury: Salisbury Cathedral; Old Sarum (Iron Age earthwork)

Wiltshire: Avebury stone ring★; Stonehenge stone ring★; numerous megalithic sites

Finland

Hämeenlinna: Church of the Holy Cross of Hattula

Joensuu: Monastery of Valamo

France

Amiens: Cathedral of Notre-Dame d'Amiens

Carcassonne: Basilica of St.-Nazaire

Carnac: Megalithic site

Chartres: Cathedral of Our Lady of Chartres, pilgrimage church atop pagan site

Conques: Abbey of Conques★

Gavrinis: Megalithic site

Le Puy-en-Velay: Cathedral of Notre Dame★; Chapel of St. Michael

Locmariaquer: Megalithic site

Lourdes: Basilica of Our Lady of Lourdes★ and Massabiele Grotto

Mont-Saint-Michel: La Merveille (Abbey of St. Michael) atop pagan site★

Montségur: Ruins of a French fortress, built on the site of a Cathar fort

Paray-le-Monial: Basilica of the Sacred Heart (Sacré Coeur)

Paris: Cathedral of Notre Dame; Basilica of the Sacred Heart (Sacré Coeur)

Recamadour: Shrine of Our Lady of Rocamadour★

Reims: Cathedral of Notre-Dame; St. Jacques de Reims

Rennes-le-Château: Medieval castle village and site of Grail mysteries

Saintes-Maries-de-la-Mer: Church of the Three Saints★

Vézelay: Basilica of St. Magdalene

Georgia

Imereti Province: Gelati Monastery

Germany

Aachen (Aix-la-Chapelle): Collegiate Church of St. Mary (Imperial Chapel of Charlemagne) and pagan hot springs

Baden-Württemberg: Monastery and church of Murrhardt on Celtic/Roman site

Cologne: Cologne Cathedral

Owen: Celtic holy mountain of Teck and oracular cave of Sybillenloch

Speyer: Imperial Cathedral of Speyer atop pagan site

Teutoburger Wald: Neolithic astronomical observatory atop the Externsteine Rocks★

Greece

Aegina Island: Ruins of the Temple of Athena Aphaia

Argos: Ruins of the Temple of Hera

Athens: Ruins of the Acropolis and the Parthenon★; Asklepios cave shrine

Delos: Ruins of ancient oracular sanctuary and Temple of Apollo

Delphi: Ruins of Tholos Temple in the Sanctuary of Athena Pronaia★; Temple of Apollo; Mt. Parnassus

Dodona: Ruins of ancient oracular sanctuary

Eleusina: Temple ruins of ancient city of Eleusis and nearby Kerata mountain

Epidavros: Ancient healing center of Epidauros with ruins of the Sanctuaries of Asklepios and Apollo Maleatas

Kamiros, Rhodes: Ruins of the Sanctuary of Apollo

Kéa: Lion of Kéa (Lionda)

Meteora: Greek Orthodox monastery of Rousanou★; other Greek Orthodox monasteries

Milos: Sanctuary of Phylakopi

Mt. Athos: Agion Oros (Holy Mountain) ★; Greek Orthodox monasteries and hermitages (Monastery of Panteleimon★; Monastery of Vatopedi★)

Mycenae: Ruins of ancient city

Olympia: Ruins of the Temple of Hera and the Temple of Zeus

Patmos Island: Holy Grotto of the Revelation; Monastery of St. John★

Thessaly: Mt. Olympus★

Tínos Island: Church of the Megalohari★; Prophet Elias mountain and monastery

Hungary

Budapest: St. Matthias Church (Church of Our Lady); St. Stephen's Basilica

Györ: Cathedral of Györ

Iceland

Thingvellir: Ruins of Althing assembly ground

Ireland

County Clare: Iniscealtra (Holy Island); Scattery Island monastery and round tower

County Cork: Blarney Castle and Blarney Stone; Mt. Gabriel

County Donegal: Station Island (St. Patrick's Purgatory) in Lough Derg (Red Lake)

County Galway: Round tower of Kilmacduagh

County Kerrig: Skellig Michael Island and monastery

County Kerry: Mt. Brandon stone circles and holy well; Shruberries stone circle and holy well of Kenmare

County Mayo: Croagh Patrick★; Knock Shrine

County Meath: Hill of Tara; Knowth, Dowth, Loughcrew, and Newgrange★ megalithic passage cairns

County Offaly: Round tower of Clonmacnois

County Sligo: Carrowmore megalithic dolmen tombs

County Tipperary: Round tower of Cashel★

County Waterford: Round tower of Ardmore

County Wexford: Our Lady's Island

County Wicklow: Round tower of Glendalough★

Italy

Assergi: Church of San Franco

Assisi: Franciscan holy places, including the Basilica di San Francesco★ and the Duomo di San Rufino★

Civitella in Val di Chiana: Church of San Michele

Loreto: Holy House of Loreto

Monte Casino: Abbey of Monte Casino; Monastery of St. Benedict

Monte Sant' Angelo: Church of San Michele Arcangelo

Padua: Basilica of St. Anthony

Paestum: Ruins of ancient city, including the Temple of Hera★

Rieti: St. Francis Fonte Colombo hermitage site

Rome: Basilicas of St. Mary Major, St. John Lateran, and St. Peter

Subiaco: Sacro Speco (Holy Cave) of St. Benedict

Syracuse: Cathedral of Syracuse, built over Temple of Athena

La Verna: St. Francis mountain shrine site

Kaliningrad

Pravdinsk: Shrine at pagan site of Romuva (Romowe)

Lithuania

Šiauliai: Hill of Crosses★

Malta

Gozo: Ggantija megalithic temple complex; Ta' Pinu Marian shrine★

Hagar Qim: Neolithic temple

Hal Saflieni Hypogeum: Underground Neolithic necropolis

Mnajdra: Neolithic temple★

Tarxien: Neolithic temple

Netherlands

Assen: Megalithic tombs

Emmen: Megalithic tombs

Heiloo: Shrine of Our Lady and holy well

Maastricht: Basilica of Our Lady

Norway

Borgund: Borgund Stave Church

Tønsberg: Ruins of round church; Church of St. Michael

Trondheim: Nidaros Cathedral★

Poland

Bialystok: Holy mountain of Grabarka

Czestochowa: Marian sanctuary of Jasna Góra★

Kalwaria Zebrzydowska: Marian sanctuary and Monastery of Kalwaria Zebrzydowska

Niepokalanów: Niepokalanów Basilica

Portugal

Braga: Sanctuary of Bom Jesus do Monte

Fátima: Basilica of Our Lady of Fátima★

Lamego: Sanctuary of Our Lady of Remedies

Russia

Kiev: Kiev-Pechersky Lavra (monastery)

Kostroma: Ipatievsky Monastery

Novgorod: Cathedral of St. Sophia★

Sergiev Posad: Trinity Lavra (monastery) of St. Sergius

Valaam: Monastery of the Transfiguration

Scotland

Iona: Holy island

Isle of Lewis, Outer Hebrides: Callanish stone ring★; numerous megalithic remains

Orkney: Stones of Stenness★; Ring of Brodgar; Maes Howe megalithic cairn

Slovenia

Brezje: Chapel of Our Lady of Brezje, Marija Pomagaj (Mary, help me)

Piran: Church of St. George

Spain

Ávila: Town and Church of St. Teresa

Montserrat: Basilica of Monserrat

Santander: Church of Our Lady of Garabandal

Santiago de Compostela: Cathedral of Santiago de Compostela★

Zaragoza: Shrines of the Two Marys★

Sweden

Gamla Uppsala: Former site of Norse Temple of Uppsala

Gotland: Bronze Age burial mounds

Husaby: Husaby Church and holy well

Öland: Stone Age passage graves and Bronze Age cairns at Stora Alvaret

Vadstena: Herrestad Church; Vadstena Abbey

Switzerland

Einsiedeln: Benedictine Einsiedeln Abbey★

Mariastein: Mariastein Abbey

St. Gallen: Abbey of St. Gall

Ukraine

Kiev: Kievo-Pecherska Lavra (Kyivan Cave Monastery)

Pochaev: Pochaev Lavra (monastery) of the Assumption of the Theotokos

Wales

Holywell: St. Winifred's Well

Middle East

Iran

Azerbaijan Province: Ruins of Takhte Soleiman (Throne of Solomon) temple complex

Bam: Ruins of ancient city of Bam★

Isfahan: Imam Mosque; Masjid-i Jami (Friday Mosque); Sheikh Lotf Allah Mosque

Mashhad: Shrine of Imam Reza★

Qom: Jamkaran Mosque★; Shrine of Fatima ibn Musa

Shiraz: Shah Cheragh Shrine; mausoleum of Amir Ahmad and Mir Muhammad

Yazd region: Pir-e-Naraki and Pir-e-Sabz Zoroastrian temple ruins

Iraq

Al Kadhimain (Al Kazimayn): Shrine of Seventh Imam, Musa ibn Ja'far al-Kadhim; Shrine of Ninth Imam, Muhammad ibn Ali al-Jawad (Ali al-Taqi)

Al Kufah: Imam Ali Mosque; Kufa Mosque; mausoleum of Muslim ibn Aqil

Al-Najaf: Hannana Mosque; Shrine of First Imam, Ali ibn Abu Talib

Baghdad: Shrine of Abd al-Qadir al Jilani

Basra: Imam Ali Mosque

Karbala: Shrine of Imam Husayn ibn Ali

Mosul: Great Mosque; Shrine of Prophet Yunus (Jonah); ruins of ancient city of Ninevah

Samarra: Shrines of Tenth Imam, Ali al-Naqi, and Eleventh Imam, Hasan al-Askari; Sardab (Cellar) of Twelfth Imam, Muhammad al-Mahdi

Israel

Bethlehem: Chapel of the Nativity★; Tomb of Rachel

Haifa: Mt. Carmel with Elijah's cave; Bahá'í Shrine of Bahá'u'lláh

Hebron: Cave of Machpelah with Tomb of the Patriarchs

Jericho: Quarantal, the Holy Grotto of the Temptation of Christ★

Jerusalem: Chapel of the Holy Sepulchre★; Dome of the Rock★; Holy City of Jerusalem (Mt. Zion)★; Western Wall★

Mt. Tabor: Basilica of the Transfiguration

Jordan

Petra: Jebel Haroun (Mountain of Aaron)★; ruins of ancient city of Petra with Nabataean Temple of Al-Deir★

Lebanon

Baalbek: Ruins of ancient temple complex of Heliopolis★

Saudi Arabia

Mecca: Holy city of Mecca; the Ka'ba at the Great Mosque★

Medina: Holy city of Medina; the Mosque of the Prophet★

Syria

Damascus: Shrine of Lady Zeinab★; shrine of Sheikh Muhi al-Din Ibn Arabi; Umayyad (Great Mosque)★

Homs: Khaled Ibn Al-Walid Mosque

Turkey

Agri Province: Mt. Arafat

Akdamar: Church of the Holy Cross (Akdamar Kilisesi)

Aphrodisias: Temple of Aphrodite★

Çorum Province: Ancient ruins of Hittite city Hattusha with rock-cut sanctuary of Yazilikaya

Darende: Sufi shrine of Somuncu Baba

Didyma: Temple and Oracle of Apollo

Istanbul: Eyüp Sultan Mosque

Konya: Shrine of the Sufi poet Rumi★

Mt. Nemrut Dagi: Ancient ruins of Nemrut Dagi, sanctuary of Commagene king Antiochus★

Africa

Algeria

Sahara Desert: Prehistoric rock art in Tassili n'Ajjer National Park (mountain range)

Tlemcen: Shrine of Abu Madyan

Egypt

Abydos: Osireion (subterranean temple of Osiris) and Temple of Seti I

Cairo: Al-Muharraq Monastery (Monastery of the Holy Virgin Mary); Zeitoun Virgin Mary Coptic Orthodox church

Dashur: Red Pyramid

Dendera: Temple of Hathor★

Edfu: Temple of Horus

Giza: Great Pyramid★; the Sphinx★

Karnak: Ruins of city of ancient Thebes, including temple complex of Karnak and Obelisk of Queen Hatshepsut★

Kom Ombo: Double Temple of Kom Ombo

Luxor: Ruins of city of ancient Thebes, including Colonnade of Amenhotep III and Luxor Temple★

Nubian Desert: Nabta Playa stone ring and megalithic site

Philae: Temple of Isis

Sinai Peninsula: Ruins of temple complex at ancient mines of Serabit-el-Khadem; Jebel Musa or Mountain of Moses (Mt. Sinai) and St. Catherine's Monastery★

Siwa oasis: Temple of Amun

Wâdi el Natrûn Desert: Monastery of Al-Baramus; Monastery of Al-Surian ("the Syrians"); Monastery of Anba Bishoi; Monastery of St. Macarius

Ethiopia

Axum: Church of St. Mary of Zion★

Bale Province: Shek Husen Islamic pilgrimage complex

Gishen: Monastery of Gishen Mariam

Lalibela: Rock-cut pilgrimage churches, including Church of Bet Giorgis★

Tana Kirkos: Tana Kirkos Monastery and Church

Gambia

Kerr Batch: Megalithic stone circles

N'jai Kunda: Megalithic stone circles

Wassu: Megalithic stone circles

Ghana

Larabanga: Larabanga Mosque

Madagascar

Ambohimanga Rova: Royal Hill of Ambohimaga, city of the Merina dynasty

Antananarivo Province: Antananarivo (Tananarive), city of the Merina Dynasty

Mali

Bandiagara region: Dogon Binu shrines★

Djenné: Great Mosque of Djenné★

Morocco

Fez: *Zawiya* (mausoleum) of Moulay Idris II★; Kairouyine Mosque★

Marrakech: Koutoubia Mosque★

Meknes: Ruins of ancient Roman city of Volubilis

Zerhoun: *Zawiya* (mausoleum) of Moulay Idris I★

Nigeria

Oshogbo: Osun-Oshogbo Sacred Grove, Yoruba forest sanctuary

Senegal

Tivaouane: Mosque of the Tijaniyyah Brotherhood

Touba: Great Mosque of Touba (Shiekh Amadou)

South Africa

Limpopo River valley: Ruins of Iron Age city on Mapungubwe hill

Sudan

Nile Province: Pyramids of Meroë★

Tunisia

Kairouan: Great Mosque of Kairouan★; Mosque of the Three Gates; Mosque Sidi Sahbi

Zimbabwe

Great Zimbabwe National Park: Ruins of ancient Munhumutapa city of Great Zimbabwe

Asia

Afghanistan

Herat: Abdullah Ansari shrine complex, Gazur Gah,

Azerbaijan

Baku: Zoroastrian Fire Temple of Baku

Bangladesh

Sylhet: Shrine of Shah Jalal, Sufi saint

Bhutan

Bumthang: Kurje Lhakhang (Temple of Guru Rimpoche)

Wangdue Phodrang: Wangdue Phodrang Dzong (monastery)

Cambodia

Angkor: Angkor temple complex★

China

Anhui: Huang Shan; Jin Hua Shan (Buddhist mountain of the south)

Henan: Song Shan (Taoist mountain of the center)

Hunan: Heng Shan Nan (Taoist mountain of the south)

Shaanxi: Hua Shan (Taoist mountain of the west)★; Heng Shan Bei (Taoist mountain of the north); Wutai Shan (Buddhist mountain of the north)★

Shandong: Tai Shan (Taoist mountain of the east)★

Sichuan: Emei Shan (Buddhist mountain of the west)

Zhejiang: Putuo Shan (Buddhist mountain of the east)★

India

Ajmer: Shrine of Mu'in al-din Chishti

Allahabad: Triveni Sangam (river confluence) holy bath site★

Amritsar: Golden Temple (Hari Mandir)★

Andhra Pradesh: Srisailam temple complex★

Badrinath: Six Badri temples, including Temple of Vishnu★

Bihar State: Bodh Gaya★

Calcutta: Dakshineswar temple complex, including Kali Temple★

Chidambaram: Sabhanayaka Nataraja Shiva Temple

Dwarka: Jagatmandir Krishna Temple★

Gangotri: Gangortri Temple (of the goddess Ganga)

Gujarat: Jain 863-temple complex of Shatrunajaya★

Hardwar: Holy city of Hardwar★, including Hari-ki-Pairi Ghat and numerous temples

Kanchipuram: Temple city

Karnataka: Sravanabelagola and great Jain statue of Sri Gomatheswar★

Kerala: Shrine of Sabarimala★

Madhaya Pradesh: Great Stupa at Hill of Sanchi

Madurai: Minakshi Temple; Paramthirsolai Temple; Tirupparangunram Murugan Temple

Maharashtra State: Ajanta cave temples; Ellora cave temples★; Grineshwar Jyotir Linga

Mt. Abu: Jain temples at Achalgarh

Mt. Girnar: Hindu Temple of Amba Mata; Jain five-temple complex

Nasik: Godavari River (site of Kumbha Mela, Hindu pilgrimage festival)

Pushkar: Lake and pilgrimage Temple of Brahma★; Hill and Temple of Saraswati★; many other Hindu pilgrimage sites

Rishikesh: Lakshman Jhula (Holy Bridge); Neela Kantha Mahadeva Temple

Sikkim: Pemayangtse Monastery; lake of Khecheopalri (Wish-Fulfilling Lake); ancient city of Yoksum and Khangchendzonga National Park

Tamil Nadu: Rameswaram Temple

Tiruchchirappalli: Vishnu temple complex of Srirangam★

Tirupati: Govindaraja Temple; Padmavathi Temple

Tiruttani: Subrahmanya Temple

Tiruvanamalai: Arunachala Hill and Arunachaleswara Temple★

Varanasi: Temples, ghats, and pilgrimage circuits of River Ganges and holy city of Varanasi★

Vrindavan: Temple city of Krishna

Indonesia

Bali: Mt. Abang; Mt. Agung and Temple of Pura Besakih★; Mt. Batukaru and Temple of Pura Luhur; Mt. Batur

Java: Borobudur Stupa★

Japan

Aomori Prefecture: Osore-san (Buddhist/Shinto Mountain of the Dead)

Gunma and Nagano Prefectures: Asama-san (Buddhist/Shinto mountain)

Hatsukaichi Prefecture: Holy island of Miyajima, including Hokoku Shrine★, Itsukushima Shrine and Otorii gate★, and Misen-san (Buddhist/Shinto mountain)

Honshu: Nantai-san (Buddhist/Shinto mountain)★

Ise: Ise Shrine

Kyoto: Zen garden of Ryoan-ji★

Kyoto and Shiga Prefectures: Hiei-san (Buddhist/Shinto mountain)

Kyūshū: Aso-san (Buddhist/Shinto mountain)

Nagano Prefecture: Ontake-san (Buddhist/Shinto mountain)

Nara Prefecture: Katsuragi-san, Omine-san, and Yoshino-san (Buddhist/Shinto mountains)

Otaru: Oshiro stone ring

Shizuoka and Yamanashi Prefectures: Fuji-san (Buddhist/Shinto mountain)★

Taisha: Izumo Taisha Temple★

Usa: Usa shrine

Wakayama Prefecture: Koya-san (Buddhist/Shinto mountain)

Yamagata Prefecture: Gassan, Haguro-san, and Yudono-san (Buddhist/Shinto mountains)

Kazakhstan

Turkestan: Sufi shrine of Sheikh Ahmad Yasawi

Laos

Champasak Province: Wat Phu (Mountain Temple), Buddhist temple at Khmer site

Luang Phabang: temples; Pak Ou Caves (Buddhist shrine)

Vientiane: Pha That Luang (Great Sacred Stupa); Wat Si Muang Temple

Mongolia

Bayan-Ölgiy Province: Mt. Tavan Bogd Uul

Myanmar

Bagan: Bagan temple complex★; Shwezigon Pagoda

Bago: Shwemawdaw Pagoda

Mandalay: Mahamuni Temple and Buddha★

Mon State: Kyaiktiyo Pagoda

Pyay: Shwesandaw Pagoda

Yangon: Shwedagon Pagoda★

Nepal

Kathmandu: Bodhnath Stupa; Budhanilkantha Temple; Changu Narayan Temple; Dakshinkali Temple; Mahankal Temple; Nagarjun Hill; Pashupatinath Temple; Swayambhunath Stupa★; Kwa Bahal Temple; Mahabuddha Temple; Matsyendranath Temple

Lapchi: Gephel Ling Temple and Jangchub Stupa (Milarepa Hermitage)

Lumbini: Lumbini Garden, birthplace of Buddha

Mustang District: Hindu and Tibetan Buddhist sanctuary of Muktinath

Pharping: Asura Cave Temple; Vajra Yogini Temple; Shikar Narayan Temple

North Korea

Hwanghaenam-do Province: Guwol-san (mountain) and temples

Kumgansan tourist region: Geumgang-san (mountain) and temples

Pyeongan Province: Myohyang-san (mountain) and temples

Pakistan

Lahore: Data Durbar Shrine; Shrine of Dadaji Ganj Baksh

Multan: Shrine of Hazrat Bahuddin Zakariya; Shrine of Shah Rukn-e-Alam; Shrine of Shah Shams Tabriz

Philippines

Luzon: Mt. Banahao; Mt. Pinatubo

Mindanao: Mt. Apo

South Korea

Busan: Haedong Yonggungsa Temple shrines

Chungcheongnam-do Province: Gyeryong-san (mountain) and shrines

Dolsan: Hyangil-am Temple

Gangwon Province: Odae-san (mountain) and temples

Geumjeong-gu: Geumjeong-san (mountain) and temples, including Beomeosa Temple

Jeju-do: Halla-san (mountain) with cave temple complex of Sanbangsa★; Sanbang-san (mountain)

Jeollanam-do Province: Jiri-san (mountain) and temples, including Hwaeomsa Temple

Jung-gu District: Nam-san (mountain)

Mt. Gaya: Haeinsa (Dharma Jewel) Monastery

Namhae: Bori-am shrine

North Gyeongsang Province: Bulguksa Temple

North Jeolla Province: Moak-san (mountain) and temples

Seoul: Inwang-san (mountain) and temples; Yeonju-dae Hermitage

Suncheon: Songgwangsa (Sangha Jewel) Monastery and temples

Taebaeksan Range: Taebaek-san (mountain) and temples

Taechon County: Samgak-san (mountain) and temples

Yangsan: Tongdosa (Buddha Jewel) Monastery

Yeongju: Buseoksa Monastery

Sri Lanka

Anuradhapura: Ruins of ancient city of Anuradhapura, including Jetavanaramaya Stupa

Kandy: Temple of the Sacred Tooth

Kataragama: Buddhist, Hindu, Muslim, and indigenous Vedda pilgrimage center

Mt. Mihintale: Mihintale Buddha★

Polonnaruwa: Ruins of ancient city of Polonnaruwa, including Gal Viharaya (Rock Temple)

Sabaragamuwa Province: Adam's Peak★

Taiwan

Pei-kang: Ch'ao-t'ien Temple

Thailand

Bangkok: Phra Sri Ratanasadaram

Kanchanaburi: Phra Thaen Dong Rang

Nakhon Pathom: Phra Pathom Chedi

Nakhon Si Thammarat: Phra Mahathat

Phitsanulok: Wat Phra Si Ratana Mahathat with Phra Phuttha Chinnarat Buddha★

That Phanom: Wat That Phanom Chedi★

Tibet

Dagpo: Daglha Gampo Monastery

Guge: Tholing Monastery; Tsaparang Monastery

Gyatsa County: Lake Lhamo Latso (Oracle Lake)

Kailash Range: Mt. Kailash★

Kya Ngatsa: Birthplace of Jetsun Milarepa

Lhasa: Jokhang Temple★; Potala Palace★

Mt. Drakar: Drakar Taso (Milarepa Hermitage)

Samye Valley: Chimpu Retreat Center and caves; Mt. Hepo Ri and Samye Monastery

Satlej River Bank: Tirthapuri hot springs

Shigatse: Tashilhunpo Monastery

Vietnam

Da Nang: Marble Mountain Buddhist shrines

Duy Phú: Ruins of ancient Cham city of My Son

Ho Chi Minh City: Quan Am Pagoda

Hoi An area: Ruins of ancient Khmer city of Amratavati

Mekong Delta: Holy Sam Mountain with temples

Nha Trang: Po Nagar Tower

Pacific

Australia

Uluru–Kata Tjuta National Park: Ayers Rock (Uluru)★; Kata Tjuta Rock (the Olgas)★

New Zealand

North Island: Mt. Taranaki and Mt. Tongariro (Maori mountains)

Rangitoto: Mt. Rangitoto (Maori mountain)

Rotorua: Mt. Ngongotaha or Te Tuahu a te Atua (Altar of God)

Tahiti

Pohnpei: Megalithic site of Nan Madol

Raiatea: Ancient marae (ceremonial site) of Taputapuatea

South America

Argentina

Luján, Buenos Aires: Basílica Nuestra Señora de Luján

San Juan: Santuario Difunta Correa

Bolivia

Copacabana: Basilica of the Virgen de la Candelaria★

Lake Titicaca: Island of the Sun★; Island of the Moon★; Tiwanaku temple complex, including Puma Punku★, Kalasasaya Temple★, Mt. Ancohuma★, and Mt. Illampu★

Potosí Department: Salar de Uyuni★; Mt. Tunupa★

Samaipata: Ruins of the ancient city of El Fuerte

Brazil

Bahia: Grotto and Church of Bom Jesus da Lapa; Santa Cruz dos Milagres

Congonhas: Sanctuary of Bom Jesus de Matosinhos

Piaui: Santa Cruz dos Milagres

Salvador: Church of Senhor do Bonfim

São Paulo: Shrine of Nossa Senhora de Conceição Aparecida

Chile

Rapa Nui (Easter Island)★

Santiago: Basilica of Nuestra Señora del Carmen del Maipú

Colombia

Buga: Basilica of Señor de los Milagros

Cauca Department: Pre-Columbian archaeological site of Tierradentro

Huila: Pre-Columbian archaeological site of San Augustín★

Ipiales: Sanctuary of Las Lajas★

Ecuador

Banos: Church of Nuestra Señora del Agua Santa

Cañar Province: Ruins of Incan city of Ingapirca

El Cisne: Basilica of El Cisne★

Pichincha: Cochasqui pre-Incan astronomic observatory and ceremonial center; El Santuario del Quinche

Paraguay

Caacupé: Church of Nuestra Señora de los Milagros

Peru

Ancash region: Chavín culture temple complex of Chavín de Huantar

Arequipa: Church of the Virgen de Chapi

Barranca: Ruins of Chimú culture fortress of Paramonga

Chapi: Sanctuary of Virgen de Chapi

Chuquibamba: Church of the Virgen de Copacabana

Cusco region: Ruins of Incan cities of Machu Picchu★ and Vilcabamba; ruins of Incan complexes of Coricancha, Kenko, Machay, Sacsayhuamán, and Tambo; ruins of Incan fortress of Ollantaytambo

Huamachuco District: Ruins of Huamachuco culture city of Marcahuamachuco

Junín: Ruins of Huanca culture temple complex of Wariwilka

Lake Titicaca: Ruins of Incan temples of Pachatata and Pachamama; pre-Incan burial ground of Sillustani

Lambayeque Valley: Ruins of city of Túcume (Lambayeque/Sican, Chimú, and Incan cultures)

Lima area: Megalithic site of Marcahuasi; ruins of Huari and Incan city of Pachakamac

Motupe: Cave shrine of Cruz de Chalpón (Cross of Chalpon)

Mt. Ausungate: Mountain shrine of Señor de Qoyllur Rit'i★

Nazca Desert: Nazca culture ceremonial center of Cahuachi; Nazca lines

Otuzco: Church of La Virgen de la Puerta

Paracas National Reserve: El Candelabro Geoglyph

Trujillo, La Libertad: Ruins of Chimú city of Chan Chan; Moche temple complex of Huacas de Moche

Utcubamba Valley: Ruins of Chachapoyas culture fortress of Kuelap

Venezuela

Isla de Margarita: Basilica Virgen del Valle

Maracaibo: Basilica of Nuestra Señora de Chiquinquira

Yaracuy State: Mt. Sorte

North America

Canada

Montreal: St. Joseph's Oratory

Peterborough: Petroglyph Provincial Park

Québec: Shrine of Ste.-Anne-de-Beaupré

Vancouver Island: Petroglyph Provincial Park

United States

Arizona: Canyon de Chelly National Monument (Anasazi ruins); Mt. Humphreys (Doko O Sliid); Red Rocks of Sedona★

California: Mt. Shasta

Colorado: Great Sand Dunes National Park; Mt. Blanca (Sisnaajini); Mt. Hesperus (Dibe Nitsaa)

Florida: Crystal River Archaeological State Park

Georgia: Etowah Indian Mounds Historic Site

Hawaii: Maui—Haleakala Crater★ and Piilanihale Heiau Temple; Hawaii—Mauna Kea★ and Pu'uhonua O Honaunau; Kauai—Ka ulu Paoa Heiau Temple

Maine: Mt. Katahdin

New Mexico: Chaco Canyon National Monument (Anasazi ruins, including Pueblo Bonito)★; Mt. Taylor (Tsoodzil); Petroglyphs National Monument; Shiprock★; White Sands National Monument★

Ohio: Great Serpent Mound

Wisconsin: Blue Mound State Park

Wyoming: Devils Tower National Monument★

Central America and the Caribbean

Belize

Belize District: Ruins of Mayan city of Altun Ha

Costa Rica

Cartago: Basilica of Nuestra Señora de Los Angeles

Cordillera Central: Irazú Volcano

Guatemala

Chiantla: Church of Nuestra Señora de Candelaria

El Petén Department: Ruins of Mayan cities/ceremonial centers of Altar de Sacrificios, Ceibal, El Mirador, Piedras Negras, Tik'al, and Uaxactun

Escuintla Department: Ruins of Mayan city of Monte Alto

Esquipulas: Church of El Cristo Negro

Haiti

Seau d'Eau Waterfall

Honduras

Copán Department: Ruins of Mayan city of Copán

Tegucigalpa: Church of Nuestra Señora de Suyapa

Mexico

Campeche: Ruins of Mayan city of Edzná

Chalma: Pilgrimage church of Chalma★ upon Aztec shrine of Oztoteotl

Chiapas: Ruins of Mayan city of Palenque (Temple of the Inscriptions)★

Cozumel: Mayan shrine of the goddess Ixchel

Guadalajara: Basilica of Nuestra Señora de Zapopan

Izamal: Convent of San Antonio de Padua★

Jalisco: San Juan de los Lagos★

México (State): Aztec archeological site of Malinalco,; Mt. Cerro Gordo

Mexico City: Ruins of ancient city of Teotihuacán, including the Pyramid of the Sun★; Basilica of Nuestra Señora de Guadalupe★ on top of pre-Columbian hill of Tepeyac

Monte Albán: Ruins of Zapotec ceremonial site of Monte Albán★

Oaxaca: Church of La Virgen de la Soledad; ruins of Mixtec and Zapotec burial site of Mitla, including the main sanctuary★

Pátzcuaro: Basilica of Nuestra Señora de la Salud

Puebla: Iglesia de Nuestra Señora de los Remedios on top of Great Pyramid of Cholula; Mt. Iztaccihuatl★ and Mt. Popocatepetl★

Quintana Roo: Ruins of Mayan city of Tulum, including Temple of Kukulcan (El Castillo)★

Talpa: Church of Nuestra Señora del Rosario, on pagan site of the goddess Cihuacoatl

Tlaxcala: Shrine of Nuestra Señora de Ocotlán at pre-Columbian site

Tula: Ruins of ancient Toltec Sanctuary of Tollan★

Yucatán: Ruins of Mayan cities/ceremonial centers of Chichén Itzá, including Temple of Kukulcan★, Izamal, Labna, Sayil, and Uxmal, including Pyramid of the Magician★

Nicaragua

El Viejo: Church of La Purísima Concepción de Nuestra Señora de Caborca

BIBLIOGRAPHY

Aitken, Bill. *Seven Sacred Rivers*. New Delhi: Penguin Books, 1992.

Aveni, Anthony, ed. *World Archaeoastronomy*. Cambridge, U.K.: Cambridge University Press, 1989.

Basho, Matsuo. *The Narrow Road to the Deep North*. Harmondsworth, U.K.: Penguin Classics, 1967.

Batchelor, Stephen. *The Tibet Guide*. London: Wisdom Publishers, 1987.

Begg, Ean. *The Cult of the Black Virgin*. London: Arkana, 1985.

Bernbaum, Edwin. *Sacred Mountains of the World*. San Francisco: Sierra Club, 1990.

Brennan, Martin. *The Stars and the Stones: Ancient Art and Astronomy in Ireland*. London: Thames & Hudson, 1983.

Brockman, Norbert C. *Encyclopedia of Sacred Places*. Santa Barbara, CA: ABC-CLIO, Inc., 1997.

Chan, Victor. *Tibet Handbook: A Pilgrimage Guide*. Chico, CA: Moon Publications, 1994.

Cleary, Thomas, and Sartaz Aziz. *Twilight Goddess: Spiritual Feminism and Feminine Spirituality*. Boston: Shambhala, 2000.

Coleman, Simon, and John Elsner. *Pilgrimage: Past and Present in the World Religions*. Cambridge, MA: Harvard University Press, 1995.

Cook, Elizabeth, and Tarthang Tulku. *Holy Places of the Buddha*. Crystal Mirror Series, vol. 9. Berkeley, CA: Dharma Publishing, 1993.

Crumrine, N. Ross, and Alan Morinis, eds. *Pilgrimage in Latin America*. Westport, CT: Greenwood Press, 1991.

de Santillana, Giorgio, and Hertha von Dechend. *Hamlet's Mill: An Essay on Myth and Frame of Time*. Boston: Gambit Incorporated, 1969.

Derereux, Paul. *Earth Memory: Sacred Sites—Doorways Into Earth's Mysteries*. Woodbury, MN: Llewellyn Publications, 1992.

Eck, Diana. *Banaras: City of Light*. Princeton, NJ: Princeton University Press, 1982.

Geldard, Richard. *The Traveler's Key to Ancient Greece: A Guide to Sacred Places*. New York: Knopf, 1989.

James, John. *The Traveler's Key to Medieval France: A Guide to the Sacred Architecture of Medieval France*. New York: Knopf, 1986.

Knight, Christopher, and Robert Lomas. *Uriel's Machine: The Prehistoric Technology that Survived the Flood*. Boston: Element Books, 1999.

The cliffside shrine of St. Amadour, Recamadour, France.

Michell, John. *The Earth Spirit: Its Ways, Shrines and Mysteries.* London: Thames & Hudson, 1975.

———. *The New View Over Atlantis.* London: Thames & Hudson, 1983.

Miller, Hamish, and Paul Broadhurst. *The Dance of the Dragon: An Odyssey into Earth Energies and Ancient Religion.* Cornwall, U.K.: Pendragon Press, 2000.

———. *The Sun and the Serpent: An Investigation into Earth Energies.* Cornwall, U.K.: Pendragon Press, 1989.

Morinis, Alan. *Pilgrimage in the Hindu Tradition: A Case Study in West Bengal.* New York: Oxford University Press, 1984.

———. *Sacred Journeys: The Anthropology of Pilgrimage.* Westport, CT: Greenwood Press, 1992.

Mullikan, Mary, and Anna Hotchkis. *The Nine Sacred Mountains of China.* Hong Kong: Vetch and Lee, 1973.

Nolan, Mary L. *Christian Pilgrimage in Modern Western Europe.* Chapel Hill, NC: University of North Carolina Press, 1989.

Olson, Carl, ed. *The Book of the Goddess, Past and Present: An Introduction to Her Religion.* New York: Crossroad, 1986.

Pagels, Elaine. *The Gnostic Gospels.* London: Penguin Books, 1982.

Pennick, Nigel. *The Ancient Science of Geomancy.* London: Thames & Hudson, 1979.

Phillips, Graham. *The Marian Conspiracy.* Rochester, VT: Bear & Co., 2005.

Picknett, Lynn. *Mary Magdalene: Christianity's Hidden Goddess.* New York: Carroll & Graf Publishers, 2003.

Picknett, Lynn, and Clive Prince. *The Templar Revelation: Secret Guardians of the True Identity of Christ.* New York: Touchstone Press, 1997.

Schele, Linda, and David Freidel. *A Forest of Kings: The Untold Story of the Ancient Maya.* New York: William Morrow & Co., 1990.

Service, Alistair, and Jean Bradbury. *A Guide to the Megaliths of Europe.* London: Granada Publishing Ltd., 1979.

———. *The Standing Stones of Europe.* London: J.M. Dent & Sons, Ltd., 1979.

Singh, Rana. *The Spirit and Power of Place.* Varanasi, India: National Geographical Society of India, 1994.

Snelling, John. *Sacred Mountain: Travelers and Pilgrims at Mount Kailash in Western Tibet, and the Great Universal Symbol of the Sacred Mountain.* London: East West Publications, 1983.

Starbird, Margaret. *The Woman with the Alabaster Jar.* Santa Fe: Bear & Co., 1993.

Statler, Oliver. *Japanese Pilgrimage.* London: Picador-Pan, 1984.

Stoddard, Robert, and Alan Morinis, eds. *Sacred Places, Sacred Spaces: The Geography of Pilgrimages.* Baton Rouge, LA: Louisiana State University, 1997.

Sullivan, William. *The Secret of the Incas: Myth, Astronomy and the War Against Time.* New York: Crown Publishers, 1996.

Sumption, Jonathen. *Pilgrimage: An Image of Medieval Religion.* London: Faber and Faber, 1975.

Tompkins, Peter. *Secrets of the Great Pyramid and the Magic of Obelisks.* New York: Harper & Row, 1971.

———. *Secrets of the Mexican Pyramids.* New York: Harper & Row, 1987.

West, John Anthony. *Serpent in the Sky: The High Wisdom of Ancient Egypt.* New York: Julian Press, Inc., 1987.

———. *The Traveler's Key to Ancient Egypt: A Guide to the Sacred Places of Ancient Egypt.* New York: Knopf, 1988.

Wolfe, Michael. *One Thousand Roads to Mecca: Ten Centuries of Travelers Writing about the Muslim Pilgrimage.* New York: Grove Press, 1997.

ACKNOWLEDGMENTS

All these people have loved me and have helped me bring this book to you. Please read their names and join me in thanking each of them.

David Frechter

Mike Petty

Dawson Hayward

James Hutton

Cliff Gaines

Mark Schultz

Jen Bethune

Rain and Gary Klepper

Eric Henkels

Bruce Orion

Karen Reider

Robert Rocheleau

John Michell

Graham Hancock

Cathy Hemming

Barbara Berger

Hannah Reich

Rebecca Cremonese

Index

Notes: Specific site names are in *italics,* and references to maps of sacred sites are in **bold** typeface. For specific cities, see the country in which they are located.

SACRED EARTH

Sacred Earth: Places of Peace and Power is composed largely in the classic font known as Bembo, which was originally designed by Francesco Griffo in 1495. Griffo worked in Venice for the renowned printer and publisher Aldus Manutius. The type was created for an essay published by Manutius enitled *De Aetna*, written by Cardinal Pietro Bembo—for whom the font was named. Today's Bembo is a revival of the original type cut by Griffo; it was created by the Monotype Corporation in 1929 under the direction of Stanley Morison. Over five hundred years later, Bembo remains an avatar of classic, elegant type design and is considered one of the primary roots of "Old Style" serif fonts.

The additional fonts used are Trajan, designed by Carol Twombly in 1989; Syntax, designed by Hans Eduard Meier in 1968; and Meta, designed by Erik Spiekermann in 1985.

The book is printed on 157 gsm Matt Gold East paper and was printed and bound by CS Graphics PTE LTD, Singapore.